Sixteen Studies

16
STUDIES

By H. W. Janson

HARRY N. ABRAMS, INC., PUBLISHERS, NEW YORK

Patricia Egan, Editor

Library of Congress Cataloging in Publication Data:

Janson, Horst Woldemar, 1913-

SIXTEEN STUDIES.

"A collection of essays published in periodicals between
1937 and 1970."

CONTENTS: The putto with the Death's
head.—Titian's Laocoon caricature and the
Vesalian-Galenist controversy.—The "image made by
chance" in Renaissance thought.—[Etc.]

 1. Art—Addresses, essays, lectures. I. Title.
N7445.2.J36 704.9'2 73-4757

ISBN 0-8109-0130-7

Library of Congress Catalogue Card Number: 73- 4757

Printed and bound in Japan

Contents

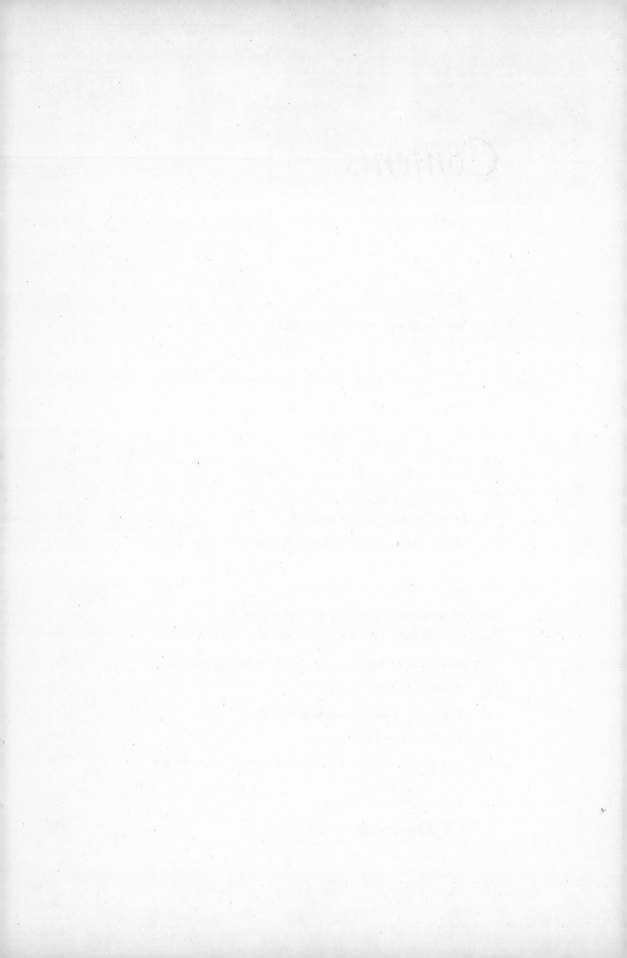

Apologia

The late Erwin Panofsky used to say that false modesty is a great deal better than no modesty at all. His remark strikes me as peculiarly comforting now that I find myself in a situation where false modesty is, as it were, thrust upon me. True modesty would have compelled me not to have anything to do with this reprinting of some of my studies, while a complete lack of it would have made me insist on the inclusion of everything I ever wrote that is not between hard covers. While I did not originate the idea of the present collection, I welcomed it to the point of agreeing to select the pieces, and I believe I owe the reader an explanation of my rationale.

It is perhaps easiest to explain why, quite apart from practical considerations, I opted for selectivity rather than inclusiveness. Few indeed are those whose every scrap deserves to be exhumed. I cannot say that I am ashamed of anything I have written in the course of the past thirty-five years; still, I find a good deal of it too slight, too narrowly tailored to circumstances now difficult to recapture, or too far off target in its conclusions. This is not to imply, however, that I believe everything I did choose to be right on target even today. Richard Krautheimer, another friend from whose wisdom I have profited on countless occasions, once observed that any piece of scholarly writing is bound to be out-of-date by the time it gets published. What possible justification can there be, then, for reprinting it years later? Any such enterprise involves a degree of presumption— the presumption that the study in question, outdated though it be, represents some kind of landmark, however tiny, in the development of our discipline, and therefore can still be read with profit. To what extent this presumption is justified for any of the papers in this volume I must leave to the reader's judgment. If I have been unduly partial to certain of my lesser brainchildren, I beg the reader's indulgence. But assuming that my choice is not altogether capricious—I have taken the precaution of checking it against the opinions of some friends and colleagues whom I hesitate to thank by name lest I be accused of buck-passing— the enterprise may be defended on grounds of convenience, since most of the studies united between these covers originally appeared in out-of-the-way places such as *Festschriften*, symposia, acts of scholarly congresses, or journals that are now defunct.

The selection having been made, there arose a number of more specifically editorial problems. In what sequence were the sixteen items to be presented? Should they be grouped by theme, by technique, by period? None of these criteria seemed wholly satisfactory, so that in the end I opted for a "biographical" se-

quence, by date of publication. On this I shall want to say more below, but first I must get another editorial decision out of the way: to what extent, and in what way, ought I to bring these studies up to date? To do so in the full sense of the term would have meant reworking them completely—a labor of Sisyphus doomed to failure. Certain halfway measures suggested themselves— rewriting or eliminating some passages, adding footnotes or postscripts. But this would have introduced just enough small changes to force the reader to compare the old and the new versions, instead of permitting him to use the reprint as a substitute for the hard-to-obtain originals. Hence I decided on the "anastatic" method, warts and all, correcting only misspellings, printer's errors, and obvious inconsistencies. Most of these were discovered by Patricia Egan, who read the text with infinitely greater care than I ever did.

A further word needs to be said about my preference for the "biographical" order of the studies. I chose it not because it reveals a clearly discernible intellectual development on my part—I believe it does nothing of the sort—but because it made me think of the circumstances that occasioned each of these pieces. Scholars rarely bother to explain why they happen to be interested in a given problem, and I thought that some candid reflections on the subject might be instructive. While I hesitate to generalize from my own experience, it seems to me that the element of chance plays a far more determining part here than is usually acknowledged. Such a discussion will also permit me to refer the reader to later publications dealing with the various themes of these studies.

In 1935, as a graduate student at Harvard, I ran across a bargain in a second-hand bookshop: a slightly imperfect copy of the *Inscriptiones Sacrosanctae Vetustatis* by the German humanist Petrus Appianus, who was familiar to me from Panofsky's research on Dürer and the antique. One of its woodcut illustrations struck me as particularly puzzling; it showed a winged putto, a skull, and a nude man, labeled with the names of the Three Fates (1: fig. 21). My attempts to explain the origin and meaning of this image eventually grew into "The Putto with the Death's Head." Soon after its publication, I discovered, to my great surprise, that Jean Seznec had been working on the same subject. His brief article, published soon after my own, duplicated some of my findings but also contained material I had missed.[1] I began to wonder then—and I have been wondering ever since—whether this and similar instances of two or more scholars simultaneously and independently investigating the same topic must be put down as mere coincidence or whether perhaps the subject in question was "an idea whose time had come" and thus likely to be hit upon by more than one investigator. In view of the frequency with which the phenomenon occurs, the latter explanation seems the more plausible. Among later publications on the subject, an article by Rudolf Wittkower deserves particular mention.[2]

The *vanitas* theme implicit in the putto with the death's head was to occupy my attention once more a few years later, when my wife gave me a little sixteenth-century engraving she had bought from a New York print dealer, of two monkeys primping against a background of ruined buildings. It led to a

[1] "Youth, Innocence and Death," *Journal of the Warburg Institute*, I, 1937-38, pp. 298 ff.

[2] "Death and Resurrection in a Picture by Marten De Vos," *Miscellanea Leo van Puyvelde*, Brussels, 1949, pp. 117 ff.

book-length iconographic study, *Apes and Ape Lore in the Middle Ages and the Renaissance,*[3] which involved, among many other things, an investigation of the role of apes in the history of anatomy and its relation to Titian's *Laocoon Caricature* woodcut.

The genesis of "The Image Made by Chance" is a more complicated affair. It began in the early 1950s with my puzzlement at the work of Jackson Pollock, whose unorthodox technique seemed to demand an appraisal of the role of chance in the creation of works of art. For me, the problem came to a head when Betsy, a young chimpanzee at the Baltimore Zoo, was launched upon her brief career as an "action painter." My first attempt to come to terms with this phenomenon was an essay, "After Betsy, What?,"[4] followed soon after by the paper reprinted here. It turned out that this was another "idea whose time had come," for Ernst Gombrich investigated it in his *Art and Illusion* and Heinz Ladendorf published an essay on a closely related theme, all at the same time.[5] I have since dealt with the subject again, in a more general way.[6]

"Fuseli's *Nightmare*" originated in the spring of 1962, when I visited the home of a San Francisco psychoanalyst to see his private collection. On the wall of a hallway I saw an engraving (4: fig. 5) after Fuseli's *Nightmare* of 1782 that seemed quite unrelated to my host's interests as a collector. When I asked him about the print, he told me that he had gone to some trouble to find a specimen because he had first seen that engraving in Sigmund Freud's Vienna apartment.[7] After that, the subject preoccupied me for several months. My findings have now been absorbed in the far more thoroughgoing monograph by Nicolas Powell,[8] and in Gert Schiff's monumental study of the artist's career.[9]

The article on Nanni di Banco's *Assumption* is a byproduct of my interest in Florentine Early Renaissance sculpture. It was motivated by my disagreement with the often repeated view that this work represents the artist's return to an essentially Gothic style. "Giovanni Chellini's *Libro,*" on the other hand, received its impulse from a postcard sent to me about 1960 by Raymond de Roover, the historian of Renaissance economics, who knew of my concern with Donatello through our common membership in the Columbia University Seminar on the Renaissance; he referred me to an article in a sociological journal that had escaped my attention as well as that of other art historians. The passage in Chellini's *Libro* dealing with Donatello made clear to me for the first time the full importance of the artist's colossal statue of Joshua, long since destroyed, and ultimately led me to an inquiry into the *giganti* of Milan Cathedral as its possible antecedents. "Donatello and the Antique" had been a long-standing preoccupation of

[3] *Studies of the Warburg Institute*, 20, London, 1952.

[4] *Bulletin of the Atomic Scientists*, XV, 2, February 1959, pp. 68 ff.

[5] "Zur Frage der künstlerischen Phantasie," *Mouseion: Studien . . . für Otto Förster*, Cologne, 1960, pp. 21 ff.

[6] "Chance Images," *Dictionary of the History of Ideas*, New York, 1973, I, pp. 340 ff.

[7] There remains some confusion as to which version of Fuseli's picture was reproduced in the print owned by Freud. Jack J. Spector, *The Aesthetics of Freud*, New York, 1973, illustrates the painting in the Goethemuseum, Frankfurt (to which he assigns the unwarranted date 1783) rather than the canvas of 1782, now in the Detroit Institute of Arts, which is by far the more likely candidate.

[8] *Fuseli: The Nightmare (Art in Context)*, London and New York, 1973.

[9] *Johann Heinrich Füssli, 1741-1825*, Zurich and Munich, 1973, p. 496.

mine, but the material proved so refractory that I might never have attempted a coherent presentation of it if Professor Mario Salmi, the chairman of the Dona-tello Congress in Florence commemorating the five-hundredth anniversary of the master's death, had not invited me to speak on the subject. Two other pieces dealing with Renaissance sculpture originated as lectures at symposia: the essay on the new image of man, at Ohio State University; and that on the equestrian monument, at the University of Texas. Both attempt to survey a rather large theme for a scholarly but non-specialized audience. Since the lecture on the eques-trian monument was originally published without illustrations, I am particularly glad to see it at last provided with the visual documentation it demands.

"Ground Plan and Elevation in Masaccio's *Trinity* Fresco" began in 1960. While writing on the famous mural in my *History of Art,* I started wondering about the location in space of God the Father's feet; was it inconsistent, consciously or not, with the perspective construction of the rest of the picture? I criticized Kern's analysis of the perspective scheme and then submitted it to Erwin Panofsky, with whom I had a long, friendly argument on the subject by correspondence. Evidently the *Trinity* fresco was another "idea whose time had come," as evidenced by Ursula Schlegel's article of 1963 in the *Art Bulletin* and Otto von Simson's in the *Jahrbuch der Berliner Museen* (1966). My own findings have been utilized and, in part, corrected in Joseph Polzer's recent exhaustive study of the mural.[10]

"The Right Arm of Michelangelo's *Moses*" might be considered an offshoot of my work on Donatello and the antique, which had alerted me to the curious fact that certain medieval works of art were considered antique in the fifteenth and sixteenth centuries. The most famous instance is, of course, the Florentine Baptistery, believed then to have been built as a Temple of Mars. The medals of Constantine and Heraclius, made around 1400 in Paris, are another. Since they were unquestioningly accepted as ancient until the seventeenth century, I won-dered whether they might not have influenced the great Renaissance masters on occasion. At the same time, I was puzzled by the claim in the Michelangelo liter-ature that the *Moses* reflects a Romanesque bronze statuette of the same subject. Could Michelangelo have known a medieval representation of Moses of this type? If so, would he have mistaken it for an antique? It struck me one day that the bust of Heraclius on the medal might be the missing link between the two, and I set about trying to assemble the intermediate steps. Freud's interpretation, which seemed an effective way of introducing the subject of my article, came to my attention only at a later point in my research.[11]

One of the consequences of my interest in Early Renaissance sculpture has been a growing awareness that the history of sculpture often presents problems quite distinct from those of painting. Nowhere is the cleavage more pronounced than in the nineteenth century, hence my concern with sculpture between the century's two great turning points, Canova and Rodin. The essay on nudity in Neoclassical

[10] "The Anatomy of Masaccio's Holy Trinity," *Jahrbuch der Berliner Museen*, 13, 1971, pp. 18 ff., with references to the earlier literature.
[11] Spector, *op. cit.*, pp. 128 ff., has attempted to mediate between Freud's approach and my own to the meaning of the gesture.

art was an early attempt to deal with a problem in this area; that on Rodin and Carrier-Belleuse is another. The specific starting point of the latter, however, was once again a matter of chance: driving westward along the south bank of the Columbia River one summer ten years ago, I gazed at the barren hills on the opposite bank and suddenly found myself staring in disbelief at a small replica of Stonehenge and what looked like an eighteenth-century mansion. My curiosity aroused, I crossed the river at the next opportunity and drove east along the north bank. The mansion turned out to be the Maryhill Museum, where I found a fine collection of Rodin sculpture, including the unpublished maquettes on which my article is based.

A few words of qualification need to be said about the two remaining pieces, both of them rather short, on originality and on criteria of periodization. The first was an invited comment on Professor Meyer Schapiro's paper, "On Perfection, Coherence, and Unity of Form and Content," in the section devoted to "grounds for judgment of artistic excellence" of a symposium on art and philosophy chaired by Sidney Hook in 1964. Finding myself thoroughly in agreement with Meyer Schapiro's remarks, I tried, as the only other art historian in an assembly of philosophers, to convey some notion of how value judgments are actually made in our discipline. Needless to say, the philosophers disagreed. My essay on criteria of periodization, too, must be seen in the context where it appeared. It was written for an issue of *New Literary History* devoted to problems of periodization in several related fields of historical study. The other contributors on periodization in the history of art were Meyer Schapiro, Ernst Gombrich, and George Kubler. My own concern was not to set up a method but to assess the current state of thinking on the subject. I had, of course, had occasional thoughts on originality and periodization before, but the opportunity to formulate them I owe to Sidney Hook and to Ralph Cohen, the editor of *New Literary History*.

There is, then, an element of the unforeseen, of opportunity grasped by the forelock, in the genesis of most of my sixteen pieces. Perhaps serendipity is a still better term. It is a faculty, a frame of mind, that can be cultivated. While it won't help us build intellectual systems, it reconciles us to our precarious condition in an insecure and changing world. Like the optimistic frog in a vat of cream who refused to drown and struggled on until he found himself sitting on a lump of butter, we may, if we trust our mental luck, find ourselves creating small islands of knowledge in a sea of ignorance.

H. W. J.

STUDY 1

The Putto with
the Death's Head

"The Putto with the Death's Head,"
Art Bulletin, Vol. XIX, 1937, pp. 423-49

Death in the numerous allegories conceived by the imagination of fifteenth- and sixteenth-century artists assumes its strangest, if not its most important, form in the putto with the death's head.[1] Unlike others, it was not founded on the literary or pictorial traditions of earlier periods. Consequently, it retained, throughout its existence, a flexibility that enabled it to be a focal point for all those conflicting notions of death which the Renaissance developed out of the heritage of the late Middle Ages. The putto with the skull had so many affiliations with other allegories of the same general import that, in order to clarify its unique position, its history may best begin with a short survey of the earlier representations of death in Western art.

Death, from its very nature, seems to have suggested to the artist two widely divergent alternatives. It could be regarded either as a physical state, illustrated by a representation of a corpse, or as a metaphysical event. In the latter case there would be shown the supernatural being causing death or performing some function in connection with the soul of the deceased. These two aspects, though frequently coexisting, have always been kept strictly apart, except in the late medieval "animated corpse" type where both appear united. The metaphysical aspect seems by far the older. Ancient Egyptian art swarms with gods of the dead; to classical Greece death appeared as Thanatos, a youthful genius, and as a symbol of death the corpse was unknown. It was in Egypt that the latter made its earliest appearance, significantly enough, as a symbol not of religion but of utter hedonism. On festive occasions, small statues of dried-out mummies were placed on the dining tables, reminding the guests of their future and thus inducing them to take full advantage of the present.[2] When the Romans took over this usage, they replaced the mummy with the skeleton when representing man's corporeal state after death.[3]

[1] This paper has grown out of an assignment in the course "History of Drawing and Engraving" conducted by Prof. Paul J. Sachs at Harvard University; it was presented, in preliminary form, at the meeting of the Harvard-Princeton Fine Arts Club in Princeton, N.J., January 30, 1937. I want to acknowledge my gratitude to Prof. Erwin Panofsky of Princeton, N.J., for many valuable suggestions; to Prof. Chandler R. Post of Harvard University for generous help and advice; to Dr. Lieselotte Moeller of Hamburg for having procured the photographs for figures 11, 16, and 24.

[2] One of these mummies is preserved in the collection of F. W. von Bissing and published by the owner in *Zeitschrift für Ägyptische Sprache und Altertumskunde*, I, 1912, p. 63. Cf. Frederick Parkes Weber, *Aspects of Death and Correlated Aspects of Life*, London, 1918, pp. 28 ff.

[3] Cf. Otto Brendel, "Untersuchungen zur Allegorie des Pompejanischen Totenkopf-Mosaiks," *Mitteilungen des Deutschen Archäologischen Instituts, Römische Abteilung*, XLIX, 1934, pp. 74–97.

Soon, however, skeletons achieved a new significance. They were taken to be the *Larvae*, the images of the deceased living in the lower world. As such they naturally could move and even talk, abilities that are depicted on the cups of Boscoreale.

The growing concern of late antiquity with the afterlife, a concern particularly evident in the cult of Psyche, created another type: the skeleton was combined with the butterfly, the well-known symbol of the soul, this striking formula showing that man's life did not end with the decay of the body. These representations seem to have occurred most frequently on gems and other objects closely attached to their owners, possibly as amulets. Since the head had always been regarded as the most important part of the human body, an attitude revealed by the frequent figurative use of *caput* in antiquity to designate importance, the skull became the most important part of the skeleton and was often used alone, as *pars pro toto*.

It was not the skull alone, however, that possessed this mortuary significance: Deonna[4] has shown that the Dionysiac mask could have the same meaning; that the putti playing with masks on many Dionysiac sarcophagi symbolize the Dionysiac paradise of eternal inebriation, whereas the mask stands for death. From the evidence of these examples Deonna has proved that a group of sepulchral reliefs, previously interpreted as representations of poets with masks as attributes of their profession, shows deceased individuals pondering over a symbol of death (fig. 1).[5] In some instances, this meaning has been made even more explicit by substituting for the mask the skull with the butterfly superimposed.[6] These melancholy figures, with their quietly contemplative attitude toward a symbol of the hereafter, have a surprisingly modern air which will bear comparison with similar creations of the Renaissance. However, their meditation is not principally concerned with death as such, but, rather, with some definite conception of the next world. The mask suggests the Dionysiac afterlife; the skull, invariably accompanied by the butterfly, suggests that the soul survives in immaterial form the death of the body.

With the rise of Christianity this tradition died out almost completely. Early Christian and Byzantine art represented death only as defeated by Christ or the Christian Virtues; for this purpose death was either identified with the Devil[7] or personified by a type derived from the Greek Thanatos.[8] The Roman type of skeleton survived in two usages only: in the grave of Adam beneath the cross of the crucified Christ; and in illustrations of the Vision of Ezekiel (37:1–8), where, at the command of God, the prophet resurrects the dead from their graves.[9] In both instances, however, the gruesome realism of Roman art was carefully avoided in order not to conflict with the idea of resurrection implied

[4] *Revue archéologique*, III, 5e série, 1916, pp. 74–97.

[5] Reproduced in *Athenische Mitteilungen*, 1901, pp. 132–33.

[6] Cf. Roscher, *Lexikon*, s.v. "Psyche," p. 3235.

[7] Derived from Christ's Descent into Limbo. Cf. Adele Reuter, *Beiträge zu einer Ikonographie des Todes*, Leipzig, 1912, pp. 14 ff.

[8] Cf. the *Topography* of Kosmas Indikopleustes; Reuter, *op. cit.*, p. 7.

[9] *Idem*, pp. 45 ff., and Rudolf Helm, *Skelett- und Todesdarstellungen bis zum Auftreten der Totentänze*, Strasbourg, 1928, p. 48.

in the representations. The illustrations of Ezekiel were rare and their influence negligible, but the grave of Adam occurred with increasing frequency from the seventh century on. Ferdinand Piper,[10] tracing the literary and theological history of the motif, has proved it to be a local Jewish legend of pre-Christian origin known to many Early Christian authors. Though most of these denied that Adam was actually buried on Mount Golgotha, they repeated the legend because of its opportune symbolic implications, as did, for example, St. Jerome. In the East, where the legend was formally accepted, Adam's grave became a standard feature of Byzantine Crucifixions.[11] The Roman Church condemned it officially, but the testimony of St. Jerome, as well as the influence of Byzantine art, helped to keep its memory alive. From the twelfth century on, the motif became popular in Western European art, especially in the abbreviated form showing only the skull of Adam and a few bones.

The summit of its popularity was reached in the fifteenth century, when Europe was preoccupied with problems of death; the motif was not discarded until the late sixteenth century. Like its predecessors in Roman art, the skull of Adam stands for nothing more than man's corporeal state between death and resurrection, and has no meaning in itself. Just as the Roman skull was combined with the butterfly, the skull of Adam had to be attached to the image of the crucified Redeemer who gave eternal life to mankind through His own corporeal death. Thus firmly restricted to a definite location, the skull of Adam could not enter other branches of medieval iconography.

The putrescent living skeleton of the late Middle Ages developed from entirely different sources. As opposed to the representations of death in the art of the first millennium A.D., this new type aimed at impressing the spectator as strongly as possible with its horrors. This aspect had been emphasized already in the ardent descriptions of death by certain Early Christian ascetics, notably Ephraem Syrus and St. John Chrysostom, but had produced no counterpart in art. From the eleventh century on, when it gradually achieved new importance all over Europe, ascetic monasticism enthusiastically turned to the writings of these authors and, for the first time, attempted to illustrate them graphically. A sixth-century monastic treatise, the so-called *Klimax,* by Johannes, abbot of the monastery on Mt. Sinai, was especially popular because of its preoccupation with death, and was preserved in numerous eleventh- and twelfth-century Byzantine manuscripts illustrated in a new, realistic manner with scores of drastically faithful representations of corpses, the earliest of their kind in Christian art.[12] These manuscripts certainly influenced Western Europe, but the most important sources for the living skeleton are the representations of moral allegory in French Romanesque art. Impurity, Luxury, and similar vices were depicted as naked women with their

[10] *Adams Grab auf Golgotha, Evangelischer Kalender, Jahrbuch für 1861,* Berlin, ed. Ferdinand Piper, pp. 17–29.

[11] I am indebted to Prof. Charles R. Morey of Princeton for reference to the earliest representation, a gilt-bronze reliquary cross of ca. 600 A.D. in the Museo Cristiano, nos. 35 and 38, described and reproduced by E. S. King in *Atti della Pontificia Accademia Romana di Archeologia, serie III, Memorie II,* 1928, pp. 193–205. That this cross, as Mr. King suggests, belongs to a group made in Palestine for pilgrims to the Holy Land, conforms very well to the origin of the legend as traced by Piper, *op. cit.*

[12] Cf. Reuter, *op. cit.,* pp. 49 ff., and references cited there.

intestines being eaten by snakes and toads.[13] Soon after, man's corporeal state after death came to be generally represented in the same way, but with the process of decay carried so far as to leave little but the skeleton. Once this type was established, it was introduced into all representations dealing with death, such as tombstones, the Last Judgment, the Legend of the Three Living and the Three Dead, and the Apocalypse. The last of the Four Horsemen in the Apocalypse, Death, was shown as an animated skeleton from the beginning of the fourteenth century on, perhaps even somewhat earlier,[14] a source from which the fourteenth century derived its conception of the animated skeleton personifying death as a universal evil power. For this purpose, the living corpse was imbued with the gruesome agility that medieval figurations of devils had long before possessed. Any attempt at anatomical correctness was naturally eschewed in these representations, the principal aim being to remind the spectator of the horrors of death and thus to evoke greater piety.

Northern art, visionary as it was, found no fault with the conception of a corpse which moved like an animated creature; welcoming the unbounded freedom of imagination that this type permitted, it made it a favorite subject. Italian art, on the other hand, was far less inclined to make the living skeleton type its own. Its appearances in the South were due to Northern influence. Corpses motionless in their coffins and depicted with all signs of putrescence were, however, employed to signify death as a state, as in the famous *Triumph of Death* in the Camposanto at Pisa:[15] Significantly enough, in the same picture death as an active force is personified by an ugly woman with a scythe,[16] who, however, bears no traces of physical decay.[17]

[13] Although, as Helm, *op. cit.*, p. 56, has shown, the *femmes aux serpents* had originally been personifications of *Terra*, they were soon reinterpreted as *Luxuria*. This change of meaning may well have been inspired by the numerous passages in the writings of Early Christian authors describing the human body as the prey of snakes and other animals. The ultimate source of this concept is Ecclesiasticus (10:13): "Cum enim morietur homo, hereditabit serpentes, et bestias, et vermes." An exceptional type of *Luxuria*, for notice of which I am indebted to Mr. Charles Niver, occurs on the west tympanum of the Puerta de las Platerías at Santiago de Compostela, and on a capital of S. Maria de Tera: a young woman holds a rather realistically modeled skull in her lap. This concept seems, however, to be derived from a purely local legend: the adulterous wife forced to fondle the rotting head of her lover, as described in the Pilgrim's Guide (cf. A. Kingsley Porter, *Romanesque Sculpture of the Pilgrimage Roads*, Boston, 1923, p. 214, pl. 679).

[14] The earliest example known to me is the MS in Weimar (ed. Von Gabelentz, *Biblia Pauperum*, Strasbourg, 1912). An interesting transitional state is represented by the fourth rider in one of the archivolts of the central portal of Notre-Dame, Paris: behind the rider appears a corpse sitting or lying on the horse (Helm, *op. cit.*, fig. 28).

[15] For the contrast between the Italian and Northern representations of the legend see the examples enumerated by Millard Meiss, "The Problem of Francesco Traini," *Art Bulletin*, XV, 1932, p. 168.

[16] This type is derived from the early medieval personifications of Death which, in some rare examples, continued their existence through the High Middle Ages. G. Swarzenski, *Die Regensburger Buchmalerei des X. und XI. Jahrhunderts*, Leipzig, 1901, pl. XII, reproduces a miniature of about 1002 in which Death, as a human figure with broken lance and scythe, appears beneath the cross, analogous to the skull of Adam. Caesarius of Heisterbach, in the *Dialogus Miraculorum*, mentions representations of Death "in specie hominis cum falce." That, in the Camposanto fresco, Death appears as a woman might be due to the female gender of *Mors*. The scythe is derived from the sickles appearing in the Apocalypse, 14:14.

[17] The same difference between the Italian and Northern conceptions occurs in the representations of Christ as Man of Sorrows. In the North, Christ was always shown as living,

The greater consistency of Italian art in the representation of life and death as contrasted with the preference for the living skeleton in the North finally produced, in the Early Renaissance, the human skull as the most condensed symbol of death. The corpses of the Camposanto had been merely its more elaborate forerunners. Although not yet symbols of death but rather concrete examples, they had only to undergo a process of abbreviation and abstraction to be transformed into the striking formula of the skull. This, however, presupposed a new approach which was not developed until the highly abstract and complex allegories and symbolisms of early fifteenth-century humanism, first pictured in the medals of Pisanello and his followers. It is among the works of these followers that the skull as a mortuary symbol makes its earliest appearance.[18]

The artist to be credited with its introduction is Giovanni Boldù, a Venetian medalist who displayed the scholarly training he had received at the University of Padua by employing particularly intricate emblems, and Hebrew as well as Greek inscriptions.[19] In 1458, Boldù made a medal for himself (fig. 2):[20] a self-portrait in contemporary costume is on the obverse; an allegorical scene referring to him with an elaborate signature in the manner of Pisanello occupies the reverse. The naked youth who is seated on a small heap of earth in the center, a scene possibly inspired by antique sculpture, is probably the artist in melancholy contemplation of the three figures that complete the design. Before him stands Faith, an angel with a chalice; behind him appears Penitence, an old woman ready to strike him with a scourge;[21] the skull which lies at his feet symbolizes Death;[22] and in the radiating sun above, Heaven appears. The design,

despite His wounds, whereas the Italians depicted the Saviour supported by the Virgin and St. John or angels so as to leave no doubt about His death. Cf. E. Panofsky, *"Imago Pietatis,"* *Festschrift Max J. Friedländer,* Leipzig, 1927.

[18] A transition from corpses, as seen in representations of the Three Living and the Three Dead and related subjects, to the skull on the Boldù medals (cf. below) may be seen in a medal of uncertain date and origin reproduced and described by Weber, *op. cit.,* p. 482 (cf. also A. Venturi, *L'Arte,* X, 1907, p. 449, and XI, 1908, p. 56). The obverse shows an imaginary profile portrait of Virgil in the costume of the early fifteenth century, an inscription in Gothic lettering said to have come from the poet's legendary medieval tomb in Naples, and the date 1134, which refers, according to Weber, to the alleged discovery of Virgil's bones. In my opinion, the medal, a rather poor work in a belated Gothic style, might very well have been done in Naples in 1434 in commemoration of the tercentenary of the discovery of the poet's bones. The reverse displays the shoulder blades, neck, and head of a skeleton eaten by worms, and the inscription *quod sum, hoc eritis, fuimus quandoque quod estis,* the leitmotif of the legend of the Three Living and the Three Dead. K. Künstle, *Die Legende der drei Lebendigen und der drei Toten,* Freiburg, 1908, p. 28, proves this inscription to be much older than the legend with which it is invariably combined; the words can be traced back to late antiquity and may even have inspired the legend itself, a twelfth-century creation. Compare Brendel, *op. cit.;* W. Stammler, *Die Totentänze des Mittelalters,* Munich, 1922; and the most recent study of the subject, L. P. Kurtz, *The Dance of Death and the Macabre in European Literature,* Columbia University Press, New York, 1936.

[19] G. F. Hill, *A Corpus of Italian Medals of the Renaissance before Cellini,* London, 1930, s.v. "Boldù."

[20] *Idem,* no. 420.

[21] Compare the *Penitentia* in Assisi, Lower Church, Chastity fresco; reproduced in I. B. Supino, *Giotto,* Florence, 1927, pls. L and LI.

[22] The surface of the medal is badly scratched so that the details of the skull are scarcely recognizable. It seems, however, that a pair of wings is attached to the sides of the death's head, denoting perhaps Eternity. Cf. the winged shell on the Marsuppini tomb in S. Croce, Florence, by Desiderio da Settignano.

then, is a Christian *memento mori:* Boldù, and through him mankind in general, meditates upon the skull symbolic of his inevitable destiny, with Faith offering salvation, and Penitence tormenting his conscience. Although this ethical concept is medieval, it is presented in the new form of Early Renaissance art. The artist's aim is no longer to frighten the onlooker, but to evoke a pensive attitude.

A second version of the same subject, made by Boldù in the same year,[23] eliminates this Christian content (fig. 3). Two reasons may have brought the artist to revise his first formula so soon: the artistically unsatisfactory character of the first design, and a sudden preoccupation with antiquity. The latter explanation can be gathered from the new form he gave to the self-portrait on the obverse of the second medal, representing himself with naked shoulders and a laurel wreath around his head, *all'antica.* The reverse, however, shows the change most strikingly, and it was this design that found so large a following among Boldù's contemporaries and that introduced the putto with the skull into Renaissance iconography.

The naked youth has remained in place almost without change. He differs from the earlier model only in that he now covers his face with both hands in a gesture of distress. The rest of the former design has been completely altered, not only making this second reverse a more satisfactory composition, but endowing it with a new content. Again the inscription offers no help, but a repetition of the same design, dated 1466,[24] bears the legend *Io son fine,* which may also apply, as a title, to the second medal of 1458. The words are spoken by a winged nude putto, who has replaced the personifications of Faith and Penitence. He reclines on a big skull and clutches a bundle of flames with his left hand. There can be little doubt about the significance of the flame, a well-known symbol of the soul. The putto, then, seems to be a kind of mortuary genius *all'antica* combined with an angel carrying the soul to Heaven. This type of angel, however, had always been represented in Christian art as adult, clad in long garments and holding a small figure of the deceased as the image of the soul. Nor could Boldù have derived the putto with the flame in his hand directly from antique art in which the genius of death always appears as a standing youth or Cupid turning a torch toward the ground. That the artist invented the type himself can be proved by the fact that he took the pose of his putto from an earlier medal, dated 1452–57, by Pietro da Fano (fig. 4),[25] showing a Cupid with bow and arrow seated opposite a porcupine. The porcupine symbolizes the invulnerable marital love of the person portrayed on the obverse. The whole conception is the invention of a witty humanist. The very fact that Boldù borrowed his mortuary putto from this design seems to indicate his ambition to come as close as possible to antique art.

The peculiar appeal that Boldù's design was to exercise upon later fifteenth-century Italian art and sixteenth-century northern European art was, however, not based on its unusual allegorical mesning, the exact significance of which may have been known only to the artist himself; but on something much more ob-

[23] Hill, *op. cit.,* no. 421.

[24] *Idem,* no. 423.

[25] *Idem,* no. 407.

vious and commonly intelligible: the striking contrast between the putto, the very image of youth and vitality, and the cold, empty shell of man's thought and sensibility against which it rests. This antithesis made the putto with the skull one of the favorite *memento mori* designs of Renaissance art, although its original implications were neglected by all who profited from it. When, about 1470, Boldù's design was copied on a marble plaque in the Certosa of Pavia, an inscription was added that was clearly based on the mere visual impression of the design: *Innocentia et memoria mortis.*[26] Here, the putto means nothing but innocent childhood. The Certosa relief is, however, the only known copy made during the fifteenth century in which Boldù's scene has been taken over as a whole. Other artists inspired by the medal were unable to comprehend the interrelations of seated youth, putto, and skull, with the result that they took the scene apart and copied either the seated man and the skull or the putto with the skull, thus creating two separate and more easily comprehensible types: the man meditating upon a skull, and the putto with the skull, i.e., childhood and death.

The first alternative was chosen by a Ferrarese medalist, Antonio Marescotti, who in 1462 made a medal of a Servite monk and preacher, Paolo Alberti (fig. 5).[27] The reverse of this medal is obviously inspired by the Boldù designs, but has been retranslated into strictly Christian terms, all humanistic elements having been eliminated. The skull alone now takes the place of Boldù's intricate allegorical devices, and the naked youth has become a realistic portrait of the monk, who again looks directly at the skull on the ground before him. Paolo Alberti's preoccupation with death is exhibited as the most conspicuous activity of a Christian ascetic.

As a challenge to the pagan trends of the period, Marescotti's motif soon became a popular source of inspiration with other monks, as can be seen in various designs of slightly later date: among others in a medal by Sperandio, of 1467.[28] Despite its utterly Christian character, the Marescotti reverse strongly resembles some of the antique works previously cited, especially a relief in Naples (see fig. 1). Not only is the spiritual content of the Marescotti medal—meditation over a symbol of death—analogous to the Naples relief; but so also are the details of its design, like the chair and the melancholy gesture which Boldù had already employed in his first medal. The heap of earth on which sits the youth of the two Boldù medals occurs in a relief in the Villa Albani of the same group as that in Naples. All these features strongly suggest a direct influence of antiquity upon Boldù and Marescotti, although it seems impossible to determine exactly how the influence came in, unless a specific monument be found to have been the prototype. Even so, the close correspondence of the antique and Quattrocento designs may serve to emphasize the contrast between the conception of death in the Italian Renaissance and that in the Gothic North.

The reverse of Marescotti's medal not only was repeated in portraiture but also

[26] Weber, *op. cit.*, p. 477.

[27] Hill, *op. cit.*, no. 83.

[28] *Idem*, no. 363; in this instance, the monk is seated on a heap of earth as is the youth of the Boldù medals, not on a chair, as in the Marescotti design.

is found to have influenced the iconography of the saints.[29] Once the skull had been established as the outstanding symbol of asceticism, it could easily be introduced into representations of hermit saints. The most popular of these in the Italian Quattrocento was St. Jerome, who was generally pictured chastising himself in front of his cave, whereas in northern European art he is conceived as the scholarly cardinal in his studio.[30] From the early 1470s on, Italian representations of the hermit St. Jerome show a large skull beneath the small crucifix at which the saint glances while beating his chest with a stone.[31] Later on, the skull also appeared in connection with St. Francis and the Magdalene.

The Italian late fifteenth-century designs of the hermit St. Jerome with the skull inspired in turn one of the most popular *memento mori* types of northern European painting: the portrait-like half-length representation of St. Jerome pointing at a skull. Scores of these were produced by Flemish masters during the third and fourth decades of the sixteenth century.[32] The earliest example of this group is thought to be Albrecht Dürer's painting in the Lisbon Museum, done during the master's sojourn in Antwerp in 1521.[33] The initial idea, however, can be traced in the master's work to a much earlier date by means of a drawing in Berlin, L. 175 (fig. 6), which still reflects the Italian type of St. Jerome. Dürer's early Basel woodcut of 1492, as well as the woodcut of 1511 and its preparatory drawing (L. 777, Ambrosiana, Milan), had shown St. Jerome in the customary type of Northern fifteenth-century art: the learned cardinal without the skull, busily engaged in the revision of the Bible.

The famous engraving of 1514, however, shows the skull conspicuously in the foreground on the window sill. The Berlin drawing, therefore, may be regarded as the master's first sketch for the design;[34] like the preceding versions, it

[29] In medieval art, Christian iconography had been influenced in various instances by portrait types. The best-known example is Giotto's *Magdalene Embracing the Cross,* a pose that occurs in donors' portraits from the ninth century on.

[30] Cf. A. Strümpell, "Hieronymus im Gehäus," *Marburger Jahrbuch für Kunstwissenschaft,* II (1925/26), p. 173.

[31] The skull seems to occur earliest with minor masters; examples in R. van Marle, *The Italian Schools of Painting,* XIII, p. 247 (Bartolommeo di Giovanni), and XII, p. 385 (Jacopo del Sellaio, who took his design for *St. Jerome* from an early Botticelli, but added the skull). The skull was placed beneath the crucifix in analogy with the skull of Adam, frequent in Crucifixions of the period. It will be remembered that St. Jerome's writings, which experienced a great rise in popularity during the Renaissance, contain one of the main references to the legend of Adam's grave.

[32] Cf. A. Goldschmidt, "Die Anfänge des Genrebildes," *Das Museum,* II, pp. 33–36.

[33] For the relation of this painting to the Flemish versions of the same subject by Reymerswaele and others, cf. Max J. Friedländer, *Die Altniederländische Malerei,* XII, Leiden, 1935, p. 70. That, as some authors have it, the Lisbon painting was inspired by an earlier Flemish picture of this type seems highly unlikely to me. None of the extant examples can be dated prior to 1521 with any degree of certainty, whereas, on the other hand, the influence of the Lisbon picture is evidenced by the existence of many direct copies, attributed to Joos van Cleve, listed in Friedländer, *op. cit.,* IX, p. 132. Strümpell, *op. cit.,* p. 233, refers to a Flemish early sixteenth-century painting in the Dresden museum which she believes to be a copy of a late fifteenth-century design, as a proof that the skull in conjunction with this type of St. Jerome is a late fifteenth-century invention. The picture is, however, by no means a faithful detailed copy of an earlier design but contains so many early sixteenth-century elements that the skull will have to be regarded as one of the latter.

[34] H. Wölfflin, *Handzeichnungen Albrecht Dürers,* no. 54, dates the drawing L. 175 between 1515 and 1520, but to me it seems much more akin to the style of the first half of that decade. Dr. Gustav Pauli of Hamburg, who has studied the drawing in question, has been kind enough to give his opinion of the matter in a recent letter to Miss Dudley, keeper of prints in the Fogg

shows the saint closer to the spectator than does the engraving, but the cell already has the same arrangement as the famed *Hieronymus im Gehäus.* The figure of St. Jerome himself differs from both the earlier and the later designs and is, in fact, unique among all representations of this type. Sitting at his desk as usual, St. Jerome looks mournfully at a skull in front of a crucifix, an arrangement strikingly similar to the Italian combination of skull and crucifix in the type of painting discussed above. Equally evident is the influence of the Italian type in the attire of the saint, whom Dürer has portrayed in a hermit's sleeveless garb rather than in a cardinal's gown.[35]

The daring combination of the Italian "hermit" type with the domestic "scholar" type is a true product of Dürer's genius and lends to the subject a strong introspective quality unsurpassed even in the master's own work. For the example of 1514, Dürer abandoned this gloomy aspect of the saint; the famous engraving was designed as a kind of companion piece to the *Melancholia I,* showing the quiet happiness of contemplative life in the pursuit of saintly work.[36] Thus, Dürer returned to the customary "scholar" type of St. Jerome, transfiguring it into an idyl of blessed old age; but retained the skull, which he now placed on the window sill in the foreground because it would have appeared very small if left on the desk in the rear. When Dürer went to the Netherlands in 1520, he revived his original concept, and the result was the Lisbon painting and its derivatives.

The meditating seated figure in Boldù's design of 1458 (see fig. 2) had, by way of the Marescotti medal, laid its influence on the Christian iconography of Renaissance art. At the same time the rest of the Venetian medalist's design, the putto with the skull, was developed into a separate *memento mori* formula. As an independent type, its earliest and most influential form occurs in an Italian woodcut of the late Quattrocento (fig. 7).[37] The purpose of the design is to impress the spectator with the short span between birth and death through the conjunction of the putto, the image of extreme infancy, with the wreck of a human head that has been cleaned of its flesh by the toads and lizards lurking in the foreground. The inscription warns "The hour passes" (*L'hora passa*), and the hourglass repeats this idea.

This contrast between life and death even appears in the green tree behind the putto and the withered trunk against which the skull is placed, an allegory derived from the *Pélérinage de l'âme* by Guillaume Deguilleville, a product of

Museum, Cambridge, Mass. Dr. Pauli, emphasizing the unquestionable authenticity of the drawing, dates it between 1511 and 1515.

[35] The only other instance, to my knowledge, of *St. Jerome* in his cell wearing the hermit's gown is a group of paintings by Joos van Cleve and his school; in these the saint chastises himself while sitting at his desk. This type, however, is evidently a later combination of Dürer's *St. Jerome* of 1521 and the Italian pictures mentioned above. Cf. Friedländer, *op. cit.,* IX, p. 132 and pl. XXIX.

[36] For the relation of Dürer's *St. Jerome* of 1514 to the *Melancholia I,* see E. Panofsky-F. Saxl, *Dürers "Melancholia I"* (Studien der Bibliothek Warburg), Leipzig, 1923, p. 73, and the analogous passage in the second edition of the same work.

[37] Paris, Bibl. Nat.; Heitz, *Einblattdrucke,* LXXXI, 1934, no. 47; Schreiber, IV, no. 1896; dated by Schreiber 1490–1500. The woodcut is one of the earliest examples showing an hourglass in a *memento mori,* a humanistic combination of time and death that does not seem to have been introduced until shortly before 1500.

fourteenth-century mysticism known in Venice in the late fifteenth century, as G. Ludwig has proved.[38] The dead tree of the *Pélérinage* was the apple tree of the Garden of Eden, withered through man's sin that brought death to both mankind and all other living things; whereas the living tree was the mystic apple tree of the Canticum Canticorum (2:3–5), and its fruits, the symbols of Christ. In the illustrations of the treatise published by Ludwig, the souls of the blessed, in the form of naked children, play with the apples of the living tree. That the anonymous artist of the woodcut was inspired by this source for his own allegorical concept is evident from the fact that here, too, the living tree appears as an apple tree. Perhaps the putto himself incorporates to some extent the souls of the blessed in the *Pélérinage*.[39] The putto of the Boldù medal, since he has been deprived of his wings, has assumed the appearance of an ordinary infant. Like many putti of antiquity, however, he acts like an adult in casting a sorrowful glance at the hourglass before him. His arm, still resting on the skull, supports his head in a meditative pose derived from that of the seated youth of the Boldù medal.

In a slightly later bronze statuette, the putto has assumed an even more philosophical attitude (fig. 8).[40] Leaning on the hourglass, he ponders upon the skull which he holds on his knee, in imitation of the ascetic monks and saints previously referred to. The inscription around the base is in the same vein. Weber gives the following translation:[41]

Time passes and death comes,
Lost is he who does not do good;
We do wrong (in this world)
And we hope for good (in the life after death).
Time passes and death comes.

— a strange admonition, indeed, when coming from a putto.

[38] *Jahrbuch der Preuss. Kstslgn.*, XXIII, 1922, pp. 163 ff.; Ludwig traces the illustrations of the treatise up to the well-known painting by Giovanni Bellini in the Uffizi, Florence. This symbolism must not be confused with the Tree of Barlaam and Josaphat, from which it was probably inspired, but which lived on as a separate type in representations like the Late Gothic woodcut of 1460/70 in Haberditzl, *Einblattdrucke*, I, Vienna, 1920, p. 168, pl. CVIII, where the tree is sawed through by Death and the Devil. Cf. E. Panofsky, *Hercules am Scheidewege* (Studien der Bibliothek Warburg, 18), Leipzig, 1930, p. 157, and Reuter, *op. cit.*, p. 52.

[39] The woodcut is traditionally called Florentine; its dependence on the Boldù medal, however, as well as on the rather rare allegory of the two trees, suggests Venice as a possible place of origin, and its style seems to corroborate this assumption. The statuettes quoted in note 40 also suggest northeast Italy as the home of the motif.

[40] W. von Bode, *Die Italienischen Bronzestatuetten der Renaissance*, Berlin, 1907, III, pl. CCXLV (formerly Oppenheimer Collection, acquired by the Victoria and Albert Museum in 1936; cf. *Review of the Principal Acquisitions during the Year 1936*, London, 1937, p. 4). Bode ascribes it to a "Paduan artist of the beginning of the sixteenth century." In a bronze hand-bell published by Bode as Andrea Riccio (*op. cit.*, pl. CCXLIX), the putto with the skull is used in an ornamental way for the handle (formerly J. P. Morgan Collection; exhibited in the Burlington Fine Arts Club Exhibition of Italian Renaissance Art, London, 1912, no. 32; in the same exhibition, no. 8, was shown another decorative variant of the motif, an Italian ivory statuette owned by F. Leverton Harris).

[41] *Op. cit.*, p. 164; the original wording is given by Weber as follows:
Il tempo passa e la morto (!) vien
Perito (?) lui (?) chi non fa ben

In one peculiar instance, the content of the *L'hora passa* woodcut has even been retransferred onto Boldù's initial concept of 1458. A bronze plaque on the tomb of Marcantonio Martinengo in the Museo Cristiano at Brescia, done by Maffeo Olivieri[42] soon after 1526 (fig. 9), repeats the design of the Boldù medal, but with significant alterations taken over from the woodcut. Olivieri used the *L'hora passa* design as an aid in interpreting the content of the medal, and took over from it such paraphernalia as could, to his mind, make the meaning of the medal more explicit. The living tree now appears behind the seated youth, while the putto leans against the withered tree, from the branches of which dangle the hourglass and an additional skull and crossbones. As a result of these changes, the youth, characterized as the image of life by the tree behind him, in horror hides his face from the display of mortuary symbols in front of him. The putto, twisted into a distinctly uneasy pose, displays signs of grief and pain that anticipate, to some extent, the changes which the putto with the skull underwent in Northern art of the sixteenth century.

Transmitted through the *L'hora passa* woodcut, the putto with the skull became highly popular in the North from the early 1520s on, especially in Germany and the Netherlands. However, the Northern Renaissance evolved a widely different conception of the motif, adapting it to its own traditions and purposes. The putto as well as the skull suggested to the Northern artist a content entirely foreign to the Italian versions.

The Italian Quattrocento had cherished the putto not iconographically but aesthetically as the product *par excellence* of antique art. From the dawn of the Early Renaissance, when Nanni di Banco's relief on Or San Michele had shown a sculptor engaged in carving a putto instead of an icon as the worthiest test of his abilities, putti had continued to impersonate the joyous vitality of youth, so congenial to the main trend of the period, without the limitations of subject matter.[43] When this type of putto became popular in the North in the early sixteenth century, it retained the *joie de vivre,* but with added moral implications, both good and evil. Putti could turn into angels, whose happy temperament made them welcome playmates for the Infant Christ[44] and messengers of heavenly joy. On the other hand, their vitality made them symbols of pagan hedonism, and relegated them to the representations of damnable sensuality like Luxuria, Venus, and the witches, where they appeared as the offspring of these evil creatures, reflecting the innate evil lust of their breed even in their childish antics.[45] As such, they had to share the destiny of their parents: to be trapped

Fac(c)iamo mal e sper(i)amo i(l) be(n)

Il tempo p(a)ssa e la mo(rte) v(i)en.

[42] Maffeo Olivieri was a native Brescian, but closely allied with Venetian and Paduan art. Cf. A. Morassi, "Per la ricostruzione di Maffeo Olivieri," *Bollettino d'Arte*, XXX, 1936, p. 237.

[43] For the general significance of the putto in Italian Early Renaissance art, cf. F. Wickhoff, *Mitteilg. d. Instit. f. Österr. Geschichtsforschg.*, III, 1882; and Wilhelm Bode, *Florentine Sculptors of the Renaissance,* London, 1928, pp. 164–80.

[44] In Altdorfer's Berlin *Nativity,* done ca. 1513, a Cupid with a bow hanging on his back has slipped into the crowd of angels clustering around the Infant Christ.

[45] Cf. Hans Baldung's representations of witches, and Dürer's engravings B. 76 (1498/99), B. 67 (about 1505), and the drawing L. 110 (1497/98). Particularly evident is the significance of the putto in B. 76, where he appears as the companion of the demoniacal Venus of the Astrolabius legend (cf. the ingenious interpretation by E. Panofsky, *Münchner Jahrbuch der Bildenden Kunst,*

14

by the Animated Corpse in the midst of their worldly pleasures.[46] Meditation over their mortal fate, as displayed in the *L'hora passa* woodcut, was utterly inconceivable to them; on the contrary, they had to antagonize Death, in order to make the punishment better deserved.

A French woodcut of the second quarter of the sixteenth century (fig. 10), for the knowledge of which I owe thanks to Mr. Hyatt Mayor of the Metropolitan Museum, is a striking illustration of this conception.[47] The composition, strangely similar to the Hellenistic type of Father Nile, shows eleven putti (*tout plaisir mondain,* according to the inscription) engaged in various worldly pleasures in the belief that the figure of Death in their midst is fast asleep. However, the skeleton's slumber is *mobile et soudain,* since he rests his elbow against a sphere, *Mobilité.* As soon as this frail support is moved, Death will wake up and end the pleasures of the putti. This event, it seems, depends upon the agency of a capricious ancestor of the modern alarm clock. The character of the putti is incorporated in two monkeys, symbols of the animal side of man's nature, his baser instincts;[48] they are chained to the sphere which their unguarded movements may dislodge any moment. *Donc faut-ilz estre tousiours prest de mourir.*

With this notion of the putto established in their minds, Northern artists naturally arrived at wrong conclusions when trying to interpret the *L'hora passa* woodcut. Their initial error was a misunderstanding of the melancholy pose of the putto; this gesture had been well known in the North since the early Middle Ages as the customary attitude of sleepers. Medieval symbolism, however, had imbued even sleeping with moral significance, either good or evil depending on the character of the scene. Because it was assumed by a putto, the pose as it appeared in the Italian woodcut had, for Northern artists, the evil import of the familiar representations of the vice of *Acedia.*[49]

When it came to know the putto with the skull, Northern art had just been introduced, through Dürer's St. Jerome designs, to the Italian conception of the skull as an object of meditation. This conception gained general recognition very slowly, and meanwhile the privilege of pondering upon skulls was, in the North, reserved for old age. As the companion of a putto, the skull retained its late medieval significance. Individual skulls had been known to Northern art since the second half of the fifteenth century, when they began to appear on the backs

N. F. VIII,, 1931, pp. 1–18). Significantly enough, however, he does not bear his usual attributes, bow and arrows, but a pair of stilts and a sphere, both symbols of the instability of human existence. Cf. R. van Marle, *Iconographie de l'art profane du moyen-âge,* Paris, 1932, "allégories et symboles," pp. 403 and 404.

[46] Cf. the *Vanitas* in the manner of Hans Baldung in the Gemäldegalerie, Vienna, and the ivory statuette of Luxury and Death in the Bayerisches National Museum, Munich, no. 81 (a reproduction and excellent comment on it by R. Berliner in vol. IV of the catalogue, Augsburg, 1926). Significantly enough, in Italian art of the period, almost the same type occurs as Prudentia. An example is on the tomb of the Infante Juan, in Avila, by Domenico Fancelli; a young woman, the upper part of her body unclothed, holds a snake with her left hand, while her right rests on a skull which she holds on her knee.

[47] 11″ x 16″, undescribed and apparently preserved in one impression only (Metropolitan Museum, New York, acc. no. 26.72.1).

[48] In medieval allegory, monkeys often appear as symbols of foolishness. In the *Renner* by Hugo of Trimberg (thirteenth century; ed. G. Ehrismann, Tübingen, 1908), the word "Affenheit" is used synonymously for "foolishness," "short-sighted stupidity."

[49] Cf. E. Panofsky-F. Saxl, *op. cit.*

of portrait panels.[50] They were intended not as focal points for contemplation but as sinister future portrayals of the sitter. This can be gathered from their artistic prototype, the so-called *gisant* tombs, which showed the deceased both in their past state, as realistic portraits, and in their posthumous state as decaying corpses.[51]

In Northern art of the late fifteenth and early sixteenth centuries the skull, then, was closely allied with the Late Gothic conception of death as an ever-present menace, and mirrored to some extent the aggressiveness of the animated skeleton type. When, in the *L'hora passa* woodcut, Northern artists saw a skull in conjunction with a putto, the symbol of hedonism, they naturally imagined the latter to be dying, like Luxuria so frequently represented in the claws of the animated skeleton. Thus, curiously enough, the psychological effect exercised by the skull upon the putto in the Italian design came to be turned into a physical effect, and Northern artists henceforth represented the putto in the agony of death or as already dead. If this change deprived the *L'hora passa* design of its meditative aspect, it made the contrast of life and death more impressive by anticipating the event which the Italian scheme had merely implied for the future.

The earliest date for the appearance in the North of the putto with the skull remains uncertain. The first dated example is the Barthel Beham engraving B. 31 (see fig. 16), of 1525. However, some other Northern versions of the subject definitely suggest the existence of a prototype that reflected the *L'hora passa* woodcut more strongly than does the Beham print. This initial design I have been unable to discover. All the examples reflecting it have, however, certain characteristics in common which permit to some extent the reconstruction of their lost or unknown prototype. It is more than likely that this prototype was a German print, since its closest derivatives are a faïence plate from Silesia, a few medals from Nuremberg, and a chiaroscuro woodcut the style of which suggests Saxon origin. All Netherlandish examples that have come to my knowledge are not earlier than the fourth decade of the sixteenth century and show greater independence, although they, too, may have derived ultimately from the German type.

The faïence plate (fig. 11),[52] presumably made during the second quarter of the century, seems closest to the original German design, as it differs least from the *L'hora passa* woodcut. As a product of folk art, the plate aims principally at a satisfactory decorative effect. The artist has, therefore, rearranged the design somewhat in order to accommodate it to the circular outline. The hour-

[50] The earliest examples seem to occur in the eighth decade of the fifteenth century (cf. the one attributed to Memling in Van Marle, *Iconographie,* fig. 401, where, significantly enough, the skull "speaks" the Biblical words: *Scio enim quod redemptor meus vivit* etc.; later examples compiled in G. Ring, *Beiträge zur Geschichte Niederländischer Bildniskunst im XV. und XVI. Jahrhunderts,* Leipzig, 1913, p. 96). The popularity of the type at that time is attested by two engravings of the master **WA** which show "model skulls" for the benefit of other artists (no. 39 in M. Lehrs, *Der Meister* **WA**, Leipzig, 1895).

[51] An early example is the tomb of the Cardinal Lagrange (d. 1402), in Avignon (E. Mâle, *L'art religieux de la fin du moyen-âge en France,* Paris, 1908, p. 377, fig. 181).

[52] Hamburg, Museum für Kunst und Gewerbe, no. 193; diameter 52.4 cm; attributed to Hafner, a Silesian master of glazed pottery.

glass has been removed from the neighborhood of the skull into the foreground, and the left leg of the putto is bent in order to make room for it. Otherwise, the composition of the *L'hora passa* woodcut still persists, and the alterations in detail illustrate the Northern conception of the motif. The putto himself, now clothed in a shirt and adorned with a neck chain and bracelet to show his hedonistic disposition, still maintains his pensive pose, but his eyes are closed, and the inscription *Heite mir morgen dir* (Today me, tomorrow you) certifies his death. His right hand holds a flower as an additional symbol of the fugitive quality of earthly life, frequent in contemporary allegories of Vanity, according to Isaiah (40:8): *Exsiccatum est faenum, et cecidit flos: Verbum autem Domini nostri manet in aeternum.* For the putto with the skull, this Biblical passage seems to have had a particularly strong connotation, since it continues (40:30): *Deficient pueri, et laboraverunt, et juvenes in infirmitate cadunt.*[53] Curiously reinterpreted is the symbolism of the apple trees of the Italian woodcut: only the living tree appears, but the apple has fallen to the ground, thus repeating the idea conveyed by the flower.

The chiaroscuro woodcut (fig. 12) seems to derive from the same source that inspired the faïence plate. The Museum of Fine Arts, Boston, owns the only known impression.[54] Unsigned and undated, it presents considerable difficulty in precise attribution. The strangely gnarled style of the putto's body suggests Saxony as its source,[55] and a date between 1520 and 1530 as a probability. In some respects, its anonymous designer has followed his model more faithfully than has the fabricator of the plate. The hourglass appears in its original place, and the inscription is given in Latin, in what can be taken as the original form. Otherwise, however, the underlying conception as it is reflected in the plate has been elaborated and dramatized with considerable imaginative power and with the naturalism of the Northern Renaissance. The putto, clad even more richly than he had been in the faïence plate, is shown with his body cramped and his face distorted by the agony of death. Around him, nature itself seems to repeat the process. A flower bush withers at his feet, heavy clouds hang over the landscape in the background, foreshadowing some natural catastrophe, and a storm tears the leaves off the trees. A sarcophagus in the middle ground to the left completes the gloominess of the scene. Thus the transformation of the two trees in the *L'hora passa* woodcut, from a theological allegory into a natural phenomenon—already intimated in the faïence plate—has now been carried to completion. The view that man's life parallels the constant growth and decay of nature as a whole had been evolved in the North as early as the second half of the fifteenth century and appears fully developed in a painting of that period in the Germanisches Museum, Nuremberg.[56]

[53] The passage from Isaiah is quoted on a scroll in a painting by Barthel Beham representing a combination of Luxuria and the Three Ages of Man being threatened by Death (Hamburg, Kunsthalle, no. 328).

[54] Acc. no. 6763; 9³/₈" x 12¹⁵/₁₆"; undescribed; printed in black and red.

[55] I am indebted to Mr. Russell Allen, of Boston, Mass., for this suggestion. The woodcut may best be compared with the work of masters like Jacob Lucius of Kronstadt (cf. H. Röttinger, *Beiträge zur Geschichte des Sächsischen Holzschnittes*, Strasbourg, 1921).

[56] Van Marle, *Iconographie*, p. 403. The same idea is illustrated in the painting by Barthel Beham mentioned above, note 53.

The prototype that inspired the faïence plate and the Saxon chiaroscuro is also reflected in the reverse designs of two anonymous portrait medals from Nuremberg, one of them (fig. 13) dated 1532, the other being of about the same date.[57] In both medals the compositions strongly resemble that of the faïence plate and hence the hypothetical prototype of the whole group, despite certain omissions in detail. The tree, barren in contrast to that in the faïence plate, again forms the central axis of the composition and, in the dated example, even retains the *cartellino*. But both lack the hourglass, and the inscriptions are not the same and are written along the circular outline of the design. However, the putti are naked and so probably preserve a feature of the original design, abandoned in the faïence plate and the Saxon woodcut. The probability of this assumption is further strengthened by two more representations related to the type, both showing naked putti. One is a painting by Jan van Hemessen, at one time owned by Mr. Beets, Amsterdam, and done presumably about 1535–40 (fig. 14).[58] In composition it resembles the Saxon woodcut mentioned above, although the mountainous landscape with the castle in the background has lost its allegorical import and reflects romantic Alpine motives collected by Netherlandish artists of the period on their way to and from Italy. Italian High Renaissance features, as introduced into the Netherlands by Jan Gossaert, have also transformed the putto. His classically beautiful Herculean body here twists in a Michelangelesque pose as his elbow slips from the top of the skull to the ground. The putto dies, not in convulsive agony, but in gentle coma, trying in vain to hold on to the stick that bears a scroll inscribed *Nassentes* (for *Nascentes*) *morimur,* words taken from the ancient author Manilius.[59]

The most original example derived from the hypothetical Northern prototype is a painting in the possession of Karl Loevenich, New York (fig. 15).[60] Its relation to the versions discussed above is evidenced by a barren tree and a *cartellino* which the owner informed me could be discerned in faint outlines in a damaged spot on the right of the painting. Otherwise, the design is independent and, in fact, depicts the prelude to the scene represented in the other examples. It is coincident with them only in the barren tree and the *cartellino,* which most probably displayed one of the inscriptions that occur on the other versions. The putto, in the bloom of youth, playfully holds a skull before him and asserts: *Mortem non timeo.* The underlying idea is like that of the French woodcut already referred to (see fig. 10), and confirms the interpretation of the Northern conception of the putto with the skull. All the examples above allow

[57] G. Habich, *Die Deutschen Schaumünzen des XVI. Jahrhunderts,* Munich, 1932, I, 2, pl. CXLV, nos. 3 (1532, for Sebastian Gienger), and 7 (between 1532 and 1543, for Hieronymus Wahl). Habich mentions two leaden plaques showing the same motif as listed in Leitschuh, *Flötner-Studien,* p. 18. The design is occasionally found on coins and medals as late as the seventeenth century; examples in Habich, pl. CLIII, no. 1, and pl. CCXVI, no. 1; Weber, *op. cit.,* pp. 535–36 and 693 (a curious German late sixteenth-century finger ring).

[58] 66 x 90 cm; listed among the works of Hemessen in Friedländer, *op. cit.,* XII, p. 189. I am indebted to the owner for the photograph and permission to reproduce it.

[59] Weber, *op. cit.,* p. 126.

[60] 17″ x 13″; the owner, to whom I want to acknowledge my gratitude for permission to reproduce it, informs me that the painting will be published as by Dürer in a forthcoming article.

the following conclusions to be drawn about their unknown Northern prototype: it showed a naked putto reclining on a skull, a design similar to that of the *L'hora passa* woodcut, but with the eyes of the putto closed; it contained an hourglass, a withered and a living tree from which was suspended a *cartellino* reading *Hodie mihi cras tibi,* and, possibly, a flower. These features permit the assumption that the earliest of those engravings by Barthel Beham showing the putto with the skull (fig. 16)[61] is also derived from the hypothetical Northern model, although it lacks the trees, the hourglass, the *cartellino,* and the inscription. The connection, however, is established by the display of a clump of grass illustrating the *faenum* of the passage from Isaiah quoted above, and fortified by the state of the putto—intermediate between sleep and death—reflecting, if in more realistic fashion, the misinterpretation of the *L'hora passa* design already evident in the faïence plate. This vacillating attitude was abandoned by Beham in 1529, in the second engraving he made of the subject (fig. 17).[62] Possibly inspired by contemporary representations of the putto in the agony of death, Beham decided to depict the putto as a corpse and to include the hourglass, thereby dismissing all doubt about the significance of the design as a *memento mori.* With his lively imagination, the master dramatized the concept by tripling the number of skulls[63] and by placing the whole group before a ruined wall. As a result, the design radiates the sinister atmosphere of a charnel house. At the same time, however, the ruined wall was a symbol of Vanity as had been the trees in the earlier versions, both having already been combined in the late fifteenth-century picture referred to above at the Germanisches Museum, Nuremberg.[64] Ruins likewise appear in the allegories of Vanity by Barthel Beham in Hamburg and by Hans Baldung Grien in Madrid.[65]

In a third engraving, done soon after the second (fig. 18),[66] Beham achieved his most striking illustration of the subject: he finally separated the putto from the skull, of which there are now four examples, and placed him on a slightly higher level in the background. Thus the artist was enabled to depict the corpselike quality of the infant's body much more effectively by using the perspective that Mantegna had employed for the dead body of Christ.[67] In a later state of the engraving, Beham made the meaning of the design wholly

[61] B. 31; G. Pauli, *Barthel Beham,* Strasbourg, 1911, no. 37.

[62] B. 27, P. 35.

[63] Significantly enough, Beham was inspired for the three skulls by the engraving of the master **WA** mentioned in note 50.

[64] The earliest occurrence, to my knowledge, of ruins as symbols of human destiny is a miniature of 1460/70 in Leningrad, reproduced in Blum-Lauer, *La miniature française aux XVe et XVIe siècles,* Paris, 1930, pl. XVII, in which Virtue is contrasted to the two Fortunes of Petrarch; behind the Good Fortune appears an elaborate castle in a landscape with bushes and flowers, and the Bad Fortune is placed on a bare rock behind which appears a castle in ruins.

[65] During the later sixteenth century, this symbolic import of ruins, combined with the studies by Northern artists of the remnants of antique monuments in Italy, was to produce the peculiar melancholy "romanticism of ruins" of the Baroque. A transitional state is illustrated in an engraving by Gourmont (Robert-Dumesnil, no. 17): in an elaborate setting of Renaissance architecture, a naked putto crouches upon some fractured architectural details that now have replaced the skull as symbols of Vanity.

[66] B. 28; P. 36.

[67] In the painting in the Brera, Milan (*Klassiker der Kunst,* XVI, ed. F. Knapp, p. 115).

explicit by adding the inscription *Mors omnia aequat* above the putto. In this ultimate form, the design became extremely popular: Pauli's catalogue lists no fewer than fifteen copies. But, because of its very perfection, the design could neither be developed further by other artists nor transferred to other materials, so that no reflections of it can be found in the minor arts. Beham himself, when he took up the subject again, introduced an entirely new idea: in an engraving dated by Pauli 1531–35,[68] the death of the child is being discovered by a young mother who has just given him the breast, the skull and hourglass appearing separately on the right. The print has sometimes been called, rather inappropriately, the *Madonna with the Death's Head*. A curious argument against this interpretation is afforded by a circular medallion inspired by the engraving (fig. 19);[69] in this, for lack of space, the skull is tucked away under the putto's arm. This feature, together with the inscription *Hodie michi cras tibi*, very definitely suggests that, to his contemporaries, Beham's *Madonna with the Death's Head* was but another variant of the putto with the skull.

Soon after the North had, in multifarious ways, made the subject of the putto with the skull entirely its own, the Boldù medal itself turned up in Germany and, naturally, met considerable difficulties of interpretation. Some German humanist or merchant with scholarly interests may have brought it with him from Venice about 1530, for its first reflection in the North is again a medal made by Matthes Gebel in Nuremberg in 1532 in commemoration of Georg Ploed (fig. 20).[70] Obviously the medal as a whole is modeled after the Boldù prototype. The obverse shows a profile bust of the deceased in the same antique style that Boldù had used for his self-portrait; and the reverse is an almost exact copy of the Italian medal, the only alterations being the upward glance of the youth and the presence of the bone in his hand. Whether or not Gebel had imagined the winged putto as a kind of angel is hard to determine; the Christian content of the two inscriptions seems to suggest this interpretation, especially the one reading *Omnia peribunt, Deus Eternus,* which the youth, by pointing toward it, designates as the summary of his own thoughts. The interpretation of *omnia peribunt* he may have found in the skull, while the putto suggested the *Deus Eternus.* Two years later, the Boldù design made another appearance in the North: Petrus Appianus published it in a woodcut copy on page 385 of his *Inscriptiones Sacrosanctae Vetustatis,* printed in Ingolstadt in 1534 (fig. 21). Curiously enough, however, Appianus included the Boldù design in his corpus of ancient inscriptions as an antique monument; the text informs the reader that the woodcut represents a leaden plaque found in Styria in 1500.[71] In his search for material, Appianus must have come across either a drawing made after the Venetian medal or a leaden plaque copied from it.[72] Unhesitatingly believing the legend

[68] B. 6; P. 5.

[69] Habich, *op. cit.,* no. 1539.

[70] *Idem.* pl. CXXVIII, no. 6.

[71] The full Latin text reads: *Nuper a Con. Cel. inventum in plumbea lamina in Stiria in Colle: in quo est Ecclesia circa Sanctum Andream. Anno M.D.*

[72] I have not been able to see the leaden plaques mentioned by Habich (cf. note 57 above); since one of them is described as circular, it might possibly, in case it is a copy of the medal and not just one of the other types of the motif, have served as a model for Appianus.

that accompanied the design, he included it in his book. The very fact of this incident, as well as the thoroughly Gothicized style of the woodcut reproduction of the Boldù design, only confirms the statement made by Erwin Panofsky,[73] that the Northern Renaissance had access to ancient art only when it had previously been translated into the Italian Quattrocento style. The inability of Appianus to distinguish a Renaissance design from a product of antiquity was universally characteristic of his period.

Equally significant is the interpretation of the Boldù design in the Appianus woodcut: the names of the Three Fates, Lachesis, Clotho, and Atropos, are attached to the putto, the youth, and the skull respectively. Whether this strange concept sprang from the mind of Appianus or was contained already in the design he copied, its sources can be traced without great difficulty. Since the Northern versions of the putto with the skull had become so far removed from their original source, it was impossible for Northern artists, when this source reappeared in the Appianus woodcut, to give it their customary interpretation. A new meaning had to be found, on the basis of two clues: the presence of a skull implied an allegory of death; this, however, had to be taken from antiquity, since the design itself was regarded as antique. Obviously suggested to the Northern mind by the figures of putto, youth, and skull was the idea of the Three Ages of Man, childhood, adult age, and death, just as they had been represented since the late fifteenth century.[74] The only ancient subject to fit this scheme was the Three Fates, the rulers of man's temporal destiny. From antiquity on, they had been paralleled to Past, Present, and Future, the third Fate, Atropos, being synonymous with death. This tradition was continued throughout the Middle Ages[75] and was taken over by the Italian Early Renaissance in its pictorial representation of the Fates. Illustrations of Petrarch's *Triumph of Death* frequently show them in place of the skeleton with the scythe.[76] In Northern art of the early sixteenth century, they even occur differentiated as the Three Ages of Man.[77] Thus they easily could lend their names to the figures on the Boldù design; the putto becoming Lachesis, the past, or childhood; the youth, Clotho, the present, or adult age; and the skull, Atropos, the future, or death. This conception also accounts for the two deviations from the Boldù design in the Appianus woodcut.

[73] "Dürers Stellung zur Antike," *Wiener Jahrbuch für Kunstgeschichte*, V (1922), pp. 23–36 (*Grundsätzliches*).

[74] An early example is the painting in the Germanisches Museum, Nuremberg, referred to above (note 56).

[75] Cf. *Fulgentius Metaforalis*, ed. H. Liebeschütz, Leipzig, 1926, s.v. "Pluto."

[76] An example reproduced in Weber, *op. cit.*, fig. 21.

[77] Woodcut by Hans Baldung Grien, 1513; it is interesting to note that for the North, at that time, the Fates, as creations of paganism, had the same evil import as the putti. In the Baldung woodcut, they are very much akin to the types used in representations of witches or Vanity; the witch in Dürer's engraving B. 67 even carries a spindle, the attribute of the Fates. The idea of the Three Ages of Man, too, seems to have possessed a moral significance at that time, as it frequently occurs combined with Vanity representations, the implication being that the transitoriness of human life as exemplified in the Three Ages was felt as a grievance only by those who had forgone the consolations of faith (compare the pictures in Hamburg and Vienna mentioned in notes 53 and 46, and the late Baldung painting in Madrid; the dead child in the latter may possibly have been inspired by the Beham engraving of the putto with the four skulls).

The now enigmatic bundle of flames in the hand of the putto has become a separate log fire in the background, a well-known symbol for the brevity of life, as are the flowers appearing behind the skull.

Strange though it was, the Appianus woodcut nevertheless initiated a new type of the putto with the skull in European art. The archaeological approach to antiquity of early sixteenth-century Northern humanism that had inspired Appianus' corpus of inscriptions gained influence in Italy during the Late Renaissance, producing similar results. Foremost among these was Vincenzo Cartari's *Immagini dei Dei degli Antichi,* first published in Venice in 1556. Significantly enough, Cartari took over various designs from the *Inscriptiones,* quoting Appianus as an authority. He also copied the woodcut of the allegedly antique type of the Three Fates (fig. 22) and repeated the story of its discovery told in the *Inscriptiones.*

Thus, through a particular irony of fate, Boldù's design, after a long sojourn in the North, returned to its place of origin, Venice, where most editions of the *Immagini* were printed. Cartari's treatise became one of the main sources for the iconography of the late sixteenth and the seventeenth century. Through its numerous reprints and translations, the wrongly interpreted and slightly changed Boldù design, as taken over from Appianus, was made accessible to all countries of Europe and could again serve as the prototype for new versions of the putto with the skull. For late sixteenth- and seventeenth-century artists, however, the illustration in Cartari's work presented the same difficulties that the Boldù medal had met in the late Quattrocento, since the idea of the Three Fates had been understood not even by Cartari himself, who cautiously refrained from comment. Gregorio Comanini attempted an interpretation soon after in a treatise on art, *Il Figino,* published in Mantua in 1591.[78] Desperately seeking an explanation, the author, in a long dissertation, loses himself in the maze of Renaissance philosophy only to arrive at the most absurd notions, the complexity of which defies description. Faced with the same difficulties, artists who found the design of the Three Fates when resorting to Cartari's book in search of new allegories, were likely to single out the putto with the skull, as had their predecessors in the late Quattrocento with the original Boldù medal. For artists of the late sixteenth or the seventeenth century, this procedure suggested itself particularly inasmuch as the Northern Renaissance versions of the putto with the skull were still lingering in their minds.

The persistence of the putto with the skull as conceived by the early sixteenth century is evident even in a French woodcut of 1569 reflecting the whole Cartari illustration (fig. 23). The figured initial "D" was carved in Lyons,[79] the French printing center where Cartari's work was likely to have been known earlier than anywhere else in the North and where during the late sixteenth century various editions of it were printed. The anonymous designer took over only the figures from the Cartari design, placing them in front of a triumphal arch in order to enhance their antique character. Yet the content of the scene was like that of the older Northern type of putto with the skull, the notion of the Three Fates

[78] The passage was brought to my knowledge by Dr. Lieselotte Moeller of Hamburg.

[79] J. Lieure, *La gravure en France au XVIe siècle,* Paris, 1927, no. 96.

having been eliminated completely. The putto, his wings omitted, represents the image of childhood, and the seated youth meditates over the contrast between infancy and death, his thoughts being summarized on the triumphal arch in the background: *Summa Sapientia Mortis Memoria.*

Before, however, the *Immagini* gained a more widespread influence in the North, Netherlandish art, during the second half of the sixteenth century, had received from the early sixteenth-century type of putto with the skull a number of new designs adapting it to the spiritual trends of the period. These designs, unrelated to the Cartari illustration, formed another source for the putto with the skull in the Baroque.

Their invention must be credited principally to the circle of artists associated, during 1550-70, with the Antwerp publisher Jerome Cock, notably Frans and Cornelis Floris. An anonymous engraving published by Cock (fig. 24)[80] shows the Beham design of the dead putto with the four skulls as the initial source of inspiration for the Flemish versions. The putto, dead, is again placed in a setting of ruined architecture; however, the whole design is pervaded by a strong flavor of antiquity, evident not only in the Herculean appearance of the putto but also in the classical column, the palmette design of the wall in the rear, and the nude female figure of Vanity in the niche under the old inscription *Hodie mihi cras tibi.* Strangely contrasted with the archaeologically almost correct ancient character of the design is the piously Christian admonition in Latin and Dutch displayed on the big *cartellino* in the foreground: *Vigilate quia nescitis diem neque horam;* and *Wheckt en bid wie dat ghy syt, want ghy en weet dach ure noch tyt* (Watch and pray while you are alive, since you know not the day, the hour, the time). The apparent discrepancy between this text and its illustration echoes the general tendency of the period to combine an increased concern with religion and a predilection for antique form as interpreted through the works of the Italian High Renaissance. These conflicting notions soon produced the division of the putto with the skull into two types, antique and Christian, both of which surprisingly resulted in the resurrection of the dead putto.

The process of separation seems to be illustrated by the puzzling design of a painting by Frans Floris formerly in the possession of Olof Granberg, Stockholm (fig. 25).[81] It consists of three separate allegories, the mutual relations of which are hard to determine. On what appears to be a tomb sits a naked putto who supports his head on his right hand and holds, turned toward the ground, a torch, a classical attribute that designates him as the ancient genius of death, Thanatos. He mourns another naked putto, obviously dead, who lies on a bundle of straw and whose head leans against that of an old man rather than against the skull. The latter, together with an hourglass equipped with a bat's and a dove's wing, symbols of night and day, has been removed to the niche in the ruined wall in the rear. In the background to the right, Ezekiel resurrects the dead from their tombs. This scene suggests that the enigmatic head in the fore-

[80] LeBlanc, *Manuel*, II, p. 30, no. 72.

[81] Olof Granberg, *Trésors de l'art en Suède*, I, Stockholm, 1911, p. 53, no. 135; cf. D. Zuntz, *Frans Floris*, Strasbourg, 1929, p. 77.

ground might possibly be interpreted as that of a corpse rising from the tomb upon which the antique genius is placed. The meaning of the picture would then be this: the dead putto, in conjunction with the hourglass, skull, ruined wall, and bundle of straw (presumably the *faenum* mentioned in Isaiah 40:8), symbolizes as usual the transitoriness of life; he is lamented by the antique genius, to whom death is unconquerable, while Ezekiel demonstrates that salvation can only be brought through the grace of God.

The mode of thought revealed by this concept recurs in a painting listed as by Frans Floris in a Helbing sales catalogue of 1912 (fig. 26).[82] Again the theme of the Resurrection is the main content and is conveyed by two analogous designs in the foreground and rear. Now, however, the demonstration is in purely Christian terms; the naked child, a martyr's palm in his right hand, has been resurrected from the tomb on which he sits, just as, in the background, Christ has risen from His grave. He steps upon the skull in order to show the power of God over death. The coat of arms in the left lower corner of the painting as well as the inscription *Salvum me fac Deus in Nomine Tuo* on the shield held by the infant prove the picture to be an epitaph for a deceased child. In the portrayal of the child, the scheme of the putto with the skull has been reversed; death is conquered through God's grace which, to the faithful, offers eternal life.[83] In other Christianized examples of later date, to which reference will be made below, the putto with the skull even appears transformed into the Infant Christ.

The creation of the classicized variety of putto with the skull by incorporating the putto with Thanatos can be traced in the sepulchral designs of Cornelis, the brother of Frans Floris. During his sojourn in Italy in 1540–44,[84] Cornelis Floris came to know Thanatos, the mourning genius of death, as he was shown in antique monuments, leaning on the torch and supporting his head on his hand. In a series of sepulchral designs published by Jerome Cock in 1557 but presumably done in 1546-49,[85] Floris combined classical features with the traditional type of Northern sixteenth-century epitaphs, employing, among others, the antique Thanatos.[86] In another design of the same series the master also used, as an equivalent of the classical genius with the torch, the putto with the skull;[87] the putto here mourns but has the familiar seated pose. Most of the designs, however,[88] show fused types, winged genii with skull and torch who crouch upon the edges of sarcophagi (fig. 27).

[82] No. 47; the picture has been brought to my knowledge by Dr. Julius Held of New York University.

[83] A German late sixteenth-century painting by Hans Mielich, which was mentioned to me by Dr. Holzinger of the Alte Pinakothek, Munich, but which I have been unable to trace, also seems to represent a child's portrait "as putto with the skull."

[84] R. Hedicke, *Cornelis Floris*, Berlin, 1913, p. 112.

[85] *Veelderley niewe Inventien etc.; idem*, p. 16.

[86] *Idem*, pl. XII, no. 6. Among the tombs built later by Floris, see the epitaph at St-Omer, the tomb of Duke Albrecht in Königsberg, and the tomb of Christian III at Roskilde; *idem*, pls. XVI and XXIII.

[87] *Idem*, pl. XII, no. 1.

[88] *Idem*, nos. 4, 5, 7, and 8. In a single example, Cristoforo Solari had achieved a similar synthesis in the very beginning of the sixteenth century. The Museo Borromeo in Milan preserves

It was this composite type that Floris constantly employed in his later designs[89] and which, as a consequence of the vast influence he exercised, spread all over Northern Europe. Innumerable examples occur in late sixteenth- and seventeenth-century tombs of Germany, Holland, and Scandinavia. Despite his popularity, however, the Thanatos-putto with the skull did not undergo any essential changes of meaning or appearance; an antique intruder upon Christian sepulchral symbolism, he always remained a minor item, used in a semi-ornamental fashion until, toward the end of the seventeenth century, he was gradually abandoned. Occasionally, the composite type appears to have reassumed its ancient significance. An interesting example of this is a portrait of himself and his wife by Bartholomäus Spranger, preserved in an engraving by Egidius Sadeler,[90] and done probably at the very beginning of the seventeenth century. Here Thanatos, leaning upon the elaborate frame in which is set the portrait of the artist's wife, hides a skull in his cloak and treads upon an hourglass. The content is a pagan equivalent of that of the epitaph by Frans Floris; Time and Death are conquered, not by Christian Faith, but by Fame. Thus, by the end of the sixteenth century, the dead putto with the skull had been replaced by new types in which the putto appeared living through the grace of God, as in the Floris epitaph, or through his identification with Thanatos.

A third living variety was created at the same time in the Netherlands by combining the putto with the skull of the Cartari design with the traditionally Northern type of the putto as a symbol of Vanity. This ingenious synthesis has been achieved in an engraving of 1594 designed by Hendrik Goltzius (fig. 28).[91] The relation between this print and the Cartari illustration is evident

a small marble statue by him, showing a wingless seated putto who leans upon a skull and holds a torch toward the ground (reproduced in A. Venturi, *Storia dell'arte italiana*, X, 1, Milan, 1935, fig. 552). Solari, during his sojourn in Venice about 1489, and in his work at the Certosa of Pavia about 1497, must have seen some of the Venetian derivatives of the Boldù design as well as the plaque at the Certosa mentioned above. The classicizing tendencies of his work after the turn of the century brought about the artist's acquaintance with the antique Thanatos, which at that time was rapidly becoming a standard feature on High Renaissance tombs. It can be safely assumed that Solari's statue, in which the tradition of the Boldù type is still prevalent, was also made for a sepulchral design. That it had an influence on Cornelis Floris, however, is highly unlikely.

[89] Hedicke arrives at the date of 1546–49 for the *Inventien* by comparing them with Floris' Epitaph of Dorothea in Königsberg, 1549, which seems to show a more mature style. The circumstance that the Dorothea epitaph already contains the fully developed composite Thanatos type corroborates this hypothesis. Occasional combinations of putti and skulls in a decorative manner occur on sixteenth-century tombs but are independent of the Floris type. Cf. the tomb of the Cardinal Juan de Tavera, in Toledo, by Alonso Berruguete, 1554–61.

[90] A. Andresen, *Deutscher Peintre-Graveur*, Leipzig, 1864–78, no. 38.

[91] B. 10 (III, p. 97); the print in the Fogg Museum, Cambridge, Mass., from which the reproduction (fig. 28) is taken, corresponds to Bartsch's description except for the date 1594 behind the signature, which it lacks. Under no. 11, Bartsch lists a smaller variant of the same design which, according to him, is copied from a small and very rare print by Agostino Carracci; the latter print, however, I have been unable to trace. O. Hirschmann (*Hendrik Goltzius*, The Hague, 1916, p. 95) mentions as wrongly ascribed to Goltzius a painting in the Stolk Collection, Haarlem, showing a sleeping Cupid and the inscription *Ante nasse morimur;* he also mentions a painted copy after B. 11, formerly in the Peltzer Collection, Cologne. Hirschmann erroneously regards B. 11 as a derivation from the *Small Tambourine Player* by Titian in Vienna, Kunsthistorisches Museum, no. 181. Two putti blowing soap bubbles occur in Goltzius' large *Allegory* of 1611, in the Basel Museum (*idem*, fig. 8).

from the pose of the putto and from such details as the fire behind the figure —
now transformed into a smoking urn—the bone under the skull, and the village in
the landscape. The content of the design, however, is that of the putto with the skull
as conceived in the North during the early sixteenth century; it is conveyed by the
flame as well as by the flower, the withering tree, and, preeminently, the soap
bubbles which the putto is blowing.[92] These features occur as symbols of the vanity
of life in a neatly versified Latin inscription by F. Estius, added at the bottom of the
print outside the frame:

> Flos novus, et verna fragrans argenteus aura
> Marescit subito, perit, ali, perit illa venustas.
> Sic et vita hominum iam nunc nascentibus, eheu,
> Instar abit bullae vanique elapsa vaporis.

> (The fresh and silvery flower, fragrant with the breath of spring,
> Withers at once, its beauty perishes;
> So the life of man, already ebbing in the newly born,
> Vanishes like a bubble or like fleeting smoke.)

On a stone, another inscription asks: *Quis evadet?* (Who will be spared?). This
double explanation seems necessary, for the design, despite the many symbols it
includes, has largely acquired the character of a genre scene. The putto, wholly
unaware of his symbolic import, is absorbed in his childish amusement, casually
using the skull as a support. This self-sufficient occupation has a direct appeal
which makes it hard for the spectator to keep in mind the allegorical implications
of the details. It was, in fact, the genre aspect that secured the Goltzius design
a long career in Netherlandish art of the seventeenth and eighteenth centuries.
With all symbolic paraphernalia omitted, the putto became an ordinary child
blowing soap bubbles, one of the favorite subjects of Dutch painting during the
Baroque period.[93] While thus the Northern early sixteenth-century type of the

[92] The comparison of man's life to a bubble already occurs in the *Charon* of Lucian (Weber,
op. cit., p. 526). In the Renaissance, bubbles first appear in the *Hypnerotomachia Poliphili* (pp.
15 and 72 of the French edition; cf. E. Panofsky, *"Et in Arcadia ego,"* Philosophy and History: Essays
presented to Ernst Cassirer, ed. Klibansky-Paton, Oxford, 1936, pp. 234–35, with extensive
bibliography for the history of related conceptions). In Northern art of the sixteenth century, the
inscription *Homo Bulla* is found on some of the St. Jerome pictures discussed in note 33 (one
example, in the Isola Bella, quoted by Goldschmidt, *op. cit.*, another reproduced in Friedländer,
op. cit., IX, pl. XXVIII). However, the bubble does not seem to have been depicted at that time;
instead, a very similar symbol is frequently encountered: the translucent sphere as the image of the
world. It occurs in various paintings by Jerome Bosch, and is often used as an attribute of Christ
(Joos van Cleve; Friedländer, *op. cit.*, IX, pl. XXVII). Two instances, in which it is combined
with a putto, may be regarded, to some extent, as forerunners of the Goltzius design. A portrait
by Hans Schöpfer, dated 1540, in the possession of the Schaeffer Galleries, New York, shows in
the upper left-hand corner a seated putto enclosed in a transparent sphere. A painting ascribed to
Amberger, in the Erzbischöfliche Residenz, Bamberg, represents Cupid riding on a translucent
sphere that encloses a skull; in the foreground are a candle and an hourglass. The conjunction of
Cupid and Death forms a separate subject, which will be discussed in the chapter "Blind Cupid"
in Erwin Panofsky's forthcoming *Studies in Iconology*, The Mary Flexner Lectures, Bryn Mawr
College, 1937.

[93] A direct reflection of the Goltzius design is preserved in an anonymous French painting

putto with the skull disintegrated into a genre subject, it inspired an Italian chiaroscuro woodcut of the early Seicento believed to be after a design by Guido Reni (fig. 29).[94] The print seems to derive from Barthel Beham's engraving of 1525 (see fig. 16), which it strongly resembles in the twist of the putto's body and the position of his arms. Again, however, the genre character of the design is predominant. The cushion, apparently added for the convenience of the putto, suggests that the infant is not dead but asleep. As in the Goltzius engraving, the putto no longer exemplifies the allegorical conception of the design; he is engaged in a harmless everyday activity, and the symbolism is restricted to the skull and hourglass.

That the putto in the chiaroscuro woodcut is definitely meant to be asleep is proved by another chiaroscuro derived from it (fig. 30).[95] Here the design is merged in a wholly different subject: the Christ Child asleep on the instruments of His prospective martyrdom, a well-known type originating in the late fifteenth century and preserved, among many examples, in a painting by Francesco Albani. Only the presence of the skull and hourglass betrays the connection between the chiaroscuro woodcut and the putto with the skull.[96]

In Germany, the home of his greatest popularity during the early sixteenth century, the putto with the skull retained favor throughout the Baroque period, if in a rather playful style. Fanciful variations of the Floris type occur, as a semiornamental motif, on tombs as late as the eighteenth century. In isolated form, however, the subject was rarely taken up again. Among the few examples of this kind, a tomb of 1693 in the Peterstiftskirche at Salzburg (fig. 31),[97] made by B. Maendl for the Guardi family, echoes in more idyllic form the conception of Vanity of the Northern Renaissance. On top of a sarcophagus, the

of the middle of the seventeenth century, for the knowledge of which I am indebted to Miss Dora Jane Heineberg of Radcliffe College (*Les peintres de la realité en France au XVIIe siècle*, Paris, 1934, exh. cat. no. 140, pl. XLVIII): symbols of Vanity, such as flowers, a candle, a skull, etc., form a still life that includes a book opened at a page on which appears a copy of the Goltzius engraving, with the flame, the tree, and the flower omitted. Strangely enough, this copy in the book bears the signature of the Lyonnais illustrator Bernard Salomon, although this artist could not possibly have been its author; the style of the design as well as the typography of the book are definitely seventeenth-century.

[94] B. 23 (XII, p. 153); Mr. Russell Allen, to whom I am indebted for photographs and information on the print, owns an undescribed state of the print made without the color plate, of which there are two more examples in Berlin and Munich; the Albertina, Vienna, preserves an undescribed reversed copy of the chiaroscuro. This design has served as a prototype for a German seventeenth-century ivory statuette by F. W. Moll, reproduced in J. von Schlosser, *Werke der Kleinplastik in der Skulpturensammlung des AH. Kaiserhauses*, Vienna, 1910, II, pl. XLVII, no. 2.

[95] P. 52 (VI, p. 233), Nagler, *Lex.*, I, p. 571, no. 1360, signed **A&CA**. (Antonio Campi?). For reference to this print I am again indebted to Mr. Russell Allen.

[96] Although, in this particular instance, the influence of the putto with the skull upon the Infant Christ seems to me beyond doubt, the widespread type of the Christ Child combined with a skull as the symbol of vanquished death must not necessarily be derived from our subject: it may well have been inspired directly from the skull of Adam beneath the cross, a type the symbolic content of which it conveys in different form (cf. the two German eighteenth-century ivory statuettes representing the Infant Christ stepping on a skull and blessing, in the Bayerisches National Museum, Munich; Berliner, *op. cit.*, nos. 660 and 681).

[97] H. Tietze, *Österr. Kunst-Topographie*, XII, Vienna, 1913, pp. 34–35, fig. 59. I am indebted to Miss Janice Loeb, New York, for notice of this example.

putto, embracing the skull with his right hand and supporting his brow with his left, seems absorbed in melancholy contemplation, while his eyes, almost entirely closed, suggest that he is asleep. The object of his thought is incorporated in the admonitory lines that appear on the tomb: *Sterblicher Wandersmann, betracht die Verwandlung sterblicher Menschen* (Mortal wayfarer, behold the transformation of mortal humans).

The original gruesome aspect of the Northern putto with the skull, hardly felt in the Salzburg tomb, appears completely subdued by the unconcerned vitality of the putto in a German alabaster statuette of about the same date in the Wallace Collection, London (fig. 32).[98] This charming piece is strangely reminiscent of the *L'hora passa* woodcut and the bronze statuette from the Oppenheimer Collection (figs. 7, 8), of which it appears to be a belated and playful echo. For the sake of contrast, it is tempting to carry the comparison further than actual evidence may permit. The scroll of the woodcut seems to have fallen to the ground, neatly curled around the putto who holds one end of it with his left hand; the skull, propped up on the barren trunk and held in place by his right hand, conveys to his astonished glance nothing of the sinister and is but a strange and shiny object of play. Thus the alabaster statuette carries to completion the Baroque approach to our subject seen already in the Goltzius design and in the Italian chiaroscuro. Becoming more and more his own childish self, the putto has ultimately won at least a psychological victory over the skull, his superior opponent for a hundred years.

[98] *Cat. of Sculpture,* London, 1931, no. S 14 (p. 4, pl. I).

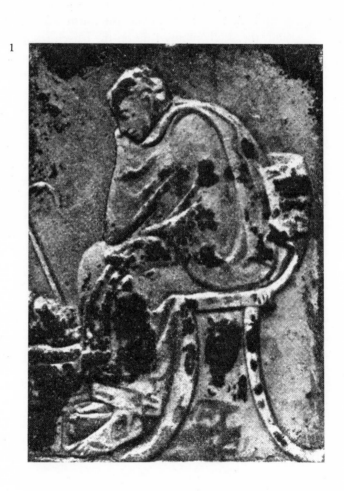

1

2

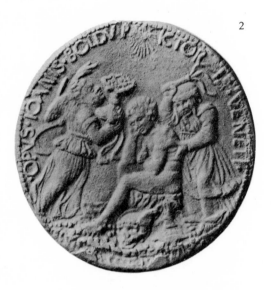

3

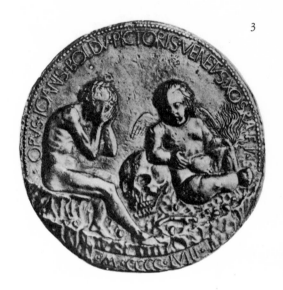

1. *Sepulchral Relief. Roman. Naples,*
Museo Archeologico Nazionale

2. *Giovanni Boldù, Reverse of*
Medal. 1458

3. *Giovanni Boldù, Reverse of*
Medal. 1458

4

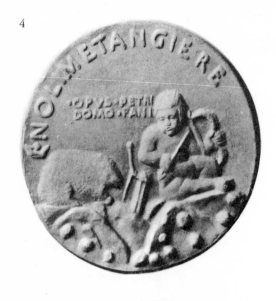

4. *Pietro da Fano, Reverse of Medal. 1452-57*

5. *Antonio Marescotti, Reverse of Medal. 1462*

6. *Albrecht Dürer,* St. Jerome. *Pen drawing, L. 175. Berlin, Kupferstichkabinett*

5

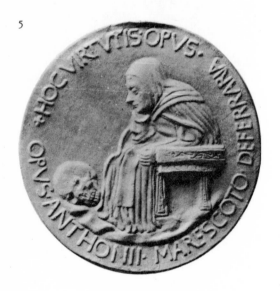

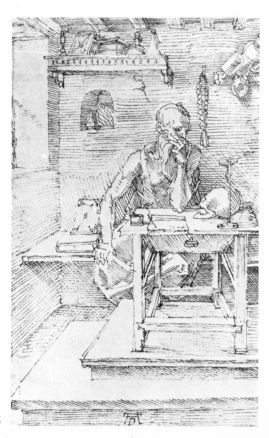

6

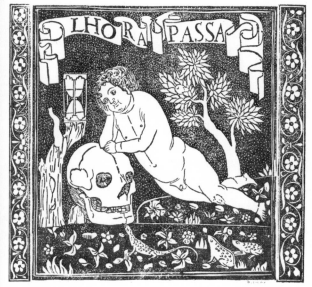

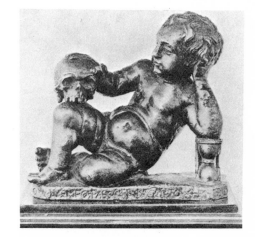

7. *Woodcut, with "L'hora passa."*
Italian, late 15th century.
Paris, Bibliothèque Nationale

8. Putto with Skull and Hourglass.
Bronze statuette; Italian, early
16th century. London, Victoria
and Albert Museum
(formerly Oppenheimer Collection)

9. *Maffeo Olivieri, Plaque from*
the Tomb of Marcantonio
Martinengo. Bronze, ca. 1526.
Brescia, Museo Cristiano

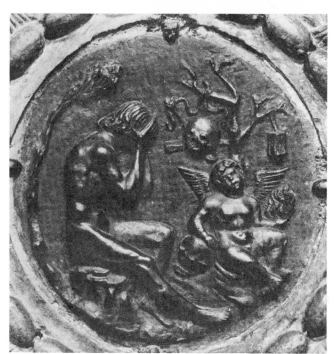

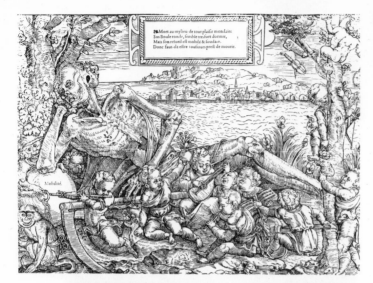

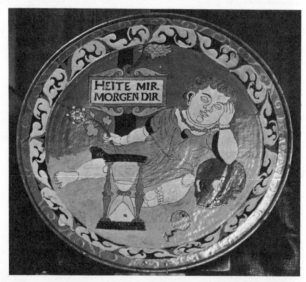

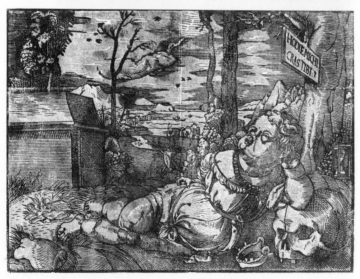

10. Putti with Death Asleep. *Woodcut; French, 2nd quarter 16th century*

11. Plate, with "Heite mir morgen dir." Faïence; German, 2nd quarter 16th century. Hamburg, Museum für Kunst und Gewerbe

12. Chiaroscuro woodcut, with "Hodie michi cras tibi?" German (Saxony?), 16th century. Boston, Museum of Fine Arts

13

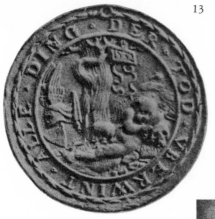

13. *Nuremberg, Reverse of Medal. 1532*

14. *Jan van Hemessen,*
Dying Putto in Landscape. *ca. 1535–40.*
Formerly Amsterdam, Beets Collection
(courtesy Paul Brandt N.V.
Kunstveilingen, Amsterdam)

15. Putto with Skull. *North European,*
16th century. New York,
Karl Loevenich Collection

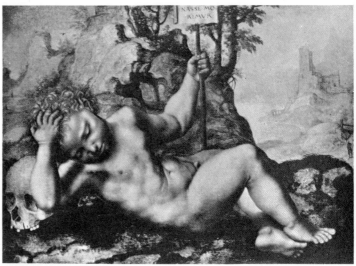

14

15

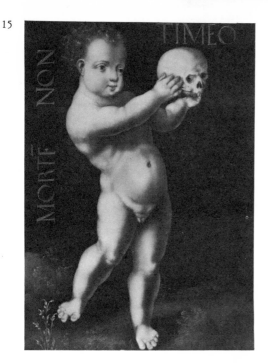

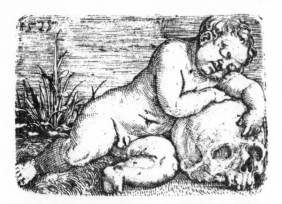

16

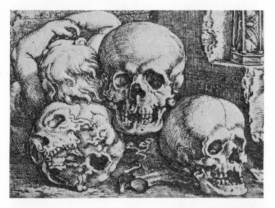

17

16. *Barthel Beham*, Dying Putto with Skull. *Engraving, B. 31; 1525*

17. *Barthel Beham*, Dead Putto with Three Skulls. *Engraving, B. 27; 1529*

18. *Barthel Beham*, Dead Putto with Four Skulls. *Engraving, B. 28; after 1529*

19. *Medallion*, "Madonna with the Death's Head." *German, 16th century*

20. *Matthes Gebel, Reverse of Medal. 1532*

21. *Petrus Appianus*, Three Fates. *Woodcut in* Inscriptiones Sacrosanctae Vetustatis, Ingolstadt, 1534, p. 385

22. *Vincenzo Cartari*, Three Fates. *Woodcut in* Immagini dei Dei degli Antichi, Venice, 1580, p. 306

23. *Initial "D." Woodcut; French (Lyons), 1569*

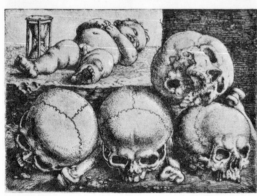

18

19

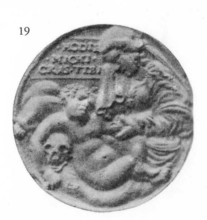

20

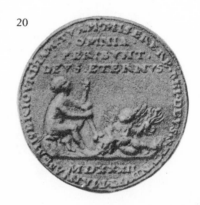

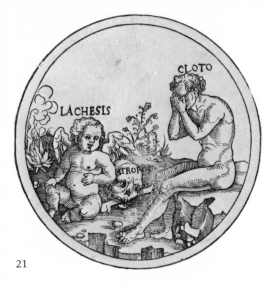

21

22

23

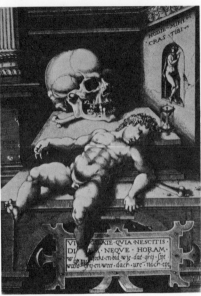

24

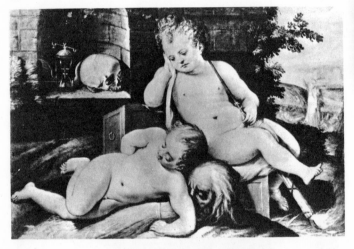

25

26

24. *Jerome Cock (?)*,
Dead Putto with Skull. *Engraving,*
Le Blanc 72; 1550-70

25. *Frans Floris,*
Allegory of Death and Salvation.
3rd quarter 16th century.
Stockholm, Olof Granberg
Collection

26. *Frans Floris,*
Allegory of Resurrection.
3rd quarter 16th century
(present location unknown)

27. *Cornelis Floris,*
"Inventien" No. 7. *Engraving,*
16th century

28. *After Hendrik Goltzius,*
Allegory of Vanity.
Engraving, B. 10; 1594

29. *After Guido Reni (?),*
Sleeping Putto.
Chiaroscuro woodcut, B. 23;
17th century

27

28

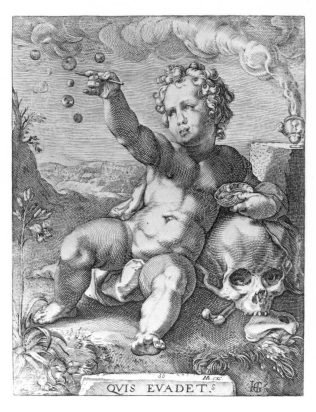

QVIS EVADET.s

29

30

31

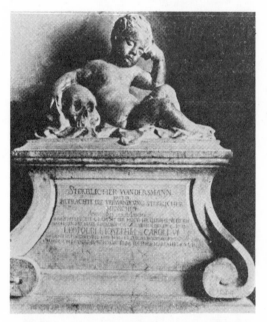

30. Sleeping Christ Child.
Chiaroscuro woodcut, P. 52;
Italian, 17th century

31. B. Maendl, Tomb of
the Guardi Family. 1693.
Salzburg, Peterstiftskirche

32. Putto Playing with Skull.
Alabaster statuette; German,
17th century. London,
Wallace Collection

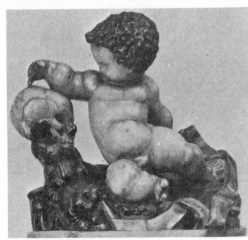

32

STUDY 2

*Titian's
Laocoon Caricature and
the Vesalian-Galenist
Controversy*

"Titian's *Laocoon Caricature* and the Vesalian-Galenist Controversy,"
Art Bulletin, Vol. XXVIII, 1946, pp. 49-53

Among the graphic works associated with the name of Titian, the large woodcut depicting three apes in the pose of the *Laocoon*[1] has long been the object of special attention (fig. 1). Its puzzling subject matter has led many scholars to speculate on the meaning of the design, but a truly satisfactory explanation still remains to be found. Unfortunately, there is an almost complete lack of tangible clues, so that any attempt to solve the problem—including the one presented here—will have to depend largely upon circumstantial evidence.[2]

The woodcut itself is neither signed nor dated, and no mention of it has been found in the archival or literary sources of the period. The earliest reference occurs in Carlo Ridolfi's *Le maraviglie dell'arte*,[3] which also furnishes the authority for the generally accepted attribution of the design to Titian, since it lists the print among the master's "invenzioni, che se ne fecero stampe." While this passage, written almost a century after the probable date of the work in question, need not be regarded as absolutely reliable, it has never been challenged on artistic grounds. The landscape setting of the *Laocoon Caricature* is indeed strongly Titianesque in character; Hans Tietze and E. Tietze-Conrat have suggested that it may reflect a sketch dating from the master's Giorgionesque period, since a very similar landscape occurs in an engraving by Giulio Campagnola.[4] With regard to the figures, however, Titian's authorship cannot be taken entirely for granted. Here the exceptional nature of the subject renders stylistic analysis of any kind highly uncertain.

The manner of execution of the print permits somewhat more definite conclusions. Its vigorous, fluid lines, imitating insofar as possible the spontaneity of the original pen drawing, represent a graphic technique that appears to have been developed by several Venetian wood-engravers under the direct influence of Titian around the middle of the sixteenth century. The individual styles of these men are often difficult to tell apart, owing to the scarcity of signed and dated examples of their work; the *Laocoon Caricature* is generally assigned to Niccolò Bol-

[1] D. Passavant, *Le peintre graveur*, Leipzig, 1864, VI, p. 243, no. 97; 278 x 410 mm.

[2] This article was reprinted, with some minor additions among the notes, as an appendix in the author's *Apes and Ape Lore in the Middle Ages and the Renaissance* (Studies of the Warburg Institute, 20), London, 1952. These additions are included here.

[3] Venice, 1648; ed. Von Hadeln, Berlin, 1914, I, p. 203.

[4] H. Tietze and E. Tietze-Conrat, "Titian's Woodcuts," *Print Collector's Quarterly*, XXV, 1938, p. 349.

drini, who is known to have worked for Titian in 1566. In that year he produced the chiaroscuro woodcut *Venus and Cupid,* his only signed and dated print, inscribed with the names of both artists.[5] However, Boldrini's collaboration with Titian may well have begun ten to fifteen years earlier, and the resemblance between the *Venus and Cupid* and the *Laocoon Caricature* is hardly sufficient for any deductions concerning the exact date of the latter print.[6]

The traditional interpretation of the *Laocoon Caricature* exists in several variants, all of them closely related in principle. The oldest of these, voiced as early as the mid-seventeenth century, asserts that the print was intended to satirize the excessive admiration for classical art prevalent in Florence and Rome;[7] a somewhat more specific version of this view suggests that it was aimed at Bandinelli's copy of the *Laocoon.*[8] The most recent hypothesis, proposed by Oskar Fischel, assumes that the print was directed against the *Laocoon* itself; that Titian conceived it out of a desire to free himself from the overwhelming impression the statue had made upon him.[9]

Of these alternatives, the Bandinelli theory might at first glance appear to be the most attractive. Apes had been used to represent inept copyists or jealous imitators ever since classical antiquity, so that Titian could easily have employed them for the same purpose had he wanted to ridicule Bandinelli. But is there any reason to assume that he actually had such a desire? After all, the presumptive object of his scorn was commissioned in 1520, thirty to forty years before the probable date of the woodcut. Furthermore, Bandinelli's copy was not the only reproduction of the *Laocoon* made at that time, even though it seems to have been the only one in marble; we know of several others in bronze, including one by Jacopo Sansovino which was given to the Venetian Senate in 1523.[10] Surely the difference in material is not important enough to explain why Titian should have singled out Bandinelli for his attack. Quite apart from all these considerations, we may well doubt whether the shortcomings of Bandinelli's copy were as apparent to Cinquecento eyes as they are to the critically sharpened vision

[5] Adam Bartsch, *Le peintre graveur,* Leipzig, 1866, XII, p. 126, no. 29; cf. Tietze, *op. cit.,* pp. 348, 353. 1566 is also the date of a privilege granted to Titian for the reproduction of his works by Cornelis Cort and Niccolò Boldrini, the only document relating to the latter master; cf. Paul Kristeller, s.v. "Boldrini," in Thieme-Becker, *Allgemeines Lexikon der bildenden Künstler,* IV, p. 242.

[6] Tietze and Tietze-Conrat, *op. cit.,* p. 355, assume that both prints were done at about the same time.

[7] By M. van Opstal in a lecture on the *Laocoon* Group on July 2, 1667, as related in Félibien, *Conférences de l'Académie Royale de Peinture et de Sculpture,* Paris, 1669 (English edition, London, 1705, p. 30). I owe this reference to Dr. Ulrich Middeldorf. Among more recent authors, the theory was adopted by Georg Gronau, *Titian,* London, 1904, p. 136, and has lately been endorsed again by Arnold von Salis, *Antike und Renaissance,* Erlenbach-Zürich, 1947, p. 142 (exhaustive bibliography on Renaissance echoes of the *Laocoon* Group on pp. 255–58).

[8] Cf. John Knowles, *The Life and Writings of John Fuseli,* London, 1831, III, p. 137, note; this passage, for which I am again indebted to the kindness of Dr. Middeldorf, is the first statement of the Bandinelli theory in print that has come to my attention. The theory itself may well be several decades older. It has recently been repeated by Margarete Bieber, *Laocoon; the Influence of the Group since Its Rediscovery,* New York, 1942, p. 7.

[9] Cf. *Amtliche Berichte, Kgl. Kunstsammlungen, Berlin,* Dec. 1917, pp. 60 ff.; Bieber, *loc. cit.,* quotes it as an alternative to the Bandinelli theory.

[10] Bieber, *op. cit.,* p. 6.

of our own day. Whatever Titian's own opinion on the subject, it appears most improbable that the prospective buyers of the woodcut possessed a sufficiently discriminating attitude toward the problem of copies after famous masterpieces to appreciate a satire of this sort.

As for the notion that the *Laocoon Caricature* represents an attack upon the classicistic dogma of the Florentine and Roman schools in general, it may have been suggested, at least indirectly, by the numerous slighting references to Venetian art in Vasari's *Vita* of Titian, especially the well-known statement that "without design and a study of selected antique and modern works, skill is useless, and it is impossible by mere drawing from nature to impart the superior grace and perfection of art, because some aspects of nature are usually not beautiful."[11] Here Vasari claims, in effect, that Titian's art is little more than a *simia naturae* (in the derogatory sense of the term). If Titian had felt it necessary to defend himself against this accusation, he could in turn have charged the Florentines with being *simiae artis,* and the *Laocoon Caricature* might have served to convey this idea. Still, there are no indications that he was ever disposed to such a spiteful exchange; being far less concerned with aesthetic theory than the author of the *Vite,* he seems to have taken a much more broadminded view of his artistic neighbors to the south. To impute to him the mentality of a Vasari would be ungenerous, to say the least.

Fischel's proposal raises equally serious misgivings. The theory that Titian, an early admirer of the *Laocoon,*[12] should at a later time have conceived such a feeling of revulsion toward the statue that he had to "abreact" in pictorial form, seems too subtle, too modern in its psychological implications. In any event, no evidence to support it can be found in the artist's life and work during the years around 1550, the probable date of the *Laocoon Caricature.* In 1545, Titian had paid his first visit to Rome, where he was very much impressed with Michelangelo and classical sculpture. His own testimony assures us that he was "learning from these most wonderful ancient stones."[13] Nor is this admiring attitude in any way surprising; ever since the early 1540s, Titian's style had developed in a direction that seemed to anticipate the effects of the Rome journey. Why, then, should he have wanted to satirize the *Laocoon* at a time when his own work was closer to the spirit of the statue than ever before? And if he did have such a desire, why should he have chosen to display this highly personal impulse to the public at large through the medium of a woodcut?

Finally, there is one argument that can be brought to bear against all three of the interpretations discussed above. For the Cinquecento as a whole, reverence toward the art of antiquity was undoubtedly the dominant tendency; thus, if Titian had conceived the *Laocoon Caricature* in order to cast ridicule upon this attitude, the print would have stirred up considerable agitation, at least in artistic

[11] *Vite,* ed. Milanesi, VII, pp. 447–48.

[12] This is evidenced by the well-known fact that the *Risen Christ* in the master's Brescia Altarpiece of 1522 reflects the pose of the statue; Titian owned a cast of it at that time (cf. Bieber, *loc. cit.*).

[13] In his letter to the Emperor, quoted by Gronau, *loc. cit.,* who concludes from it that the Rome journey had brought about a reversal of Titian's previous estimate of classical sculpture as expressed in the *Laocoon Caricature,* which he dates before 1545.

circles. In view of these circumstances, the complete silence of contemporary authors seems most surprising, especially in the case of Vasari, who had every opportunity to learn of the matter when he visited Titian in Venice in 1565. Why did he fail to mention it in the *Vite,* where he could have used it so effectively to underline his general criticism of Titian's style? Ridolfi, too, knew nothing of the significance of the design; in fact, he did not even recognize its satirical implications, since he describes it simply as "un gentil pensiero di tre Bertuccie sedenti attorniati da serpi, nella guisa del Laocoonte e di figlioli posti in Belvedere di Roma." Nevertheless, the *Laocoon Caricature* surely was intended to be more than just a monumental piece of *drôlerie;* nor can there be any doubt that classical sculpture is somehow involved in the satirical message it conveys. Why, then, did Ridolfi and the other chroniclers of artistic affairs in sixteenth- and seventeenth-century Italy remain ignorant of this message? Could it be that the object of the satire must be looked for, not in the realm of aesthetics but in one of the many other areas where the authority of the ancients might become a matter of dispute?

A controversy of this kind was in progress during the middle years of the Cinquecento in the field of anatomy. It not only seems to fit the chronological and artistic circumstances of our case but has the further advantage of providing a direct explanation for the apes in the *Laocoon Caricature.* The event that set off this conflict was the publication, in 1543, of Andreas Vesalius' *De humani corporis fabrica libri vii.* In this famous work, with its magnificent woodcuts,[14] Vesalius defied for the first time the authority of Galen, whose opinions in matters anatomical had hitherto been accepted as gospel truth by the doctors of the Renaissance. Not only did he cite several hundred factual errors from the writings of the Pergamene physician; in order to drive home his attack, he leveled another and, in the eyes of many of his contemporaries, even more shocking charge: that Galen had never really dissected any human bodies, that he had "described the structure, not of humans but of apes, despite the innumerable differences between the two."[15] This sweeping accusation, prompted by Vesalius' eagerness to break down the wall of respect that protected Galen against any kind of professional scrutiny, soon rallied the traditionalists to an ardent defense of their hero and to an equally ardent campaign of vilification against the author of the *Fabrica.*[16] Reports of hostile reactions to his book must have reached Vesalius with-

[14] The illustrations of the *Fabrica* are generally regarded as the work of John Calcar, on the strength of Vasari's testimony as well as of the fact that Calcar's name appears on one of the plates of Vesalius' *Tabulae sex* (Venice, 1538). The latter, however, are much inferior to the *Fabrica* woodcuts, as pointed out by Charles Singer in the *Bulletin of the History of Medicine,* XVII, 1945, pp. 429 ff., and in *A Prelude to Modern Science . . . the History, Sources and Circumstances of the Tabulae Anatomicae Sex of Vesalius* (Publications of the Wellcome Historical Medical Museum, N.S., I), Cambridge, 1946, pp. ix ff.

[15] ". . . qui [Galenus] et si huius [anatomes] procerum facile est primarius, humanum tamen corpus nunquam agressus est, et simiae potius quam hominis ab illius fabrica innumeris sedibus variantis partes descripsisse (nedicam nobis imposuisse) modo colligitur;" quoted by Moritz Roth, *Andreas Vesalius Bruxellensis,* Berlin, 1892, p. 143. Even so, Vesalius himself perpetuated a good many errors of the same kind, since he did not always realize the simian character of the anatomical formations described by Galen. Cf. Singer, *A Prelude . . . , passim.*

[16] Galen certainly did use human bodies, even though his opportunities for doing so must have been severely limited. It is true that many of his observations were most probably based on

in a few months after publication; in his *Epistle on the China Root,* written two years later, he states that he burned all his accumulated notes and manuscripts late in 1543 or early in 1544, apparently in a fit of despondency over the attacks of his colleagues.[17] However, this frame of mind soon gave way to a fighting mood, since part of the *Epistle* is devoted to a restatement of the author's position in regard to Galen and to a vigorous defense of the *Fabrica.*

Such defiance incited the Galenists to new heights of indignation, and in 1550–51 they began to denounce Vesalius in print. The controversy was now in full swing, with accusations and counter-accusations following each other in rapid succession until 1564, the year of Vesalius' death. Repercussions of the dispute reached far into the seventeenth century, and as late as 1699 the English anatomist Edward Tyson found it of sufficient interest to include a detailed account of the whole matter in his book on the anatomy of a chimpanzee.[18] Fortunately, Vesalius was not alone in defending his point of view; while he was preparing the second edition of the *Fabrica,* which appeared in 1552–55, others took up the cudgels for him. In Italy, his spiritual homeland, the Vesalians outnumbered the Galenists, whose stronghold, characteristically enough, was in the northern countries.[19]

The foremost, as well as the most vituperative, of Vesalius' enemies was his former teacher at the University of Paris, Jacobus Sylvius. After casting aspersions on the *Fabrica* in his commentary on Galen,[20] he published in 1551 a vicious pamphlet, *Vaesani cuiusdam calumniarum . . . depulsio,* "a refutation of the calumnies of a certain madman," grossly insulting Vesalius in the very title. Some of the arguments used by Sylvius are of particular interest in connection with our problem. His basic aim, of course, was to prove that every word of Galen's anatomy applies only to humans, not to apes. For the most part he simply denied, with or without further discussion, the specific charges of error made by Vesalius; in some instances, however, Galen's descriptions disagreed so obviously with the results of direct observation that not even Sylvius could shut his eyes to the existence of discrepancies. In order to cover all cases of this kind, he fell back on a theory that had existed in various forms as a minor current in medieval philosophy: the idea of the progressive decay of nature since the days of old.[21] Trans-

apes, but he never assumed that the anatomy of the latter was identical with that of man, since he recommended them for study purposes only when human bodies could not be procured. Cf. William C. McDermott, *The Ape in Antiquity* (The Johns Hopkins University Studies in Archaeology, 27), Baltimore, 1938, pp. 93 ff.

[17] *Epistola, rationem modumque propinandi radicis Chynae . . . pertractans: et praeter alia quaedam, epistolae cuiusdam ad Iacobum Sylvium sententiam recensens, veritatis ac potissimum humanae fabricae studiosis perutilem: quum qui hactenus in illa nimium Galeno creditum sit, facile commonstret,* Basel, 1546. The incident took place in Padua, where Vesalius held the chair of anatomy; cf. Roth, *op. cit.,* pp. 208 ff., and Harvey Cushing, *A Bio-Bibliography of Andreas Vesalius,* New York, 1943, p. 156.

[18] *Orang-Outang, sive Homo Sylvestris: Or, the Anatomy of a Pygmie Compared with that of a Monkey, an Ape, and a Man,* London, 1699. The passage referred to is reprinted in M.F. Ashley Montagu, "Edward Tyson," *Memoirs of the American Philosophical Society,* XX, Philadelphia, 1943, pp. 294–98, with bibliographical annotations.

[19] Cf. Roth, *op. cit.,* p. 251.

[20] *Galenus de ossibus . . . , commentariis illustratus;* according to Roth, *op. cit.,* p. 277, the first edition dates from ca. 1550.

[21] For the development of this theory, which might be termed the metaphysical ancestor of

ferring this pattern to the field of anatomy, Sylvius maintained that man had degenerated to some extent since classical antiquity, an assumption which enabled him to claim that Galen's statements, even if they were no longer true today, had certainly been correct at the time they were recorded.[22] As an argument against the *Fabrica,* this line of reasoning was so tenuous that even the Galenists failed to be impressed by it. To the Vesalians, on the other hand, it must have given a good deal of satisfaction. Sylvius had, after all, been forced to acknowledge at least part of Vesalius' critique of Galen; he admitted that his hero's observations did not always fit the human body as the anatomists of the Cinquecento knew it. But instead of calling these discrepancies errors, he concluded that the human species itself must have changed in the meantime, even though Vesalius, the original discoverer of these errors, had already demonstrated that they were due to Galen's habit of dissecting apes instead of humans. By insisting that in classical antiquity mankind had actually possessed the simian features attributed to it by Galen, Sylvius postulated, in effect, that the men of that time had looked like apes.

To the modern reader this may look like a daring, if unintentional, anticipation of Darwin; the Vesalians of four hundred years ago could have regarded it only as a masterpiece of Galenist stupidity. Sylvius' faith in the authority of his classical source had indeed been blind, in the most literal sense of the term. A significant passage in his *Depulsio* decries the lavish plates of the *Fabrica,* and in fact all anatomical illustrations, as utterly useless; they are misleading because they are "covered with shadows," and dangerous in that they tempt the student to neglect the dissection of actual bodies.[23] But in upholding the infallibility of Galen by means of the degeneration theory, Sylvius had neglected a far more impressive source of visual evidence, namely, classical sculpture. Here, through works of art unsurpassed for their exact rendering of anatomical detail, the ancients themselves had provided posterity with incontrovertible proof that the structure of the human body had remained unchanged through the ages, and no one could have been more appreciative of this fact than Vesalius. The full-length figures among the *Fabrica* plates often betray the inspiration of classical statuary in stance and proportion.[24] The same is true to an even greater extent of the numerous if less well-known cuts of torsos, all of them strongly suggestive of the *Torso Belvedere* and similar pieces (fig. 2); the extremities are invariably treated as if they were broken off, rather than severed by the surgeon's knife, with the jagged edges and rough surfaces characteristic of cracked marble. This

the second law of thermodynamics, and its recurrence in other branches of Renaissance learning, cf. Richard F. Jones, *Ancients and Moderns,* Washington University, St. Louis, Mo., 1936, pp. 23–42 and 291–96.

[22] Cf. Roth, *op. cit.,* p. 230, who points out that this argument is not wholly original with Sylvius. It occurs in the writings of several Italian anatomists of the late fifteenth and early sixteenth centuries, even though at that time Galen had not yet been accused of dealing with apes instead of humans. The "degeneration theory" is of considerable interest for the historian of science; despite the futile purpose which it was made to serve, its implications were decidedly "modern" in that it helped to overthrow the medieval doctrine of the immutability of species. For the latter, cf. Lynn Thorndyke, *Science and Thought in the Fifteenth Century,* New York, 1929, p. 216.

[23] Translated by Cushing, *op. cit.,* p. xxxi.

[24] This was already noted by Roth, *op. cit.,* p. 171.

admiration for antique sculpture must be credited, at least in part, to Vesalius himself. To be sure, the actual designing of the *Fabrica* plates had been done by a professional artist, but it was Vesalius who conceived the entire scheme, a veritable revolution in the field of anatomical illustration, and who supervised its execution step by step with the most painstaking care.[25] It is possible, in fact, that he was quite a skillful draftsman in his own right.[26]

Under the circumstances, we may not be going too far afield if we attribute to the author of the *Fabrica* the original idea for the *Laocoon Caricature*. For what could have been a more effective pictorial rebuke to the Galenists in general and to Sylvius in particular than this *reductio ad absurdum* of the Galenist point of view, showing the most famous, as well as the most anatomically detailed, sculptural masterpiece of antiquity transposed into simian terms? If we accept this as the true meaning of the woodcut, its message might be formulated as follows: "This is what the heroic bodies of classical antiquity would have to look like in order to conform to the anatomical specifications of Galen!" Fundamentally, then, the *Laocoon Caricature* is the visual equivalent of Vesalius' original denunciation of Galen in the 1543 edition of the *Fabrica*, although the satire is focused less upon Galen himself than upon Sylvius and his followers.

Considering the violent and insulting tone employed by both sides throughout the controversy—a practice not at all uncommon in the Renaissance—the ruthlessness of the travesty is understandable enough. From the first, Vesalius himself had been far from temperate, and the vicious attacks of his detractors certainly did not serve to restrain him.[27] Sylvius had alluded to him as a madman ("vaesanus"), a compliment that was repaid a few years later by one of the defenders of the *Fabrica*, the Swiss anatomist Renatus Hener, who referred to Sylvius and his friends as the "asini bipedes sylvani."[28] In the preface to the second edition of the *Fabrica*, Vesalius once more denounced his enemies in the most vigorous terms, but since in this instance pictures and text were of equal importance, he expressed his scorn for the Galenists in graphic form as well. The first edition of the *Fabrica* had been adorned with large figured initials repre-

[25] For the artistic and scientific importance of the *Fabrica* illustrations and for Vesalius' share in their preparation, cf. Roth, *op. cit.*, p. 159 and *passim;* also, more recently, William M. Ivins, "Woodcuts to Vesalius," *Metropolitan Museum Bulletin*, XXXI, 1936, pp. 139–42, and the literature occasioned by the four-hundredth anniversary of the first edition of the *Fabrica* (listed in Cushing, *op. cit.*, p. 216).

[26] As surmised by Roth, *loc. cit.*

[27] Even the great Italian anatomist Gabriele Falloppio, although fully appreciative of the greatness of the *Fabrica*, had to admit that ". . . Vesalius, as a great warrior, aroused, so to speak, by the ardour of victory and moved by its force, frequently undertakes something which neither contributes to his own glory nor satisfies the greatest dukes and emperors; in that he sometimes seizes upon the words rather than the ideas of Galen . . . and . . . often carps at and accuses Galen in a manner unbefitting an anatomist . . ."; the passage occurs in the preface of his *Observationes anatomicae*, Venice, 1561 (quoted by Arturo Castiglioni, "Fallopius and Vesalius," in Cushing, *op. cit.*, p. 184), a treatise in which he takes issue with Vesalius on certain anatomical matters quite unrelated to the controversy over Galen. The public reply of Vesalius (*Anatomicarum Gabrielis Falloppii observationum examen*, Venice, 1564; excerpts quoted by Castiglioni, *supra*, pp. 190 ff.) is couched in extremely respectful terms except for the passages dealing with Galen and the Galenists.

[28] Renatus Henerus, *Adversus Jacobi Sylvii depulsionem . . . pro Andrea Vesalio apologia*, Venice, 1555; cf. Roth, *op. cit.*, p. 246.

senting various phases of dissection demonstrated by putti; in the second edition, these were augmented by a specially cut initial "V" designed by an unknown artist, in which Apollo is shown preparing to flay Marsyas (fig. 3). The choice of this particular subject in combination with the first letter of Vesalius' own name permits only one interpretation: the victorious Apollo, Vesalius, is about to "dissect" his unsuccessful rival, the "sylvan" Marsyas.[29] Vesalius, then, was no stranger to the possibilities of pictorial invective. The "V" initial apparently was his first effort of this kind;[30] it may well have whetted his appetite for a more ambitious venture in the same direction, thus becoming the spiritual ancestor of the *Laocoon Caricature*.

As an anti-Galenist allegory, the Apollo and Marsyas motif suffers from a lack of directness, since it fails to convey the nature of the conflict involved. In the *Laocoon Caricature,* this purpose is accomplished by the apes, whose anatomy Galen had allegedly substituted for that of man. The effectiveness of this device may be judged by the fact that after the death of Vesalius the ape became the accepted visual symbol for the entire controversy. Several interesting examples of its use in such a capacity have come to my attention, among them the elaborately engraved title page of an edition of the *Fabrica* issued in Venice in 1604 (fig. 4).[31] The design shows a triumphal arch, its niches filled with various anatomical figures; in the archway, Vesalius is seen performing a dissection in the presence of several learned colleagues, while above him, reclining on the sloping sides of a broken pediment, are shown two animals of special significance to the professional reader: a pig, commonly used for vivisections because its inner organs were regarded as similar to those of man,[32] and an ape, the source of Galen's mistakes and the creature closest to man in its bony structure. A somewhat different arrangement may be seen in the engraved portrait of the Swiss anatomist and botanist Gaspard Bauhin, by Johann Theodor de Bry,[33] which forms the frontispiece of Bauhin's *Theatrum anatomicum,* published in Frankfurt in 1605. The portrait is placed in an oval frame within a rectangular field, and the two lower corners are occupied, respectively, by a human skull and the head of an ape, both

[29] The symbolic meaning of the design was already recognized by Roth, *op. cit.*, p. 231; it is reproduced in Henry S. Francis, "The Woodcut Initials of the *Fabrica,*" *Bulletin of the Medical Library Association,* XXXI, 1943, p. 237, fig. 7.

[30] The attempts of Roth, *op. cit.*, pp. 178 ff., to find anti-Galenist implications in two of the original *Fabrica* woodcuts must be regarded as unsuccessful. His interpretation of the inscription and the dissected arm in the portrait of Vesalius as referring to a weak point in Galen has already been refuted by Cushing, *op. cit.*, p. 85; as for the two "grinning apes' heads" on the title page, which he regards as symbols of Galen's simian propensities, they are nothing but ordinary decorative *diavolini*.

[31] Cf. Cushing, *op. cit.*, p. 94, fig. 67; it bears the signature of Francesco Valesio, a Bolognese engraver who helped to decorate several Venetian publications of the early seventeenth century (cf. *Bryan's Dictionary of Painters and Engravers,* new ed., New York and London, 1905, V, p. 229, s.v. "Valesio").

[32] During the Middle Ages, when the dissection of human corpses was almost impossible, the pig seems to have played a role analogous to that of the ape in Galen's time as a substitute for the direct study of human anatomy.

[33] Reproduced in Agnes Arber, *Herbals, Their Origin and Evolution,* Cambridge, 1912, pl. xi; Johann Theodor de Bry, 1561–1623, was active in Frankfurt, where he was the teacher of Sandrart (cf. Thieme-Becker, *Lexikon,* V, p. 162).

glaring at each other as if they were about to start disputing the merits of Galen vs. Vesalius between themselves (in which case we may be sure that the ape would take the Vesalian side of the argument).[34]

On a purely iconographical basis, then, our new approach to the *Laocoon Caricature* appears to be, if not completely secure, at least more solidly founded than the previous theories. However, in order to be fully acceptable, our interpretation will have to pass a further test: it must prove compatible with the artistic character of the woodcut. What connection, if any, can be established between Vesalius and Titian? Here it is useful to recall that until the nineteenth century the *Fabrica* plates were commonly believed to be by Titian, the explicit testimony of Vasari in favor of John Calcar notwithstanding.[35] From the point of view of style, this attribution is understandable enough, and Erika Tietze-Conrat has recently discovered new evidence suggesting that Titian may indeed have been more closely associated with the *Fabrica* illustrations than hitherto assumed, perhaps as the artistic supervisor of the entire project.[36] Since Vesalius was teaching at the University of Padua while the work on the *Fabrica* was in progress, it would have been only natural for him to consult the most renowned artist of the neighboring city. Whether we assume that it was Titian who introduced him to John Calcar, or vice versa, there can be little doubt that the two great men knew each other directly. Thus, at some later time, Titian might very well have obliged Vesalius with a drawing for the *Laocoon Caricature,* leaving the actual execution to his favorite wood-engraver, Boldrini.

But what was the concrete purpose of the print? It could hardly have been offered for sale to the general public without some explanatory text. Most probably Vesalius intended to use it as an illustration for a tract or pamphlet directed against Sylvius and the other Galenists.[37] Would Titian have deigned to help him out on an occasion such as this? There is reason to believe that, as a special favor to a friend, he might have been willing to do so; for, in 1537, he designed a woodcut, *Aretino and the Siren,* for the title page of Aretino's *Stanze in lode della sirena.*[38] In any event, assuming that Vesalius planned to bring out a pamphlet of this sort, Venice would have been his most likely choice as a place of publication, since most of the literature dealing with Galen vs. the *Fabrica*

[34] Bauhin must have been thoroughly conversant with the arguments on both sides of the controversy; as early as 1577 he owned a copy of Vesalius' reply to Falloppio (the title page bearing his autograph is reproduced in Cushing, *op. cit.,* fig. 88). The juxtaposition of ape and pig also occurs on the engraved title pages of later *Anatomies,* such as those of Adrian Spigel (Frankfurt, 1632) and Casserius (Amsterdam, 1645).

[35] Cf. Roth, *op. cit.,* p. 166, and Cushing, *op. cit.,* p. xxix.

[36] E. Tietze-Conrat, "Neglected Contemporary Sources Relating to Michelangelo and Titian," *Art Bulletin,* XXV, 1943, pp. 156–59.

[37] He might, for instance, have planned an answer to Francesco Pozzi (Puteus), whose *Apologia in anatome pro Galeno contra Andream Vesalium* was published in Venice in 1562. Such a reply, long erroneously attributed to Vesalius himself but actually by Gabriele Cuneo, did indeed appear two years later under the title, *Apologiae Francisci Putei pro Galeno in anatome examen,* Venice, 1564 (cf. Cushing, *op. cit.,* p. 201, no. 100). The large size of the *Laocoon Caricature* need not be regarded as an obstacle to our hypothesis, since the plates of the *Fabrica* were of a similar scale.

[38] Cf. Tietze, "Titian's Woodcuts," p. 467.

was printed in that city.[39] Still, the fact remains that no such pamphlet ever reached the public; if it had, we would undoubtedly find references to it among the writings of other Cinquecento anatomists. Perhaps the disrupted pattern of the last twenty years of Vesalius' career may help to explain his failure to make appropriate use of the *Laocoon Caricature*. From the beginning of 1544 until his death, he was a court physician in the service of Emperor Charles V, a position that forced him to travel a great deal and thus made it almost impossible for him to continue his scholarly and publishing activities. He died during a trip to Palestine, the purpose of which is still something of a mystery. However, in the course of his last journey he spent some time in Venice, possibly in connection with publishing plans frustrated by his untimely end. Could the *Laocoon Caricature* have played a part in these? Perhaps the wood block for the print, already cut, remained in Titian's workshop, and separate impressions were made from it at some later date because of the diverting subject matter. When the *Laocoon Caricature* finally entered into the written records of the history of art in the mid-seventeenth century, the Vesalian-Galenist dispute was already well on its way to oblivion, so that the meaning of the design had to remain obscure. The role we have assigned to it here ultimately relates it to the same general problem as the older, aesthetic interpretation: the struggle between ancient authority and modern critical reason.

[39] E.g., Hener's *Apologia*, including a complete reprinting of Sylvius' *Depulsio;* the writings of Pozzi and Cuneo; Falloppio's *Observationes;* and Vesalius' own *Examen* (cf. notes 27, 28, and 37 above); also Bartholomaeus Eustachius, *Opuscula Anatomica*, 1564, another defense of Galen.

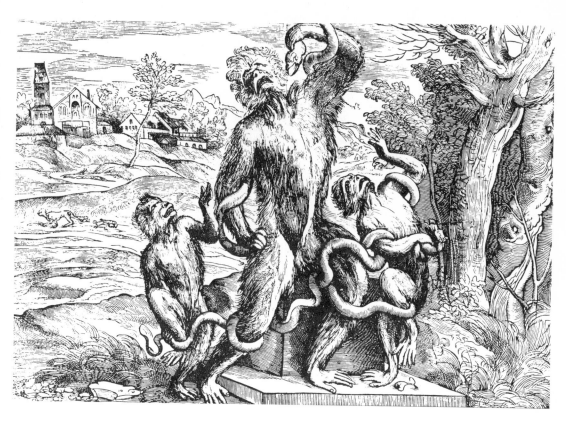

1: *Niccolò Boldrini after Titian*. Caricature of the *Laocoon* Group. *Woodcut. New York, Metropolitan Museum of Art*

2

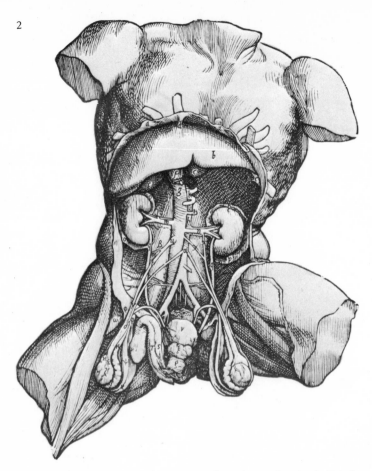

3

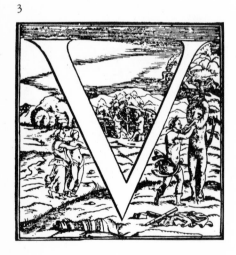

2. Torso. *Woodcut in the* Fabrica *(Book V, pl. 22), 1st edition, Basel, 1543*

3. *Initial "V" with Apollo and Marsyas. Woodcut in the* Fabrica, *2nd edition, Basel, 1555*

4. *Francesco Valesio, Engraved Title page (detail) of the* Fabrica, *Venice, 1604*

4

3

STUDY

*The "Image
Made By Chance"
in Renaissance Thought*

"The 'Image Made by Chance' in Renaissance Thought,"
De artibus opuscula XL: Essays in Honor of Erwin Panofsky, ed. Millard Meiss,
New York University Press, 1961, pp. 254-66

In the opening sentences of his treatise *De statua,* Leone Battista Alberti describes the origin of sculpture as follows:

Those [who were inclined to express and represent . . . the bodies brought forth by nature] would at times observe in tree trunks, clumps of earth, or other objects of this sort certain outlines (*lineamenta*) which through some slight changes could be made to resemble a natural shape. They thereupon took thought and tried, by adding or taking away here and there, to render the resemblance complete.

Before long, the author adds, the primeval sculptors learned how to make images without depending on such resemblances latent in their raw material; some— those who used wax, stucco, or clay—worked by adding as well as by taking away, while others worked by subtraction only, removing, as it were, the superfluous material concealing the figures potentially present within the marble.[1]

This passage, although well known and frequently cited, has not so far received the scholarly attention it deserves. It is a true primordium of art theory and psychology, the first explicit statement linking artistic creation with "images made by chance." Moreover, it may well claim to be the only idea in the entire body of Renaissance art theory that is of greater importance today than it was at the time of its inception: the process described by Alberti—the spontaneous discovery of representational meanings in chance formations—has been verified by students of paleolithic art on the cave walls of Spain and the Dordogne,[2] it has become a central aesthetic tenet of Dadaism and Surrealism, and psychologists have put it to practical use in projective tests of the Rorschach ink-blot type.

Alberti's insight into this particular mechanism of the imagination seems the more extraordinary in view of the absence of any similar notions in his treatise

The present essay forms part of a larger study begun in 1955–56. I gratefully acknowledge my indebtedness to the John Simon Guggenheim Foundation, which awarded me a Fellowship for that year. I also wish to thank Dr. Millard Meiss for several important suggestions and references.

[1] Leone Battista Alberti, *Kleinere kunsttheoretische Schriften.* ed. Hubert Janitschek (*Quellenschriften* . . ., ed. Eitelberger v. Edelberg, XI), Vienna, 1877, pp. 168 ff.

[2] For recent discussions of the phenomenon, see Herbert Kühn, *Die Felsbilder Europas,* Stuttgart, 1952, pp. 32 f., and Paolo Graziosi, *L'arte dell'antica età della pietra,* Florence, 1956, pp. 274 f., pls. 267–73.

Della pittura. There he shows little concern with the problem of origins. Instead, his interest centers on a precise definition of the nature of pictorial activity, so that he refers, somewhat jocosely, to Narcissus as the inventor of painting, since the painter's aim, too, is to seize—by means of his art—the mirror image reflected on the water.[3] Alberti then reports the opinion of Quintilian that the earliest painters simply traced the outlines of shadows cast by the light of the sun and that the art of painting grew from this practice,[4] but adds that "it is of small importance to know the earliest painters or the inventors of painting." While he apparently had no greater faith in the historical accuracy of Quintilian's tale than in Pliny's account of Philocles and Cleanthes as the inventors of the art,[5] it fitted his own analytical view of painting so well that he must have granted it at least a kind of phylogenetic validity; when, in Book III, he sets up a learning procedure for beginners, he advises them to start with the outlines of planes and to draw large objects in natural scale, a method strongly reminiscent of the "shadow-tracing" theory.[6] Yet Alberti was quite aware of chance images when he composed *Della pittura.* Near the end of a lengthy passage detailing the high regard in which painting had been held by the ancients, he writes: "Nay, nature herself seems to take delight in painting, as when she depicts centaurs and the faces of bearded kings in cracked blocks of marble. Pyrrhus is said to have owned a gem on which nature had painted the nine muses with their attributes."[7] The latter example is taken directly from Pliny, who in his discussion of precious stones refers to "the agate of Pyrrhus on which could be seen Apollo with his lyre and the nine Muses, each with her proper attribute, rendered not by art but by nature, through the pattern of the spots."[8] The images in the cracked blocks of marble are a variant on another Pliny passage, which tells of a picture of Silenus found inside a block of Parian marble that had been split open with wedges.[9] Alberti's purpose in mentioning these *mirabilia* is obviously rhetorical: the fact that Nature herself produces images becomes the crowning argument for his claim that painting is a noble and "liberal" activity. The images themselves are absurdly complete and explicit, down to the last iconographic detail, so that they (unlike the tree trunks of *De statua*) are immediately recognizable and do not need to be "perfected" by their discoverers.

Pliny, however, did not furnish the framework in which Alberti cites these "images made by nature"; to Pliny they had no bearing, rhetorical or otherwise, on the character of man's creative efforts; rather, they demonstrated the strange powers of *fortuna,* and were thought remarkable for that reason alone. The same is true of another story he tells about an "image made by nature" that might at first glance seem closer to our context: it concerns a panting dog in a picture

[3] Book II, in Alberti, *op. cit.,* pp. 92 f. The source of the passage is discussed in Erwin Panofsky, *Idea* (Studien der Bibliothek Warburg), Leipzig, 1924, p. 93, n. 125.

[4] *Inst. or.,* X, ii, 7.

[5] *Hist. nat.,* XXXV, iii, cited by Alberti as "sono chi dicono...."

[6] Alberti, *op. cit.,* pp. 148 f., 152 f.

[7] *Ibid.,* pp. 94 f.

[8] *Hist. nat.,* XXXVII, i.

[9] *Ibid.,* XXXVI, v. Alberti's reference to the faces of bearded kings apparently derives from Albertus Magnus (cf. n. 16, infra).

by Protogenes.[10] The artist tried in vain to represent the foam issuing from the mouth of the animal until, enraged by his futile efforts, he hurled a sponge at his panel and thus, by sheer chance, achieved the desired effect. This dog, the author states, "was wondrously made, since it was painted equally by chance and by art" *(fecitque in pictura fortuna naturam).* He then informs us that the same story is told of Nealces, with a horse taking the place of the dog. A variant of the latter version, substituting Apelles for Nealces, is recounted at some length in the sixty-fourth oration of Dio Chrysostom, which deals, characteristically enough, with the workings of *fortuna.*[11] Here again, the representational quality of the chance image is perfect—so much so, in fact, as to surpass any human endeavor. The only inference to be drawn from the sponge story is that Fortune reserves such a "stroke of luck" only for the greatest of artists, as if on occasion she took pity upon their ambition to achieve the impossible. It must have been these accounts of chance images of incredible perfection that provoked the following skeptical rejoinder from Cicero:[12]

> Pigments flung blindly at a panel might conceivably form themselves into the lineaments of a human face, but do you think the loveliness of the Venus of Cos could emerge from paints hurled at random? If a pig should trace the letter A on the ground with its snout, would one be justified in concluding that it could transcribe the *Andromache* of Ennius? Carneades used to tell that once upon a time, in the quarries of Chios, a stone was split open and the head of a little Pan appeared; well, the bust may not have been unlike the god, but we may be sure that it was not so perfect a reproduction as to lead one to imagine that it had been wrought by Scopas, for it goes without saying that perfection has never been achieved by accident.

A different species of "image made by nature," unstable and imprecise, was equally well known in classical antiquity: the figures to be seen in certain kinds of clouds. Aristotle seems to have been the first to take note of this effect,[13] Pliny mentions it briefly,[14] and Lucretius at somewhat greater length.[15] Since Lucretius claims that all images are material films given off by objects, somewhat in the manner of snakes shedding their outer skin, he is hard put to

[10] *Ibid.,* XXXV, x. For another derivation of Alberti's etiology of sculpture, published too late to be considered here, see Alessandro Parronchi, "Sul 'Della Statua' Albertiano," *Paragone,* IX, no. 117, Sept. 1959, pp. 9 ff.

[11] For a discussion of this story motif, see Ernst Kris and Otto Kurz, *Die Legende vom Künstler,* Vienna, 1934, pp. 53 f.

[12] *De divinatione,* I, xiii. The literate pig appears to be the source of the more recent proposition, expounded in a famous sketch, *Inflexible Logic,* by Russell Maloney, that "if six chimpanzees were set to work pounding six typewriters at random, they would, in a million years, write all the books in the British Museum." See also *ibid.,* II, xxiii, and the ample scholarly glosses on both passages in the edition of Arthur Stanley Pease (University of Illinois Studies in Language and Literature, VI, VIII, 1922–23, pp. 123 ff., 431 ff.).

[13] *Meteorology,* I, ii.

[14] *Hist. nat.,* II, lxi, "De nubium imaginibus."

[15] *De rerum natura,* IV, 129 ff. For additional references to cloud images in both ancient and modern literature, see Pease, *op. cit.,* p. 433.

58

explain the origin of cloud figures such as "giant faces . . . mountains . . . monsters," of which he says that "in their fluidity they never cease to change their form, assuming the outline now of one shape, now of another." Clearly there cannot be any objects from which these image films emanate, so that he has to postulate the spontaneous generation of such films in the upper air. As late as the eleventh century the Byzantine scholar Michael Psellus could refer to the varied and ever-changing configurations of clouds, which may resemble the shape of "men, bears, dragons, etc."; they are, he explains, like the bodies of demons, which can assume different guises with the same facility.[16] Yet the notion that figures in clouds, or chance images generally, might provide an insight into the work of painters and sculptors, was not expressed until near the end of classical civilization. We find it in a memorable dialogue in Philostratus' *Apollonius of Tyana:*[17]

Apollonius. Does painting exist?

Damis. Just as surely as truth exists.

A. What is the painter's business?

D. To blend all possible colors. . . .

A. And what is the purpose of such mixture? Not merely to produce a brilliant surface impression, like wax-candles?

D. The purpose is a make-believe—to make an exact likeness of a dog, a horse, a man, a ship, in fact of everything that the sun beholds. Nay, the painter may make a likeness of the sun himself, sometimes in a chariot-and-four (as they say he appears here) and sometimes illuminating the sky with a beacon-glow, as in pictures of heaven and the house of the Gods.

A. Painting is making believe, then?

D. Certainly. Failing that function, it becomes an absurdity—mere silly daubing.

A. Now the appearances which are seen in the sky when masses of cloud are sundered, the centaurs and heraldic animals—yes, and the

[16] ΠΕΡΙ ΕΝΕΡΓΕΙΑΣ ΔΑΙΜΟΝΩΝ ΔΙΑΛΟΓΟΣ, ed. Gilbert Gaulmin, Paris, 1615, pp. 72 ff. In Western Europe, too, medieval thought remained aware of cloud figures but tended to regard them as real rather than as mere images. Thus Albertus Magnus (*On Meteors,* III, iii, ch. xxiii, citing Avicenna) claims that exhalations from the earth, if aided by heavenly constellations, may be able to form in the clouds perfect though lifeless animal bodies, and that on one occasion such a body, in the shape of a calf, had actually dropped from the sky. In his treatise *On Minerals* (II, iii, ch. i) Albertus likewise records the chance images in stone familiar from ancient literature, emphasizing their miraculous character; he even reports that he himself had seen the head of a bearded king on the cut surfaces of a block of marble that had just been sawn in two, and that all those witnessing the event agreed that Nature had painted this image on the stone. Appropriately enough, the heavenly calf and the marble image described by Albertus were subsequently cited (and illustrated) as arguments for the Immaculate Conception in the *Defensorium inviolatae virginitatis Mariae* of Franciscus de Retza (fig. 1). I owe my acquaintance with these passages to the kind help of Dr. W. S. Heckscher of the University of Utrecht. The history of chance images in stone as an aspect of medieval and Renaissance mineralogy, from the lapidary of Marbod of Rennes to Ulisse Aldrovandi and Athanasius Kircher, has recently been traced by Jurgis Baltrušaitis ("Pierres imagées," *Aberrations: quatre essais sur la légende des formes,* Paris, 1957, pp. 47 ff.).

[17] II, 22, trans. J. S. Phillimore, Oxford, 1912, I, pp. 75 ff.

wolves and the horses—are not all these make-believe effects?

D. I dare say.

A. Then God is an artist, Damis, eh? And when he leaves the winged chariot in which he goes on progress round his realm and disposes the affairs of Gods and men, he sits and amuses himself by drawing these figures, as children draw in the sand? . . . Why, Damis, surely your meaning is that those appearances are produced at random without any divine significance; and that it is reserved for man, with his natural gift of make-believe, to give them regular shape and existence?

D. Yes, let us believe that, Apollonius; a far more creditable and worthier opinion.

A. So, Damis, we conclude that the art of making believe is of two kinds: one consists in the manual and mental reproduction of an object—this is painting—the other in a merely mental perception of likeness.

D. Not two kinds; but we must hold that the art of make-believe only deserves the name of painting in its more perfect form, that is to say, when it is able to reproduce likeness manually as well as mentally; the other make-believe is but a fraction of this; a man may quite well perceive and form a mental image, and yet be no artist; his hand will not serve him to execute it.

A. You mean a man who has been disabled by accident or disease?

D. No, no; I mean disabled by never having handled a brush, or any tool or pigment, and by having never been trained to draw.

A. In fact, we are agreed that the instinct of make-believe comes to man by nature, but design comes by art. This will also hold good of plastic art. Only when you talk of painting, I do not take you to mean only design executed in the medium of color . . ., but the term ought to include also line without color, pure effects of light and shade.

. .

If we were to draw one of these Indians in uncolored outline, he will certainly be recognized for a black man: to any intelligent spectator, the flattish nose, erect locks, overdeveloped jaw, and what you may call the terrified look about the eyes, darken the portrait and suggest the Indian. And this leads me to say that you need the faculty of make-believe [also] when you look at the performance of an artist; for you cannot praise the execution of a horse or a bull in a picture unless you have in your mind a notion of the original; or admire Timomachus' Ajax (I mean the famous *Ajax Mad*) unless you conceive a certain mental image of Ajax—how he would be likely to sit, weary and dejected after his massacre of the cattle at Troy, and meditating his suicide.

Here Philostratus seems on the verge of discovering the relationship so clearly expressed in Alberti's *De statua*, but he turns back before the final (and decisive) step. Although recognizing that it is man's "natural gift of make-believe"—i.e.,

imagination—that gives regular shape and existence to the figures produced at random among the clouds, he concedes this faculty to all men, artists and non-artists alike; it operates in the same way, whether we look at a chance image or a man-made one. What sets the artist apart is not a particular capacity to perceive and form mental images but his ability to reproduce these images manually. Thus in Philostratus' view the formation and the material externalization of the mental image are two processes separated, as it were, by an invisible barrier; and hence he cannot conceive of chance images as the actual starting point of artistic endeavor. In Alberti's *De statua,* on the contrary, artists are people with a special predisposition to discover chance images, to find incipient resemblances in random shapes that others do not perceive; and it is their desire to perfect these chance images that leads to the making of works of art.

The Philostratus text clearly reflects the growing ascendancy of *fantasia* over *mimesis*—or, in modern parlance, imagination over imitation—that had been asserting itself in the attitude of the ancients toward the visual arts ever since Hellenistic times.[18] But while the concept of *mimesis* had its counterpart in the eminently rationalistic notion that art had originated with the tracing of shadows,[19] the ancient world never produced an etiological theory based on *fantasia* as the motivating impulse, even though Philostratus hints at tendencies in that direction. To inquire why late classical thought failed to formulate such a theory is a task far too complex for the present essay.[20] Suffice it to say that Alberti's *De statua* text owes little if anything to the ancient sources we have examined. At best they could have done no more than draw his attention to the existence of "images made by chance." How, then, did he arrive at his etiology of sculpture? Perhaps the key to the puzzle is to be found in the fact that his theory postulates tree trunks and clumps of earth, rather than stone or marble, as the primeval materials of sculpture. Does this not suggest that he started out by wondering what the earliest statues were made of? If so, he probably tried to find an answer in ancient literature, and in the course of his search he must have taken note of a passage in Pliny concerning the central importance of trees in the development of religious practices:[21] after mentioning sacred groves and various kinds of trees associated with specific deities, Pliny adds that the statues of the gods, too, used to be of wood *(ex arbore et simulacra numinum fuere).* With this statement as a point of departure, Alberti might well have reflected on the anthropomorphic shape of certain trees, which made it seem plausible enough that the earliest statues of gods should have been tree trunks that happened to be particularly suggestive of the human form. If such is the train of thought behind the *De statua* text, Alberti may be said to have reached his conclusions about the origin of sculpture by reversing, as it were, the well-known myth of

[18] Cf. Bernhard Schweitzer, "Der bildende Künstler und der Begriff des Künstlerischen in der Antike . . .," *Neue Heidelberger Jahrbücher,* new ser., 1925, pp. 28 ff.

[19] For the history of the legend see Robert Rosenblum, "The Origin of Painting: A Problem in the Iconography of Romantic Classicism," *Art Bulletin,* XXXIX, 1957, pp. 279 ff., and the references cited there.

[20] Some of the reasons may be gleaned from the analysis of ancient art theory in Panofsky, *op. cit.,* pp. 5–16.

[21] *Hist. nat.,* XII, i.

Daphne turned into a laurel tree. That this kind of transformation did indeed evoke his particular interest is evidenced by a passage in an early work of his, the dialogue *Virtus et Mercurius,* where Virtus complains to Mercury about the persistent abuse she has been suffering at the hands of Fortuna: "While I am thus despised, I would rather be any tree trunk than a goddess" *(malo truncum aliquem esse quam deam).*[22] The notion of a withdrawal into arboreal shape as a result of ill-treatment certainly owes something to the Daphne legend,[23] but Alberti's choice of a nonspecific *truncus* (i.e., a mutilated and presumably dead tree) rather than of a specific (and live) tree, also suggests the Plinian tree deities and the sculptors' *trunci* of *De statua.* This "truncated" Virtue-in-distress was translated into visual terms by Andrea Mantegna; she appears as *Virtus deserta* in an allegorical engraving after his design,[24] and as *Mater virtutum* in the well-known Louvre picture, *Minerva Expelling the Vices from the Grove of Virtue* (fig. 2).[25] While the *Virtus deserta* is clearly patterned after a Daphne-laurel tree,[26] the *Mater virtutum,* in the shape of an anthropomorphic olive tree,[27] might almost serve as an illustration of Alberti's *De statua* text.

Like many another explorer of new territory, Alberti did not grasp the full significance of what he had discovered. His chance-image theory is subject to two severe limitations: it applies only to the remote past, rather than to contemporary artistic practice, and it specifically excludes painting. Right after the passage with which we are here concerned, he remarks that there are those who would link painting to the kind of sculpture "done by addition," since the painter, after all, works by adding pigments to a bare surface, but he quickly denies the validity of this comparison and adds, *Verum de pictore alibi* ("But of the painter [I treat, or shall treat, or have treated] elsewhere"). His approach to painting as laid down in *Della pittura* does indeed leave little room for any application of the chance-image theory, since his interest there is focused not on the physical aspects of the process but on a rational method of representing the visible world. Which treatise, one wonders, was written first? Is the chance-image theory to be placed before or after 1435–36, the date of *Della pittura?* Among older scholars it used to be taken for granted that *De statua* was a work of Alberti's old age,[28] but the *terminus post quem* of 1464, based on the dedication to Giovanni Andrea Bossi, applies only to that one manuscript copy and does not justify the inference that the text itself was composed in the 1460s. *Verum de pictore*

[22] L. B. Alberti, *Opera inedita* . . ., ed. G. Mancini, Florence, 1890, p. 122; cf. Richard Foerster, "Studien zu Mantegna," *Jahrbuch d. Kgl. Preussischen Kunstsammlungen,* XXII, 1901, p. 82. and Wolfgang Stechow, *Apollo und Daphne* (Studien der Bibliothek Warburg), Leipzig, 1932, p. 20, n.4.

[23] According to the allegorical interpretation of Ovid's *Metamorphoses* by Giovanni Buonsignori of Città di Castello (ca. 1375), Daphne means "virtue" in Greek (see Stechow, *op. cit.,* p. 5); on the other hand, none of the several versions of the legend has Daphne expressing a desire to become a laurel tree—she merely wants to be rescued, and her metamorphosis is brought about by a deity in response to a general plea for help.

[24] Bartsch 17, by Zoan Andrea(?).

[25] See Foerster, *loc. cit.*

[26] Cf. especially the North Italian *cassone* panel of ca. 1480 in Stechow, *op. cit.,* fig. 16.

[27] See Foerster, *op. cit.,* p. 161.

[28] Cf. Janitschek, in Alberti, *op. cit.,* p. xxxv; Julius Schlosser-Magnino, *La letteratura artistica,* Florence, 1935, pp. 109 f.; Hans Kauffmann, *Donatello,* Berlin, 1935, p. 162.

alibi, whether we choose to put the missing verb in the past, present, or future tense, certainly suggests a close chronological sequence of the two treatises. Luigi Mallé, in his recent critical edition of *Della pittura,*[29] assumes that *De statua* is the earlier one, and Krautheimer has pointed out that the instrument described there is fundamentally identical with the surveyor's transit in Alberti's *Descriptio urbis Romae* of 1432–33.[30] The chance-image theory, then, could very well have been conceived in Rome, before Alberti's return to Florence in 1434. It is tempting to think that it emerged from conversations with Donatello, who was in Rome in 1432–33 and very probably also in 1430,[31] and whose name appears immediately after that of Brunelleschi among the masters to whom Alberti dedicated *Della pittura.*[32] The tenor of the dedication, however, also makes it clear that Alberti regarded Brunelleschi as the dominant personality of the new era; apparently it was the impact of the "Father of Renaissance Art" that accounts to a great extent for the difference in outlook and structure between the two treatises.

Whatever its exact date, *De statua* was soon eclipsed by *Della pittura.* The very fact that *De statua* was not translated into Italian until 1568 is indicative of its limited circulation. Thus Alberti's etiology of sculpture could not have been widely influential. Still, its effect can be traced in a number of ways. When Michelangelo spoke of "liberating" the figures "hidden" or "imprisoned" in the block of marble,[33] his thought reflected, directly or indirectly, Alberti's description of the carver's procedure. But while in *De statua* this notion is derived from the primeval sculptor's dependence on chance images, Michelangelo uses it as a Neoplatonic metaphor entirely removed from its etiological context.[34]

On the other hand, the chance-image theory was extended to the field of painting and to contemporary artistic practice by Leonardo da Vinci. His unfinished *Treatise on Painting* contains the following passage:[35]

I shall not fail to include among these precepts a new discovery, an aid to reflection, which, although it seems a small thing and almost laughable, nevertheless is very useful in stimulating the mind to various discoveries. This is: look at walls splashed with a number of stains or stones of various mixed colors. If you have to invent some scene, you can see there resemblances to a number of landscapes, adorned in various

[29] Florence, 1950.

[30] Richard Krautheimer and Trude Krautheimer-Hess, *Lorenzo Ghiberti,* Princeton, N.J., 1956, p. 322.

[31] See H. W. Janson, *The Sculpture of Donatello,* Princeton, N.J., 1957, II, pp. 99 ff.

[32] Cf. also the influence of *Della pittura* on the composition of Donatello's relief, *The Feast of Herod,* in Lille, discussed in Kauffmann, *op. cit.,* pp. 63 ff., and Janson, *op. cit.,* p. 130.

[33] Cf. Panofsky, *op. cit.,* pp. 65 ff.

[34] As pointed out by Panofsky, *op. cit.,* p. 79, n. 59, there is ample precedent in ancient literature for describing the sculptor's work as "the removal of superfluous material." It should be emphasized, however, that these sources do not speak of "figures hidden in the block," since according to ancient art theory the figure exists originally in the artist's mind and can be transferred to the stone only in imperfect fashion.

[35] I am following the translation by A. Philip McMahon, Princeton, N.J., 1956, I, pp. 50 f.

ways with mountains, rivers, rocks, trees, great plains, valleys, and hills. Moreover, you can see various battles, and rapid actions of figures, strange expressions on faces, costumes, and an infinite number of things, which you can reduce to good, integrated form. This happens thus on walls and varicolored stones, as in the sound of bells, in whose pealing you can find every name and word you can imagine. Do not despise my opinion, when I remind you that it should not be hard for you to stop sometimes and look into the stains of walls, or the ashes of a fire, or clouds, or mud, or like things, in which, if you consider them well, you will find really marvelous ideas.

The spotted walls obviously play the same role as the tree trunks and clumps of earth in *De statua;* Leonardo, moreover, understands more clearly than Alberti did that chance images are not objectively present but must be "read into" the material by the artist's imagination. While he does not acknowledge his source and presents his study of chance images as "a new discovery," there can be little doubt that he did in fact derive the idea from Alberti, whose writings are known to have influenced his thinking in a great many instances. That he should have transferred the chance-image theory from the remote past to the present and from sculpture to painting is hardly a surprise in view of his lack of interest in historical perspectives[36] and his deprecatory attitude toward sculpture.[37] Whether or not he practiced what he preached we are unable to determine; none of his surviving works seem to bear any traces of such study.

There was, however, at least one other artist who followed Leonardo's advice. According to Vasari, Piero di Cosimo was in the habit of staring at clouds and spotted walls, "imagining that he saw there equestrian combats and the most fantastic cities and the grandest landscapes ever beheld." These words are suspiciously close to those of Leonardo, but Vasari, we may assume, would hardly have introduced this "quotation" from the *Treatise* into his biography of Piero if it did not fit the character of his subject. He does, in fact, report a good many other details of Piero's idiosyncratic personality, presumably told to him by people who had known Piero.[38] And in this instance we need not rely on Vasari's testimony alone: two of Piero's pictures, *The Discovery of Honey* and *The Misfortunes of Silenus,* show extravagantly shaped willow trees with pronounced chance-image features,[39] yet rendered in the most painstakingly realistic fashion. To all appearances, they are based on a close study of actual trees of this sort, perhaps with certain elaborations to emphasize their chance-image aspects. We can

[36] His *Treatise* does, however, include a brief sentence stating that "the first picture was only one line, which circumscribed the shadow of a man cast by the sun on a wall" (McMahon, *op. cit.,* I, p. 61).

[37] Cf. the comparison of the two arts in Part I of the *Treatise* (McMahon, *op. cit.,* I, pp. 32–44).

[38] Piero di Cosimo died in 1521, less than a quarter century before Vasari set to work on the *Vite*.

[39] The trunk of one suggests an open-mouthed human face, the other has an excrescence resembling the head of a deer. For reproductions and an exhaustive discussion of the provenance and iconography of these pictures, see Erwin Panofsky, in *Worcester Art Museum Annual,* II, 1936–37, pp. 32–43, and in *Journal of the Warburg Institute,* I, 1937, pp. 12 ff. A similar instance of a truncated willow tree with half-hidden human features, in the *St. Jerome* panel of

well believe, therefore, that Piero went out of his way to look for any such phenomena.

The two paintings in question were very probably done in 1498 or shortly after,[40] while Leonardo was still in northern Italy. If Piero owed his awareness of chance images to Leonardo, he must have acquired it in his youth, during the early 1480s, before Leonardo's departure for Milan. A second reference to the subject in the Treatise likewise suggests that Leonardo became concerned with chance images fairly early in his career:[41]

> If one does not like landscape, he esteems it a matter of brief and simple
> investigation, as when our Botticelli said that such study was vain,
> because by merely throwing a sponge full of diverse colors at a wall, it
> left a stain on that wall, where a fine landscape was seen. It is really
> true that various inventions are seen in such a stain. . . . But although
> those stains give you inventions they will not teach you to finish any
> detail. This painter of whom I have spoken makes very dull landscapes.

Since Botticelli is here referred to as still living, the passage could have been written at any time before 1510, the year of his death; it seems likely, however, in view of Botticelli's inactive status after 1500, that the remark reported by Leonardo was made about 1480, when the older artist was at the height of his career and when his opinions mattered a great deal more than they did during the final years of his life. Leonardo's account has all the earmarks of personal experience. And in view of the dearth of champions of landscape among Florentine painters about 1480, it does indeed seem likely that Botticelli's outburst was aimed at none other than Leonardo himself (whose early interest in landscape is evidenced by the Uffizi drawing of 1473).

Botticelli's remark is noteworthy in another respect as well: his reference to the sponge thrown at a wall clearly derives from the sponge-throwing Protogenes-Nealces-Apelles of classical anecdote. Significantly enough, however, Botticelli interprets the stain left by the sponge in thoroughly modern, "post-Albertian" terms as a chance formation into which the imagination projects representational meanings. "Botticelli's stain" thus corresponds to the dirty walls, varicolored stones, etc., which Leonardo urges the painter to contemplate; it is the first "home-made" chance image enshrined in art-theoretical literature.

1515 by Hans Leu in the Kunstmuseum, Basel, has recently been brought to public attention by Enrico Castelli (Umanesimo e simbolismo: Atti del IV convegno internazionale di studi umanistici, Padua, 1958, pp. 19 f., pls. viii, ix bis, b). It seems doubtful, however, that the author is justified in defining these features as a Christ crowned with thorns and in drawing far-reaching tiefenpsychologische conclusions from its "unconscious symbolism." Even less explicit is the other "unconscious symbol" adduced by Castelli, a death's head nestling among the folds in Michelangelo's Pieta in St. Peter's that emerges (rather imperfectly) only in one particular photo under a strong raking light (ibid., pl. ix bis, a). If, as Castelli suggests, the actual presence of such "involuntary symbols" needs no proof other than our ability to perceive them, what is to stop us from regarding chance images among clouds or rocks, too, as "involuntary symbols"? Clearly, there must be a line of demarcation somewhere between "unconscious symbols" that may reveal the stato dell'animo of their creator and those betraying only the stato dell'animo of the beholder.

[40] Cf. Panofsky, Worcester Art Museum Annual, p. 43, n. 2.

[41] McMahon, op. cit., I, p. 59.

Did Leonardo, then, receive his original impulse toward the investigation of chance images from Botticelli? It is certainly conceivable that even before he formulated the chance-image theory of pictorial invention there was some awareness among Early Renaissance painters of the role of chance effects in actual artistic practice.[42] That such was the case may be gathered from one small but important piece of visual evidence, which in point of time stands midway between Alberti's *De statua* and "Botticelli's stain" half a century later. The *Martyrdom of St. Sebastian* by Andrea Mantegna in the Kunsthistorisches Museum, Vienna, a work usually dated about 1460,[43] shows in the upper left-hand corner a cloud containing the image of a horseman (fig. 3). The tiny figure, only 4.5 cm tall in a panel measuring 68 x 30 cm, has attracted little attention even among Mantegna specialists. Paul Kristeller, the first to comment on it,[44] suggested that the rider might be Theodoric of Verona, who according to legend was lured to the gate of Hell by a stag he was chasing. Erika Tietze-Conrat still accepts this view and adds that Mantegna may have derived the figure from a relief on the façade of S. Zeno, Verona.[45] There are, however, some basic difficulties. What connection does Theodoric have with St. Sebastian? Why did Mantegna fail to characterize him as a hunter? Why is there no trace of a stag or of the gate of Hell? Quite apart from the specific interpretation proposed by Kristeller, do we have reason to assume that Mantegna intended the horseman to have any meaning at all in terms of rational iconography? Not only is there a complete absence of similar figures in other representations of St. Sebastian, but our horseman is not "in the clouds" (as Tietze-Conrat calls him), since he *consists* of cloud. In fact, the hindquarters of the horse are omitted entirely, so as not to disturb the soft contour of the cloud, and the whole image is so delicate and unobtrusive that only an exceptionally sharp observer is likely to become aware of it. All these considerations have led Millard Meiss, the most recent student of the problem, to define the horseman as "a sort of visual pun" that seems devoid of iconographic significance.[46] And such, to all appearances, it is. Its genesis might be reconstructed as follows: while he was painting this particular cloud, Mantegna suddenly became aware that some of the shapes suggested the image of a horseman and then, not unlike the primeval manipulators of tree

[42] This awareness might have been acquired in the course of imitating colored marble surfaces, a well-developed technique capable of striking *trompe-l'oeil* effects even in the Trecento. There must have existed a special tradition of "tricks of the trade" for this purpose, probably utilizing all sorts of unorthodox devices such as sponges. The history of this technique in post-classical times has never, to my knowledge, been investigated. *Trompe-l'oeil* imitations of veined marble panels flourished in Graeco-Roman wall painting, as evidenced by the surviving specimens in Pompeii. Their earliest modern successors appear in the work of Giotto (e.g., on the throne of the *Madonna with Angels* in the Uffizi) and his followers (Taddeo Gaddi, dado of the Baroncelli Chapel, S. Croce). It is tempting to think that Giotto reintroduced such illusionistic effects on the basis of ancient examples he may have seen in Rome; if so, this would be another, and peculiarly tangible, instance of the "revival of antiquity" pioneered by the great Florentine.

[43] E.g., in the catalogue of 1954 (*Kunsthistorisches Museum, Gemälde-Galerie: Die italienischen, spanischen, französischen und englischen Malerschulen*, p. 26) and in E. Tietze-Conrat, *Mantegna*, London and New York, 1955, p. 200.

[44] *Andrea Mantegna*, London, 1901, p. 168.

[45] *Loc. cit.*

[46] *Andrea Mantegna as Illuminator*, New York, 1957, p. 62; the reference to "horsemen" I take to be a slip of the pen.

trunks in *De statua,* he added or took away a bit here and there to emphasize the resemblance. But since the horseman had no place in the iconographic context of the panel, Mantegna stopped short of "developing" the image to the point of full explicitness. Here, however, we face another question—why did he "develop" it at all? Surely the emergence of unintended partial images in the working process must have been a familiar experience to him (as to any painter). Why did he, in this special case, not follow the usual procedure of destroying it immediately? We can only conclude that he must have been taken with the idea of cloud images, and that he expected his patron, too, to appreciate the downy horseman. Unfortunately, we do not know the identity of this patron.[47] He would seem to have been a passionate admirer of classical antiquity, for the panel is exceptionally rich in antiquarian detail, even by Mantegna's own standard, down to the unique Greek signature (fig. 4). Apparently our horseman is yet another antiquarian detail, a visual reference to one of the discussions of cloud figures in ancient literature mentioned previously. There is nothing to preclude our assumption that the learned Mantegna and his like-minded patron knew the passages we have cited from Lucretius, Philostratus' *Apollonius of Tyana,* or even the demonology of Michael Psellus,[48] and could thus share an appreciation of our horseman as a "visual pun" legitimized by classical literary antecedents. Such an interpretation would also explain the "semi-private" quality of the little image, calculated not to offend less sophisticated beholders. If this view is correct, our horseman need have no connection at all with the chance images of Alberti, even though Mantegna, who as we have seen was acquainted with the little-known dialogue *Virtus et Mercurius,* almost certainly knew *De statua* as well.

As a chance image made explicit, our horseman seems to be unique in Mantegna's oeuvre.[49] Yet it is the ancestor of a wide variety of figures made of clouds in sixteenth-century painting, which range from those in Mantegna's *Minerva* of 1501–2 and the amorous Jupiter in Correggio's *Io* to the cloud-angels of Raphael's *Sistine Madonna* and of Tintoretto's *Last Supper* in S. Giorgio Maggiore, Venice, to name only a few of the best-known examples. All of them, however, are planned and intentional, and the iconographic meaning of most of them is quite explicit. The technique of our horseman has here become "institutionalized" as a new pictorial device for representing incorporeal beings, so that its chance-image aspect is lost completely.

[47] It might have been Jacopo Antonio Marcello, the governor of Padua, who had ordered an *operetta* from Mantegna not long prior to March 14, 1459; for a discussion of this problem see Meiss, *op. cit.,* pp. 46 ff. and the literature cited there.

[48] The Psellus treatise was known to Marsilio Ficino, who translated it before 1488; cf. Paul Oskar Kristeller, *Studies in Renaissance Thought and Letters,* Rome, 1956, pp. 170, 195. The Greek text was thus almost surely available in Italy at the time Mantegna painted the Vienna panel. The nascent horseman may also have recalled to Mantegna's mind the classical tradition linking clouds and centaurs (as the sons of Nephele, they were said to be "cloud-born"). Cf. Pease, *op. cit.,* pp. 433 f. I owe this suggestion to the kindness of Mr. Michael M. Wigodsky.

[49] Meiss, *op. cit.,* p. 62, links our horseman to another "visual pun," in a Ferrarese breviary of ca. 1470 (fig. 69: Cambridge, Mass., Harvard College Library, Hofer Collection, MS Typ 219, fol. 484), where the ragged edge of a (painted) piece of vellum turns into the profile of a human face. While this dual image, too, is surely an unplanned one, and of the same kind as the horseman, it suggests the further possibility that there might be precedents for it among the marginal grotesques of Northern Gothic manuscripts.

Thus the concept of the chance image as a source of creative endeavor survived only in Alberti's *De statua* text and the two passages from Leonardo's *Treatise,* where it lay dormant, as it were, until the late eighteenth century.[50] At that time it was suddenly put into practice by the British landscape painter Alexander Cozens, who presented it to the public in an illustrated treatise entitled *A New Method of Assisting the Invention in Drawing Original Compositions of Landscape.*[51] The author describes what he calls "a mechanical method . . . to draw forth the ideas of an ingenious mind disposed to the art of designing"; it consists in making casual and largely accidental ink blots on paper with a brush, to serve as a store of compositional suggestions (fig. 5). Cozens recommends that these blots be done quickly and in quantity, and that the paper be first crumpled up in the hand and then stretched out again. The next step is to select a particularly suggestive sheet of blots, place a piece of transparent paper over it and make a selective tracing; the author cautions us to "preserve the spirit of the blot as much as possible by taking care not to add anything that is not suggested by it, and to leave out what appears to be unnatural." The drawing is then finished by adding ink washes. Cozens claims that he perused Leonardo's *Treatise* only after he had discovered the blot method on his own, but delightedly cites the old master's words concerning the images to be seen on dirty walls and varicolored stones. "I presume to think," he adds, "that my method is an improvement

[50] One possible exception is the curious groups of paintings published in Baltrušaitis, *op. cit.* These pictures, dating mostly from the first half of the seventeenth century, are done on the polished surfaces of agates or other strongly veined stones in such a way that the colored veins become a part of the composition, providing "natural" backgrounds of clouds, landscape, etc., for the figures. They were prized as marvels of nature no less than of art (a description, cited by Baltrušaitis, *op. cit.*, p. 52, terms them "an interplay of *ars* and *natura*") and tended to accumulate in the *Kunst- und Wunderkammern* of royalty. Linked with the legendary gem of Pyrrhus, they might be defined as elaborated chance images were it not for the fact that the painter's share always remains clearly distinguishable from nature's. Apparently a real merging of the two spheres was deemed aesthetically undesirable. Conspicuous examples are preserved in Berlin, Upsala, and Naples (Baltrušaitis, figs. 30, 32–35, 39) as well as in Florence (Lando Bartoli and E. A. Maser, *Il Museo dell'Opificio delle Pietre Dure di Firenze,* Florence, 1954, pp. 25 f., 44). More complex is the case of the extraordinary panel by Matieu Dubus in the collection of Jacques Combe, Paris, which Baltrušaitis believes to be a direct reflection of the Leonardo text (p. 48, fig. 31). The painting, insofar as we can judge from the reproduction, is a unique kind of dual image: the entire surface is filled with what at first glance appears to be the face of a cliff of cracked and weathered rock, full of deep clefts and caverns. These painstakingly well-imitated stone textures, however, can also be read as a sweeping view of a valley showing the destruction of Sodom and Gomorrah; at the same time, all sorts of faces and figures emerge from the rock. Here, then, the interplay of *ars* and *natura* obeys a different rule, since the artist is in control of both. Dubus may indeed have been inspired by the Leonardo passage, but the degree to which chance has entered into the making of the rock formation can be determined only by a minute technical analysis which Baltrušaitis fails to provide. Did the artist perhaps throw a sponge at his panel? (The total effect is often strikingly similar to the *frottages* of Max Ernst.) Or did he simply put the *trompe-l'oeil* technique of Netherlandish tradition to new and unexpected use? In any event, Dubus' picture seems to have no direct relation to the paintings on actual stone surfaces. Artistically, it suggests a link with Hercules Seghers; in view of the latter's passion for unorthodox technical experiments, the link may help us to explain Dubus' technique as well.

[51] London, n.d.; published in 1785–86, according to A. P. Oppé, *Alexander and John Robert Cozens,* Cambridge, Mass., 1954, p. 41. The text and some of the forty-three aquatint illustrations are reproduced in Oppé, *op. cit.,* pp. 165–87. On the title page the author cites a description of cloud images from Shakespeare's *Antony and Cleopatra,* IV, 2 (he might also have quoted a similar though briefer passage from *Hamlet,* III, 2).

upon the above hint of Leonardo da Vinci," since it permits the artist to produce his chance images at will, while according to Leonardo, "the rude forms must be sought for in old walls, etc., which seldom occur." Oddly enough, he fails to quote the Leonardo passage dealing with "Botticelli's stain," which anticipates his own procedure so closely that one wonders if he was really ignorant of it.[52] The ink blots of Cozen's *Method* are not meant to be entirely accidental; he defines them as "a production of chance, with a small degree of design," since the artist is expected, while producing them, to think of a landscape subject in general terms. Yet the readers of his treatise tended to disregard the nonfortuitous aspects and to view the blots as accidents pure and simple. Cozens did not live to suffer from the resulting storm of ridicule or (in the words of Oppé) "the obloquy which was for long his only memorial." On the other hand, it was this very notoriety that kept the *Method* before the public eye until far into the nineteenth century.[53] Here, then, we have come within hailing distance of the Rorschach test. Those who practice it as a parlor game may be interested to learn that a similar game, derived from the *Method*, was being played in the fashionable drawing rooms of Turner's day.[54]

While Cozens was thus asserting the primacy of the imagination, the efforts of this lonely champion of *fantasia* were quite literally overshadowed by the great vogue for *mimesis* that had seized public taste in the late eighteenth century. Not only did the skiagraphic theory of the origin of painting find new credence among artists and scholars; the legend embodying it became a frequent subject for paintings, prints, and even reliefs, and the shadow-tracing technique

[52] McMahon, *op. cit.*, I, pp. 362 f., lists eight printed editions of the *Treatise* before 1784 (when Cozens advertised the imminent publication of the *Method*), four in Italian, two in French, and one each in German and English. I have been unable to determine how many of these include the Botticelli episode. Cozens could surely have perused one of the Italian editions, since he spent the year 1746 in Rome and must have acquired at least a fair command of the language (cf. Oppé, *op. cit.*, pp. 11–20). There is no hint in the *Method* that Cozens was acquainted with the tradition of "elaborated chance images" mentioned above in note 50, which might have helped to inspire his blot technique. Still, he could have seen such paintings on oddly veined stone surfaces in one or the other of the private museums that treasured these objects. If, as seems likely, he touched Florence on his way to or from Rome, he may well have visited the Opificio delle Pietre Dure, where (to judge from its present holdings) paintings on veined stone were produced in quantity. Perhaps he even looked up his Italianized countryman, Father Henry Hugford, who had become an expert painter of landscapes on *scagliola* (a very fine plaster specially developed in Florence for imitating the colored surfaces of *pietre dure*). On Hugford and his work, see Bartoli and Maser, *op. cit.*, p. 26.

[53] Cf. Oppé, *op. cit.*, p. 41. Oppé himself still found the notion of "landscapes made by accident" so unworthy of serious consideration that he exaggerated the purposeful aspects of the *Method* in an effort to salvage Cozens' reputation.

[54] Oppé, *loc. cit.*, n. 3, reports having come across metrical instructions for playing the game, dated 1816. One wonders whether these (or their descendants) might have fallen into the hands of the German physician and Romantic poet Justinus Kerner, who in the 1850s produced a series of *Klecksographien*, i.e., ink blots on folded paper which he modified slightly to emphasize the chance images he had found in them without destroying the character of the original blot. These images in turn inspired him to write descriptive poems, of an oddly humorous and macabre cast. The blots and poems together made up his "Hadesbuch" of 1857, which remained unpublished until 1890, long after the author's death. This belated interest in Kerner's *Klecksographien*, reflecting the artistic and intellectual climate of the *art nouveau* era, suggests that they may have been known to Hermann Rorschach, who used the same folded-paper technique for the blots of the test that bears his name.

itself was practiced on a vast scale in the production of silhouettes, either freehand or with the aid of various mechanical contrivances.[55] Nor has this trend abated since then. The mechanical shadow-tracing devices, such as the "physionotrace" invented by Gilles Louis Chrétien in 1786, were the direct predecessors of photography, which for more than a century has been feeding the apparently insatiable appetite of modern man for mimetic images. At the same time, modern painting has become increasingly "accident-prone" and nonrepresentational.[56] Perhaps we have thus at last resolved the ancient Greek dichotomy of *mimesis* and *fantasia* by assigning each of them to its own separate domain.

[55] Cf. Rosenblum, *op. cit.*, especially p. 287 and the references cited there.
[56] Cf. H. W. Janson, "After Betsy, What?" *Bulletin of the Atomic Scientists*, XV, 2, February 1959, pp. 68 ff.

1. *Chance Image in Stone, after Albertus Magnus. Woodcut in Franciscus de Retza,* Defensorium inviolatae virginitatis Mariae, *Speyer, 1470*

2. *Andrea Mantegna,* Minerva Expelling the Vices from the Grove of Virtue *(detail).* Paris, Louvre

3

3. *Andrea Mantegna*, The Martyrdom of
St. Sebastian *(detail)*. *ca. 1460. Vienna,*
Kunsthistorisches Museum

4. *Andrea Mantegna*, The Martyrdom of
St. Sebastian. *ca. 1460. Vienna,*
Kunsthistorisches Museum

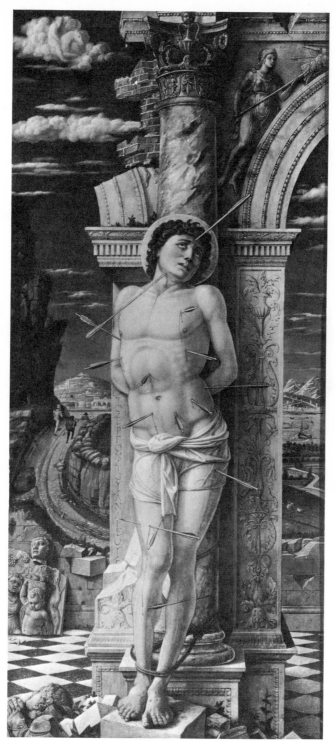

4

5. *Alexander Cozens,* Blot Landscape,
in A New Method of Assisting the Invention . . . ,
London, n.d. Aquatint. New York,
Metropolitan Museum of Art

STUDY 4

Fuseli's Nightmare

"Fuseli's *Nightmare*,"
Arts and Sciences, Vol. II, No. 1, 1963, pp. 23-28

Henry Fuseli—or Johann Heinrich Füssli, his original Swiss name—played a paradoxical role in the art of the late eighteenth century and the early years of the nineteenth. His fame was international, and his works, known practically everywhere through engravings, left their mark on artists as diverse as William Blake and Eugène Delacroix. He had, in fact, a most important catalytic function in the decades of "Sturm und Drang" and early Romanticism. Yet he never achieved popular success as a painter, and his most ambitious ventures, the vast cycles of the Shakespeare Gallery and the Milton Gallery, were resounding failures. Only once did Fuseli enjoy the wide acclaim he craved: in 1782, when he exhibited a picture entitled *The Nightmare* at the Royal Academy in London. And his modern fame, after a century of almost total neglect, also rests very largely on this one subject, which earned him a reputation among twentieth-century critics as a precursor of Surrealism.

The Nightmare, however, is not at all typical of Fuseli's work. John Knowles, in his *Life* of Fuseli, published in 1831, gives a list of the sixty-nine pictures exhibited by the artist at the Royal Academy between 1774 and 1825, and almost every one of them is based on a literary source—Homer, Sophocles, Dante, Milton, Shakespeare, Spenser, and many others—while no such source is indicated for *The Nightmare*. This record quite agrees with Fuseli's views on art as laid down in his numerous letters, Royal Academy lectures, and aphorisms. Art, he believed, must have a noble subject, and he found such subjects in the storehouse of the world's literature; when he pleads for freedom of invention, he means freedom to choose literary themes not previously illustrated, rather than the exploitation of subjective fancy. Among his aphorisms, it is true, we find one that says, "One of the most unexplored regions of art are [*sic*] dreams, and what may be called the personification of sentiment," but the dreams he had in mind were the dreams, visions, and apparitions of literature, such as the ghost in *Hamlet* or the dream of Richard III, not private nightmares. How, then, did he come to paint *The Nightmare*? Oddly enough, scholars so far have done very little to help us understand the genesis of the picture, or the extraordinary response it found among the public. The best-known version, now in the Goethemuseum at Frankfurt (fig. 1), has been reproduced countless times, but with a minimum of analytical comment. One might almost say of Fuseli's *Nightmare* what Mark Twain said of the weather—everybody is talking about it but nobody does anything about it.

There is, needless to say, no dearth of nightmares in literature (even Homer

mentions them). Yet Fuseli seems to have been the first to attempt a visual representation of the subject. The basic difference between his conception and the traditional ways of depicting dreams is well illustrated by a comparison with Giulio Romano's *Dream of Hecuba* (fig. 2), a well-known Renaissance work that Fuseli saw during his Italian sojourn of 1770–78. It follows a traditional formula established in Western art ever since the ancient Greeks: Hecuba has the conventional pose of the dreamer—reclining but with the head supported by one arm instead of resting on the pillow, to signify sleep as distinct from death. Above her we see the content of her dream, a dark, cloud-borne winged genius with a flaming torch, prophetic of the destruction of Troy. Hecuba does not react in any way to his frightening presence; the two levels of reality are kept strictly separate. In *The Nightmare,* on the contrary, the dreamer is obviously in agony. She seems, indeed, near death. And the demon squatting on her chest, and the spectral, grinning horse, are the agents of her torture. Here the two levels of reality interact; the artist's main concern is the traumatic experience of a bad dream, not its content, whether symbolic, prophetic, or otherwise. With enormous effectiveness, Fuseli has succeeded in visualizing something that had never, so far as we know, been visualized before.

This is particularly evident when we turn from the Frankfurt painting to the earliest known version of Fuseli's *Nightmare* (and presumably the original one), a large drawing in the British Museum dated March 1781 (fig. 3). It is described by Knowles, who owned it at the time he published his *Life* of Fuseli, and it is the first version known to him. The demon here is far larger and more frightening than in the Frankfurt canvas; the horse, surprisingly, is absent; and the young woman is stretched out, almost like a corpse, parallel to the picture plane. She is in fact modeled on a corpse—the corpse in the center of the *Noah* panel on the East Doors of the Florentine Baptistery, by Lorenzo Ghiberti (fig. 4). For that Early Renaissance master, this is an unusually expressive figure, inspired not by classical sources but by certain Gothic representations of the Dead Christ. Fuseli could have taken it from the engraving here reproduced, one of a set issued in 1774 and illustrating the East Doors in detail; but I prefer to think that he studied the *Noah* panel directly and made a drawing of this figure when he was in Florence in 1777, since his tortured dreamer stresses all the expressive aspects of Ghiberti's corpse, which are somewhat softened in the engraving. Ghiberti's fame was just then rising once more, after centuries of neglect, and Fuseli had a special reason to study the East Doors: had not his idol, Michelangelo, pronounced them worthy to be the Gates of Paradise? The *Noah* panel, moreover, must have held particular interest for him; a few years before, he had illustrated an epic poem on the life of Noah by his mentor, the Zurich professor Johann Jakob Bodmer. (It was Bodmer who introduced Fuseli to Shakespeare and Milton; he had translated *Paradise Lost* into German, and had written his Noah epic as a sort of sequel to Milton's poem.) Be that as it may, Fuseli knew the East Doors well, for in one of his Royal Academy lectures many years later he gave a lengthy and accurate description of certain details of the work. He even transmitted the Ghiberti corpse to his friend William Blake, who used it for the figure of Dante in his engraving of the Paolo and Francesca scene in the *Inferno.* Dante, after telling the story of the two lovers, wrote that "I fell to the ground like a dead body"; Blake could hardly have chosen a more suitable prototype.

John Knowles remarks that the *Nightmare* drawing of 1781 lacks the horse's head. This, he says, was added in the painting of 1782. The picture, according to Knowles, was sold for twenty guineas. An engraving of it by Burke was so popular, he tells us, that the publisher made a profit of more than 500 pounds even though the prints sold for a few pennies apiece (fig. 5). Although the painting disappeared from public view—it turned up a few years ago and is now in the Detroit Institute of Arts—the engraving traveled far and wide. A few months after its publication on January 30, 1783, it was available at the Leipzig Fair, where it was admired by Goethe's patron, the young duke Carl August ("I have not seen anything for a long time," he wrote, "that gives me as much pleasure."). This, then, is *Nightmare II,* as against *Nightmare I,* the drawing of 1781. According to Knowles, Fuseli did several more Nightmares after the big success of 1782, each different from the others. The Frankfurt canvas, or *Nightmare III,* must be one of these; it was probably painted toward 1790, since there is an engraving after it dated 1791. Although it is the most melodramatic of the group, it has become famous only in modern times. The composition that made Fuseli known all over Europe was *Nightmare II.*

Except for the addition of the horse and the somewhat less rigid attitude of the maiden, *Nightmare II* closely resembles *Nightmare I.* The animal pokes its head through the drapery at the foot of the bed, and its questioning expression is directed at the incubus-demon. Its function is still a subsidiary and far from frightening one; it even wears a collar, as well it might, for it represents the demon's means of transportation. We gather this from the four-line verse below the engraving, which reads:

—on his Night-Mare, thro the evening fog,
Flits the squab fiend, o'er fen, and lake, and bog,
Seeks some love-wilder'd maid by sleep opprest,
Alights, and grinning, sits upon her breast.

Is this quotation the literary source of the picture? Or did Fuseli perhaps compose it himself? Here again Knowles comes to our aid; he cites a description of the picture in verse by Erasmus Darwin (a physician and poet, the grandfather of Charles), and its first four lines agree with the words on the engraving. This description—which is a great deal longer than Knowles acknowledges—appears in part II of Darwin's *The Botanical Garden,* subtitled "The Loves of the Plants," a long discourse in verse, part allegorical, part scientific, that enjoyed great popular favor. The first edition, however, was not published until 1789, six years after the engraving. There was, then, an intimate association between Darwin and Fuseli; they shared the same publisher, Joseph Johnson, who must have brought them together soon after Fuseli's return from Italy. Thus Darwin (who had been at work on *The Botanical Garden* since 1777) probably saw *Nightmare II* before the canvas was finished and decided to incorporate a description of it in his poem. It may indeed have been he who was responsible for the addition of the horse, a somewhat distracting element in the picture, that apparently was introduced because of the punning line, "—on his Night-Mare . . . flits the squab fiend . . ." Etymologically, the "mare" of "nightmare" is quite distinct from "mare" meaning a female horse, although in folklore the two were often compounded. In Eng-

land, the nightmare, i.e., the night demon that sits on the sleeper's chest and thus causes the feeling of suffocation characteristic of the pathology of nightmares, was often thought of as female, a night-hag or night-witch, while in German-speaking areas such as Fuseli's hometown of Zurich, it was masculine ("Nachtmar" or "Alp"). In either case the incubus would "ride" his victim, or at times even assume the shape of a horse. But the notion that the night-mare is the steed which carries the demon from one victim to the next seems to have no antecedent in the vast literature on nightmares; in all likelihood, it was invented specifically for *Nightmare II.*

But why did the picture have such fascination for Darwin? The reason becomes evident from his discussion of it, which follows a passage concerning the Pythian priestess, drunk with a poisonous decoction of laurel, who "speaks . . . with words unwill'd, and wisdom not her own." The nightmare, too, he says, illustrates a suspension of the power of the will. Fuseli's maiden experiences not the incubus but a train of frightful images set off by the demon's pressure on her chest:

> Then shrieks of captur'd towns, and widows' tears,
> Pale lovers stretch'd upon their blood-stain'd biers,
> The headlong precipice that thwarts her flight,
> The trackless desert, the cold starless night,
> And stern-eyed murderer with his knife behind,
> In dread succession agonize her mind.
> In vain she *wills* to run, fly, swim, walk, creep;
> The WILL presides not in the bower of SLEEP.

In a long footnote appended to the last line, Darwin restates the nature of sleep in scientific terms: the sensory organs remain alert but cannot perceive external objects so long as volition is suspended. "When there arises in sleep a painful desire to exert the voluntary motions, it is called the nightmare or incubus." And, he claims, a similar state of reverie, or suspension of the will, occurs when we contemplate a great work of art; hence an artist with sufficient powers of persuasion, such as Fuseli, can with impunity violate every standard of verisimilitude. Only if the image presented to our imagination is an unbearably horrid one will we endeavor to rouse ourselves from our reverie, as from a nightmare. Darwin here draws upon a tradition of physiological psychology ultimately based on Sir Isaac Newton, developed by Berkeley, Locke, Hume, and Gay, and popularized in the later eighteenth century by David Hartley's *Observations on Man.* Fuseli's *Nightmare* must have seemed to him an admirable illustration of this theory, and many other contemporary admirers of the picture may have had similar thoughts, since the "new psychology" had aroused considerable interest among the educated public.

If Darwin's intervention accounts for the difference between *Nightmare I* and *Nightmare II,* Fuseli alone appears to be responsible for the further development of the composition in *Nightmare III.* There the entire design has been rearranged within a vertical format; the horse now looms as the most conspicuously frightening creature; the incubus, smaller and less weighty, looks as if he might be squatting beside the sleeper, rather than on her; and the maiden is placed

obliquely, her head toward the beholder. *Nightmare III* thus appears both more Baroque and more "Gothic" (in the eighteenth-century sense) than its predecessors. There is, at Chatsworth, a painting of ca. 1630 by Jacques Blanchard that may have suggested the new position of the sleeper (fig. 6); it represents the death of Cleopatra, whose body appears in a similarly foreshortened view. The picture was already at Chatsworth in Fuseli's day, and there also was an engraving after it, so Fuseli very probably knew it, directly or indirectly. The new role of the horse is less easy to account for. Here apparently the artist recalled a picture he had painted in 1779 on his way back from Italy, while stopping at Zurich (fig. 7). It shows him in conversation with his revered friend Bodmer, while a huge bust of Homer looms between them. In *Nightmare III*, the bust's place has been taken by the horse—an evil spirit usurping the dominant role of a beneficent one. The fascinating spectral, luminescent quality of the horse would seem to reflect a much earlier source: the wild horses in a woodcut by Hans Baldung Grien of 1534 (fig. 8). In his youth, Fuseli had made numerous drawings after German and Swiss sixteenth-century prints such as this. These studies, which are among the earliest examples of the "Gothic Revival," were inspired by a national pride, a patriotic interest in one's own local past, that was a characteristic feature of early Romanticism, fostered among others by Bodmer, who was professor of Swiss history at Zurich. Fuseli even then may have been attracted by Hans Baldung's preoccupation with witches and demons, and the wild expressiveness, the strange luminous eyes of Baldung's horses must have stuck in his memory.

One final question remains to be answered: what was the genesis of *Nightmare I*? Why did Fuseli conceive it at the time he did, soon after his return from Italy, and why does the motif have so isolated a position in his oeuvre? As Ernest Jones has amply documented in his psychoanalytic study of the subject, nightmares always have a strongly sexual connotation, sometimes quite openly expressed, at other times concealed behind a variety of disguises. In the voluminous literature on nightmares from the fifteenth to the eighteenth century (a field halfway between demonology and medicine), the incubus "riding" its victim is almost invariably of the opposite sex. John Bond, whose *Essay on the Incubus or Nightmare* of 1753 Fuseli might well have known, lists "fond pining lovers" among the chief victims of the affliction, and Burton, in his *Anatomy of Melancholy*, regards nightmares as a symptom of the melancholy of maids, nuns, and widows, adding that the cure is marriage. Against this background, we must now take a glance at Fuseli's own love life. While in Italy, he seems to have been something of a gay dog, without any serious emotional attachments. He liked to tell how he used to lie on his back day after day musing on the splendors of the Sistine Ceiling, and that "such a posture of repose was necessary for a body fatigued like his with the pleasant gratifications of a luxurious city." The passage suggests that perhaps he identified himself to some extent with the prone male body he found in Ghiberti's *Noah* panel (fig. 4). On his return trip to England in 1779, however, he fell violently in love, apparently for the last time in his life (he was then thirty-eight), with a young niece of his friend, the physiognomist Lavater. His passion came to nothing, and soon after he reached London he learned, to his great distress, that the girl had been married to a respectable merchant, in accordance with the wishes of her family. Fuseli was terribly upset

82

through most of the year 1779, and probably for some time thereafter. Whether he wrote directly to the lady of his dreams we do not know, but we have a series of extravagantly passionate love poems, as well as letters to Lavater and others who knew the girl and whom Fuseli somehow expected to plead his cause. One of these letters is particularly revealing in our context: "Is she in Zurich now? [Fuseli was writing to Lavater from London] Last night I had her in bed with me—tossed my bedclothes hugger-mugger—wound my hot and tight-clasped hands about her—fused her body and her soul together with my own—poured into her my spirit, breath, and strength. Anyone who touches her now commits adultery and incest! She is *mine,* and I am *hers.* And have her I will—I will toil and sweat for her, and lie alone, until I have won her." In another letter, he expressed the hope that the heart of his beloved would respond to his vibrations from afar, and continued, "Each earthly night since I left her, I have lain in her bed ..." And all this despite the fact that while Fuseli was in Switzerland he had never dared to declare his love to the girl! Is it too bold a conjecture to think that the "love-wilder'd maid" of *Nightmare I* is a projection of his "dream-girl," with the incubus-demon taking the place of the artist himself? The drawing dates from early 1781, but its highly finished character indicates that it is not a first sketch but the result of previous studies which may well go back a year or more. We have no likeness of the girl in question, although Fuseli surely made drawings of her while in Switzerland. Perhaps he destroyed them in despair at the news of her marriage. Did he try to paint her in London on the basis of these sketches? After the Detroit Institute of Arts acquired the painting of *Nightmare II,* it was found that a second piece of canvas had been pasted on its back; when the restorer removed it, he found underneath an unfinished but fascinating portrait of a beautiful young woman (fig. 9). If the front of the picture is Fuseli's original *Nightmare II,* rather than a copy, then the portrait, too, must be by Fuseli, and its sensuously seductive quality suggests that it represents the artist's beloved. By the time he painted *Nightmare III,* Fuseli's personal involvement had abated to the point where he was able to push the incubus-demon aside and develop the melodramatic aspects of the composition, now centered in the mare's head.

As a postscript, it is worth noting that one of the owners of the engraving after *Nightmare II* (fig. 5) was Sigmund Freud; a framed specimen of the print hung for years in his Vienna apartment. Did he sense the fascinating psychological aspects of Fuseli's picture? Ernest Jones, who began his work on nightmares as early as 1909, makes no reference to that engraving. Instead, the book which eventually resulted from his studies carries *Nightmare III* as a frontispiece. It is tempting to think, though, that perhaps Jones' interest in the subject was first aroused when, as a pupil of Freud, he saw the print of *Nightmare II* on the wall of his teacher's study.

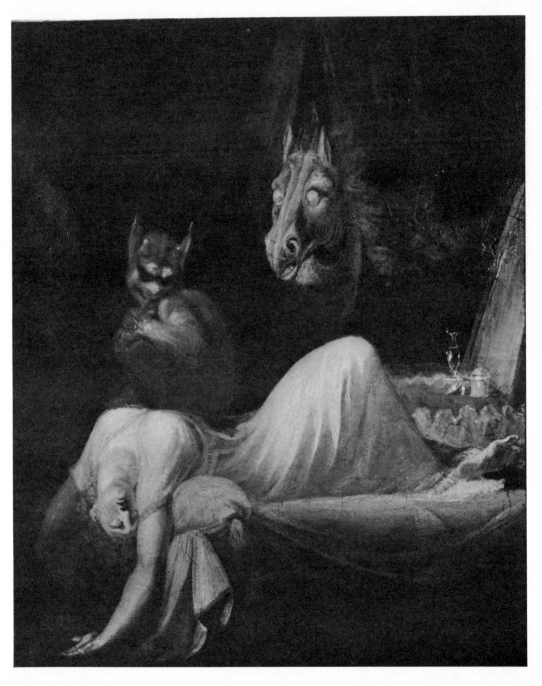

1. Henry Fuseli, The Nightmare (III). *ca. 1785–90. Frankfurt, Goethemuseum*

2. Giulio Romano, Dream of Hecuba. *Fresco, 1538. Mantua, Palazzo Ducale*

3. Henry Fuseli, The Nightmare (I). *Drawing, March 1781. London, British Museum*

4. Lorenzo Ghiberti, The Story of Noah *(detail of engraving in T. Patch (A. Cocchi) and F. Gregori*, La porta principale del Battistero di S. Giovanni, *Florence, 1774)*

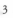

9. *Henry Fuseli,* Portrait of a Young Woman,
on reverse of The Nightmare (II). *ca. 1780.*
The Detroit Institute of Arts

STUDY 5

*Nanni di Banco's
Assumption of the Virgin
on the Porta della
Mandorla*

the *Isaiah* of 1408 and covering a span of eight or nine years, form a coherent group, even though the problem of their chronological sequence has not yet been solved to everyone's satisfaction. They include, on the niches of Or San Michele, a number of reliefs; but these do not forecast the style of the *Assumption* any more than do the statues. Between 1414 and 1418—we do not know just when—Nanni's style must have undergone a decisive change. How are we to account for this change, how interpret its significance? Insofar as the problem has been dealt with in the literature, Nanni's *ultima maniera* has been viewed as a return to Gothic qualities, analogous to the pronounced Gothic flavor of Jacopo della Quercia's Trenta Altar.[4] Could Nanni have fallen under the influence of the great Sienese master? The suggestion seems far from compelling: the salient features of the *Assumption*—the billowing, wind-blown draperies, the dynamic movement of the bodies, especially among the angels—have no counterpart in the Trenta Altar. We do not know, moreover, when the Trenta Altar was actually done; all we can say is that Jacopo finished it in 1422 and that he could not have started it before 1413.[5] And the documentary references to Nanni di Banco in Florence between 1414 and 1418 are so numerous and so closely spaced that he could not have been absent from the city for any significant length of time.[6] Perhaps the idea of a stylistic link between Jacopo della Quercia and Nanni rests on a misinterpretation of Vasari's comment on the *Assumption*. Vasari, it will be remembered, is full of praise for the monument; he speaks of the angels as "displaying the most beautiful movements and attitudes, for there is vigor and decision in their flight such as had never been seen before," and he describes the Virgin as "clothed so gracefully and simply that nothing better could be desired, for the folds of the drapery are soft and beautiful, the clothes following the lines of the figure, and while covering the limbs disclose every turn."[7] His appraisal is, in fact, so perceptive that it could hardly be improved upon. But he claims the work for Jacopo della Quercia, not Nanni. It is tempting to think, therefore, that Vasari sensed a stylistic kinship between the *Assumption* and certain works by Jacopo, and drew his own conclusions from this insight, since Nanni's authorship of the *Assumption* had been forgotten. It can be shown, however, that Vasari was not motivated primarily by considerations of style. We need only compare his comments on the *Assumption* in the first edition of the *Lives* with the equivalent passages in the second edition, in order to understand what he had in mind.[8]

In the first edition, interestingly enough, Vasari reports as the prevailing opinion that the *Assumption* was done by Nanni di Banco. But he argues against this, for three reasons: the work is far too good for Nanni; its style recalls that of Jacopo della Quercia; and, moreover, Jacopo had been in Florence for four years

[4] Pope-Hennessy, *loc. cit.*

[5] See Pope-Hennessy, *op. cit.*, p. 213.

[6] For Nanni's administrative offices during those years, see Manfred Wundram, "Antonio di Banco," *Mitteilungen des kunsthistorischen Instituts in Florenz*, 1961, pp. 23–31.

[7] Giorgio Vasari, *Le vite . . .*, ed. G. Milanesi, Florence, 1906, II, p. 115.

[8] *Le vite del Vasari nell'edizione del MDL*, ed. Corrado Ricci, Milan-Rome, n.d., I, pp. 235 ff., 245 ff.

at the time of the competition for the Baptistery Doors, waiting for the prize to be awarded; he surely produced something in Florence besides the competition relief, and since the *Assumption* is the only likely candidate for this distinction, it must be his rather than Nanni's. Vasari then repeats the same argument in shorter form in his Life of Nanni di Banco, but there he claims only that some people believe the *Assumption* to be Nanni's, while others attribute it to Jacopo della Quercia. In the second edition, Vasari's scruples have disappeared entirely, and he no longer mentions Nanni even as a possibility. To understand this hardening of Vasari's opinion, we must keep in mind that he chose Jacopo as the subject of the first Life for the second part of the *Lives;* he explains this choice in the Introduction, making it clear that he regards Jacopo as a figure of fundamental importance. And among the works he discusses, the *Assumption* is praised and described at greater length than any of the rest. Nanni di Banco, in contrast, appears as a rather modest master, a disciple of Donatello; and most of his biography is devoted to anecdotes demonstrating the generosity and artistic superiority of his supposed teacher. Little wonder, then, that Vasari held Nanni incapable of having produced a key monument such as the *Assumption*. It simply did not fit Vasari's historic framework, so he felt he had to assign it to a master worthy of so great an achievement. Having once made this basic decision, Vasari hit upon Jacopo as the most plausible author. He may have been impelled by local pride to some extent, since it just would not do for Florence to possess no work by an artist whom Vasari believed to have been one of the Founding Fathers of the Renaissance. The style of the *Assumption* is cited, one feels, merely to reinforce these other considerations; it remains brief and vague. Still, we can feel some sympathy with Vasari's attitude. What would we ourselves think of the *Assumption* if we had no documents to establish its authorship? We should certainly reject the attribution to Jacopo and link the work with Nanni, but with all kinds of reservations such as the hypothetical collaboration of a younger artist.

Be that as it may, Vasari clearly attributed far greater historic significance to the *Assumption* than modern scholars have done. Before attempting to assess this significance, let us consider briefly a peculiar detail of the scene, the bear cub that tries to climb an oak tree in the lower right-hand corner. Here again Vasari's comment in the first edition of the *Lives* is far more elaborate than what he has to say in the second edition. He tells the reader that everybody has divergent opinions about the meaning of this curious motif, and then presents his own view: the bear represents the Devil. There is no need to reproduce his arguments in full, since he himself did not put much stock in this explanation. He omitted it in the second edition and called the motif a *capriccio* (a term he had not applied to it before). Since we know of no other Assumption that includes this feature, we are not much better off than Vasari in trying to explain it. Yet Vasari unwittingly provides a clue that may help to clarify the problem. In describing the motif, he speaks of "a bear climbing a pear tree," although it is quite unmistakably an oak, even when viewed from the street. We might dismiss the pear tree as a simple lapse, were it not for the fact that there is a tree-climbing bear in another well-known Florentine relief, Andrea Pisano's *Adam and Eve in the Wilderness* on the Campanile of the Cathedral (fig. 2); and this bear is climbing, if not a pear tree, at least an apple tree. There can be little doubt that Vasari had the Andrea Pisano bear in mind when he wrote about Nanni's bear, and

and, so far as we can determine, quite independently. In the North, the great pioneer was the Master of Flémalle; the flying angels in his *Entombment* owned by Count Seilern in London, or in the Dijon *Nativity* (fig. 11), differ from those in the S. Eustorgio altar in a basic way—the wind-blown draperies are no longer an ornamental accompaniment, but have become functional, sustaining the figure in the air like inflated sails or parachutes. This type, which anticipates so completely the Late Gothic flying angels of Martin Schongauer and Veit Stosz, probably originated between 1415 and 1420, at the very time when Nanni di Banco created the angels of his *Assumption*. But Nanni cannot have depended on any Northern models here; his angels, although as convincingly airborne as those of the Master of Flémalle, produce this effect by very different means. The Master of Flémalle imbues the drapery of his angels with vigorous dynamic life, while the body underneath tends to disappear or to play a passive role. Nanni, in contrast, endows the body with energetic movement, and the drapery serves mainly to dramatize this movement rather than to act as a parachute. This, surely, is an even more decisive innovation than that achieved by the Master of Flémalle. And while it presupposes both the new interest of the International Gothic style in aerial locomotion and the classical flying tradition of the "Victory type," it nevertheless represents a great step beyond these antecedents. It is, in fact, so fundamental an invention that it opens the road to the entire development of the flying figure during the next three centuries of Italian art.

If this rather extravagant-sounding claim is correct, we may expect to find the flying angels of the Porta della Mandorla reflected in Florentine art of the 1420s and 1430s. Such, however, is the case only in a few instances. In Masaccio's *Virgin and Child with St. Anne* we find a marked contrast, often commented upon, between the two flying, curtain-holding angels: the one on the left is conservative, Masolinesque, while the other displays far more energetic gestures and bits of wind-blown drapery to suggest movement (fig. 12). This angel may be regarded as an echo, though strongly modified, of Nanni di Banco's angels. The same is true of the angel with the sword in Masaccio's *Expulsion from Paradise* (fig. 13); here again, however, the effect of the streaming and billowing draperies is a good deal more restrained than in Nanni's angels. Masaccio, then, was aware of Nanni's invention, but his own art was not one of movement, hence these figures play only a minor part in it. Where we do find an exploitation of movement in the 1420s—in Ghiberti and Donatello—we also find alternative solutions to the problem of the flying figure. Ghiberti, in the Shrine of the Three Martyrs and the East Doors of the Baptistery, retains the angels of the "Victory type," enriched by a play of drapery that echoes the International Gothic style. Donatello, in contrast, arrives at a revolutionary solution of his own in the *Assumption* of the Brancacci tomb (fig. 14). Here we find none of the spread-out, convoluted drapery of Nanni's angels, nor do Donatello's angels "tread the air" with their legs as Nanni's do. Instead, they swim or dive through an atmosphere that has made palpable, like a liquid, by means of layers upon layers of clouds. Donatello thus provides his angels with a concrete "medium" in which their movements seem entirely plausible.[18] Luca della Robbia patterns his an-

[18] It may be of interest to note that this solution had a certain influence on Ghiberti, who

gels after those of Ghiberti and the even more classicistic ones of Michelozzo from the Aragazzi tomb.

Only toward 1450, when movement once again becomes a major concern in Florentine art, do we begin to feel the full impact of Nanni's *Assumption*. Castagno admired it and acknowledged his indebtedness in the Berlin *Assumption* (fig. 15); we need only point to the Virgin, who repeats, mirror-fashion, the *contrapposto* movement of Nanni's Madonna. The four angels sustaining her cloud-*mandorla* reflect both the poses and the draperies of Nanni's angels. A dozen years later, in Antonio Rossellino's Tomb of the Cardinal of Portugal (fig. 16), the flying angels of Nanni di Banco are reincarnated, as it were, with even greater emphasis on the dynamics of aerial locomotion. They, in turn, lead us directly to Verrocchio's flying angels on the Forteguerri Monument, to Botticelli and Filippino Lippi.

provided a limited "pool of clouds" for the Lord and His angelic companions in the *Moses* panel of the East Doors.

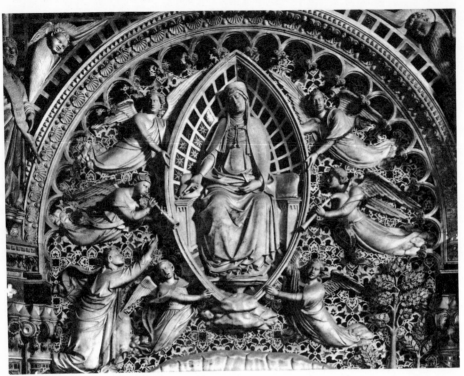

4. *Andrea Orcagna*, Assumption of
the Virgin. *Upper half of tabernacle
relief, ca. 1355. Florence,
Or San Michele*

5. *Giotto*, Lamentation *(detail)*.
*Fresco, 1305–6. Padua,
Arena Chapel*

6. Sacrifice of Iphigenia *(detail)*.
*Roman wall painting from Pompeii.
Naples, Museo Archeologico Nazionale*

7. *Tuscan Master*, Assumption of the Virgin. *Mid-14th century. Prato, Cathedral*

8. Flying Angel, *detail of Byzantine sarcophagus. Istanbul, Archaeological Museum*

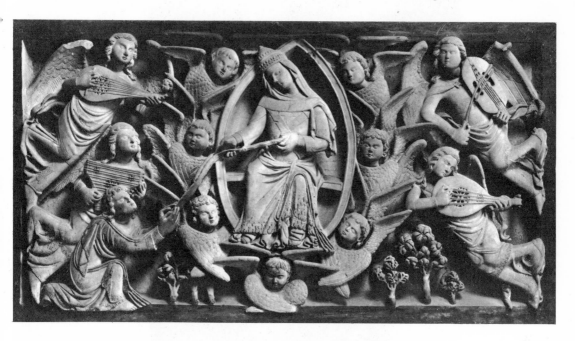

9

9. *Nanni di Banco,* Angel *(detail of* Assumption of the Virgin)

10. *Lombard Master,* Crucifixion *(detail). ca. 1400.* Milan, S. Eustorgio

11. *Master of Flémalle,* Nativity *(detail). ca. 1415–20.* Dijon, Musée de la Ville

10

11

12

13

12. Masaccio, Virgin and Child with St. Anne *(detail). 1426. Florence, Uffizi Gallery*

13. Masaccio, Expulsion from Paradise *(detail). Fresco, ca. 1427. Florence, S. Maria del Carmine, Brancacci Chapel*

14. Donatello, Assumption of the Virgin, *on the Tomb of Cardinal Brancacci. 1427–28. Naples, S. Angelo a Nilo*

14

15

16

15. *Andrea Castagno,* Assumption of
the Virgin. *1449-50.*
Berlin, Staatliche Museen

16. *Antonio Rossellino,* Flying Angel,
on the Tomb of the Cardinal of
Portugal. 1460-66.
Florence, S. Miniato

STUDY

6

Giovanni Chellini's Libro and Donatello

"Giovanni Chellini's *Libro* and Donatello,"
Studien zur toskanischen Kunst: Festschrift für Ludwig Heinrich Heydenreich,
Prestel, Munich, 1964, pp. 131-38

Donatello's career is more fully documented than that of any other Quattrocento master. The archives of Florence, Siena, and Padua provide an almost continuous record of his activity from the age of twenty until a few years before his death. In contrast to this mass of factual data, however, there is a great dearth of contemporary statements providing some insight into the artist's personality, intellectual interests, friendships, reputation—in short, those intimate glimpses that might tell us what kind of a man Donatello was. An important addition to this small group of sources came to light a few years ago; but since it was published by a historian of economics in a yearbook devoted to studies in his field, it seems to have escaped the attention of art historians. It may be useful, therefore, to reproduce the text in full here, and to offer some commentary.

The passage that concerns us is from the *Libro debitori creditori e ricordanze* of Giovanni Chellini or Saminiati (1372/73–1462), the Florentine physician best remembered today for his fine portrait bust of 1456 by Antonio Rossellino. This *Libro* turned up among a large number of business records of the Saminiati and Pazzi families acquired after the Second World War by the Università Bocconi in Milan. Aldo de Maddalena, who presented a first survey of the content of these papers in 1959,[1] excerpted the following entry from fol. 199 r of the *Libro:*

Ricordo che a di 27 d'Agosto 1456 medicando io Donato chiamato Donatello, singulare et precipuo maestro di fare figure di bronzo e di legno e di terra e poi cuocerle, e avendo fatto quello huomo grande che e sullo alto di una cappella sopra la porta di Santa Reparata che va a Servi e così che avendone principiato un altro alto braccia nove, egli per sua cortesia e per merito della medicatura che avevo fatta e facevo del suo male mi donò un tondo grande quant'uno tagliere nel quale era scolpita la Vergine Maria col bambino in collo e due Angeli da lato, tutto di bronzo e dal lato di fuori cavato per potervi gittare suso vetro strutto e farebbe quelle medesime figure dette dall'altro lato.

(On August 27, 1456, Donato, called Donatello, the singular and outstanding master of bronze, wood, and terra-cotta figures who made the large male statue above a chapel over the portal of S. Reparata toward the

[1] "Les Archives Saminiati: de l'économie à l'histoire de l'art." *Annales: Économies, Sociétés, Civilisations,* XIV, 1955, pp. 738–44. I owe my acquaintance with this article to Professor Raymond de Roover.

Servi and had begun a companion figure nine braccia tall, generously presented me, in consideration of the medical care I had been giving him, with a bronze roundel the size of a trencher, on which was sculptured the Virgin Mary with the Child at her neck, flanked by two angels; the outer side is hollowed so that molten glass can be cast in it to make the same figures as those on the other side.)

The description of the roundel has been known to art historians since 1962.[2] It occurs in an account of Giovanni Chellini's life that forms part of a *Discorso sopra la Famiglia de Saminiati* compiled in the late Cinquecento by Scipione Ammirato, who had access to the *Libro* and other family documents. Ammirato states that the description of the roundel is in Giovanni's own words; the rediscovery of the *Libro* thus provides welcome proof of his accuracy, which otherwise might be subject to doubt.[3] As for the relief in question, nothing like it is known today, nor is it mentioned in any other source. What Chellini says about its back sounds so implausible that Lightbown, quite justifiably, refuses to accept it at face value. If the tondo was a particularly thin and clean cast, the back would to some extent have resembled a female mold; perhaps someone pointed this out to Chellini—who was not an art patron, so far as we know, and probably knew little of such matters—and the old gentleman misunderstood the technical explanation. That there are no replicas of the panel in cheaper materials, and that neither Vasari nor any of the other historiographers knew of it, is a puzzling circumstance to which we shall return later.

The part of the *Libro* entry not quoted by Ammirato holds even greater interest for us. Here Chellini gives a general characterization of Donatello for the benefit of future generations of his family, to whom the great sculptor's name might mean less than it did to him. Perhaps the most intriguing aspect of this "layman's view" of the post-Paduan Donatello is the enumeration of materials: bronze, wood, and terra-cotta. How could Chellini have omitted marble? Evidently, he had no mental image of Donatello's Florentine oeuvre as a whole, since, in the perspective of 1456, the sheer bulk of the works in marble must have far outweighed the few bronzes then on public view (which did not yet include the *Judith* and the S. Lorenzo Pulpits). It seems likely, therefore, that Chellini came to know Donatello only after the latter's return from Padua, and judged him mainly in terms of his current activities rather than past achievements. There is testimony that the artist was in very poor health toward the end of his Paduan sojourn; Leonardo Benvoglienti, in a letter of April 14, 1458, quotes him as having said four years earlier that he "would dearly love to come to Siena, so as not to die among those Paduan frogs, which he almost did."[4] The entry in the *Libro* implies protracted treatment (*medicatura che avevo fatta e facevo*). If Donatello was seriously ill when he arrived in Florence during the winter of 1453–54, and Chellini restored his health, the valuable gift of a good-

[2] R. W. Lightbown, "Giovanni Chellini, Donatello, and Antonio Rossellino," *Burlington Magazine*, CIV, 1962, pp. 102-4.

[3] The *Discorso* itself, moreover, is known only from a seventeenth-century manuscript copy; cf. Lightbown, *op. cit.*

[4] G. Milanesi, *Documenti per la storia dell'arte senese*, II, Siena, 1854, pp. 299 f.

sized bronze relief becomes understandable. We must imagine, then, that the two saw a good deal of each other in 1454–56; their conversation could not very well have been limited to medical matters alone, so that Chellini probably knew in some detail what Donatello was working on during those years. Thus his mention of wooden figures permits us to infer that the *Mary Magdalene* in the Baptistery was finished, or at least near completion, by August 27, 1456—a *terminus ante quem* fully consonant with the dating of the statue on stylistic grounds, and doubly welcome in the absence of any other documentation.[5] But bronze was the primary material that came to Chellini's mind. Was this only because the artist had given him a bronze roundel? We have no documentary evidence of any bronzes on which Donatello was at work on August 27, 1456, but some recently published entries in the account books of the Cambini brothers' bank inform us that on October 14 the artist received an advance of 100 florins, all of which he had spent by November 19 on 965 pounds of bronze, a vast quantity of charcoal, and other materials.[6] This major enterprise must have been commissioned a good many months before the date of the advance to cover the expense of the casting, and the wax model must have been nearing completion at the time Donatello presented the tondo to Chellini. Hence, we may suppose, the mention of bronze in first place in the *Libro*. What was this commission? Unless we are willing to assume, against all probability, that the work in question was either abandoned after it had been cast, or, if completed, remained unrecorded and is now lost, we have only two choices: the *Judith* or the S. Lorenzo Pulpits.[7] The money came to Donatello from Bartolommeo Serragli, acting as agent for an unknown patron. Hartt has argued emphatically that the patron must have been the Medici, with whom Bartolommeo had frequent dealings, and that the commission was for the *Judith,* which is recorded as in their possession in 1464.[8] The problem is not easily settled, however. Bartolommeo, an art dealer and professional middleman, had many non-Florentine clients, and the documents published by Corti and Hartt give no indication that he procured works of art for the Medici locally; the only evidence that he had anything at all to do with the Medici collections is a group of letters he wrote from Rome to Giovanni di Cosimo in the fall of 1453 about certain pieces of ancient sculpture.[9] Why indeed should the Medici have needed such a broker when dealing with Donatello, who had done so much work for them before? And does it not seem doubly

[5] The wooden *Mary Magdalene,* dated 1455 from S. Croce in Vinci, now in the Museum of Empoli, has been cited as reflecting the influence of Donatello's *Magdalene* (H. W. Janson, *The Sculpture of Donatello,* Princeton, N.J., 1957, p. 191, with references to the earlier literature), but the figure is so provincial and retardataire that this conclusion is far from compelling. I rather think now that the Empoli statue represents a traditional type which Donatello appropriated. The only recent scholars to date the Baptistery *Magdalene* later than 1456 are W. and E. Paatz (*Die Kirchen von Florenz,* Frankfurt, 1940–54, II, p. 206), who place it well after the Siena *St. John* of 1457, or toward 1460.

[6] G. Corti and F. Hartt, "New Documents Concerning Donatello, Luca and Andrea della Robbia, Desiderio, Mino, Uccello, Pollaiuolo, Filippo Lippi, Baldovinetti, and Others," *Art Bulletin,* XLIV, 1962, pp. 155–67.

[7] The Siena *St. John,* delivered on October 24, 1457, weighs only 588 pounds, according to the document published in Milanesi, *op. cit.,* p. 297.

[8] Corti and Hartt, *op. cit.,* pp. 158 f.

[9] *Ibid.,* p. 157, note 12. The letter of November 12, 1453, mentioning twelve heads for Giovanni di Cosimo's study, is interpreted by Hartt as a reference to certain heads by Desiderio

strange that the artist received his advance on a Medici commission through the Cambini brothers' bank rather than that of the Medici?[10] We thus arrive at the same conclusion as Hartt, but by the opposite route: for if Bartolommeo did not represent the Medici in disbursing money to Donatello, then the bronze cast of 1456 could not have been the S. Lorenzo Pulpits (either of which surely required 965 pounds of bronze or more) and we are left with the *Judith*. But once we eliminate the Medici, it becomes highly improbable that the statue was a Florentine commission; a public body would not have acted through Bartolommeo as an intermediary, and what private patron could afford to order so ambitious a work? The *Judith,* then, was in all likelihood destined for one of Bartolommeo's many out-of-town clients, as suggested by the signature, OPUS DONATELLI FLO[RENTINI].[11]

But let us return to Giovanni Chellini. His mention, in a rather awkward-phrase, of terra-cotta figures may strike us at first glance as no less strange than his omission of marble. After all, this was the material least favored by Donatello. The next clause supplies the reason, for the *huomo grande* above the north tribune of the Cathedral was indeed made of terra-cotta. We know its appearance today only in the vaguest outline, from a fresco by Bernardo Poccetti in S. Marco, where it appears silhouetted against the sky in the distance.[12] It was still in place toward the end of the seventeenth century, though badly weathered,[13] and must have been taken down soon after. Donatello probably received the commission for it during the latter part of 1409, when the *operai* had decided that his marble *David* and Nanni di Banco's *Isaiah* were too small to occupy their intended positions on the buttresses of the north tribune.[14] Although the documents speak of the figure simply as *della terra chotta,* it must have been made up of many small pieces comparable to molded bricks—Vasari speaks of *mattoni*—which were cemented in place as they came from the kiln in small batches, so that all Florence could watch the statue grow layer by layer, like a house, for about two years. At the end of 1410 a good part of the figure was already assembled; we hear of the purchase of 82 pounds of linseed oil, 3 pounds

da Settignano for which Bartolommeo made payments two years later; but the text gives no hint of this, and probably again refers to antique, or pseudo-antique, sculpture (as do the letters of October 27 and 31).

[10] It may not be irrelevant to note that in 1426, while working in Pisa, Donatello received payments through the local branch of the Medici bank (probably for the tomb of Rainaldo Brancacci, from Cosimo de' Medici on behalf of the Cardinal); cf. Janson, *op. cit.,* p. 89.

[11] See *ibid.,* pp. 202 f. In September 1457 the chamberlain of the Siena Cathedral workshop sent 25 ducats to Donatello in Florence, to buy bronze for a *mezza fighura di Guliatte,* a possible misspelling or misreading of *Giuditta* or *Giulitta,* (as suggested *ibid.*). Could this still be the *Judith,* which was cast ten or eleven months earlier? Quite plausibly, I should say. Casting the group must have been a very risky matter, because of its complexity of form and because Donatello had incorporated actual cloth in the wax model (see the detailed analysis by B. Bearzi, "Considerazioni di tecnica sul S. Ludovico e la Giuditta di Donatello," *Bollettino d'arte,* XXXVI, 1951, pp. 119 ff.); it was cast in no less than eleven pieces, one of which might have turned out so poorly that it had to be done over again and such a piece would have been called a *mezza figura* (a term meaning not a half-length figure but "part of a statue"; cf. Janson, *op. cit.,* p. 197). A mishap of this sort must have befallen the Siena *St. John,* which was delivered with the right arm missing.

[12] G. Poggi, *Il duomo di Firenze,* Berlin, 1909, p. xxii, fig. 2.

[13] See F. Bocchi, *Le bellezze di Firenze . . ., ampliate da Giovanni Cinelli,* Florence, 1677, p. 44.

[14] Cf. G. Poggi, *op. cit.,* doc. 413.

of liquid varnish, and 30 pounds of white lead *per la figura della terra chotta di su lo sprone,* evidently for a protective coating.[15] In February 1412 the statue received a coat of gesso, followed by additional coats of oil and white lead later in the year.[16] By now it was referred to as *homo magnus* and *l'uomo grande,* [17] an indication that it was complete, since previous documents had termed it merely a *figura.* In June, it was identified as a *Joshua.* [18] A month later Donatello, whose name had not been linked with the statue in earlier documents, received a part payment of 50 florins, and on August 12 the *operai* decided to pay him a total of 128 florins for it.[19]

The documents tell us nothing of the size of the *Joshua* other than that it was exceptionally tall. The sixteenth-century sources call it a *gigante,* again without giving dimensions.[20] Perhaps the *operai* did not define the exact height of the statue in advance, either because of the novel method of fabrication or because they themselves were uncertain about the most desirable size. However that may be, they found the *Joshua* very satisfactory; when the project was resumed in 1463, they commissioned Agostino di Duccio to produce a "giant or Hercules" as tall as Donatello's.[21] Apparently it was not thought necessary to state the height and the material in explicit terms—the location, too, was defined merely as *in sullo edifitio . . . di sancta Maria del Fiore*—but Agostino must have used the technique pioneered by Donatello, for he completed the project in the astonishingly short time of six months.[22] The following year the *operai* commissioned him to do a *gigante* of Carrara marble, to be placed atop one of the buttresses, and nine braccia tall.[23] That, presumably, was also the height of the two earlier *giganti,* [24] although the contract does not say that the marble figure had to match them. Giovanni Chellini's statement that the *huomo grande* was nine braccia tall confirms this inference. And the fact that the only work of Donatello he mentions was done forty-five years before the entry in the *Libro,* attests the tremendous impression the *Joshua* must have created. The entire city, it seems, knew that the figure was nine braccia tall, and thought it a well-nigh incredible feat. Even the designation, *huomo grande,* shows how vividly Giovanni Chellini recalled the time when the statue was being put together, for soon afterward people began calling it a *gigante.* [25] In the eyes of those who had witnessed its erection, the *Joshua* remained Donatello's most spectacular achievement—and deservedly so, perhaps; it was after all the first free-standing

[15] *Ibid.,* doc. 415; the preceding document, of August 27-September 1, refers to *chiavatori* and *castagni* for the *chiusa* of the figure, apparently iron bolts or clamps to reinforce it.

[16] *Ibid.,* docs. 417, 418, 421.

[17] *Ibid.,* doc. 417.

[18] *Ibid.,* doc. 418.

[19] *Ibid.,* docs. 419, 420.

[20] The term appears in the documents for the first time in 1426, when the statue needed yet another coat of linseed oil and white lead; see *ibid.,* doc. 436.

[21] *Ibid.,* doc. 437.

[22] *Ibid.,* doc. 440. Agostino was paid almost triple the price of the *Joshua.* His statue was to share the fate, but not the fame, of Donatello's; we do not know how long it lasted.

[23] *Ibid.,* doc. 441.

[24] As suggested by R. and N. Stang, "Donatello e il Giosuè per il Campanile di S. Maria del Fiore alla luce dei documenti," *Acta ad archaeologiam et artium historiam pertinentia,* Institutum Romanum Norvegiae, I, 1962, p. 121.

[25] R. and N. Stang (*op. cit.,* p. 119) point out that the buttress statues at Milan Cathedral, which also date from the early Quattrocento, were likewise referred to as *giganti.* None of them,

colossal statue since late antiquity, equally daring in its conception and execution,[26] and the original progenitor of Michelangelo's *David*.[27]

Giovanni Chellini also helps to clear up another problem. The documents, as we have seen, mention only one *gigante* by Donatello, yet Vasari and subsequent authors speak of two.[28] How can this contradiction be resolved? R. and N. Stang have postulated that the second *gigante* was begun but never finished. They believe it to be the mysterious *David* mentioned in a document of August 12, 1412, the very day when the *operai* determined the final price of the *Joshua*.[29] The statement in Chellini's *Libro* that Donatello had *principiato un altro* [*huomo grande*] bears out the Stangs' hypothesis of a second, unfinished

however, seem to antedate the *Joshua* and thus do not furnish a precedent for the Florentine venture. What program the *operai* had in mind for these figures remains uncertain. R. and N. Stang suggest a cycle of youthful heroes such as Joshua and Hercules, but the documents reveal no clear intention.

Donatello's statue of Joshua seems to have received its baptism only after it was finished, and the name never caught on. Agostino's first statue, it is true, appears in the contract as *uno ghugante overo Erchole*, but "Hercules" here is no more than a synonym for "giant"; three days later, the *operai* decided to leave to Antonio di ser Matteo Piccini, *ceremoniere*, the responsibility of finding an appropriate title for the figure (Poggi, *op. cit.*, doc. 438). The marble *gigante* is defined in the contract as a prophet, but without a name, and the subsequent documents (*ibid.*, docs. 442–47) simply call it *figura* or *gigante*. Only in 1501, when the unfinished block was about to be entrusted to Michelangelo, do we find it referred to as a "David." Much the same indifference to nomenclature emerges from the documents relating to the prophets for the Campanile (cf. Janson, *op. cit.*, pp. 33–41). Apparently this attitude was characteristic of the times; the *operai* tacitly acknowledged the individuality of the artist and his work as incompatible with traditional iconographic programs. Art-historical arguments assuming consistency of purpose on the part of official bodies in fifteenth-century Italy must thus be treated with caution.

[26] The attempt to develop a durable white coating for the *Joshua* seems to be the first step on the road to Luca della Robbia's glazing technique.

[27] A genuinely colossal statue must not only be significantly larger than lifesize; it must also confront the beholder in a way that makes him realize how superhumanly large it is. The *Joshua* certainly fulfilled both conditions, as evidenced by the Poccetti fresco. Medieval statues, in contrast, may be as tall as the *Joshua*, but they do not strike us as gigantic unless we see them outside their architectural context. A striking example is the *Synagogue*, 4.20 m tall, that was shown in the exhibition *Cathédrales* at the Louvre in 1962 (Cat. No. 71) and astonished every visitor by its size; it came from next to the rose window on the south transept façade of Reims Cathedral, where it must have looked as "normal" as do its many companions still *in situ*. The only exceptions I know to this rule are figures such as the *St. Christopher* of 1331 by Giovanni Griglio, on the façade of Gemona Cathedral (Venezia Giulia); it is ca. 5.50 m tall, and obviously meant to impress the beholder as a giant. But then St. Christopher, after all, *was* a giant. The figure is not a statue, even in the Gothic sense, but a relief, the more durable counterpart of the innumerable wall paintings of huge St. Christophers in medieval churches.

[28] Ed. Milanesi, II, p. 416 (. . . *fece due colossi di mattoni e di stucco* . . .); similarly Bocchi, *ibid.*, p. 44. Albertini's *Memoriale* of 1510 refers to Donatello's *gigante primo*, implying the existence of others. The Anonimo Magliabechiano alone speaks of a single *gigante*. See R. and N. Stang, *op. cit.*, p. 120, note 2.

[29] R. and N. Stang, *op. cit.*, p. 122. For previous attempts to cope with the *"David* of 1412," see Janson, *op. cit.*, pp. 23, 27 f. These efforts had all been based on the assumption that the figure must have been of marble, but such need not be the case. The document (Poggi, *op. cit.*, doc. 199) is self-contradictory in this respect: it grants Donatello an advance of 50 florins *pro figura s. Johannis evangeliste et Davit* without mentioning any materials, and then makes certain stipulations about the *paga fienda magisterii et marmi albi dicte opere*, implying that only one of the two figures is of marble; another entry, however, referring to the same matter on the same date, speaks of *picturas marmoreas s. Johannis evangeliste et David*. This may be no more than a slip of the pen. Similar discrepancies exist in other documents, e.g., Poggi, *op. cit.*, doc. 423, where the *figuretta di pietra* and the *figura marmoris* are obviously one and the same work.

gigante, whether or not we choose to identify it with the *"David* of 1412."[30] But how, we wonder, could Vasari speak of two colossi by Donatello if one of them had remained a mere stump? Why does he fail to mention Agostino's giant of 1463? It would seem that in Vasari's day only two *giganti* were visible above the roof-line of the Cathedral, Donatello's *huomo grande* of 1410-12 and Agostino's, and that Vasari claimed both for Donatello. If there were any traces of Donatello's second giant, they must have been so insignificant as to be easily overlooked. Vasari's error may, of course, reflect nothing more than the well-known tendency of the Renaissance to substitute the names of great masters for those of lesser (and less well-remembered) ones; on the other hand, it may contain a grain of truth. At the very least, it suggests that Agostino's "giant or Hercules as tall as Donatello's" resembled the *Joshua* in more ways than size alone. One cannot help wondering why the *operai* should have commissioned Agostino to do a third *gigante,* if the second remained an unfinished and unsightly stump. Is it not likely that Agostino's task was to complete Donatello's second giant rather than to produce an independent third statue? Such an assumption would explain why the *operai* specified the size of the "giant or Hercules" with reference to Donatello's giant but not its material, and why Agostino was able to carry out his assignment in a mere six months. If he had a good deal of guidance from Donatello's design for the second *gigante* (apart from the lower portion of the figure itself, there may have been a small-scale model, possibly the *figuretta* mentioned in the document of October 9, 1415), we can understand how Agostino could be so successful with his brick giant of 1463 yet spoil the block of his marble giant of the following year.

A word needs to be added concerning Aldo de Maddalena's interpretation of the relationship between Giovanni Chellini and Donatello. Having informed himself generally on the author of the *Libro,* he knew that Giovanni, in 1456, had built the Chapel of SS. Cosmas and Damian in the Church of S. Domenico (then S. Jacopo) at San Miniato al Tedesco and was buried there six years later. He also knew that the attribution of the tomb had been disputed among art historians until Weinberger and Middeldorf settled the question in favor of Bernardo Rossellino.[31] Thus he was astonished to find among the Saminiati papers at the Università Bocconi a family chronicle by Baccio di Francesco Saminiati, the great-grandson of Giovanni Chellini, asserting that Giovanni's tomb was *fatto da Donatello. con dua statue.* Looking further, Aldo de Maddalena found the same claim in unpublished family history by Scipione Ammirato and in an eighteenth-century source.[32] Here, he thought, was proof of the true authorship of the tomb, and he saw his view confirmed by the fact that Giovanni's

[30] The reason why Donatello did not complete the second *gigante* may have been partly the pressure of other commissions, partly the search for an improved technical procedure, as suggested by a document of October 9, 1415 (Poggi, *op. cit.*), that refers to work by Brunelleschi and Donatello on *una figuretta di pietra, vestita di piombo dorato, . . . per pruova e mostra delle figure grandi che s'anno a fare in su gli sproni . . .*; cf. R. and N. Stang, *op. cit.,* p. 120.

[31] M. Weinberger and U. Middeldorf, "Unbeachtete Werke der Brüder Rossellino," *Münchner Jahrbuch der bildenden Kunst,* N. F., V, 1928, pp. 85–94. For a review of older opinions see A. Matteoli, "Il monumento sepolcrale di Giovanni Chellini," *Bollettino dell'Accademia degli Euteleti della Città di San Miniato,* XIV, 1948–49, pp. 17–21.

[32] Cf. above, note 1.

Libro contains a long entry on Donatello but no mention of either Bernardo or Antonio Rossellino. So Giovanni received a bronze roundel of the Madonna from Donatello in the very year when he built the chapel that was to hold his tomb! All the pieces of the puzzle seemed to fall into place.

Art historians, committed to the primacy of visual evidence, will want to arrange the pieces of this particular puzzle in a different pattern. Instead of trusting the testimony of Giovanni Chellini's great-grandson, we must ask how it happened that he claimed for Donatello what is surely a work of the Bernardo Rossellino shop. Apparently Baccio had seen the tomb, since he speaks of two statues— or, if we make allowance for the often rather loose meaning of *statue,* two pieces of sculpture. Ammirato is less specific and less positive, since he states that the tomb has "many statues" and "is said to be by Donatello."[33] He seems to have relied on family tradition here, or on Baccio's chronicle, which must antedate his by fifty to seventy-five years; for the Chellini tomb, whatever its original appearance (only the lower part has survived), could hardly have included "many statues." However, he also cites the text of the funerary inscription—presumably from family records, rather than from the tomb itself—and thus was aware of an important fact disregarded by Aldo de Maddalena: the monument was erected not by Giovanni but by his nephew and heir Bartolommeo (SEPULCHRUM HOC BARTHOLOMEUS NEPOS ET GRATUS HERES CONSTRUENDUM CURAVIT). Giovanni's friendship with Donatello, then, and the lack of any reference to Bernardo or Antonio Rossellino in the *Libro,* have no bearing on the authorship of the tomb. The portrait bust of 1456, too, was probably ordered by Bartolommeo, perhaps as a gesture of respect and gratitude when Giovanni, after the death of both his sons, made Bartolommeo his heir. Had Giovanni himself commissioned the bust,[34] we would expect this fact to be recorded in the *Libro*.[35] That its date coincides with the founding of the Chapel of SS.Cosmas and Damian by Giovanni, and with Donatello's gift to him of the bronze roundel, suggests that in 1456 Giovanni Chellini was preoccupied with thoughts of death: he made his last will, naming Bartolommeo as his heir, and built the chapel that was to receive his mortal remains. Donatello in all likelihood knew about the chapel; the roundel was probably intended for the new structure, and Giovanni, we may assume, had it installed there without delay.[36] It may even have been incorporated in his tomb after 1462.[37] In any event, its presence in the chapel was quite sufficient to make Giovanni's descendants believe that the tomb itself must be by Donatello. Finally, our hypothesis also explains why the relief, despite the fame of its author, escaped the attention of all Florentine writers on art in the following centuries.

[33] See Lightbown, *op. cit.,* pp. 103 f.

[34] As assumed by Lightbown, *op. cit.,* p. 104.

[35] The final entries, according to Ammirato, date from 1457. Despite its explicit inscription, the bust was claimed for Donatello by Cinelli (in Bocchi, *op. cit.,* p. 402, and later authors; see Lightbown, *op. cit.,* p. 102).

[36] Comparison with a trencher—a large platter for carving or serving meat—is not a very precise indication of size, but it suggests that the roundel had a diameter of 60 to 90 cm and was thus not too small to be set in the wall of a chapel.

[37] This possibility is suggested by Baccio di Francesco's statement that the tomb had "two statues."

STUDY 7

The Image of Man in Renaissance Art: From Donatello to Michelangelo

"The Image of Man in Renaissance Art: From Donatello to Michelangelo,"
The Renaissance Image of Man and the World, ed. Bernard O'Kelly,
University of Ohio Press, Columbus, 1966, pp. 77-103

Since the Renaissance is a vast and complex area, I shall confine my remarks to a particular section of it: the Florentine Early and High Renaissance. Or, if we are to express these limits in political terms, the span of slightly more than a century that began about 1400 with Leonardo Bruni's *Laudatio Florentinae Urbis* and the city's successful defiance of Giangaleazzo Visconti, and ended in 1512 with the re-entry of the Medici into Florence and the crushing of the republican spirit in the city. I propose, in other words, to include in my discussion the Michelangelo of the *David* but not the Michelangelo of the Medici tombs. Such a limitation is not wholly arbitrary; it will permit me to cover only one chapter of my subject—the new image of man in Renaissance art—but perhaps the decisive one: the creation of the new image in the first half of the fifteenth century and that phase of Michelangelo's art which still reflects his awareness of this basic achievement. After 1512, it seems to me, such an awareness plays a less and less significant part in Michelangelo's work.

I must acknowledge a further limitation: I have tried to confine myself to works of art about which we have sufficient data to let us see them, to some extent at least, as the Renaissance itself saw them. For the period under consideration, this is quite a severe limitation. Viewed in isolation, statues and paintings are mute witnesses, and direct verbal testimony about specific works of art is rare indeed until the mid-sixteenth century, the time of Vasari. Nor can we take Vasari's words at face value when they concern works of art created a century or more before his day. The Renaissance view of art and artists underwent decisive changes during the second quarter of the Cinquecento,[1] so that we must use extreme caution in accepting judgments or interpretations of Early Renaissance art by Vasari and his contemporaries. If we want to learn how the men of the period 1400–1512 viewed the artistic achievements of their day, we shall have to rely very largely on indirect testimony—evidence gathered from the unselfconscious statements in account books and similar records, from relationships we can discover among the works of art themselves, from inferences that may sometimes be drawn about the link between art and the political, intellectual, and social climate. There is only a limited number of instances in which we can

[1] Cf. Anthony Blunt, *Artistic Theory in Italy, 1480–1600*, Oxford, 1956, pp. 97 f., on the influence of Baldassare Castiglione's *Cortegiano*, as well as the illuminating paper, "Maniera as an Aesthetic Ideal," by John Shearman, in *Studies in Western Art, Acts of the Twentieth International Congress of the History of Art*, II, Princeton, 1963, pp. 200 ff.

hope to reconstruct the contemporary attitude toward a work of art without getting entangled in the vague generalities of *Geistesgeschichte*. Let us, then, try to be as specific as the present state of our knowledge permits.

In our quest of the new image of man in Renaissance art, we are primarily concerned with sculpture, for several good reasons. Most obvious is the matter of chronological priority: Early Renaissance art begins with sculpture—if I had to give specific dates, I should say between 1408 and 1416—while Renaissance architecture makes its appearance in 1419 with Brunelleschi's designs for the Ospedale degli Innocenti and the Old Sacristy of S. Lorenzo, and painting has to await the emergence of Masaccio in the early 1420s. How did it happen that sculpture can claim this priority? We must, of course, give due credit to the individual genius of Donatello, but this genius could unfold only in the particular circumstances created by the spiritual climate of Florence during those decisive years. The new civic and republican humanism of Leonardo Bruni and his circle that made its appearance about 1400 gave birth to a vision of Florence as the modern counterpart of Periclean Athens,[2] and inspired a communal effort to beautify the city which in intensity and cost was entirely worthy of comparison with the art patronage of Athens during the later fifth century B.C. In Florence, this campaign meant first of all the completion of the unfinished artistic enterprises of earlier days; it began with the famous competition of 1401–3 for a second set of bronze doors for the Baptistery, then spread to the Cathedral (the Porta della Mandorla, the façade, and the Campanile) and to the niches of Or San Michele. All these were sculptural tasks of great scope, challenging the best talent available. The most ambitious task of all, to be sure, was to build the long-projected dome of the Cathedral, but this took so much deliberation that it did not get under way until 1420. Thus, for almost twenty years, the sculptors were the main beneficiaries of this great surge of communal art patronage. They had to work in a medieval setting, it is true, yet they soon managed to explode this framework and to create an image of man utterly unmedieval and attuned to the civic-patriotic humanism of the time.

Even if the painters had shared in the new art patronage from the start, I rather think the sculptors would have been in the van. For the image of man, in the most concrete, physical sense, is after all the central theme of sculpture anywhere and at any time; or at least of sculpture in the full meaning of the word, i.e., sculpture in the round and on a monumental scale, sculpture conceived as self-sufficient, free-standing statues rather than as the handmaiden of architecture. Sculpture thus defined had not been produced since the end of the Roman Empire—all medieval sculpture is "applied sculpture," whether or not it be physically in the round. Of course, most of medieval painting, too, is "applied," since it appears on surfaces such as walls, windows, altar frontals, or book pages, whose primary purpose was not to serve as carriers for images. Still, through the icons of Byzantine art, the tradition of ancient panel painting (that is, painting on surfaces that had no other purpose than to be painted on) survived throughout the Middle Ages and ultimately gave rise to the modern easel picture.

[2] See Hans Baron, *The Crisis of the Early Renaissance*, Princeton, N.J., 1955, and the same author's *Humanistic and Political Literature in Florence and Venice*, Cambridge, Mass., 1955.

The free-standing statue, on the other hand, survived neither in Byzantium nor in the medieval West (the last recorded instance is the statue of a Byzantine emperor made in the late eighth century). The reason is obvious: free-standing statues were "idols" par excellence. The Early Christian fathers—I am thinking especially of a famous passage by Arnobius[3]—had expended great powers of rhetoric in trying to persuade their readers that the statues of the gods were not "real" but merely convenient depositories for the droppings of birds, yet the faith in the magic power of such statues would not die out. Only by placing sculpture in the service of the Church—and I mean this quite literally: by applying sculpture to church architecture—could the Middle Ages take the curse off monumental statuary. A statue standing unabashedly on its own two feet without being imprisoned by its architectural context was unthinkable. Not that all free-standing statues of ancient times were destroyed as idols in the Middle Ages; we know that a small number of them survived in public view, such as the statues on the Lateran in Rome, which included the equestrian monument of *Marcus Aurelius* (rechristened Constantine the Great) and the *Spinario,* or *Thorn Puller.*[4] Occasionally such statues would turn up elsewhere as well. But no medieval artist dared to imitate them as free-standing figures; their poses or outlines were often borrowed, but always with a change of meaning and with a change from free to applied status. Clearly, these statues, especially if nude, retained some of their old magic; they were still looked upon as "the seats of demons," good or bad. Of the large number of medieval accounts attesting this fact,[5] let me cite just one, which I have chosen because it is so close in time to the Early Renaissance and can be linked to a fascinating visual example. About 1300—we do not know exactly when—there was discovered in Siena a nude Venus statue of the *pudica* type (the best-known example is the *Medici Venus*), inscribed with the name of Lysippus. The famous Greek sculptor, mentioned by Pliny and other Roman authors, had not been forgotten in the Middle Ages; the Sienese were delighted with their find, and after a while placed the figure atop the fountain in front of their city hall, a place of honor and responsibility that gave this particular statue something of the rank of a protective deity, like the *Tyche* statues of ancient cities. It was thus quite natural that the Lysippean *Venus* should be held accountable for the fortunes of mid-fourteenth-century Siena; and since these were largely misfortunes—we recall the plague of 1348— the city government decided, apparently in response to popular pressure, to get rid of the statue. A resolution passed by the city council in that year pronounced the figure *inhonestum* (indecent) but did not specify what should be done with it after its removal from the fountain. According to a somewhat later account,

[3] *Adversus Gentes,* VI, 16; cf. also Clement of Alexandria, *Cohortatio ad Gentes* (Migne, *Patrologia Graeca,* VIII, cols. 155 ff.).

[4] See W. S. Heckscher, s.v. "Dornauszieher," in *Reallexikon zur deutschen Kunstgeschichte,* 1955, IV, cols. 289 ff., and the literature cited there.

[5] Cf. Julius Schlosser, *Leben und Meinungen des florentinischen Bildners Lorenzo Ghiberti,* Basel, 1941, p. 156. For the statue of Mars on the Ponte Vecchio in Florence, destroyed in 1333, see Giovanni Villani, *Historie Fiorentine,* XI, i; for the imperial equestrian monument nicknamed the Regisole in Pavia, see Hans Kauffmann, *Donatello,* Berlin, 1935, pp. 134, 236 n. 413; and Ludwig H. Heydenreich, "Marc Aurel und Regisole," in *Festschrift Erich Meyer,* Hamburg, 1959, pp. 146 ff. (with exhaustive bibliography).

the *Venus* was broken into pieces and buried in Florentine soil, so that she might transfer her evil qualities to the enemy.[6] This *Venus*— or perhaps another one of the same type—appears on the Pisa Cathedral pulpit by Giovanni Pisano (fig. 1), in the astonishing role of one of the Cardinal Virtues.[7] (Shortly before, Giovanni Pisano had been in charge of the sculptural program of Siena Cathedral and thus must have seen the Lysippean *Venus* if she was discovered while he was there.) This is a case unique in all of medieval art, and I suspect that in order to account for it we must assume that Giovanni Pisano wanted to take the curse off the *Venus* by giving her a place in the Christian scheme of things, symbolically speaking, and by putting her to use in the physical sense as well, since she is combined with four other figures that form one of the supports of the pulpit. Let us note, also, that he has been careful to deprive her of all sensuous appeal and to concentrate expression in the face; whereas in ancient nude statues, it is the body, rather than the face, that speaks to us most eloquently. (The loincloth, amusingly enough, is a modern addition.)

Against this background, it becomes understandable why the revival of the free-standing, self-sufficient statue was the first achievement of Early Renaissance art, an achievement that signals a radically unmedieval image of man. While ancient painting was barely known before the end of the Quattrocento, the free-standing statue was a primary symbol of that classical humanity whose modern heirs the Florentines of Leonardo Bruni's time had declared themselves to be. The other great visible symbol of the glories of antiquity was, of course, classical architecture, to which the young Brunelleschi devoted such painstaking study in Rome before he emerged, toward 1420, as the father of Renaissance architecture. But by then the new image of man in statuary form had already been coined. The new style in painting, that of Masaccio, needed both these precedents in order to become a reality.

Interestingly enough, sculpture maintains its priority even in the field of art theory, another great achievement of the Early Renaissance. Its founder, Leone Battista Alberti, was a humanist who came to the practice of art through his interest in art theory. He wrote three famous treatises, on sculpture, painting, and architecture; and that on sculpture has now been clearly established as the earliest, composed about 1430.[8] It is entitled, characteristically, *De statua*, and deals almost entirely with the free-standing statue. Moreover, Alberti is at pains to explain the origin of sculpture, while the origin of painting has little interest for him. His thesis, briefly stated, is that sculpture came into existence when some of our distant ancestors whose imaginations were so inclined became aware that certain tree trunks and clumps of earth suggested natural shapes (he implies the shape of human bodies). By modifying the tree trunks and clumps of earth, these people endeavored to make the resemblance more perfect, and eventually they learned how to achieve such a resemblance even if their material did not suggest it. Alberti's etiological theory, amazingly modern in its psycho-

[6] For a detailed account, see Schlosser, *loc. cit.*

[7] The choice seems to be between Temperance and Chastity. The arguments have been summarized in Erwin Panofsky, *Studies in Iconology,* New York, 1939 and 1962, p. 157.

[8] See H. W. Janson, "The 'Image Made by Chance' in Renaissance Thought," in *De artibus opuscula XL: Essays in Honor of Erwin Panofsky,* New York, 1961, pp. 254 ff. (and above, pp. 61 f.).

logical implications, is not borrowed from the ancients.[9] It represents, I believe, an attempt to establish a solid basis for his definition of sculpture as free-standing statuary rather than as "applied sculpture." At the time he wrote down these thoughts, he probably had already become a friend of Donatello, the actual creator of the new image of man; and it may be no mere coincidence that the first lifesize free-standing nude statue created since the end of antiquity, Donatello's bronze *David* (fig. 2), dates from the same years in which Alberti was composing *De statua*.

Let us now trace the road from Giovanni Pisano's Gothic *"Venus"* to Donatello's bronze *David*. It so happens that we can do this in some detail, and with enough testimony from contemporary records to lend conviction to our reading of the visual evidence. Our starting point is a pair of marble figures of 1408, the earliest known works—and very likely the first lifesize statues—by Nanni di Banco and Donatello (figs. 3, 4). Today they are physically separated: Donatello's *David* is in the Museo Nazionale, Nanni's *Isaiah* in the Cathedral. But they were clearly meant to be companion pieces, dependent on each other in their complementary body curves. These curves are still Gothic, and this is hardly surprising, since both figures were intended to crown the buttresses on the north side of Florence Cathedral.[10] Such statues—an entire cycle of prophets and apostles—had been planned long before, as we can see from the mid-fourteenth-century representation of Florence Cathedral by Andrea da Firenze (fig. 5); and all of these statues have the quality of curvilinear ornaments sprouting from the rigidly vertical buttresses to which they are anchored (and of which they are, in a sense, the outgrowth). Neither the *Isaiah* nor the *David* stands on its own two feet. They stand, rather, on their drapery, in the Gothic fashion. These folds are firmly united with the base, and both artists still rely on the material strength of the marble, not the inner balance of the bodies, to make their statues stand upright. Yet we also feel hints of an allegiance to ancient sculpture in the thrust-out right hip of the *Isaiah* and in his youthfulness, so different from the traditional image of Old Testament prophets in medieval art (who are almost invariably old, and usually bearded). Since the *Isaiah* was commissioned some months before the *David*, Nanni made the basic decision in choosing this youthful type; Donatello had to follow his example, not only in the complementary body curve of his figure, but in representing David, too, as a youth. He might have shown him as a young king. Instead, he preferred the shepherd boy triumphing over Goliath. We know of only one earlier image of the victorious youthful David on a monumental scale, a fresco by Taddeo Gaddi of the 1330s (fig. 6), which provided the iconographic precedent for Donatello's statue. Artistically, however, Donatello owes nothing to Gaddi. His figure, less weighty and less aggressively plastic than Nanni's, reflects the lithe elegance of Ghiberti's style in both drapery and posture. We also note that the *David* has a more assured stance than the *Isaiah,* and that the mirror-image symmetry of the two is not consistent in some details. David's right hand, which ought to hold the prophet's

[9] Cf. Janson, *op. cit.*
[10] A detailed account of the two statues and the documents relating to them is given in H.W. Janson, *The Sculpture of Donatello*. Princeton, N.J., 1957, II, pp. 3 ff. (hereinafter referred to as Janson, *Donatello*).

124

scroll, actually held the strap of the sling (the strap was of metal and is now lost, but the drill holes for its attachment can still be seen). As I have tried to show elsewhere, the symmetry of the two statues was originally complete; such departures from it as we observe today were introduced when Donatello recarved parts of his figure in 1416.[11] As a matter of fact, we can still trace the "ghost" of the scroll on the bare patch of drapery over the right upper leg of the *David*. Similarly, the odd bits of drapery below the left hand originally extended as far downward as the drapery over the right leg of the *Isaiah*, largely obscuring the left leg of the *David*. Why these modifications? Before we can answer this question, we must ask another: Why weren't the two statues placed on their buttresses as intended? The *Isaiah* actually reached its destination, but the statue was taken down again after a short while because it was found too small to be effective at such a height; and the *David* was simply put in storage for the time being. This decision was made by the Opera del Duomo, the public body in charge of the cathedral workshop, and it was a revolutionary one, unthinkable before that time. Gothic cathedrals, north and south of the Alps, abound with statuary at all levels from the ground, but the scale of these figures is not governed by their distance from the beholder. After all, they were made *ad majorem gloriam dei*, so that their visibility to human eyes could not be a determining factor. Yet that is exactly what the decision of the cathedral workshop implies with respect to the *Isaiah* and the *David*. Two years later, the Opera commissioned Donatello to make another prophet for one of the buttresses, a *Joshua* of brick and plaster, which was intended as a temporary figure, to be replaced by a marble version if its size proved right.[12] That statue, demolished in the seventeenth century because of its poor condition, was no less than eighteen feet tall, or three times the height of the *David* of 1408! Its effect must have been dramatic—it came to be regarded as one of Donatello's chief claims to fame[13]—but the task of replacing it with a marble version and of completing the entire series on the same scale was overwhelming. We shall return to this problem shortly. For the moment, let us note that in Florence, about 1410, we find the first colossal statue since antiquity, inspired not by the classical precedents then known, such as the remains of the colossal statue of Constantine on view at the Lateran, but by a thoroughly modern consideration, the eye measure that demanded such a huge scale because of the distance of the statue from the beholder.[14]

[11] Janson, *Donatello*, pp. 3 ff.

[12] Giovanni Poggi, *Il Duomo di Firenze*, Berlin, 1909, nos. 414–21; and Janson, *Donatello*, pp. 4 f., 14 f., 226.

[13] The well-known physician and scholar Giovanni Chellini recorded in his *Libro debitori creditori e ricordanze* that on August 27, 1456, he had treated Donatello, "singulare et precipuo maestro" who had done the eighteen-foot-tall giant above one of the chapels of the cathedral. That Chellini should have chosen this figure from the multitude of Donatello's works in Florence suggests that he regarded it as the master's greatest feat. The *Libro* is preserved in the Saminiati Archives at the Università Bocconi in Milan; the passage cited above was published by Aldo de Maddalena in *Annales: Economies, Sociétés, Civilisations*, XIV, 1955, p. 743. Cf. H. W. Janson, "Giovanni Chellini's Libro . . .," in *Studien zur toskanischen Kunst: Festschrift Ludwig Heinrich Heydenreich*, Munich, 1964, pp. 131–38 (and above, pp. 107–16.

[14] The term "colossal" here implies not merely that a statue is significantly larger than lifesize but also that the beholder must experience it as gigantic (as the Florentines evidently did Donatello's *Joshua*). Erwin Panofsky's generalization (in *Renaissance and Renascences in Western Art*, Stockholm,

Meanwhile, however, a most interesting fate awaited the *David* of 1408. In 1416, the city government urgently requested its transfer from the storerooms of the Cathedral to the Palazzo Vecchio, the city hall, where it was placed against a wall in one of the great public rooms. We do not know who conceived this idea or what particular occasion prompted the request. An informed guess, however, would be that the suggestion came from one of the humanists prominent in the city government, such as Leonardo Bruni, and that the occasion was some anticipated visit by an important political figure whom the city fathers wanted to impress, symbolically, with that Florentine resolution in the face of external threats which had enabled the city to resist Giangaleazzo Visconti at the turn of the century. That such was indeed the new role of the *David* is evident from the inscription attached to the statue once it was installed in the Palazzo Vecchio: "To those who bravely fight for the fatherland, the gods will lend aid even against the most terrible foes." The plural, "gods," is especially piquant in relation to an Old Testament hero; but Donatello had endowed the head of his *David* with a victory wreath from the very start and thus given him something of the cast of a classical victor. Now that the statue had become a civic-patriotic symbol, the victory aspect had to be emphasized, and it was for that purpose that Donatello recarved some portions of it. He removed the prophet's scroll as superfluous and exposed the left leg to stress the assurance—indeed, the insouciance— of the hero's stance. One is almost tempted to describe this pose as a precocious instance of *sprezzatura*, that studied lack of conscious effort which played so important a part in Cinquecento art theory.[15]

In exposing the left leg of his *David*, Donatello superimposed his style of 1416 on a figure carved eight years before. It was these eight years that made all the difference; for in the meantime, he had re-created the free-standing statue. The occasion was again one of the great communal artistic campaigns, the filling

1960, pp. 28 f.) that "in a Gothic cathedral . . . none of the statues is appreciably over lifesized" because medieval architecture is "epanthropic" (i.e., scaled with reference to the absolute size of the human body, while ancient architecture is dimensioned in analogy to the relative proportions of the human figure), is valid in terms of the beholder's subjective experience if not of objective measurement. At Reims Cathedral, the jamb statues—the only ones within the beholder's direct physical range—are indeed not "appreciably over lifesized," but others, at greater distance from the ground, are over twelve feet tall. Yet these do not strike the beholder as gigantic unless he sees them at ground level, removed from their architectural context (one such figure, the *Ecclesia*, was thus displayed in the summer of 1962 in the Louvre, as part of an exhibition devoted to French cathedrals). Panofsky's claim thus remains true in principle. It certainly serves to dramatize the fundamental, and as yet insufficiently explored, fact that the medieval sculptor labored under limitations not imposed on the medieval painter. Perhaps we must look for the legitimate successors to the colossal statues of Roman emperors, not in medieval sculpture, but in painting; the Pantocrator mosaics in the domes and apses of Byzantine churches, and the standing saints of stained glass in the clerestory windows of Chartres and Bourges, are surely intended to be experienced as colossal images. In contrast, medieval sculptured figures more than twice lifesize would seem to occur only under very special circumstances that permitted a suspension of the ordinary rules. Such a case is the *St. Christopher*, more than eighteen feet tall, on the façade of the Cathedral of Gemona (Venezia Giulia), carved by Giovanni Griglio and dated 1331; St. Christopher, after all, was a giant, hence the statue was not really "over lifesized." Moreover, he was the special patron of travelers, who believed that a glance at an image of the saint would protect them from mishaps for the rest of that day, so that the huge size of the Gemona figure appears doubly justified (no passerby could miss it). The Roland statues in certain North German towns may owe their large size to similar considerations.

[15] On *sprezzatura*, see the references cited in note 1 above, and in Janson, *Donatello*, pp. 36, 40.

126

of the empty niches on the exterior of the church of the Florentine guilds, Or
San Michele. The plan had been conceived many years before, but nothing much
had been done about it until 1410, when the city government enjoined all the
guilds to provide statues for their niches or forfeit the right to do so. Here, too,
Nanni di Banco and Donatello worked side by side, and again a comparison of
their work is instructive. Nanni's earliest niche holds the *Quattro Coronati*, pa-
tron saints of the stonecarvers (fig. 7). Since these four martyrs, whose individual
identities are obscure, formed a unit, Nanni had to fill the niche with four stat-
ues rather than a single figure. Their style, especially that of the second, third,
and fourth figures from the left, is strikingly reminiscent of classical statues—far
more so than is the *Isaiah* of 1408. Still, Nanni could not yet free himself
of the medieval habit of thinking in terms of "applied" sculpture: each statue
is placed against a pilaster, so that it functions like the statues attached to col-
umns on the jambs of Gothic church portals. And, in order to stress the depen-
dence of the figures on their architectural setting, Nanni has taken a bite out
of the niche floor, so to speak, reducing it to a semicircular ledge (and thus pin-
ning the statues against the pilasters). About the same time, 1411–13, Dona-
tello filled the niche of the linen weavers' guild with a *St. Mark* (fig. 8).[16]
Here, at one stroke, we find ourselves in the Early Renaissance, although the
niche itself is no less Gothic than that of the *Quattro Coronati*. This statue no
longer depends on its setting for support; it could stand with perfect poise and
assurance anywhere. Unlike the earlier figures discussed here, it sustains itself on
its own two legs, displaying that complex internal body balance, or *contrapposto*,
familiar in classical statues (which in every other respect it resembles far less
than do the *Quattro Coronati*). It is the first statue since antiquity constructed
on a vertical line—the axis of gravity—linking the top of the head with the heel
of the "engaged leg" (the leg carrying the main weight of the body), and the
first statue since antiquity that can be said to have been conceived as a nude
body subsequently covered with clothing: the drapery now no longer plays its own
rhythmic game of curvilinear folds, but follows—and thus conveys to the
beholder—the body forms underneath. This, then, is the earliest post-medieval
image of man we know, an image of the human body conceived as a functional,
articulated mechanism sustained by muscular power. Donatello makes this clear,
apart from everything we have observed so far, by placing the statue on a cushion
(the earliest case of its kind), an elastic support that yields under the weight of
the body, with the engaged leg causing a deeper imprint than the free leg. What
device could be better calculated to remove the flavor of "stoniness" that still
clings to the two prophets of 1408 and the *Quattro Coronati*?

In his next niche statue, the *St. George* of ca. 1416, carved for the armorers'
guild (fig. 9),[17] Donatello took a further step. The figure now begins to pro-
trude beyond the front plane of the niche, because the engaged leg (the left one
in this instance) is placed forward, so as to endow the statue with a sense of
alertness, of readiness for combat, or *prontezza* (as the artist's contemporaries
called it).[18] With this physical tension goes a new psychological alertness, a

[16] For a detailed account, see Janson, *Donatello*. pp. 16–21.
[17] For a detailed account, see *ibid.*. pp. 23–32.
[18] The earliest use of the term in praise of the *St. George* is found in Filarete's *Trattato*

strained gaze from under knitted eyebrows—our first encounter with that calculated dominance over the beholder which, in the hands of Michelangelo, became the quality called *terribilità* (fig. 10). Had Donatello been called upon at this point to produce a free-standing statue for the center of a courtyard or public square, he would have been fully capable of doing so. Public art patronage, however, did not yet afford him this opportunity. The closest he could come to it was to transfer something of the vigor of his *St. George* to the *David* of 1408 in the Palazzo Vecchio.

Until now Donatello, unlike Nanni di Banco, had not introduced any overt references to classical sculpture into his work. The *contrapposto* of the *St. Mark* reflects the stance of an ancient statue in a very general way, but it was only the principle, not the external appearance, that the artist had taken over. This situation was to change dramatically from about 1416 onward: Nanni di Banco, in his last work, the *Assumption of the Virgin* above the Porta della Mandorla of Florence Cathedral (ca. 1418–21), relinquished his classicism and achieved an utterly novel dynamic style,[19] while Donatello during these years betrayed an ever keener interest in ancient sculpture. After the basic conquests of the *St. Mark* and the *St. George,* he needed the inspiration of ancient art in order to arrive at a full definition of his new image of man. His main project of the decade following the *St. George* was a series of prophet statues for the Campanile of Florence Cathedral, a commission he shared with some lesser sculptors who followed his lead.[20] The Gothic niches of the Campanile were far more confining than were those of Or San Michele. Since they were not only tall and narrow but high above the street level, Donatello could not repeat what he had done in the case of the *St. George,* i.e., let the statues protrude from their niches in order to establish their rapport with the beholder. The four figures I shall discuss show him groping for a solution and finding it, triumphantly, in the end. Although these statues are amply documented, their individual identities remain in doubt; apart from one instance, the records refer to them simply as "prophets" without giving their names. We can thus call the earliest of the series only "the beardless prophet" (figs. 11, 15). The statue shows the conventional medieval type—an old man in long garments displaying a large scroll—except for the head, which is its most impressive feature. This clean-shaven, thoroughly individualized face with its sharply cut lines clearly reflects a Republican Roman portrait such as the specimen in figure 16. A strange and incongruous union! Donatello must have felt this, for his second prophet (fig. 12) represents a different alternative: the bearded head is not portrait-like at all—it recalls the type of the *St. Mark*—but the whole concept of the figure no longer suggests the traditional prophet type. The scroll has almost disappeared; it is rolled up and held in the left hand, whose main function is to support the right arm, which reaches up to the chin. This gesture, here meant to convey deep meditation, is thoroughly familiar in classical art as a gesture of mourning. There are countless

dell'architettura. written 1451–64 (ed. Wolfgang von Oettingen, Vienna, 1890), p. 622. See Janson, *Donatello.* p. 24.

[19] Cf. H. W. Janson, *History of Art.* New York, 1962, p. 306; and "Nanni di Banco's *Assumption of the Virgin* on the Porta della Mandorla," *Studies in Western Art.* pp. 98 ff. (and above, pp. 96 f.).

[20] For a detailed account, see Janson, *Donatello.* pp. 33–41.

examples of it in funerary sculpture and in representations of captive barbarians.[21] Donatello interpreted it as expressing concentrated thought; his aim must have been to give this prophet the appearance of an ancient philosopher, and he has come astonishingly close to matching the spirit, if not the detail, of classical statues of philosophers (which, in all likelihood, were not known to him). The third prophet (figs. 13, 17), nicknamed Zuccone (bald-head), is an intensified synthesis of the previous two. The scroll is now tucked away beneath the right hand, the great mantle descending from the left shoulder strongly suggests a Roman toga, and the sleeveless undergarment is just as obviously of classical inspiration. In the fascinating ugliness of the head, we find qualities reflecting the two great periods of Roman portraiture, the Republic and the third century A.D. (compare figs. 16, 18). Here, then, is an integrated, and radical, reinterpretation of a Biblical prophet. But what thoughts was the *Zuccone* meant to evoke in the contemporary beholder's mind? Clearly he is not a philosopher like his meditative predecessor. Instead of being withdrawn into the world of his thoughts, he seems to address the crowd down below—note that his mouth is partly open. This impression is recorded in the Renaissance anecdote that Donatello, while at work on the *Zuccone,* used to shout at him, "Speak, speak, or the plague take you!" The statue thus suggests a figure from the world of antiquity, but a figure devoid of idealization or classical balance. What was the type that Donatello wanted to revive and to equate with the prophets of the Old Testament? There can be only one answer: the *Zuccone* is the Biblical counterpart of a Roman Republican *rhetor,* a kind of Cato preaching civic virtue, liberty, and patriotic fervor. He is, in short, the tangible embodiment of the historic vision of Leonardo Bruni and his circle, with its exaltation of the free cities of ancient Etruria, of Republican Rome, of the city Republic of Athens. In the guise of a religious subject, Donatello has created a monument to the political *ethos* of Florentine humanism. No wonder the statue won lasting popularity almost at once, a popularity reflected in the large number of anecdotes that came to cluster around it. The final member of the series, later dubbed Jeremiah,[22] repeats the same idea; because of the exposed right shoulder, he comes even closer to the appearance of an ancient hero, and his forensic spirit is equally pronounced (figs. 14, 19). The two figures were always linked in the popular imagination of Florence. Characteristically enough, that they represented Biblical prophets seems to have been forgotten soon after they were put on public display. From the early Cinquecento onward, the sources refer to them as portrait statues of Francesco Soderini and Giovanni di Barduccio Cherichini. This, of course, is nonsense, factually speaking, but the story fits the character of the statues very well indeed. It must have arisen during the brief interval between the expulsion of the Medici and their return, when the city was governed once more according to its traditional republican institutions, under a gonfaloniere who was a descen-

[21] Cf. Dorothy C. Shorr, "The Mourning Virgin and Saint John," *Art Bulletin,* XXII (1940), pp. 61 ff., for the use of the gesture in ancient art.

[22] In the cathedral records, Donatello's last Campanile prophet is called a Habakkuk; none of the documents or sources mentions a Jeremiah, although that name is inscribed on the scroll of the statue which, for reasons of style, seems the latest of the series. There is reason to believe that the inscription was added by a later hand, probably in 1464. See Janson, *Donatello,* p. 39.

dant of the Francesco Soderini supposedly portrayed by the *Zuccone* or the *Jeremiah*. Moreover, Francesco Soderini and Giovanni di Barduccio Cherichini both were conspicuously involved in the banishment of Cosimo de' Medici from Florence in 1433. Three-quarters of a century later, their anti-Medicean politics earned them the status of heroes of republican virtue, and identification with Donatello's statues.

Discounting the gigantic *Joshua* of ca. 1410 (which, apart from its size, probably did not look very different from the *David* of 1408), Donatello by the end of the third decade of the century had not yet produced a statue that was free-standing in fact as well as in spirit. This, it seems, became possible only about 1430. At that time the artist received two commissions for such works, one public and one private. The former, unfortunately, is lost: it was a figure of *Dovizia* (Wealth), a female personification analogous to Fortuna or Tyche, atop a column in the center of the Mercato Vecchio, the old market square of Florence. In the seventeenth century it was replaced by a Baroque statue, since it had been badly damaged by wind and weather (the material was either marble or limestone). We do not even have an adequate visual record of its appearance; it was placed too high above the ground for anybody to sketch it in detail, and general views of the old market give us only a vague suggestion of what the *Dovizia* looked like. From contemporary records, however, we know that the figure enjoyed great popularity, and that it must have been done about the same time as the Prato pulpit, or ca. 1430. The column form was, of course, the classic way of displaying a free-standing statue, a method well remembered in the Middle Ages, for there were countless representations of pagan idols on columns in medieval art.[23]

The other commission, from an unknown but surely private source, produced the famous bronze *David* (fig. 2), the first free-standing bronze statue since antiquity and the first lifesize free-standing nude.[24] Its pose contains reminiscences of the *David* of 1408, but the most daring—and still rather enigmatic—aspect of the figure is its nudity. This has been explained in a number of ways: iconographically, it could be the nudity of humility,[25] or the nudity of the "athlete of virtue," an Early Christian concept identifying the athletic contests of Greece with the quest for Christian virtue.[26] Be that as it may, the most striking fact about the bronze *David* is not that it is nude but that it is nude in the classical sense; Donatello here recaptures the full sensuous beauty of the nude body, the element that had been so conspicuously absent from Giovanni Pisano's copy of the Lysippean *Venus*. It is part of this classical quality of the bronze *David* that the body is more eloquent than the face, which by Donatello's standards seems oddly impersonal and emotionally neutral (fig. 20). It reminds us of the Antinous heads in Roman art (fig. 21). Perhaps it is no mere chance that Hadrian's favorite, too, was often represented nude, although Donatello probably did not know such statues. There is yet another likely motivation for the nudity of the bronze *David*: its date coincides with that of

[23] See Werner Haftmann, *Das italienische Säulenmonument*, Leipzig, 1939, pp. 139 ff., and Kauffmann, *op. cit.*, pp. 41 ff.

[24] For a detailed account, see Janson, *Donatello*, pp. 77–86.

[25] As maintained by Kauffmann, *op. cit.*, pp. 159 ff.

[26] See Colin Eisler, "The Athlete of Virtue," *De artibus opuscula XL: Essays in Honor of Erwin Panofsky*, New York, 1961, pp. 82–97.

Alberti's treatise *De statua*, which deals at length with the structure and proportions of the nude body.[27]

Much as one would like to think that Donatello actually saw (and adapted to his and Alberti's conception) an ancient lifesize statue of a nude youth, the classical inspiration of the bronze *David* probably reached Donatello by a less direct path, through small bronze statuettes of Etruscan or Roman manufacture. These, we know, were available and highly appreciated in the Early Renaissance, before excavations in Rome during the sixteenth century brought to light ancient marble figures of monumental scale in such quantity as to redefine the Renaissance appreciation of classical sculpture. The immediate ancestors of the bronze *David* in Donatello's oeuvre are the three bronze statuettes of nude angel putti which Donatello did in 1429 for the central tabernacle of the font in the Baptistery of Siena Cathedral.[28] The finest of them (fig. 22) was stolen and is now in the Berlin Museum. From the appearance of this enchanting little figure—its height is fourteen inches—we would never surmise that it was made as a piece of architectural sculpture in miniature. Completely free and balanced in movement, turning on its base with spontaneous *joie de vivre,* it has all the unselfconscious, natural state of nudity that is the heritage of the classical putto. There can be little doubt, even though we have no matching example, that its source of inspiration was an ancient small bronze. Here the nudity, being that of a child, is noncontroversial, while that of the *David* undoubtedly needed justification along the lines I suggested above.

We do not know the original location of the bronze *David.* The statue enters the known records only in the 1460s, when it stood in the courtyard of the Medici Palace in Florence. After the expulsion of the Medici in 1494, it came to share the fate of the marble *David;* transferred to the courtyard of the Palazzo Vecchio, it, too, became a public monument, a civic symbol like the earlier figure. At that time the bronze *David* so impressed the French ambassador that he requested in 1501 to have a replica made and offered to pay the cost of the casting.[29] It was in response to this wish that the young Michelangelo made his first *David,* a bronze statue, now lost, which followed the lines of Donatello's. We know its appearance from one of the master's drawings (fig. 23).

What had happened, meanwhile, to the project of those colossal statues for the buttresses of Florence Cathedral? After Donatello's provisional *Joshua* of ca. 1410, he and Brunelleschi were paid for some small-scale models,[30] but that is the last we hear of the matter for several decades. A marble block of the right size was eventually procured, but no Florentine sculptor of the later Quattrocento was capable of carving an eighteen-foot statue from it, and the attempt was abandoned once more. Finally, in 1501, the cathedral authorities turned this huge block over to Michelangelo, who made it into his famous marble *David* (fig. 10), the companion or replacement of Donatello's *Joshua* on the north side of

[27] A few years later, the publication of Alberti's treatise on painting evoked a similarly immediate response in the relief compositions of Donatello and Ghiberti; see Janson, *Donatello,* pp. 129 ff., and the literature cited there.

[28] For a detailed account, see *ibid.*, pp. 65–75.

[29] See *ibid.,* p. 78.

[30] See Poggi, *op. cit.,* no. 423.

the cathedral. Yet, like the *David* of 1408, Michelangelo's *David* never reached its intended location. It, too, was taken away from the cathedral authorities by municipal action and erected in front of the Palazzo Vecchio—the third, and most impressive, civic-patriotic symbol of the Florentine republic.[31] Artistically, too, it sums up the entire long development that began in 1408, combining the colossal size of the *Joshua*, the nudity of the bronze *David*, the conversion from a religious to a civic purpose first experienced by Donatello's marble *David* in 1416, and the *prontezza*, the aggressive alertness, of the *St. George*.

In closing, we must refer once more to Leonardo Bruni, the most important of the intellectual godfathers of the new image of man. It is an oddly symbolic circumstance that Bruni's tomb in S. Croce (fig. 24) should be the earliest complete formulation of a Renaissance funerary monument and the model for countless later ones. The new image of man that we saw emerging in the statues of Donatello also demanded a new image of man in relation to death, but the latter emerged only in 1445–50, while Donatello was absent from Florence.[32] Had he been available at the time of Bruni's death in March 1444, he surely would have been asked to carve the great humanist's tomb; under the circumstances, the commission fell to a younger and lesser master, Bernardo Rossellino, only recently established in Florence. His chief qualification, it seems, was that he had worked in Arezzo, Bruni's home town, and thus was well known to the Aretines, who took a great interest in the monument honoring their most distinguished native son.[33] The importance of the Bruni tomb rests less on the quality of its sculpture than on the concept of the entire design; and this we cannot credit to Rossellino alone. He must have had at least the advice of a far more important artist, charged by the Florentine authorities with the task of seeing to it that the Bruni tomb was fully worthy of the deceased. This man, it has been suggested, was Leone Battista Alberti, and I believe that this hypothesis, although generally disregarded nowadays, has a good deal of plausibility.[34] Bruni himself had no faith in funerary monuments. In his will, he requested burial in S. Croce under a plain marble slab. We know from a famous letter he wrote in 1429–30 to Poggio Bracciolini about the tomb of another humanist, Bartolommeo Aragazzi, that he thought nobody with faith in his own fame should want a conspicuous tomb, since deeds alone ensure everlasting memory.[35] Yet it is exactly the idea of fame that dominates the design of Bruni's tomb and distinguishes it from all its predecessors. Medieval tombs were based on the juxtaposition of time and eternity: man's fleeting presence on this earth as against the destiny of his immortal soul. The former aspect is conveyed by the effigy of the deceased on its bier and the inscription stating his name, his rank or office, and the date of his death; the latter aspect by religious imagery such as the Resurrection of Christ, the Man of Sorrows, Christ in Majesty, the Madonna, and so forth. Of all this, there is barely a hint in the Bruni tomb;

[31] See Janson, *Donatello*, pp. 198 f.

[32] Donatello worked in Padua from late 1443 to 1453. For the circumstances of his departure and return, see *ibid.*, pp. 147 ff., 188 f.

[33] For the most recent discussion of the Bruni tomb, and a critical summary of earlier literature, see John Pope-Hennessy, *Italian Renaissance Sculpture*, London and New York, 1958, pp. 297 f.

[34] Pope-Hennessy, *loc. cit.*, rejects it without argument.

[35] Cited, in part, by Pope-Hennessy, *op. cit.*, p. 41.

the only religious element is the Madonna with angels in the lunette, which certainly does not dominate the monument as a whole. There is, to be sure, the effigy, but Bruni looks as if he were peacefully slumbering, and various details record the state funeral specially arranged for Bruni. According to the description by Vespasiano da Bisticci,[36] it was a ceremony "in the manner of the ancients," with the corpse dressed in the same silk robe Bruni had worn in life, and with a copy of his famous *History of Florence* placed in his hands. (That is clearly what the heavy tome on the chest of the effigy is intended to represent.) The climax of the funeral was the crowning of Bruni's head with a laurel wreath; and that, too, is shown in the effigy. Moreover, the inscription, composed by Carlo Marsuppini, Bruni's successor as secretary of the Republic, conspicuously omits all the usual data: we learn from it neither the last name of the deceased nor his station in life and the date of his death. All it tells us is: "After Leonardo's passing, History grieves, Eloquence is silent, and the Muses, 'tis said, Greek and Latin alike, cannot restrain their tears." The tablet on which these words are inscribed is held by two winged genii, rather than by angels, and two more such genii, nude this time, support the family coat of arms above the lunette. It seems to have escaped attention that the framing architecture, which unites all these sculptural features so harmoniously, is also meant to convey a message to the beholder. Tombs in niches had been customary for a long time; what is new here is the shape of the niche and its framework—two classical pilasters supporting an equally classical entablature, above which rises a round arch. There is a specific source in ancient architecture for this design, and its choice is highly significant: the doorway of the Pantheon in Rome as seen from the interior of that structure (fig. 25). The motif was surely meant to be recognized by the contemporary beholder, for in the eyes of the Quattrocento the Pantheon was a uniquely famous monument combining the highest aspirations of both antiquity and Christianity. To Alberti, the Pantheon represented the perfect temple and thus also the perfect church. (In his treatise on architecture, completed by 1452, he strenuously argues in favor of church plans based on the circle and against the traditional basilican plan, declaring basilican churches imperfect because in antiquity the basilica had not been a religious type of building.[37]) The Pantheon, moreover, was dedicated to all the immortals—the gods of old as well as the martyrs of the Christian faith. (In the early Middle Ages, it was consecrated as S. Maria ad Martyres, and the remains of martyrs were gathered there by the wagonload from the catacombs.) The archway of the Bruni tomb thus suggests to the beholder that Bruni is about to enter the realm of immortality, in both the classical and the Christian sense. The moment of Bruni's passing from this earth, when his mortal remains are still aboveground but surrounded by the accouterments of undying fame—the book, the wreath, the inscription—has thus been eternalized by showing the effigy, as it were, on the threshold of the Pantheon. The medieval juxtaposition of time and eternity, of body and soul, has lost its force. That this concept (though not its artistic execution) originated with

[36] Summarized by Pope-Hennessy, *ibid.*, p. 297.

[37] For Alberti's theories, and their philosophical background, see Rudolf Wittkower, *Architectural Principles in the Age of Humanism*, rev. ed., London, 1962, *passim*.

Alberti seems likely not only in view of what he says about the Pantheon in his architectural treatise but also because the doorway of the Pantheon was one of his favorite motifs as a church architect: he used it for the main portal of S. Maria Novella in Florence and again, on an even grander scale, as the central feature of the façade of S. Andrea in Mantua. By introducing the motif into the design of tombs, Alberti accomplished two objectives at once. He gave the Renaissance tomb a new, unmedieval significance, and he raised it from the level of "church furniture" to that of monumental architecture, endowing it with a stability and grandeur fully expressive of its "fame-centered" meaning.

1. *Giovanni Pisano*, Virtue, *on Pulpit.*
1302–10.
Pisa, Cathedral

3

2. *Donatello*, David. *Bronze, ca. 1430–32.*
Florence, Museo Nazionale

3. *Nanni di Banco*, Isaiah. *1408.*
Florence, Cathedral

4. *Donatello*, David. *Marble, 1408
(modified 1416).
Florence, Museo Nazionale*

5

6

5. *Andrea da Firenze*, Florence Cathedral
(*detail of* The Church Militant and Triumphant).
Fresco, 1365–68.
Florence, S. Maria Novella, Spanish Chapel

6. *Taddeo Gaddi*, David. *Fresco, ca. 1330–35.*
Florence, S. Croce, Baroncelli Chapel

7. *Nanni di Banco*, Four Saints (Quattro Coronati). *ca. 1410–14. Florence, Or San Michele*

8. *Donatello, St. Mark. 1411–13.*
Florence, Or San Michele

9. *Donatello,* St. George. *ca. 1416.*
Florence, Museo Nazionale

10. *Michelangelo,* David. *1501–4.*
Florence, Accademia

11. *Donatello,* Beardless Prophet.
1416–18. Florence,
Museo dell'Opera del Duomo

12 13

12. Donatello, Bearded Prophet.
1418–20. Florence,
Museo dell'Opera del Duomo

13. Donatello, Prophet (Zuccone).
1423–25. Florence,
Museo dell'Opera del Duomo

14. Donatello, Prophet (Jeremiah).
1427–35. Florence,
Museo dell'Opera del Duomo

15. Donatello, Beardless Prophet
(detail). 1416-18. Florence,
Museo dell'Opera del Duomo

16

17

18

16. Roman Portrait. *Republican,*
ca. 50 B.C. *Museo Vaticano*

17. *Donatello,* Zuccone (*detail*).
1423–25. Florence,
Museo dell'Opera del Duomo

18. Portrait of "Trajanus Decius."
3rd century A.D.
Rome, Museo Capitolino

19. *Donatello,* Jeremiah (*detail*).
1427–35. Florence,
Museo dell'Opera del Duomo

20. *Donatello,* David (*detail*).
Bronze, ca. 1430–32.
Florence, Museo Nazionale

21. Head of Antinous.
Bronze, ca. 125 A.D.
Florence, Museo Archeologico

22

22. *Donatello,*
Angel with Tambourine.
Bronze, 1429.
Berlin, Staatliche Museen

23. *Michelangelo,* David.
Pen drawing, 1501. Paris,
Louvre, Cabinet des Dessins

24. *Bernardo Rossellino,*
Tomb of Leonardo Bruni.
ca. 1445–50. Florence, S. Croce

23

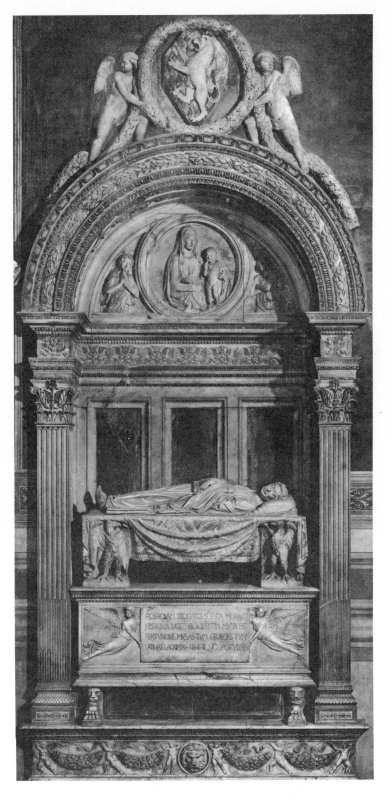

25. *Interior Doorway of the Pantheon, Rome. ca. 115–25* A.D.

STUDY 8

*Originality as
a Ground
for Judgment
of Excellence*

"Originality as a Ground for Judgment of Excellence,"
Art and Philosophy: A Symposium, ed. Sidney Hook,
New York University Press, 1966, pp. 24-31

What I have to say is not really a comment on Professor Schapiro's paper. If I were to follow my instructions literally and confine my remarks to "Perfection, Coherence, and Unity of Form and Content," I could do so in a single word: Amen. That these concepts are of little use as criteria of value Dr. Schapiro has, I think, made abundantly clear. I venture to guess that he would arrive at the same conclusion regarding similar terms, such as "balance" or "proportion." He does not commit himself, however, on what he regards as valid criteria of value. Surely he must have some; along with the rest of us, he constantly makes value judgments about works of art, judgments that are understood and widely shared by his colleagues. I hope that Dr. Schapiro will consent to tell something of the criteria governing his judgments. Meanwhile, I should like to venture a tentative sally in the same direction.

Let me begin by affirming that the problem itself is a valid one. Since it is quite impossible to act as an art critic or art historian without judging artistic value, we ought to be able to formulate the criteria of such judgments. I propose, however, to limit myself to the visual arts; not only because I know more about them than I do about music, literature, and the dance, but also because I am not sure that there can be criteria of value which hold true for *all* the arts. The roof concept of "art" as that which unites music, literature, painting, architecture, etc., only dates from the late eighteenth century, as Paul Kristeller proved in a well-known article in the *Journal of the History of Ideas* some years ago; perhaps the concept has done more harm than good. Be that as it may, as an art historian I am embarrassed by the need to generalize. If I stay within the area I know best, I may be able to avoid at least the more obvious empirical objections to my theorizing.

In his paper, Dr. Schapiro has emphasized that our perception of works of art is always selective, limited, explorative, and conditioned by previous experience, our own as well as others'. Such complexity of response suggests that we may be chasing a will-o'-the-wisp if we assume a single "aesthetic value" as the common focus of all this activity. Perhaps there is instead a multiplicity of aesthetic values, possibly unrelated, or related in ways still unknown. What are some of these values? Let us look, not at a hypothetical situation, but at an everyday one: the art historian confronted with an object he has never seen before, an object presented to him as a work of art. What questions will he ask of this object? How will he evaluate it? That depends on the circumstances of the confrontation, which may cast our art historian in more than one role, as it were. Suppose,

then, that he is an acknowledged expert on Rembrandt, and a Dutch seventeenth-century drawing is brought to him that has been attributed to Rembrandt: his role, in that event, is narrow and specific—he is the connoisseur who must decide whether the attribution is correct. Having spent the better part of his career scrutinizing the work of Rembrandt, our art historian has developed a special sensitivity, an "eye" as we say, comparable to the "nose" of the wine expert who need only sniff the cork in order to diagnose the vintage and place of origin of a given bottle. Such authenticating, on the basis of long experience, need not involve a value judgment at all; a drawing *not* by Rembrandt is not necessarily less good than a drawing by Rembrandt. To the outsider, the process of scrutiny here—involving, probably, comparison with other, "safe" drawings by Rembrandt and by various followers and disciples—may look very much like the process by which the handwriting expert authenticates a signature. Yet the two procedures are not as analogous as they may appear. While I am not prepared to assert that the handwriting expert's work involves no value judgments whatever, that of our Rembrandt expert involves a whole succession of them, though none of them need be articulated. He must decide, first of all, "Is this a work of art?" It could, after all, be a facsimile reproduction; or it may be a hand-drawn copy of an authentic Rembrandt made by a student for practice; or a forgery. Of these possibilities, only the first can be dealt with on technical grounds alone; all it takes to spot a facsimile reproduction is a powerful magnifying glass and an intimate knowledge of printing techniques. Once our expert has satisfied himself that what he has before him is not a facsimile, he can no longer proceed without value judgments. From here on, he must be guided by what the connoisseur calls "a sense of quality," an elusive yet palpable thing which more often than not will lead him and his fellow experts to the same conclusion. This conclusion is, of course, not always verifiable, but it has in the past been verifiable often enough to confound the scoffing layman. It has happened, for instance, that an expert diagnosed a drawing as a copy after an unknown work by a certain artist, and a few years later the hypothetical original turned up. The "sense of quality," then, is real enough; but how does it involve value judgments? It rests, I think, on a whole series of unspoken assumptions about the nature of works of art and the values they embody. What is on the expert's mind when he asks, "Is this a copy? A forgery? A drawing by a Rembrandt imitator? A work of the master's own hand?" is not the difference in monetary value between these classifications; that's merely the outward reflection of the underlying aesthetic values he believes in. The expert asks these questions, rather, because the answer will determine the rank of our particular drawing in a hierarchy of artistic qualities: a forgery ranks lowest—so long as we see it "merely" as a forgery, it is assumed to have no aesthetic value at all. (Paradoxically, however, this condition is a temporary one; the "life expectancy" of a forgery—that is, its capacity to deceive—rarely exceeds one generation. A forgery older than that no longer looks like a forgery to us and thereby achieves a limited aesthetic value in its own right.) Next in rank are copies: here the assumption is that no copy can capture the essence of the original, hence the more faithful the copy, the lower its aesthetic value. "Creative" copies, in contrast, such as Rembrandt's drawings after Indian miniatures or Dürer's copies after Mantegna, are accorded equal rank with other drawings by these masters, since they were not intended as substitutes or reproductions.

Instead, we think of them as "interpretations"; Rembrandt's response to an Indian miniature, we believe, is in essence no different from his response to a view of nature, both having in common that unique quality which makes it so important to differentiate between an authentic Rembrandt drawing and one that merely approximates his style.

'Twas not ever thus. The Romans, for instance, saw little difference between original and copy. If we share Plato's view that a statue is no more than the imperfect material embodiment of the shapes that existed in the mind of its creator, it is indeed difficult to understand the modern cult of the original. Academic doctrine perpetuated this blurring of the distinction between original and copy far into the nineteenth century, as the collections of dusty plaster casts in the basements of art schools used to attest (they have all been smashed by now, I suspect). Yet our present-day faith in the uniqueness of the original work of art as a physical object also has deep roots in the past. It began with the cult of genius in the Renaissance, exemplified by the worshipful awe in which Leonardo, Michelangelo, and Raphael were held by their contemporaries and the bestowal upon them of the epithet "divine." It was only in the sixteenth century that people began to speak of painters and sculptors as "creators"—until then they had simply been "makers." And with this began the cult of the *non finito,* the imputing of aesthetic value to unfinished works, fragments, sketches, etc.; drawings, for instance, hitherto discarded when their usefulness as intermediate stages in the working process was at an end, were now eagerly collected, and have been ever since. One is tempted to think of the cult of the fragmentary work of art as the secularized counterpart of the medieval cult of holy relics. The merest scrap of paper touched by Michelangelo conveyed "the breath of genius," and thus achieved a potency equivalent to that of a splinter from the True Cross.

It will be clear from the above that the *summum bonum* of our Rembrandt expert scrutinizing that drawing is *originality.* His efforts are bent on finding out whether or not the drawing before him is "an original Rembrandt" and not something that derives from Rembrandt (e.g., a copy, a product of the Rembrandt school, a forgery). An original is assumed to have a uniqueness, or individuality, that places it at the top of the aesthetic hierarchy. And Rembrandt is valued as a great master because his work has a greater measure of uniqueness, or individuality, than that of his Dutch fellow artists. We might say with George Orwell, "All works of art are unique, but some are more unique than others."

Originality as a measure of artistic value has its pitfalls—to which I shall come presently—but it does seem a bit more manageable than perfection, coherence, unity of form and content, balance, and similar criteria. While we cannot measure it or fully know it, we have methods of estimating it. And in order to do this, we must compare the work of art in question with other works of art in every possible way, rather than contemplate it in isolation as we do when we try to judge its perfection, coherence, balance, etc. Originality, after all, is by definition relative. We can grasp it only by matching the work in question against those done before, in an effort to determine how far, and in what respects, it departs from them. We can grant, presumably, that to duplicate what already exists is easier than to make something that is novel in some sense. It is also less interesting. But to achieve something that is significantly new entails an effort of the imagination, a willingness to take risks and to overcome the resis-

tance of established practices and convictions, that few of us can manage. Hence we marvel at this minority of creative individuals, and attribute their accomplishments not to their own endeavors but to some outside influence, such as divine favor or "genius." (Originally, genius meant a spirit that seizes a person and makes him act as if in a frenzy, or "beside himself." Even today we can speak of an artist as being "in the grip of his genius," or as a "mad genius.")

We still have to define—if we can—how originality in art differs from originality in science. From what we know of the actual process of creation, it seems to me, we may conclude that the difference lies not in the process—creation in both art and science demands the peculiar psychological impulse summed up in the term "inspiration"—but in the goal. Science is perfectible, progressive; its tasks are thus defined by the state of its development in a given field at a particular time. Its inner dynamic is such that, broadly speaking, we can say that once a discovery becomes possible it also becomes inevitable. Scientific discoveries have indeed been made independently and simultaneously by workers who had nothing in common except an up-to-date knowledge of their discipline. It is probably for this reason that creative scientists rarely achieve enduring fame: their discoveries soon become outmoded, overtaken by more recent discoveries. Artistic achievements, of course, do not become obsolete. Which is not to say that there is no inner dynamic in the history of art. But an attempt to formulate any sort of "principles of growth" here would take far more time than I have at my disposal. Perhaps eventually we shall learn to interpret the history of art, along with the history of everything else, as a special case within a general theory of evolution.

Let us return again to the concept of originality as a measure of aesthetic value. It implies, I think, that no meaningful statement is possible about the aesthetic value of a given work of art except by comparison—overt or not—with other works. I believe this is true. All of us, experts and laymen alike, approach works of art with certain expectations based on other works of art that we happen to be familiar with. The "man who knows nothing about art" does not exist; to be a member of any human community means, among other things, to know something—however little—about art. Acceptance of originality as a measure of aesthetic value also implies that no judgment based on it can ever be final, since we can never, in a given instance, hope to carry out all possible comparisons. Our Rembrandt expert (whom we left some time ago scrutinizing a supposed Rembrandt drawing) is in rather a good position in this respect, because of the extraordinary wealth of related material available to him. But let us suppose we confront him instead with a piece of wood carving from Central Africa. How will he be able to evaluate *that*? Presumably his general training as an art historian will enable him to place it in the proper context ("Primitive sculpture, Central Africa"), but how is he to know how good a piece it is? A hundred years ago, the problem would not have troubled him; he would have admitted, grudgingly, that the object was a work of art of some sort, but he would have responded to it as an anthropological exhibit rather than as an object of possible aesthetic value. Today, thanks to what has happened in Western art since 1900, he does respond to the beauty of primitive sculpture, and hence is concerned with the rank of the wood carving in question. By immersing himself in the specialized scholarly literature and assembling related objects from the same tribe, our art historian will be able to gain some idea of the merits of the piece in question,

yet he is likely to feel far less certain of his conclusions than in the case of the Rembrandt drawing. For one thing, the related material is apt to be much less plentiful; and he will find that primitive art is extraordinarily conservative, so that the "margin of originality" may be very narrow indeed. There is, in addition, a more basic difficulty here. In Western art, we assume that the most original artists were also the most influential, so that we often can measure the degree of originality of a work of art by tracing its impact upon the art of its time. We are therefore encouraged to believe that we can measure the quality of a Rembrandt drawing by seventeenth-century standards. But how are we to acquire the aesthetic standards of the tribe that produced our wood carving? Are we not bound to see that object with Western eyes, measuring it against its relatives as we would measure a work of Western modern art against *its* relatives? Every student of primitive art will readily admit how uncertain aesthetic judgments are in his area. Even so, I do not believe that these difficulties invalidate the "originality theory of aesthetic value." Over the past fifty years, we have certainly learned a great deal about primitive art; we find that we now can to some extent differentiate the mediocre from the outstanding, and we have achieved this with basically the same tools we have developed for dealing critically with works of art in the Western tradition.

STUDY 9

The Equestrian Monument from Cangrande della Scala to Peter the Great

"The Equestrian Monument from Cangrande della Scala to Peter the Great,"
Aspects of the Renaissance: A Symposium, ed. Archibald Lewis,
University of Texas Press, 1967, pp. 73-85

Those who deny that the Renaissance—as distinguished from the various earlier classical revivals—deserves to be viewed as a major period intervening between the Middle Ages and modern times like to observe that each historic discipline provides its own unique definition of the Renaissance. The charge is not unfounded. I have heard historians of science place the beginning of the Renaissance as late as 1550, and literary historians, as early as 1300—an alarming discrepancy, although not, to my way of thinking, a valid argument against the concept of the Renaissance. Among art historians the anti-Renaissance trend has probably been weaker than in any other field; it attracted a number of scholars in the 1920s and 1930s, when, under the influence of modern Expressionism, the positive aesthetic qualities of medieval art were being rediscovered, but it has found no conspicuous defenders in recent years. Nevertheless, we disagree among ourselves as to the meaning and the chronological limits of the Renaissance. Where and when did it start? Did it really begin in Italy, or more or less simultaneously throughout Western Europe? How long did it last? What phases can we distinguish within the Renaissance, north and south of the Alps? Let me describe the possible answers to these questions in terms of two extremes: the exclusive and the inclusive views. The "exclusivists" tend to narrow the application of the term; some would confine the Renaissance to a single hundred years' span, ca. 1420–1520, and to Italian art alone. To them, Italian fourteenth-century art and northern fifteenth-century art are "Late Gothic," while the art of the years 1520 to 1620 throughout Europe is "Mannerist," followed by the Baroque (ca. 1620–1750). The modern era, we all agree, began with the generation that made the French Revolution. The "inclusivist" view is about as follows, in its broadest form: the Renaissance is a "megaperiod," like the Middle Ages or classical antiquity, beginning ca. 1300 and ending ca. 1750, with the following subdivisions:

Fourteenth century: "Proto-Renaissance," confined to Italy
Fifteenth century: "Early Renaissance" in Italy (and according to some, in the north as well)
Early sixteenth century: "High Renaissance" in north and south
Later sixteenth century: "Mannerism" in north and south
Seventeenth and early eighteenth century: "Baroque" in north and south.

I myself am an "inclusivist," although with some reservations. And I have cho-

sen the equestrian monument as my subject because it demonstrates, I believe, the fundamental unity of the Renaissance as well as the relationship of its various phases. Since equestrian monuments are inevitably public enterprises, they also serve to demonstrate the close involvement of the history of art with other areas of historic study; yet their clearly defined character as a formal type forces us to pay due regard to the evolution of this type in terms of style.

In order to define the equestrian monument—its power as a symbol of greatness—I must begin with a thumbnail sketch of its history before the Renaissance. The horse entered Western civilization about the middle of the second millennium before Christ, but the equestrian monument did not appear until a thousand years later. To the ancient Egyptians and Mesopotamians, horseback riding was not symbolic of high status, perhaps because they associated it with the nomadic enemies who had brought the horse to the Near East from Asia. We find few representations of riders in Egyptian art, and when we do find them they are incidental, such as that of a boy on a horse on one of the reliefs from the tomb of Horemheb (fig. 1). In Mesopotamia mounted hunters in pursuit of swift game are represented. But the Pharaoh and the kings of Assyria, Babylonia, and Persia appear standing in horse-drawn chariots. The ruler in his chariot, rather than on horseback, conveyed the sense of all-conquering majesty. And this remained so even after mounted troops had developed into an important branch of the military forces. We see here, I think, a reflection of the peculiar Near Eastern conception of kingship, which lifted the ruler so high above all other men that horseback riding—a physically strenuous and, without benefit of stirrups, somewhat precarious activity—must have seemed incompatible with royal dignity.

The Greeks endowed riding with the aura of heroism that still clings to it. The earliest equestrian statues (preserved only in fragments) date from the sixth century B.C. and probably represented the victors of horse races—votive offerings to the god who had brought victory and at the same time memorials to the victor. Soon thereafter we find Greek tomb stelae showing the deceased on horseback conquering a fallen enemy (fig. 2), a symbolic visual tribute to his bravery. The motif was to persist, under Roman auspices, until the very end of the classical era, almost a thousand years later. Alexander the Great, however much he may have borrowed from Oriental ideas of divine kingship, remained a Greek hero. In the famous Alexander mosaic, which reflects a painting of the early third century B.C., we see him, on horseback, discomfiting Darius in his chariot (fig. 3). Hellenistic rulers must have been the first to adopt the equestrian monument as a symbol of majesty, but none of these statues has survived. As for the Romans, the equestrian statue became established during the later days of the Republic as the prerogative of the *eques,* the aristocrat, as evidenced by the equestrian figures of the Balbus family found at Pompeii (fig. 4). During the Empire, however, the privilege of being so represented was restricted to the emperor alone, as the most monumental and awe-inspiring visible expression of his authority. And the material of choice was the finest and most enduring—gilt bronze. The famous equestrian statue of Marcus Aurelius on the Capitol in Rome is the only surviving specimen today (fig. 5). In the later days of the Empire hundreds similar to it must have been scattered throughout the Roman realm. They were destroyed by invading barbarians not only, or not mainly, for the value of the

metal, but also for the imperial magic that clung to them. With one possible exception (a statue in Limoges about which we know very little), equestrian monuments survived into the Middle Ages only on ancient imperial soil—in Italy and Byzantium. The most famous of these in the East Christian world, and the only one of which we have any kind of pictorial record, was that of Justinian outside the Church of Hagia Sophia. It was toppled by the Turks soon after 1453, and the remains destroyed in the sixteenth century. In Italy the *Marcus Aurelius* survived because it had been rechristened "Constantine" and erected on the Lateran, thus conveying the relationship of Papacy and Empire. Florence had an equestrian bronze, locally known as "Mars" but surely also an emperor's image, which was thought to be linked with the legendary ancient origins of the city. It fell victim to a great flood of the Arno River in 1333, as it stood on a bridge that collapsed under the onslaught of the waters. At least two late Roman examples, one representing Theodoric, were in Ravenna. The *Theodoric* was abducted by Charlemagne after his coronation as Western Roman emperor, and erected between the imperial chapel and the palace at Aachen, obviously as a visible embodiment of the renewed Empire. With the division of Charlemagne's realm after his death the statue disappeared and Aachen lost its claim as the "new Rome." The other equestrian monument in late classical Ravenna (fig. 6) was transported to Pavia, perhaps again by Charlemagne. It, too, was thought to represent Theodoric and thus received a place of honor in the forecourt of the palace of the Lombard kings. Later, it was re-erected in front of the Cathedral and became a symbol of municipal sovereignty, appearing even on the city seal. When Pavia was conquered—in 1315 by the Milanese and again in 1527—the statue, then known as the *Regisole,* was removed to humiliate the city, but both times it eventually was returned. Its final destruction dates from 1796; it fell victim to the local revolutionaries, who followed the French example in their iconoclastic zeal. To them, the statue was simply a symbol of tyranny. From visual records of the *Regisole,* we know that the statue stood atop a tall column, like that of Justinian in Constantinople. The emperor, his right hand raised in the ceremonial gesture associated with the imperial *adlocutio* or *adventus,* appeared in military garb, including pants; he sat on a regular saddle, not merely a saddlecloth as does the *Marcus Aurelius,* and had his feet in stirrups (which had just been adopted). The rider, then, was of far less classical appearance than the *Marcus Aurelius,* a fact which helps to explain why the monument had only a limited influence on the equestrian statues of the Renaissance.

The Middle Ages, as we have seen, retained an awareness of the ancient Roman meaning of these imperial images. And it was for that reason, apparently, that they produced no equestrian monuments of their own. There is a gap of about a thousand years between the last of the Roman examples and the first bronze equestrian monument since late antiquity. That pioneer achievement, contrary to general belief, was not Donatello's *Gattamelata* of 1448–50, but a statue of Nicolò d'Este in Ferrara, commissioned in 1441 of two Florentine sculptors, Niccolò Baroncelli and Antonio de Cristoforo. It must have been a work of little artistic distinction, since it never became famous. In fact, we have no visual record of its appearance. Like the *Regisole*, it was destroyed by the Italian revolutionaries of 1796. We do, however, know where it stood—on a sort of extended bracket projecting from the ducal palace and supported by a column (fig. 7).

It thus was not a truly free-standing monument. While it is surely significant that the Este family should have dared to assert their own legitimacy and authority by erecting this rival to the *Marcus Aurelius* and the *Regisole,* it is equally characteristic that they did not yet dare to detach the statue from its architectural background. In that respect, the Nicolò d'Este monument was still medieval. It recalls the equestrian monuments of stone done in Gothic times, such as the famous *Bamberg Rider* (whom Otto von Simson has tried to identify as Emperor Frederick II) or the posthumous monument of Otto I in Magdeburg. These, and their analogues elsewhere, are all encased in an architectural framework, or attached to it, and thus do not rival the ancient imperial statues in position or material. To erect the equestrian statue of a modern sovereign, whether in stone or in bronze, on a tall, columnar pedestal of its own appears to have been unthinkable to the Middle Ages. The short life of Charlemagne's *Theodoric* in Aachen only reinforces this conclusion.

Donatello's *Gattamelata* (figs. 8, 9), as you all know, does away with these inhibitions. It stands on a tall, columnlike pedestal, and it is of bronze (though not gilded). And what makes it even more astonishing is that it represents not a sovereign but a mere condottiere, the captain of the land force of the Venetian Republic. The Venetian state, which must have pondered deeply before permitting its erection, had to suffer many a jibe in later years about the "imperial arrogance" of the monument, so unsuited to a republic. How did all this become possible?

The prehistory of the *Gattamelata* is long and complicated. I can here offer only its highlights. The beginning of the tradition from which it sprang leads us back to the Florence of ca. 1300, but not to the equestrian "Mars" on the Arno bridge. Instead, we must enter the second cloister of the Church of the SS. Annunziata, where we find an inconspicuous but surprising object: the tomb of a certain Guglielmus, who died, so the inscription tells us, in 1289, in the battle of Campaldino (fig. 10). It is the earliest appearance of a horseman on a medieval tomb, and, even more astonishingly, Guglielmus is not merely shown on horseback in order to indicate his status as an *eques,* a knight, but charging into battle with drawn sword, like the military heroes on Greek stelae or certain Roman tombstones. This completely contradicts what Dr. Erwin Panofsky has so well defined as the "prospective" character of medieval tombs, that is, their exclusive concern with the afterlife of the deceased rather than the commemoration of his deeds on earth. The only exception to this rule, before the tomb of Guglielmus, are certain English tomb slabs of knights showing the deceased in a kind of death agony. These, however, very probably represent a special privilege restricted to those who died battling the Infidels in the Holy Land and thus earned the honor of being eternalized in the act of dying for the Faith. In the case of Guglielmus, this religious aura is missing entirely; no religious issues were at stake in the battle in which he died, although for the Florentines it was a decisive engagement in which Dante also fought. Apparently, then, this is a true instance of secularization for political reasons. In a similar way, Dante introduced living characters into the *Divine Comedy,* thus suffusing it at times with the flavor of the politics of his own day, and certain Italian representations of the Last Judgment in the fourteenth century show specific, labeled individuals of recent memory in the jaws of Hell. Such intrusion of present-day, local con-

cerns into sacred imagery—or into the realm of tombs—is a uniquely Italian venture at that time, indicative of the "proto-Renaissance."

Since there are antecedents in classical art for equestrian images on tombs, we might expect our Guglielmus to be modeled on a Roman tombstone, but such is obviously not the case. Instead, the design derives from a northern source—the seals of knights in Gothic France and England, which show the same charging figure on horseback, simply as an identification of status, without reference to any specific battle and without commemorative purpose (fig. 11). They are, of course, purely secular works, a fact that makes their influence on the Guglielmus tomb particularly significant. Were such tombs built in the north, too, by any chance? We cannot be absolutely sure that they were not, but it seems highly unlikely, since not a single example is known to us. Equestrian images of the deceased appear north of the Alps only in the sixteenth century, under obvious Italian influence, and even then rarely. Among them was one—now destroyed, but known from a seventeenth-century engraving—of Nicolas du Châtelet, who died in 1562, and who was shown in the same charging pose as Guglielmus (fig. 12); apparently this was another, quite independent, transfer of the pose from a seal, now transposed into a free-standing statue.

But let us return to Italy. The Guglielmus tomb, it seems, started a tradition of honoring military heroes, especially condottieri, with tombs incorporating equestrian statues. At first, these statues were of impermanent materials such as wood; their primary purpose may have been to be carried in the funeral cortege. In any event, documentary notices of several of these from the later fourteenth and the early fifteenth century exist in Florence and Siena. Sometimes, the equestrian figures were only painted above the tomb. Paolo Uccello's famous *John Hawkwood* (or Giovanni Acuto, as he was known in Italy) of 1436 is a replacement of an earlier fresco of the same subject, done at the very beginning of the century in Gothic style (fig. 13). Uccello, perhaps under the guidance of his friend Donatello, transformed this earlier image into a strikingly Early Renaissance conception. This manner of honoring condottieri spread from central Italy to northern Italy, and produced the only two surviving examples of such wooden equestrian tomb statues, neither very impressive artistically: that of Paolo Savelli, soon after 1405, in the Frari, Venice (fig. 14), and that of Bartolommeo Colleoni in Bergamo seventy years later (fig. 15). This tradition eventually migrated to France in the sixteenth century and gave rise to the French equestrian tomb statues mentioned before.

Meanwhile, however, and very soon after the Guglielmus tomb, a far bolder tradition of equestrian tomb statues arose in northern Italy: that of the Scaligeri, the lords of Verona. It may not be entirely coincidental that the Scaligeri were thoroughgoing Ghibellines, and that Cangrande, the most famous of them, became the host and protector of Dante in exile. Here the equestrian image clearly serves as a symbol of sovereignty, in conscious recall of the imperial significance of such images. The earliest, on the sarcophagus of Alberto I della Scala, about 1300, still is a modest relief, of about the same size as the image of Guglielmus, but the horse now has the walking gait of equestrian statues (fig. 16). Alberto is flanked by saints, to suggest divine sanction of his rule. Cangrande himself, however, thirty years later, eternalized himself in a lifesize stone figure proudly perched on a tall base in the shape of a truncated pyramid above his tomb (fig.

17). The monument has by now outgrown the interior of any church and is placed out of doors within the sacred precinct of S. Maria Antica. Here we have indeed a free-standing equestrian statue, although not yet in the classical—or Renaissance—sense. Not only are the statue and the base made of the same material, but the motionless, arched form of the horse seems to grow, like a Gothic pinnacle, from the towering base that supports and at the same time dwarfs it. Cangrande himself radiates the brash self-confidence of the victorious captain; he appears in full armor, sword in hand, and with a broad grin on his face—the same grin that creases his features on the effigy of the tomb proper. (We must be careful not to interpret this facial expression psychologically; it is meant, like the "archaic smile" of Greek statues, to convey a generalized "aliveness"—what an incongruous notion in the solemn context of a tomb!) On the sarcophagus appear a number of biographical scenes showing the military exploits of Cangrande, another startling departure from the "prospective" character of medieval tombs. Unlike the battling Guglielmus, these reliefs are not linked to the circumstances of the Cangrande's death but cover a considerable portion of his earthly life.

If we look for the antecedents of this monument, we can cite the imperial symbolism of the equestrian statue only on the plane of ideology. In terms of its shape, the *Cangrande* statue recalls, rather, another similar medieval monument, that of Henry the Lion in Brunswick, erected more than 150 years earlier (fig. 18). It shows an impressive bronze lion, the symbol of the arch-Guelph, on a tall base surprisingly similar in shape to that of the *Cangrande* statue. And the intention of the monument is, of course, to proclaim an authority equal to that of the emperor himself. Now Cangrande was a Ghibelline, who held Verona as an imperial fief, yet he fancied himself the equal of any ruler on earth. Hence this "imperial" equestrian statue, and hence also his chosen title, which originally meant not "the great dog" but "the great Khan," that is, the rank of that mysterious "emperor of the East" in the unknown reaches of Asia about whom Cangrande may have heard from Marco Polo or a similar source. He even had his body wrapped in a Chinese silk gown, as we learned some decades ago when the sarcophagus was opened. The imperial flavor of the monument is greatly enhanced by the tall pyramidal base, which must have carried a symbolic message of its own. Such structures are extremely rare in medieval art—in fact, the Brunswick *Lion* is the only other example I have been able to find. Yet we have testimony linking this shape with imperial grandeur, and, more specifically, imperial tombs. According to a medieval chronicler, the equestrian *Theodoric* which Charlemagne took to Aachen had stood in Ravenna on top of a truncated pyramid; and in medieval Rome the huge obelisk behind St. Peter's (a shape not so very different from that of a slender pyramid) was regarded as the "tomb of Caesar." One of these traditions, or perhaps all of them, entered into the *Cangrande* monument.

Its successors in the later fourteenth century were numerous, but none rivaled its boldness. The later members of the Della Scala family continued to build outdoor tombs topped by equestrian statues, while the Visconti of Milan, who took over the type, moved it inside the church, behind the altar (as in the case of the tomb of Bernabò Visconti, now in the Castello Sforzesco; fig. 19).

The fifteenth century in Italy thus inherited two separate types of equestrian monument from the fourteenth: free-standing stone statues for sovereigns, and

wall tombs with wooden equestrian figures on sarcophagi for condottieri (cf. the *Savelli* monument in Venice and its lost antecedents in Florence and Siena). These two traditions now began to merge, as we can see from the tomb of Cortesia Sarego, about 1432–35, in S. Anastasia, Verona (fig. 20). As a wall tomb, it follows the condottieri type, reflecting the station of the deceased; but the equestrian figure is now of stone, and a strong classical influence is beginning to make itself felt. The gait of the horse, with one front leg raised high, recalls the *Regisole* of Pavia; the rider is now bareheaded, another classical feature, and wears pseudoclassical rather than contemporary armor. And pseudoclassical costume is also worn by the two soldiers who withdraw the curtains to reveal the equestrian image to the beholder. Here, then, we are approaching many of the qualities that distinguish the *Gattamelata* monument. In fact, there is reason to believe that originally Donatello was commissioned to do a monument rather like that of Cortesia Sarego—a wall tomb inside the Church of St. Anthony in Padua. I suspect that it was the artist himself who "escalated" the job, substituting a free-standing bronze statue in the cemetery next to the church but no longer containing the tomb. That would explain why the tomb of Gattamelata, a modest affair inside the church, was made only *after* the equestrian "monument to fame" had been completed. The only reference to burial in Donatello's statue is very indirect, and classical rather than Christian—the false doors on both sides of the pedestal, one set closed, the other slightly ajar, as on certain Roman sarcophagi. The statue itself is an attempt to rival the *Marcus Aurelius* in Rome; its scale is over-lifesize, and the gait of the horse is similar. The animal is, of course, of the heavy breed which alone can support a man in full armor, and probably a bit too large for the rider, while the horse of the *Marcus Aurelius* is a bit too small. This creates the impression that the rider dominates his mount not by sheer physical force but by intellectual superiority, or *virtù*. Gattamelata's armor is still more pseudoclassical than that of Cortesia Sarego, and richly encrusted with classical genii and allegorical figures, somewhat like the armor of Roman imperial statues such as the *Augustus* of Primaporta. The head, too, is an "ideal portrait" rather than an actual one (fig. 21). Gattamelata was at least seventy at the time of his death, two years before Donatello came to Padua, and had been incapacitated for some time by a series of strokes. If a death mask was taken of his features and supplied to Donatello, the artist must have transformed it completely, for the features of the statue are those of a man in vigorous middle age, instinct with a "Roman" nobility of character that recalls the finest portraits of the soldier-emperors of the second century.

The precedent of the *Gattamelata* monument directly inspired the second bronze equestrian statue of the fifteenth century, that of Bartolommeo Colleoni (fig. 22). He, too, was the captain of the land armies of the Venetian Republic, and felt that he deserved the same honor granted to Gattamelata. Although he had made provisions for an elaborate tomb in his home town of Bergamo (see fig. 15), in his last will he asked the Venetian Senate to erect his equestrian monument on the Piazza S. Marco, an even more honorific spot than the Piazza del Santo in Padua. The Venetians honored his request but shifted the monument to a less conspicuous place in front of the Church of SS. Giovanni e Paolo. Again the commission was given to the best Florentine sculptor of the time, Andrea del Verrocchio, who must have stopped in Padua to admire the *Gattamelata* on

his way to Venice. Yet the two monuments are so different that the *Colleoni* is in some ways the antithesis of Donatello's work. Standing in his stirrups, stiffly erect on a rather small and delicate horse, the *Colleoni* dominates his surroundings with an almost frightening sense of indomitable power. Some of the qualities of the *Cangrande* statue seem revived here; and why should not Verrocchio have visited Verona—the home of Dante in exile—on his journey, and retained a vivid impression of the *Cangrande* monument? Be that as it may, the *Colleoni*, unlike the *Gattamelata*, wears a helmet and a thoroughly modern suit of armor, so that the *all'antica* element is missing in his makeup.

The *Colleoni* monument, in turn, furnished the model for the two equestrian statues designed (but never executed) by Leonardo da Vinci in Milan a few decades later. For the earlier of these, the *Sforza* monument, Leonardo explored the possibility of a radically new solution, the rearing horse (fig. 23), but in the end adopted a design not very different from that of the *Colleoni* monument (fig. 24). Leonardo's second venture in this field, the *Trivulzio* monument, would have shown the rider on a rapidly striding horse modeled on the *Regisole*, as we know from the artist's drawings (fig. 25). And the rider would have been bareheaded, and probably clad in armor *all'antica*, thus resuming elements of the *Gattamelata* monument.

The quality that binds together the equestrian figures we have examined so far, from that of Guglielmus to Leonardo's *Trivulzio* monument, is the emphasis on *virtù*, the prowess of the individual hero. From the mid-sixteenth century on, with the growth of the idea of absolute monarchy, the equestrian monument assumes a different flavor and a different purpose: in conscious imitation of Roman imperial practice, it becomes a public assertion of dynastic authority. Space forbids me to examine here the development of this type in its early phases (i.e., the equestrian monuments of Giovanni da Bologna, Pietro Tacca, and Francesco Mochi). Let us be content with a single specimen, the statue of Duke Alessandro Farnese in Piacenza, of 1612, by Mochi (fig. 26). Here again we find the rapid forward stride of the *Regisole*, while the costume of the duke is a Baroque version of Roman imperial garb—the lack of stirrups and saddle is notable among many other details meant to evoke analogies with the *Marcus Aurelius*. The great billowing cloak, reflecting the invisible force of the wind, gives the statue a dynamic quality thoroughly characteristic of the Baroque style. When Bernini, the greatest sculptor of the seventeenth century, was commissioned to design an equestrian monument of Louis XIV in 1665, he carried this dynamism to its ultimate conclusion by placing the king (again in classical costume and without stirrups) on a rearing horse (fig. 27). The drawing of the projected monument shows the base Bernini intended for it: a mass of rocks to represent the top of a mountain. In the artist's own words, recorded by his son:

[The King is] not represented in the act of commanding his armies. That, after all, would be appropriate for any prince. But I wanted to represent him in a state which he alone has been able to attain through his glorious enterprises. And since the poets tell us that Glory resides on top of a very high and steep mountain whose summit only few can climb, reason demands that those who nevertheless arrive there . . . joyfully breathe the air of sweetest glory. . . . I have shown him as a rider on that summit, in full possession of that Glory which . . . has become

synonymous with his name. Since a benignant face and a gracious smile are proper to him who is contented, I have represented the monarch in this way.

The drawing and the splendid terra-cotta model of 1670 do not yet show the royal smile, but the statue itself must have done so—and that, as Rudolf Witt-kower has pointed out recently, was the chief reason why the monument was rejected by the French monarch, as incompatible with his dignity. I suspect, however, that other considerations also entered into the decision. Bernini's monu-ment was by definition unique, while the French court needed a prototype that could be varied and multiplied as necessary—in other words, an adaptation of the *Marcus Aurelius*. François Girardon, a French sculptor of far lesser talent than Bernini, provided such a prototype in his design of the equestrian monu-ment of Louis XIV for the Place Vendôme. Dozens of others succeeded it in the next hundred years, all of them destroyed during the French Revolution, so that we know them only from a few models or from engravings (fig. 28). Their most distinguished surviving descendant is Andreas Schlüter's monument of the Great Elector of Prussia in Berlin, made about 1700 (fig. 29). It combines the basic pattern of Girardon's design with some of the dynamism of Mochi's *Farnese* statue.

Thus Bernini's bold design of the rearing horse, first adumbrated by Leonardo da Vinci, left no trace on the Baroque dynastic monument. His statue was ban-ished to the farthest reaches of the park at Versailles and recarved into a *Marcus Curtius,* defeated, so to speak, by a combination of French classicism and court decorum. It was revived only once, during the later eighteenth century, at the eastern periphery of Europe: in the monument to Peter the Great, the last and one of the most impressive of these descendants of the *Marcus Aurelius* statue. Étienne Maurice Falconet, who designed it, took over Bernini's "summit" idea as well, along with the classicizing costume (fig. 30). The allegorical message of the monument is stressed by the snake of envy which the horse is trampling underfoot. What made this monument possible was the very fact that from the start it was meant to be unique, a homage by Catherine the Great to the founder of modern Russia—and simultaneously a tribute to herself as his legitimate suc-cessor (witness the inscription: *Petro Primo Catharina Secunda*). Peter the Great had been far too preoccupied with more practical matters to sponsor equestrian monu-ments of himself seriatim the way the French kings did. Fortunately, the Soviet revolutionaries of 1917 also were too busy with other things to destroy Falconet's masterpiece.

It is not difficult to see why the French Revolution sounded the death knell of the equestrian monument as a viable artistic form. Neither constitutional mon-archs nor dictators could very well present themselves as "rulers by the grace of God"—or as paradigms of Roman virtue. Thus the equestrian monument soon degenerated to "the man on horseback," the holder of effective power by whatever means, but devoid of majesty. The aura of *magnificentia* (to use a favorite Ren-aissance term) that radiates from the *Cangrande* as well as from Falconet's *Peter the Great* could not be recaptured.

BIBLIOGRAPHICAL NOTE

The only general history of the equestrian monument in Western art is Hjalmar M.C. Friis, *Rytterstatuens History i Europa* (Copenhagen, 1933), a book difficult of access, linguistically and physically, and by now out of date in many respects. The bibliographical references listed below, though far from exhaustive, will serve to lead the reader to the scholarly literature dealing with the main phases of my subject.

ANTIQUITY:

Harold von Roques de Maumont, *Antike Reiterstandbilder*, Berlin, 1958.
Ludwig H. Heydenreich, "Marc Aurel und Regisole," *Festschrift Erich Meyer*, Hamburg, 1959, pp. 146–59.
Hans Hoffman, "Die Aachener Reiterstatue," *Das erste Jahrtausend*, ed. Victor H. Elbern, Düsseldorf, 1962, I, pp. 318–31.

MIDDLE AGES AND EARLY RENAISSANCE:

Otto von Simson, "The Bamberg Rider," *Review of Religion*, V, 1940, pp. 257–81.
H.W. Janson, *The Sculpture of Donatello*, Princeton, N.J., 1963, pp. 151–61, 250 f.
Erwin Panofsky, *Tomb Sculpture*, New York, 1964, pp. 83–85, figs. 378–94.

DYNASTIC MONUMENTS, SIXTEENTH TO EIGHTEENTH CENTURIES:

Sterling A. Callisen, "The Equestrian Statue of Louis XIV in Dijon . . . ," *Art Bulletin*, XXIII, 1941, pp. 131–40.
Valentino Martinelli, "Francesco Mochi," *Commentari*, III, 1952, pp. 35–43.
Rudolf Wittkower, "The Vicissitudes of a Dynastic Monument," *De artibus opuscula XL: Essays in Honor of Erwin Panofsky*, New York, 1961, pp. 497–531.

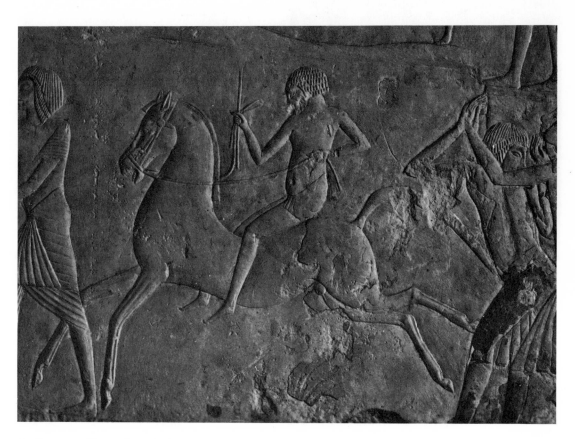

1. Boy on a Horse, *from Tomb of Horemheb, Saqqara. ca. 1345 B.C. Bologna, Museo Civico*

2

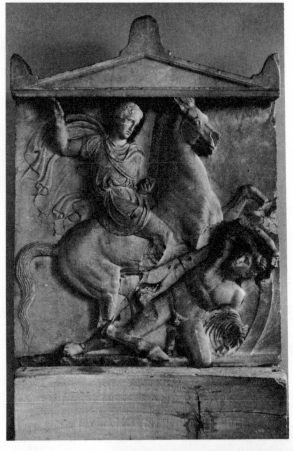

2. *Tomb Stele of Dexileos. Early
4th century* B.C. *Athens,
Kerameikos Museum*

3. The Battle of Issus *(center
portion). Mosaic (copy of Hellenistic
painting, 3rd century* B.C.*). Naples,
Museo Archeologico Nazionale*

4. *Equestrian Monument of
M. Nonius Balbus. 1st century* B.C.
Naples, Museo Archeologico Nazionale

5. *Equestrian Monument of Marcus Aurelius.
Bronze, 161–80* A.D. *Rome,
Piazza del Campidoglio*

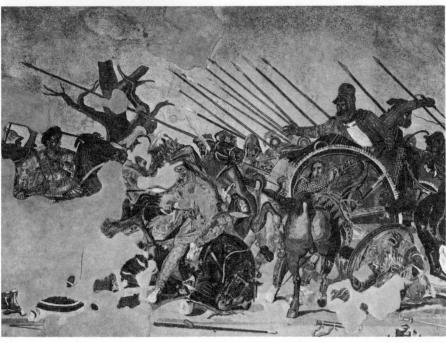

3

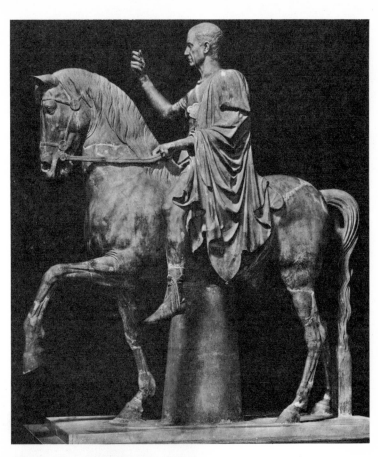

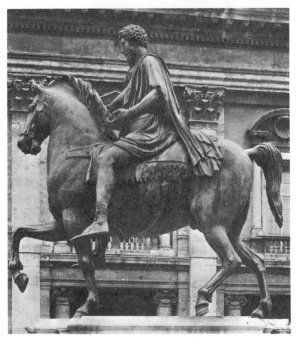

6

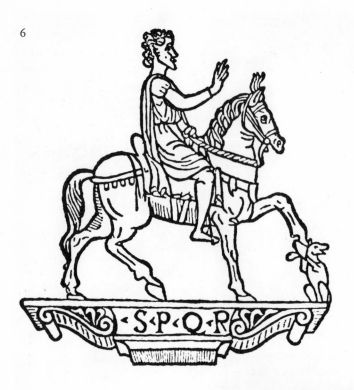

7

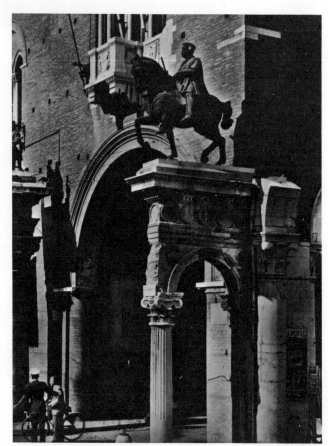

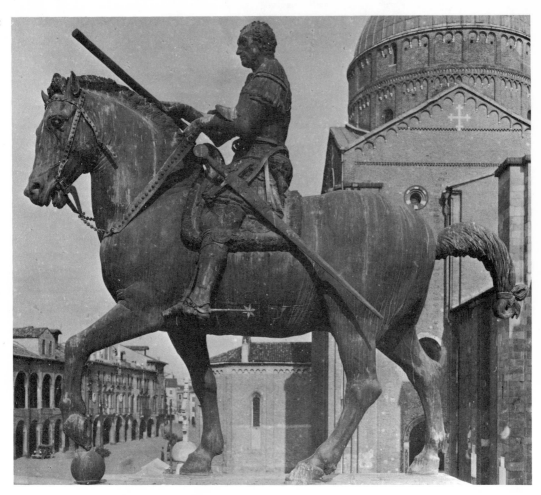

6. Regisole *(Equestrian Monument of*
Theodoric). Woodcut (from Statuta Papiae, *1505)*
after original bronze. Late Roman. Ravenna;
Pavia (destroyed 1796)

7. *Base of Equestrian Monument of*
Nicolò d'Este. 1441. Ferrara,
Piazza della Cattedrale

8. *Donatello, Equestrian Monument of*
Gattamelata. Bronze, 1448–50. Padua,
Piazza del Santo

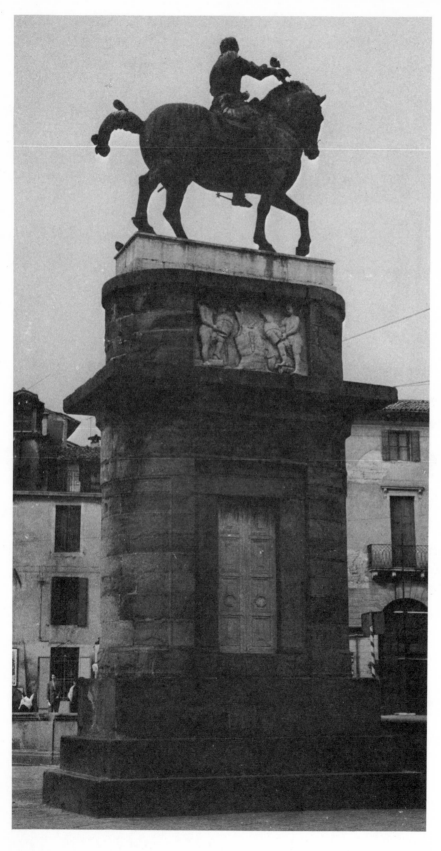

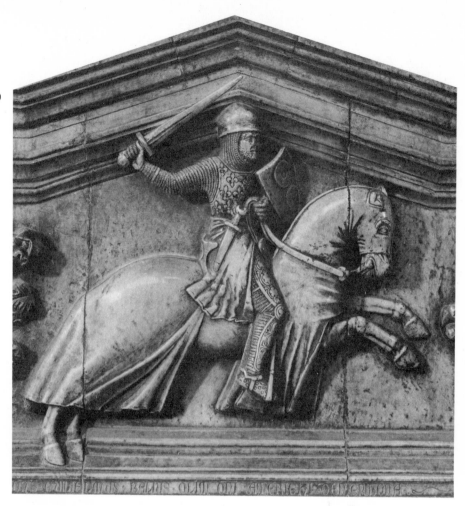

10

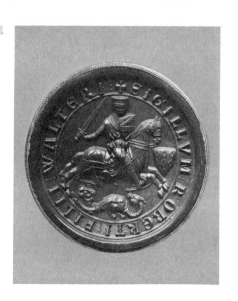

9. *Donatello*, Gattamelata *(bronze) and Base of Statue. 1448–50. Padua, Piazza del Santo*

10. *Tombstone of Guglielmus (d. 1289). ca. 1300. Florence, SS. Annunziata (2nd Cloister)*

11. *Seal of Robert Fitzwalter. English, Gothic. London, British Museum*

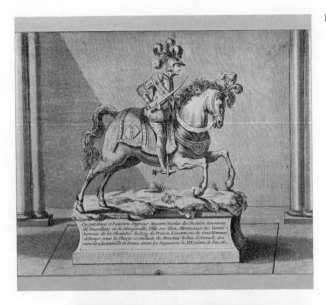

12

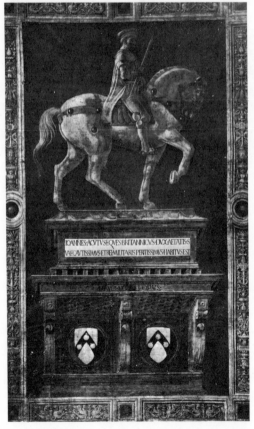

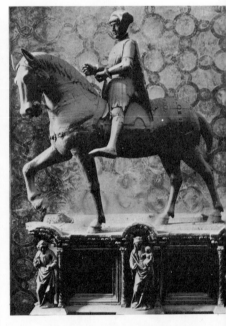

13

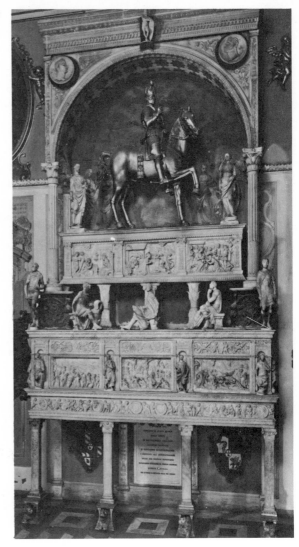

12. *Equestrian Tomb Monument of
Nicolas du Châtelet (d. 1562;
17th-century engraving). Formerly
Vauvillers (Haute-Saône), Church*

13. *Paolo Uccello,* John Hawkwood.
*Fresco, transferred to canvas;
1436. Florence, Cathedral*

14. *Equestrian Tomb Monument of
Paolo Savelli (d. 1405). Wood, gilded and
painted. Venice, Church of the Frari*

15. *Giovanni Antonio Amadei, Tomb of
Bartolommeo Colleoni (d. 1475). Wood,
gilded (statue). Bergamo, Cappella Colleoni*

16. *Tomb of Alberto I della Scala (d. 1301).
Verona, S. Maria Antica*

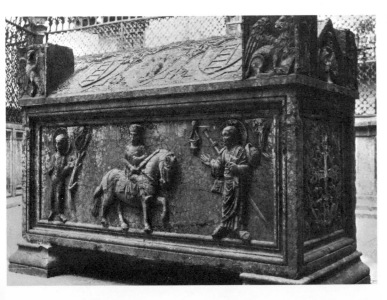

17

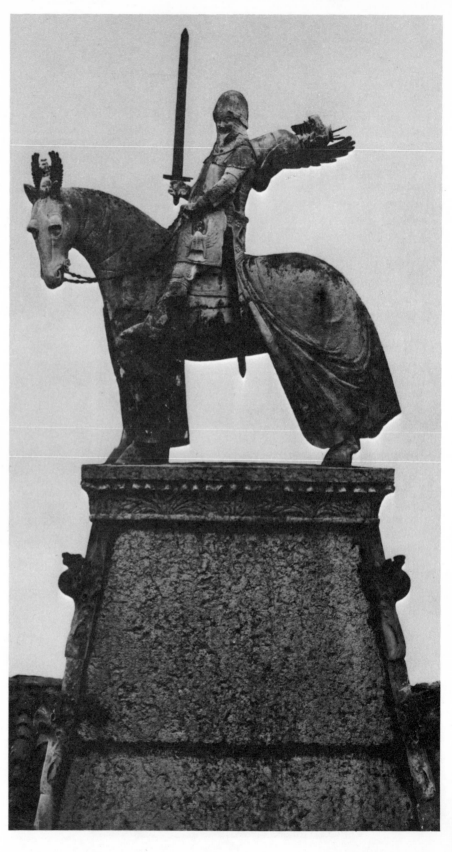

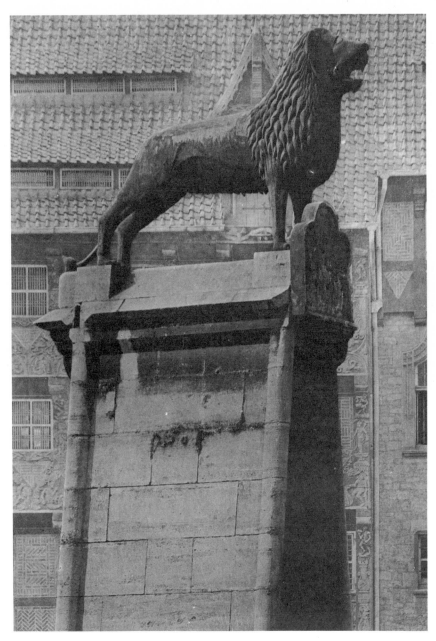

17. *Equestrian Tomb Monument of Cangrande della Scala.*
1330. Verona, S. Maria Antica

18. *Monument of Henry the Lion. Bronze (statue),*
1166. Brunswick, Cathedral Square

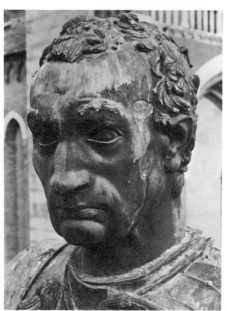

19. *Tomb of Bernabò Visconti.*
Mid-14th century. Milan, Castello Sforzesco
(removed from S. Giovanni in Conca)

20. *Equestrian Monument of Cortesia Sarego.*
ca. 1432–35. Verona, S. Anastasia

21. *Donatello, Gattamelata (detail).*
Bronze, 1448–50. Padua, Piazza del Santo

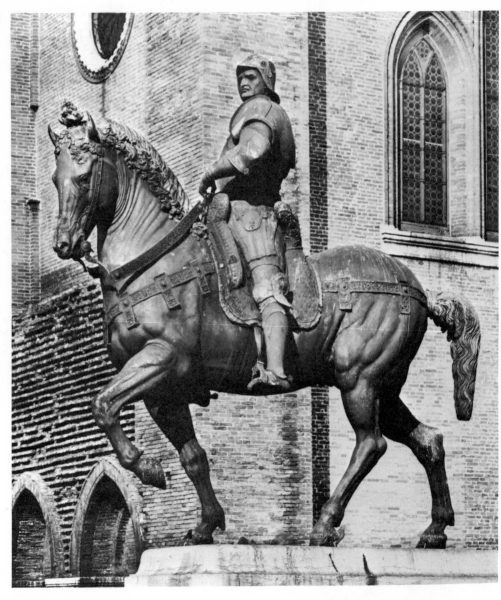

22. *Andrea Verrocchio, Equestrian Monument of Bartolommeo Colleoni. Bronze, ca. 1483–88. Venice, Campo SS. Giovanni e Paolo*

23. *Leonardo da Vinci, Study for*
Equestrian Monument of Francesco Sforza.
Silverpoint drawing, ca. 1485.
Windsor, Royal Library

24. *Leonardo da Vinci, Study for*
Horse, Equestrian Monument of
Francesco Sforza. Chalk drawing, ca. 1493–95.
Milan, Ambrosiana (Codex Atlanticus,
fol. 216v)

23

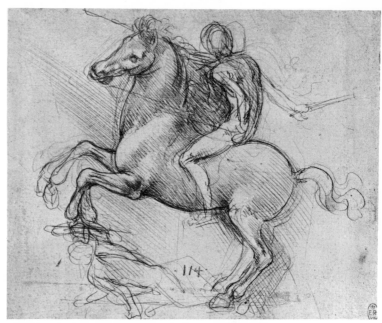

24

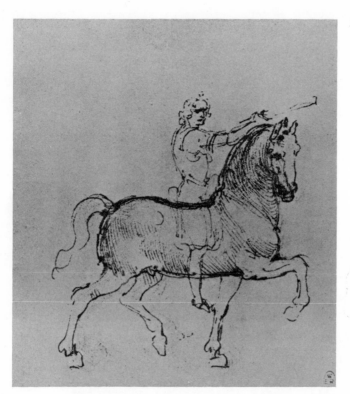

26

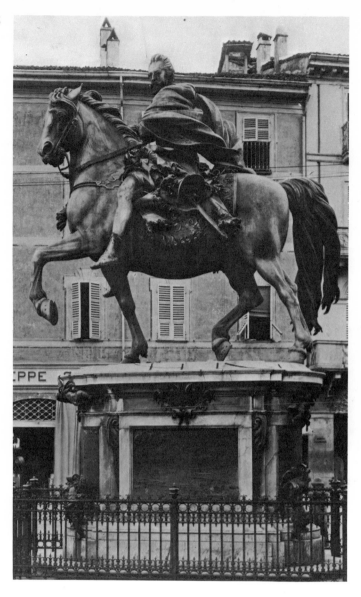

25. *Leonardo da Vinci, Study for*
Equestrian Monument of Marshal Trivulzio.
Pen drawing with chalk, ca. 1500.
Windsor, Royal Library

26. *Francesco Mochi, Equestrian*
Monument of Duke Alexander Farnese.
Bronze, 1612. Piacenza, Piazza Cavalli

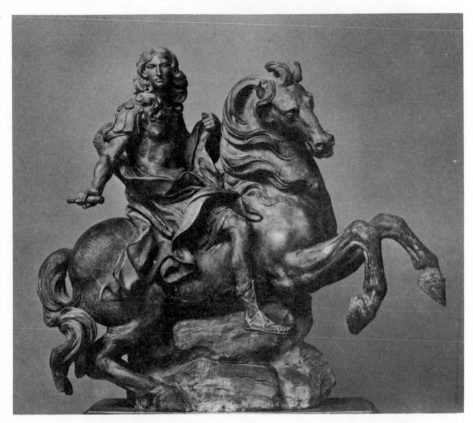

27. *Gianlorenzo Bernini,* Bozzetto
for Equestrian Monument of Louis XIV.
Terra-cotta, 1665. Rome, Galleria Borghese

28. *Francois Girardon,* Maquette
for Equestrian Monument of Louis XIV.
Wax, 1683–92. New Haven, Conn.,
Yale University Art Gallery (Gift
of Mr. and Mrs. James W. Fosburgh,
B.A. 1933)

29. *Andreas Schlüter, Equestrian*
Monument of the Great Elector
of Prussia. Bronze, 1698–1703.
Berlin, Charlottenburg, Schloss

28

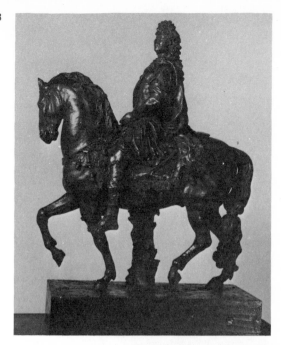

29

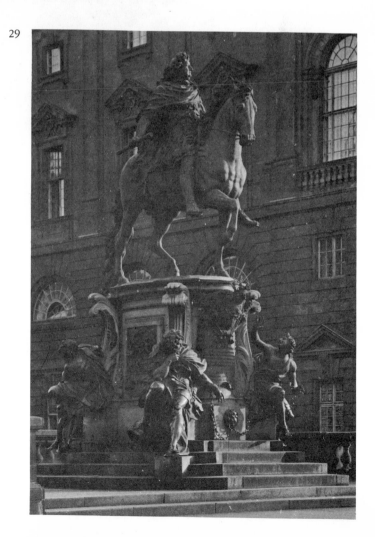

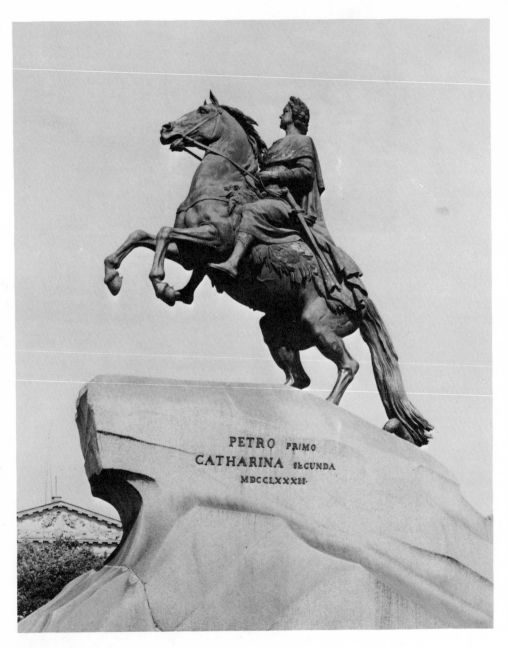

30. *Etienne Maurice Falconet,*
Equestrian Monument of Peter the Great.
Bronze, 1766–82. Leningrad

STUDY 10

Observations on Nudity in Neoclassical Art

"Observations on Nudity in Neoclassical Art,"
*Stil und Überlieferung in der Kunst des Abendlandes: Akten des 21.
Internationalen Kongresses für Kunstgeschichte in Bonn, 1964,*
Berlin, 1967, pp. 198-207

Of all the aspects of Neoclassicism, perhaps the most puzzling to the modern beholder is the representation, in the nude, of contemporary individuals. Once established, the custom survived until the end of the nineteenth century and beyond; one thinks of Rodin's nude *Victor Hugo* and *Balzac,* and of the nude *Beethoven* of Klinger. There may, for all I know, even have been a nude *Hitler* in the 1930s and, conceivably, a nude *Stalin.* When and how did this idea get started? What were the reasons for it, overt or unacknowledged?

When Canova, at the time of Napoleon's greatest power, had produced his colossal nude marble statue of the emperor, Napoleon told him that he would have preferred a clothed statue. To this the sculptor had a simple reply: "The Good Lord Himself," he said, "could not make a beautiful statue in modern dress."[1] For a more detailed explanation, we must turn to Quatremère de Quincy, the travel companion of Jacques-Louis David's Italian years, a lifelong friend and biographer of Canova, and the most rigidly idealistic theoretician of Neoclassicism, in whose writings we find the problem of "contemporary nudity" discussed again and again, from the *Considérations sur les arts du dessin en France* of 1791 and the essays scattered through the *Archives littéraires* and the *Nouvelles des arts* of the early 1800s, to the *Essai sur la nature, le but et les moyens de l'imitation dans les beaux-arts* of 1823.[2] Although the ancients, Quatremère de Quincy concedes, were more accustomed to nudity in everyday life than we are, they did not produce nude portrait statues in order to evoke memories of the stadium or gymnasium but as a "poetic metaphor" *pour assimiler les hommes célèbres aux personnages divins.* Today, he says, we no longer believe in these divine heroes, yet we are justified in employing "metaphoric nudity" as the Greeks did, since nudity is "natural" and "timeless." He warns, however, against anatomic realism. In order to show that the sitter's fame is beyond all strictures of time and circumstance, that it belongs to all ages and all countries (as in the case of Canova's *Napoleon*), the artist must show the nude body not by direct imitation, as it actually is, but as it may be imagined in a higher order of being. Otherwise the figure will simply be a study in anatomy, not a *monument honorifique*—and he cites the nude *Voltaire* by Pigalle (fig. 1) as a horrible example. *Il n'y a*

[1] Quatremère de Quincy, *Canova et ses ouvrages,* Paris, 1836, p. 195.

[2] The following summary is based mainly on the *Essai,* III, xvi–xvii (pp. 400 ff.), althoug many of the same arguments can be found in the author's earlier writings. Cf. François Benoit, *L'art français sous la révolution et l'empire,* Paris, 1897, p. 42.

192

point de métaphore sans métamorphose. The same argument applies to scenes of history, whether ancient or modern: if the artist truly wants to express their universal significance, he must show the protagonists neither in the dress of the period nor in classical costume, but nude. The ideal costume, according to Quatremère de Quincy, is no costume—although he concedes that in a place like Siberia a nude statue is likely to evoke downright painful sensations in the shivering beholder.[3]

This last remark is, I am afraid, characteristic of my subject: wherever we meet contemporary nudity in Neoclassical art, the sublime is never very far from the ridiculous. Canova's nude *Napoleon* itself is a good case in point (I am referring to the marble original, not the smaller bronze replica in Milan). By the time the statue reached Paris, in 1812, Napoleon's military and political situation had become so difficult that he decided not to exhibit it in public, for fear of offending his allies. The figure was hidden away in the Louvre, where only a few specially favored artists and critics could see it. After Waterloo, Louis XVIII gave the statue to the British, who in turn presented it to the Duke of Wellington.[4] The duke treated it as a kind of souvenir, putting it in his house in Piccadilly "below a stair, where it not only cannot be seen to any advantage but where it is exposed to all manner of accidents."[5] An even worse fate befell the colossal nude bronze statue of General Desaix by Claude Dejoux, executed in 1805–7 (fig. 2). Having died at Marengo in 1800, Desaix was not in a position to object to its nudity. Dejoux at first designed the monument as "Desaix Dying," but Napoleon intervened, insisted that it must be *Desaix vivant,* and approved the concept of the *nu héroïque.* Once it had been erected on the Place des Victoires, the statue was criticized as "heavy" and "lacking nobility," and the style was pronounced *démodé.* Soon the figure was covered with cloth to hide it from the glances of the *pudiques bourgeois du quartier,* and a year later dismantled and stored. Under Louis XVIII it was melted down and the bronze turned over to the sculptor Lemot for a statue of Henri IV.[6] Since General Desaix's chief fame rested on his role in the Egyptian campaign, Dejoux had to combine "timelessness" with a reference to Egypt. He did this by showing the general triumphing over the Egypt of the Pharaohs, rather than over the Egypt of the Mamelukes which he had actually helped to conquer.

Quatremère de Quincy's defense of contemporary portraits in the nude rests on a passage from Pliny (*Hist. nat.,* XXXIV). The traditional Roman type of portrait statue, states Pliny, was the toga statue, but later the Romans also made nude portrait statues, like those in Greek gymnasia, which they termed "Achillean" portraits. The Greek custom is to veil nothing (*Graeca res nihil velare*), Pliny continues, while the Romans, in contrast, liked to show their heroes in military garb.[7] "Achillean" portraits of the kind Pliny mentions actually exist in Roman art. Among the earliest is that of a Roman official from Delos in the

[3] *Considérations . . . ,* pp. 22 ff.
[4] De Quincy, *Canova,* p. 212.
[5] J. S. Memes, *Memoirs of Antonio Canova,* Edinburgh, 1825, p. 389 f.
[6] For a fully documented account of the history of the statue, see Marie-Louise Biver, *Le Paris de Napoléon,* Paris, 1963, pp. 151–61.
[7] Cf. Giovanni Becatti, *Arte e gusto negli scrittori romani,* Florence, 1951, pp. 234 f.

National Museum, Athens; the head, a realistic likeness from the late first century B.C., has been grafted onto a body of Polyclitan type.[8] Here "heroic nudity" as such has an iconographic function, lifting the person portrayed to a higher sphere of being, as Quatremère de Quincy put it. The great majority of nude Roman portrait statues, however, belong to a different category, not mentioned in Pliny but referred to by other Roman authors. A typical specimen is the group of a married couple in the Terme Museum, Rome, in the guise of Mars and Venus, he with a body of the type of the *Ares Borghese,* she with a body of the type of the *Venus de Milo.*[9] In this instance, as in countless others, nudity is not an end in itself; what matters is the identification of the persons portrayed with specific deities through the use of instantly recognizable statue types, which may or may not be nude, depending on the patron's (or artist's) choice of these types. Statius, in his *Epicedion in Priscillam,* gives a vivid picture of the purpose of such portraits; addressing himself to Priscilla, the recently deceased wife of the secretary of Emperor Domitian, he exclaims: "Time will be unable to harm you in your tomb, such have been the precautions taken for your body, and such is the number of statues of yourself. In this bronze, you are Ceres, in that one you are Ariadne; you are Maia [one of the Pleiades], and a chaste Venus in that marble. This is not a tomb but a home."[10]

The passage, needless to say, does not permit us to conclude that every Roman portrait in mythological guise was meant to commemorate a dead person (in the case of emperors, who after all had an official claim to divine status, we know that such portraits were produced while they were still alive); but the idea of endowing the sitter with a species of immortality through identification with a divinity must have been widespread in Roman times, and nudity, as we saw, was incidental to this purpose. Surely not all the statues of Priscilla enumerated by Statius showed her in the nude. The same is true of the Renaissance and Baroque, which revived the Roman mythological portrait but not the "Achillean" portrait in ideal nudity as described by Pliny. Again, nudity was incidental to such mythological portraits. Male portraits could be nude if the sitter was a famous seafarer represented as Neptune (Bronzino's *Andrea Doria* or Haunce Eworth's *Sir John Luttrell* come to mind here); nude female portraits usually represent famous courtesans or royal mistresses in the guise of Venus or Diana. But the great majority of Renaissance and Baroque mythological portraits are in "fancy dress" appropriate to the role assigned to the sitter.

Judged in the light of these antecedents, Pigalle's nude *Voltaire* still belongs the Renaissance and Baroque tradition. As Professor Sauerländer has recently pointed out, Voltaire is here represented, at the suggestion of Diderot, in the guise of the dying Seneca,[11] and since Seneca died by bleeding to death in his bath, the nudity of the statue is functional rather than simply "heroic." Still, one wonders whether Diderot did not pick this particular role for Pigalle's *Voltaire* because it permitted—indeed, forced—the artist to show his subject nude.

[8] Becatti, *op. cit.,* pl. lviii, fig. 116.
[9] Becatti, *op. cit.,* pl. lix, fig. 117.
[10] Cf. Becatti, *op. cit.,* pp. 385 ff.
[11] Willibald Sauerländer, *Jean-Antoine Houdon, Voltaire* (Werkmonographien Nr. 89), Stuttgart, 1963, pp. 5 ff.

The functional aspect of Voltaire's nudity was apparently soon forgotten; Quatre-mère de Quincy, as we saw, no longer understood the Seneca allusion. He regarded the statue as an instance of heroic nudity, but a poorly conceived one.[12] In fact, Pigalle's *Voltaire* became the precedent for a long series of nude statues of literary and artistic geniuses whose nudity was either frankly heroic (as with Rodin's *Victor Hugo* and *Balzac*) or was justified by the lamest of afterthoughts, such as a *Poussin* by Julien (before 1804), which supposedly represented the painter at a moment when he had risen from his bed in the middle of a hot Roman night to put a sudden inspiration on canvas, or an apotheosis of Montaigne by Stouf, who explained that Montaigne liked to look at himself in the nude and that, in any event, to go naked was not contrary to nature.[13]

Heroic nudity was certainly in the air at the time Diderot conceived the role of the dying Seneca for Voltaire. Winckelmann, in his *Geschichte der Kunst des Altertums* (1764), had hinted that the beautiful bodies of Greek art were not idealized but rendered the actual appearance of the ancient Greeks: "Vieles, was wir uns als idealisch vorstellen möchten, war die Natur bei ihnen ... in Griechenland wird sie ihre Menschen aufs feinste vollendet haben ... die Künstler sahen die Schönheit täglich vor Augen."[14] A decade later, in his *Physiognomische Fragmente*, Lavater made the same claim in more explicit fashion. If modern bodies fail to match those of Greek statues, this is due to our unnatural mode of life, which has corrupted the physical—and hence the moral—stature of men. The "science" of physiognomy, according to Lavater, is not limited to the head; the congruence of physical and spiritual qualities extends to every part of the human body.[15] Hence, to portray a modern individual by putting his head on a perfect Greek body, as Canova was to do with his nude *Napoleon*, had a double justification: it showed the sitter as Nature intended him to be, and at the same time endowed him with the spiritual perfection expressed by a perfect body.

It took a whole generation, however, from ca. 1770 to 1800, for these ideas to be fully translated into practice. When the young Canova, in 1779, carved his portrait statue of Antonio Vallaresso as Asclepius (fig. 3), he followed Winckelmann and Lavater only part of the way: the figure is nude for "heroic" rather than functional reasons—unlike the dying Seneca, Asclepius does not have to be nude, nor did Canova derive the statue from an established classical Asclepius type—yet with with a bit of late Baroque drapery discreetly wrapped about the hips and the body too well padded to meet Greek standards (to judge from the face, Vallaresso was not exactly slender), a fact that made the artist ashamed of this early work in later years. But to return to Pigalle's *Voltaire*. A year after he had done the *bozzetto* for it of 1770, Pigalle was commissioned to carve the tomb of Count Henri-Claude d'Harcourt for Notre-Dame in Paris (fig. 4). Here we meet the direct artistic descendant of the nude *Voltaire*: the old count, having thrown off his shroud, emerges nude from the half-open coffin to stretch out

[12] Heroic nudity is also suggested by the inscription the statue was to bear, as originally formulated in 1770: *A Voltaire vivant, par les gens des lettres ses contemporains.* The present inscription was added only after Voltaire's death. See Sauerländer, *loc. cit.*

[13] See Benoit, *op. cit.*, pp. 409 ff., who cites many further examples.

[14] Pp. 127 ff.

[15] See especially Lecture xxviii.

his arms toward the grief-stricken widow approaching him from the left. The subject of this somewhat macabre scene, as defined in the contract between Pigalle and the widow,[16] is *réunion conjugale,* a concept without precedent in the tomb monuments of the past. The widow, of course, was still alive then, but she too wears a shroud rather than modern dress, and the scene must be imagined as taking place in the future, at the time of her death—she is about to join her husband in the tomb. Pigalle could surely have visualized the scene in less literal fashion, but the idea of the "entry into the grave" was familiar to him from the monument of Maurice de Saxe (fig. 5), on which he was still working at the time although he had designed it twenty years before,[17] and the nude, dying Seneca-*Voltaire* was equally on his mind, since that statue and the tomb of the Comte d'Harcourt were finished in the same year, 1776.[18]

Surprisingly, the notion of the nude dying hero arose in England about the same time as in France, i.e., around 1770, as evidenced by the monument to General Wolfe in Westminster Abbey. The death of Wolfe in 1759 at the siege of Quebec had released a tremendous wave of patriotic sentiment in England. We are all familiar with the famous painting of the general's death by Benjamin West, in modern costume (contrary to academic doctrine) but with all the trappings of the grand manner.[19] Wolfe's monument is perhaps less well known but equally interesting. Parliament had petitioned the king for such a monument in 1759, and the king appointed a committee, which chose Louis François Roubiliac, a French sculptor long resident in England. Roubiliac made a terra-cotta model but died soon after, in 1762. The commission then went to Joseph Wilton, whose monument was unveiled in 1773.[20] Roubiliac's design—the model itself seems to be lost—is known from an engraving (fig. 6);[21] it was conceived not as a tomb but as a memorial, and a purely secular one. There are only two inscriptions, "Wolfe" on the base of the central statuary group and "Britannia posuit" above. From what sources did the artist derive this conception? The hero dying in the arms of Victory must stem from Tuby's tomb monument of Turenne (fig. 7), designed almost a century before by Lebrun,[22] while other elements—the upright pose of Wolfe, the flags, the British lion triumphing over an Indian with the map of Quebec and a Canadian beaver— suggest the influence of the monument to Maurice de Saxe.[23] Both these tombs, moreover, are secular in character, although the personifications of Wisdom and Fortitude on the Turenne monument still betray their kinship with

[16] Published in Samuel Rocheblave, *Jean-Baptiste Pigalle,* Paris, 1919, p. 245.

[17] See Rocheblave, *op. cit.,* for the history of the commission.

[18] For his *Voltaire,* Pigalle used an old veteran from the Hôtel des Invalides as a model (Sauerländer, *op. cit.,* p. 9); to all appearances, the same model served him for the Comte d'Harcourt.

[19] For a bibliography on this and related pictures, see David Irwin, "James Barry and the Death of Wolfe in 1759," *Art Bulletin,* XLI, 1959, pp. 330 ff.

[20] For the history of the commission, see J. Clarence Webster, *Wolfe and the Artists,* Toronto, 1930, pp. 50 ff., and Margaret Whinney, *Sculpture in Britain 1530–1830* (Pelican History of Art), Baltimore, 1964, p. 139.

[21] *The Gentleman's Magazine,* LIX, 1789, frontispiece. Further references to the monument in *ibid.,* LIV, p. 54, and LVIII, pp. 668 f.

[22] André Michel, *Histoire de l'art,* VI, 2, Paris, 1922, pp. 733 f.

[23] Wilton had been a pupil of Pigalle.

Christian Virtues. The most surprising aspect of Roubiliac's design is the intrusion of historic realism; unlike Turenne and Maurice de Saxe, Wolfe appears neither in classical costume nor in heroic armor but in his actual military uniform, and the row of army tents in the background establishes the setting of the scene as the general's campaign headquarters.[24] In Wilton's monument (fig. 8), this element of "authenticity" is carried much further: Wolfe now dies—in a pose reminiscent of Turenne—inside a tent cluttered with furniture, and in the arms of one of his soldiers, with another standing by. Yet, astonishingly enough, he is nude, and thus cast in the role of a classical hero. At the same time his nudity suggests a martyred saint, for his gaze is fixed upon the winged Victory descending into the tent on the left and proffering him a wreath and palm. Wilton must have seen this combination in countless Baroque scenes of martyrdom during his years in Italy;[25] perhaps he even knew the earliest example I have found so far, Donatello's *Death of St. Lawrence* on the South Pulpit of S. Lorenzo (fig. 9). Actually, Wolfe's nudity is threefold: he is nude like a classical hero, nude like a secularized saint, and functionally nude as well, for his uniform is piled on the floor at his feet, as if he had been undressed by his soldiers for medical reasons. So far as I have been able to determine, the Wolfe monument is the earliest instance of its kind, with the single exception of the death scene on Andrea Riccio's tomb of Girolamo and Marcantonio della Torre (fig. 10), where Girolamo is shown dying in the nude, consistent with the *all'antica* character of the entire monument.[26] The death scenes on Roman sarcophagi, be it noted, do not show the death of the "inmate" but of mythological heroes such as Meleager. Wilton might conceivably have known the Della Torre tomb, then still in Verona (the reliefs were sent to the Louvre, where they are today, in 1796); even if he did, however, the *Death of Girolamo della Torre* is hardly an adequate precedent for the Wolfe memorial, which represents to my mind a fresh start rather than the resumption of a type that had remained without successors in the Renaissance.

Some ten years after the unveiling of the Wolfe memorial, the nude dying hero reappears on French soil, in the splendid *bozzetto* supposedly made by Houdon for the monument to Prince Michael Galitzin (fig. 11). Half sitting, half reclining on the edge of his sarcophagus, the prince is attended by Virtue (who consoles him) and Friendship, while the Vices are seen fleeing in the background.[27] The further history of our subject leads us to Jacques-Louis David, whose memorials of 1793 to the martyrs of the Revolution—Lepelletier, Marat,

[24] It is noteworthy that these contemporary elements make their appearance in this unexpected context, antedating the painted versions of the general's death (Romney, 1763; Penny, 1764; West, 1771; Barry, 1776).

[25] He spent a decade, 1745–55, in Rome and Florence.

[26] Cf. Erwin Panofsky, *Tomb Sculpture*, New York, 1964, p. 70.

[27] A. E. Brinckmann, *Barock-Bozzetti*, III, Frankfurt, 1925, pl. 75. The identification is based on an old slip of paper attached to the *bozzetto*. Houdon exhibited sketches for the Galitzin tomb in the Salon of 1777, and the Louvre *bozzetto* might be one of these, or related to them. However, it bears no resemblance to the tomb itself (completed 1784; Our Lady of Khasan, Moscow) and does not match Houdon's style of those years. The pose of the hero strongly resembles that of Girolamo della Torre in the relief of the latter's illness (see Panofsky, *op. cit.*, fig. 293); unless this similarity can be accounted for by a common antique source, the Louvre *bozzetto* would seem to have been done after 1796, when the reliefs of the Della Torre tomb arrived in Paris.

and Bara (see figs. 15, 17, 18)—depict all three of them nude. What do they have to do with Voltaire and General Wolfe? There is, I believe, one antecedent for the famous trio that has been generally overlooked and may serve to establish this connection. In 1791, two years before the Terror, the revolutionary government decided to arrange a belated state funeral for Voltaire and to place his remains in the Panthéon, thus proclaiming him an official "patron saint" of the Revolution. The funerary procession, designed by David, is known to us only from accounts in the newspapers of the time, but these are so detailed and agree so well among themselves as to furnish a fairly complete picture. Everything was arranged *à l'antique*, including the costumes of the bearers, the mourners, and the musicians. Even the musical instruments were copied after those of the ancients. There were two central features: a platform with a gilt plaster copy of Houdon's seated *Voltaire* statue, and a chariot with the sarcophagus, which was of imitation porphyry. On it was a bier with the nude effigy of Voltaire, a broken lyre at his side and a figure of Immortality bending over him with a wreath of stars. This chariot was drawn by twelve white horses *attelés à nu, comme les chevaux des chars antiques*. . . .[28] Surely the notion of showing the dead Voltaire nude owes something to Pigalle's nude *Voltaire*. Immortality proffering a wreath recalls the Turenne tomb as well as the Wolfe memorial, and it is not impossible that David knew the latter at least indirectly. Quatremère de Quincy, in his *Considérations sur les arts du dessin* . . ., published in the very year when the Voltaire funeral took place, speaks of the social usefulness of art through *sujets nationaux et les tableaux patriotiques*, and adds, *l'exemple de l'Angleterre à ce sujet nous servira de leçon*, acknowledging the leadership of English art in "national and patriotic subjects."[29]

What might this nude *Voltaire* after David's design have looked like? One thinks of the dead Hector in David's *Mourning Andromache* of 1783, which in turn reflects the central figure in a *Death of Socrates* painted as early as 1762 by Jean-François Sané,[30] or Gavin Hamilton's *Hector Mourned by Andromache* of 1791.[31] More likely, however, David drew for the design of the entire funeral upon the vast corpus of studies after the antique which he had produced during his Roman years, 1775–80. Among these, in the sketchbook recently published by Jean Adhémar, we find women mourning a dead classical hero (fig. 12) who is completely nude and probably comes closest to the Voltaire effigy.[32] This drawing, although labeled *arrangé d'après un tombeau à Florence*, does not reproduce a classical monument; it is, rather, a fantasy *à l'antique*, perhaps reflecting the influence of Henry Fuseli, whom David had met in Italy and who had made drawings of Biblical, Shakespearean, Miltonian, and classical subjects in the nude ever since about 1770 (fig. 13). David's nude corpse

[28] M. E. J. Délécluze, *Louis David*, Paris, 1855, p. 135, and Maurice Dreyfous, *Les arts et les artistes pendant la période révolutionnaire*, Paris, n. d. (1906), pp. 422–25.

[29] *Considérations* . . ., pp. 50 f.

[30] Jean Loquin, *La peinture d'histoire en France de 1747 à 1785*, Paris, 1912, pl. vi.

[31] Since both paintings were engraved—Hamilton's by Cunego, 1764, Sané's by Jacques Danzel—David could easily have known them. Cf. Dora Wiebenson, "Subjects from Homer's Iliad in Neoclassical Art," *Art Bulletin*, XLVI, 1964, p. 30.

[32] *David, naissance du génie d'un peintre*, Paris, 1953, no. 424, pl. 280.

also is oddly reminiscent of the famous nude *gisant* of Henry II by Germain Pilon (fig. 14). And since in the funerary procession Voltaire appeared twice, alive (in the Houdon statue) and as a nude corpse, it is conceivable that this double representation was inspired—supreme irony!—by the royal tombs at St-Denis, where several of the sovereigns are also represented twice: *au vif,* in full regalia, and as nude corpses.[33]

From here it is but a short step to the funeral of Lepelletier, whose body, nude to the thighs so as to show the gaping wound made by the assassin, was displayed on a classical catafalque in the Place Vendôme before it was solemnly conducted to the Panthéon for burial.[34] David's lost painting, known from a drawing by one of his pupils (fig. 15), represented the corpse as it was actually displayed before the funeral. In place of the allegorical figure that had accompanied the effigy of Voltaire, we now have a simpler and more gruesome emblematic device: the murderer's sword, suspended by a hair and piercing a piece of paper, Lepelletier's vote for the death of the king. The only departure from the "Hector" or "classical hero" type is the turn of the head toward the beholder; but in view of Lepelletier's actual appearance as recorded in an earlier drawing by David (fig. 16), it is obvious why a strict profile view of the head would not do.

Marat's corpse was publicly displayed nude to the thighs like Lepelletier's,[35] and David's painted memorial (fig. 17) was designed as a companion piece to the Lepelletier memorial. The two bodies face in opposite directions, and even the inscriptions match: *David à Lepelletier* and *À Marat, David.*[36] Marat would thus have been nude in David's picture even if he had not been killed in his bathtub. But since he was, David could now combine heroic and functional nudity, and integrate the weapon and the piece of paper (here, Charlotte Corday's petition) into a simplified account of the actual murder scene—circumstances that help to explain the singular artistic success of the picture. Martyrs though they were, it hardly seems appropriate to speak of the "Christlike nudity" of Lepelletier and Marat, as Cantinelli and others have done.[37] What David had in mind was the nudity of classical heroes or dying philosophers like Seneca and Socrates: "Plato, Aristotle, Socrates," he exclaimed, "I have never lived with you, but I have known Marat, and I have admired him as I do you."[38]

The third and last picture of this series, that of the boy martyr Bara (fig. 18), again purports to show the actual murder scene, but the nudity here is purely heroic. Cantinelli's claim that Bara was undressed by his enemies[39] has no basis in any of the accounts of the murder, as far as I can see; it seems to be

[33] Cf. Panofsky, *op. cit.,* pp. 63 ff., for the antecedents of these effigies, and pp. 79 ff., for the royal tombs in St-Denis.

[34] Délécluze, *op. cit.,* p. 151, and David L. Dowd, *Art as Propaganda in the French Revolution: a Study of Jacques-Louis David,* Ph.D. dissertation, University of California, Berkeley, 1946 (typescript), p. 156.

[35] Dowd, *op. cit.,* p. 168, and Klaus Lankheit, *Jacques-Louis David, Marat* (Werkmonographien Nr. 74), Stuttgart, 1962, pp. 9 ff.

[36] Lankheit, *op. cit.,* p. 16.

[37] Richard Cantinelli, *Jacques-Louis David,* Paris-Brussels, 1930, pp. 48 f., and Lankheit, *op. cit.,* pp. 18 ff.

[38] Dowd, *loc. cit.*

[39] Cantinelli, *loc. cit.,* and Délécluze, *op. cit.,* p. 160.

no more than a modern attempt at rationalization. As in his *Marat,* David has kept the setting extremely simple: a barren hillside, and the vague forms of the murderers withdrawing in the distance on the far left. The only identifying emblem is the *cocarde tricolore,* symbol of his loyalty, that the dying boy presses to his heart.[40]

If we accept—and I think we must—Bara's nudity as heroic rather than functional, what are we to make of the huge fragment, now at Versailles, of the *Oath of the Tennis Court (Le serment du Jeu de Paume)* with its nude figures? The picture was commissioned in 1790 but never finished because so many of the participants in the Oath had become politically suspect or had even been executed.[41] There can be no doubt that as of 1791, when David showed a large drawing of the composition in the Salon, all the figures were intended to be in historically accurate dress. There is equally no doubt that the Versailles picture is not a sketch but a cut-down fragment of the unfinished canvas itself. The nudity of the figures in the Versailles picture, it has always been assumed, was for study purposes only, in keeping with academic procedure, and David intended to put costumes on the figures in the end. But these nude bodies are painted, while academic procedure calls for nude studies in the form of drawings.[42] Moreover, David is not known to have painted nude bodies and then covered them with clothing in any other instance;[43] and the Versailles canvas shows faint, *drawn* outlines of costumes around the nude figures.[44] Is it not possible, I wonder, that the Versailles fragment represents a final, desperate attempt by David, sometime during the mid-1790s, to rescue the picture by making the figures nude and eliminating or drastically simplifying the specific architectural background of the tennis court? Such a step would have made the event "universal" in accordance with the ideas on nudity of Quatremère de Quincy and would thus have eliminated the embarrassing problem of politically disgraced personalities. The history of the design, so far as we know it through drawings, shows a constant tendency to reduce the number of figures and to increase their size relative to the setting. The Salon drawing of 1791 already represents an advanced stage in this process. If my conjecture is right, the Versailles canvas shows a still later, and more radical, step. We should recall here that as late as 1797 David offered to complete the *Oath* by substituting famous men of the day for those who had become "insignificant" (that is, dead or disgraced), and that he did not finally declare his intention to abandon the canvas until 1801.[45] It might also be worth remembering that in 1784, when he was working on the *Oath of the Horatii,* his favorite pupil, Drouais, had urged him to make the

[40] The *cocarde* serves to differentiate Bara from another boy martyr, Agricole Viala, whose emblem was the hatchet with which he had cut the cable of a ferry across the Durance that served the Marseilles rebels. Cf. David's own proposal for the state funeral of Bara and Viala, reprinted in J. L. Jules David, *Le peintre Louis David,* Paris, 1880, p. 210.

[41] Délécluze, *op. cit.,* p. 137; Cantinelli, *op. cit.,* p. 33.

[42] Several such drawings survive for groups of figures in the *Oath.*

[43] Cf. J.-G. Goulinat, "La technique de David," *L'Art vivant,* I, No. 24, Dec. 1925, pp. 27 ff.

[44] As noted by Cantinelli, *loc. cit.*

[45] David, *op. cit.,* pp. 344 ff., and Dowd, *op. cit.,* p. 61.

Horatii nude, and that David replied, "Later; right now I am not yet sure enough of myself for something as difficult as that."[46]

Finally, to suggest the degree to which nudity was accepted during the Terror, we may cite an account of the unveiling of the Goddess of Reason on November 10, 1793, in Notre-Dame, which had become a "temple" of the new cult. "We do not call you to the worship of inanimate idols," the high priest exclaimed to the assembled crowd. "Behold this masterpiece of nature"—here he lifted the veil which had concealed a beautiful nude girl, a certain Mlle Barbier—"this sacred image should inflame all hearts."[47] We do not know Mlle Barbier's physical qualifications for this role, but they must have been rather special if we are to judge from an engraving in Peyrard's *De la nature et de ses lois* published that same year, which shows the unveiling of the Goddess of Nature (fig. 19).[48] If this was possible in 1793, a nude *Oath of the Tennis Court* was also possible, I submit.

[46] André Maurois, *Jacques-Louis David*, Paris, 1948, No. 12.

[47] Irwin Primer, "Erasmus Darwin's Temple of Nature," *Journal of the History of Ideas*, XXV, 1964, p. 71.

[48] Primer, *op. cit.*, p. 72.

1. *Jean-Baptiste Pigalle.* Voltaire. 1770–76.
Paris, Louvre

2

2. *Claude Dejoux, Colossal Monument of General Desaix (engraving from Biver, Le Paris de Napoléon).*
Bronze, 1805–7

3. *Antonio Canova,* Antonio Vallaresso. *1779. Padua, Museo Civico*

4. *Jean-Baptiste Pigalle,*
Tomb of Comte Henri-Claude d'Harcourt.
1771–76. Paris, Notre-Dame

5. *Jean-Baptiste Pigalle,*
Tomb of Maurice de Saxe. 1770–76.
Strasbourg, St-Thomas

3

6

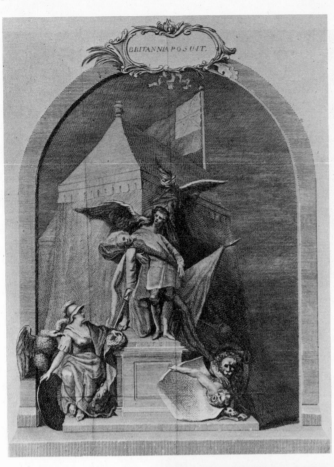

6. *Louis François Roubiliac,*
Model for the Monument to General Wolfe
(engraving from
Gentleman's Magazine, *LIX). ca. 1770*

7. *Jean-Baptiste Tuby*
after Charles Lebrun, Tomb of
Marshal Turenne (d. 1675). Paris,
Dôme des Invalides

8. *John Wilton,*
Monument to General Wolfe. 1773.
London, Westminster Abbey

9. *Donatello,* Martyrdom of St. Lawrence
(detail), on Bronze Pulpit.
ca. 1460–70. Florence,
S. Lorenzo

10. *Andrea Riccio,*
Death of Girolamo della Torre.
Bronze, 1511. Paris, Louvre
(originally Verona, S. Fermo)

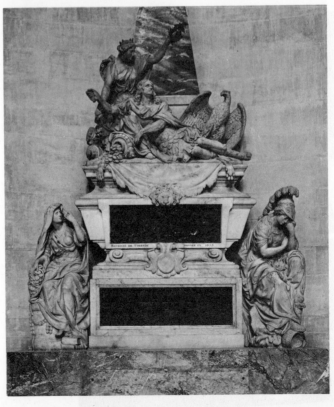

7

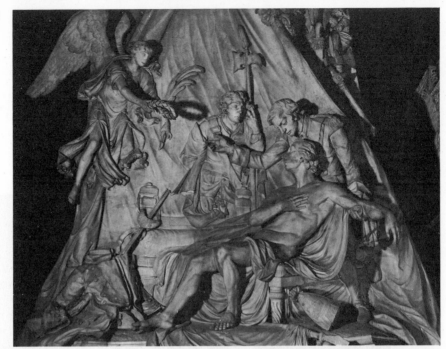

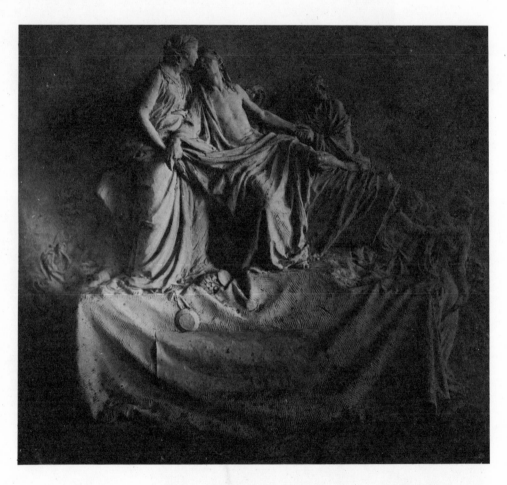

*11. Jean Antoine Houdon (?), Bozzetto for
the Tomb of Prince Michael Galitzin (?). Terra-cotta,
ca. 1783 (or after 1796?). Paris, Louvre*

12

13

12. *Jacques-Louis David,*
A Classical Hero Mourned
(*pen drawing from Adhémar,*
David). *1775–80*

13. *Henry Fuseli,*
Richard III Asleep, Haunted
by the Ghosts of His Victims.
Pen and wash drawing. London,
Victoria and Albert Museum

14. *Germain Pilon,*
Gisant of Henry II (*detail*),
on Tomb of Henry II and
Catherine de'Medici.
1563–70. St-Denis,
Abbey Church

14

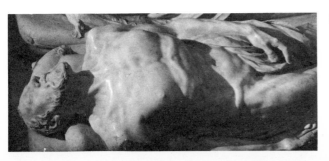

15

16

15. *Desvosge after
Jacques-Louis David.* Funeral
of Lepelletier de Saint Fargeau.
*Pencil drawing. 1793.
Dijon. Musée des Beaux-Arts*

16. *Jacques-Louis David.*
Lepelletier de Saint Fargeau.
*Wash drawing. Paris.
Bibliothèque Nationale*

17. *Jacques-Louis David.* Marat.
*1793. Brussels. Musée
Royal des Beaux-Arts*

18. *Jacques-Louis David.* Bara.
1793. Avignon. Musée Calvet

17

18

19. Delvaux after Monnet, The Goddess of Nature
Unveiled *(engraving in Peyrard,* De la nature et ses
lois, *1793)*

STUDY 11

Ground Plan and Elevation in Masaccio's Trinity Fresco

"Ground Plan and Elevation in Masaccio's *Trinity* Fresco,"
Essays in the History of Art Presented to Rudolf Wittkower,
Phaidon, London, 1967, pp. 83-88

A little more than half a century ago, G. F. Kern published a detailed study of the perspective construction of Masaccio's *Trinity*. [1] His findings—though not his art-historical conclusions—have been so widely accepted that it has remained the only scholarly paper on the subject. These findings may be summarized as follows: the projection of the architectural interior is mathematically correct, permitting us to derive from it an unambiguous ground plan (fig. 1) whose central feature is a square covered by a barrel vault. The figures inside this chapel, on the other hand, fail to show the same mastery of the new scientific perspective; they are not seen *di sotto in su,* as they ought to be, and the position of God the Father in space is irrational, since His feet rest on a platform attached to the rear wall of the chapel while His hands support the arms of the cross, which is in the same plane as Mary and John, near the entrance.

That the perspective of the architecture is accurate enough to yield an unambiguous ground plan is certainly true, but in every other respect Kern's analysis leaves ample room for doubt. It contains, in fact, one gross factual error, which should have alerted Masaccio scholars not to take Kern's reliability for granted. The author states that he took all important measurements from the fresco itself, [2] yet the only figure he cites—the depth and width of the area covered by the barrel vault—is far off the mark: 320 cm, more than the maximum width of the entire fresco. [3] While the depth of the area in question (VTZG; fig. 1) is conjectural, its width can be measured directly; it corresponds to the distance between the pilasters, which is 204 cm. Nor can Kern's figure be a printer's error. It agrees with the scale included in his perspective diagram, [4] according to which the width of the mural is 490 cm, the width of the aisle of S. Maria Novella 685 cm, and the distance between the central and the lateral vanishing points (i.e., the distance of the beholder from the picture as set by the artist) 775 cm. Only one of these figures is correct: the width of the aisle, measured

[1] "Das Dreifaltigkeitsfresko von Santa Maria Novella, eine perspektivisch-architektur-geschichtliche Studie,"*Jahrbuch der königlich preussischen Kunstsammlungen,* XXXIV, 1913, pp. 36–58.

[2] *Ibid.,* p. 39, footnote.

[3] This width, including the protrusions beyond the vertical edges, is 317 cm; see Eve Borsook, *The Mural Painters of Tuscany,* London, 1960, p. 143. Without the protrusions, the width of the fresco is just under 300 cm.

[4] Kern, *op. cit.,* p. 38; this is the only one of Kern's drawings to show a scale.

from the wall to the center of the piers. If we change the scale in Kern's diagram to accord with the actual size of the mural, the distance of the beholder as determined by Kern becomes 520 cm, only three-quarters the width of the aisle and suspiciously short. Kern was quite unaware of the confusion, since in his text he claims to have corroborated Schmarsow's observation that the distance of the beholder approximately equals the width of the aisle.[5] An error of 35 percent in these basic measurements makes one wonder about the trustworthiness of Kern's conclusions regarding the shape of the area covered by the barrel vault.

The vault, as Kern correctly observed, consists of seven bands of eight coffers each, the nearest band hidden from the beholder by the arch over the entrance to the chapel. In order to fit this vault over a square, Kern is forced to assume that the coffers are not uniform squares but rectangles of varying sizes, the two rows at the top of the vault being the most nearly square, those at the bottom the most elongated. Is it likely that Masaccio—or Brunelleschi, if we grant him the role of consultant—planned such irregular coffers? To maintain this is about as plausible, it seems to me, as to claim that the columns in the *Trinity* were intended to have oval instead of circular cross sections. While oblong coffers and oval columns are not entirely unknown in later times, neither belong to the architectural vocabulary of classical antiquity or would be conceivable in any design based on the style of Brunelleschi. If in the fresco the two bottom rows of coffers, half concealed behind the columns of the entrance, appear elongated in relation to the rest (as in fact they do), we must regard this as a slip—or perhaps an intentional departure from accuracy to mitigate the extreme distortion of these coffers—in the process of executing the mural, rather than as part of the plan of the architectural structure. That Masaccio had a ground plan of the chapel, and that this ground plan must have reflected the thinking of Brunelleschi, can hardly be doubted; how else could he have worked out a perspective view so intricate and precise? We must also postulate that the plan of the chapel was a square; a less regular form would be inconsistent with the solemnity of the subject.[6] But the plan of the chapel is not coextensive with the barrel-vaulted area. The interior depicted by Masaccio includes, in addition, four space compartments: two on the flanks (containing the four columns on which the barrel vault rests), the entrance area, and its counterpart in the rear of the structure. In Kern's plan (fig. 1), these four compartments have identical dimensions, so that, together with the square of the vaulted area, they form a Greek cross. Here, however, Kern disregards a bit of visual evidence which he explicitly acknowledges elsewhere in his paper.[7] The columns at the entrance—and their counterparts in the rear—are set so closely against the wall that about one-quarter of the (originally square) abacus has been cut off. These abacuses, then, are rectangles of the ratio 4:3, with the shorter side toward the beholder. Their longer side defines the depth of the entrance area and its equivalent in the rear, while the shorter

[5] *Ibid.*, p. 43.

[6] On the pervading importance of the square as a "perfect figure" in Renaissance religious architecture, see Rudolf Wittkower, *Architectural Principles in the Age of Humanism*, London, 1952, *passim*.

[7] Kern, *op. cit.*, pp. 38 (diagram) and 39.

side corresponds to the width of the lateral compartments.[8] Thus the lateral compartments are narrower than those at the front and rear, and the complete symmetry of Kern's ground plan becomes illusory. Another argument against the assumption that the barrel vault covers a square is purely aesthetic: if it did, the interior of the chapel would give the impression of being wider than it is deep, since in the perspective view the lateral space compartments are partly visible while those in the front and rear do not enhance the depth aspect of the interior (note that the arch over the entrance obscures the first band of coffers). In order to balance the *apparent* width and depth of the chapel, Masaccio had to make the vaulted area oblong rather than square; and the barrel vault in the fresco does, in fact, look deeper than it is wide.

How did Masaccio manage to design a square ground plan for his chapel despite the oblong shape of the vaulted area? I suggest that he did so by making a square of the vaulted area *plus* the lateral compartments; the front and rear compartments he treated as "entrances" that do not form part of the chapel proper (fig. 2). In order to retrace the steps by which he arrived at this solution, we shall find it helpful to measure the component parts of the structure, not in centimeters but in the unit employed in Florence at the time, i.e., the braccio (58.36 cm). For our purposes, the half-braccio, or palmo (29.18 cm), is even more convenient; the scales in figures 2 and 3 are calibrated in palmi. It turns out that the distance between the pilasters in the fresco, and thus the diameter of the barrel vault, equals seven palmi (204 cm); the width of the abacus over the columns at the entrance, which as we have seen equals the width of the lateral space compartments, is one palmo. The total width of the chapel interior, therefore, is nine palmi, and its depth—i.e., the length of the barrel vault— must also be nine palmi (leaving aside the "entrance areas"). The true size of the coffers cannot be measured directly, since the nearest visible band of them is more than two palmi behind the picture plane, but it is clear that they are three times as wide as the intervening ridges (excepting the anomalously elongated first and last sets of coffers). Masaccio's choice of seven palmi as the diameter of the vault (by trial-and-error or calculation) must be regarded as a singularly fortunate one, since it made the circumference of the vault another integer, eleven palmi ($r\pi = 3.5 \times 3.1416 = 10.996$).[9] By making each coffer one palmo square, and the width of the ridges a third of a palmo, he achieved an even distribution of eight coffers and nine ridges over the full length of the circumference by the simplest of arithmetic ($8 + \frac{9}{3} = 11$; cf. the lower part of fig. 3). Had he wanted this vault to cover a square area, he could have done so easily enough; for five bands of coffers, plus six ridges, would

[8] By analogy, we must assume that the columns in the lateral compartments are as close to the wall as those at the entrance.

[9] Seven is the only simple integer which, when taken as the diameter of a semicircle, yields a circumference closely approximating another integer. Did Masaccio learn this from Brunelleschi, or did he consult a mathematician such as Paolo Toscanelli or Fra Ubertino Strozzi? The latter, a Dominican, was living in the monastery of S. Maria Novella in the early fifteenth century, according to P. Vincenzo Marchese, O.P., *Memorie dei più insigni pittori . . . domenicani*, Florence, 1845, I, p. 275, who cites Borghiniani's chronicle of S. Maria Novella (II, p. 217, *ad ann.* 1413). The chronicle has recently been published in its entirety by Stefano Orlandi, O.P., in his *Necrologia di S. Maria Novella*, Florence, 1955. The ratio of the circumference of a circle to its diameter, 22:7, had been known to mathematicians ever since Archimedes.

have made the depth of the vault seven palmi—the same as its diameter. Instead, he chose to make the vault nine palmi deep, and in order to do so he added an extra band of coffers in the front and rear but omitted the accompanying ridges, so that the farthest band of coffers abuts directly against the arch of the "rear entrance," as is clearly visible in the fresco.

We might pause at this point to inquire how Kern arrived at the—in my view, mistaken—conclusion that the vaulted area is a square. The analytical drawings he provides are entirely consistent within themselves, despite the confusion of scales mentioned earlier, and yield the result he claims; the source of the trouble is the diagrammatic representation of the painted architecture, which does not simply record the principal lines of the fresco but simplifies and "idealizes" them. Thus, in his diagram, all the orthogonals meet perfectly in a single vanishing point just below what was then the bottom line of the picture, i.e., the platform with the kneeling donors. In reality, the level of the vanishing point cannot be fixed with precision. All the available orthogonals are comparatively short, far above the vanishing point, and close together; they converge at rather sharp angles, so that the exact point of intersection is difficult to establish. Some of them are blurred by the damaged condition of the surface, and must have been even harder to make out before the recent cleaning and restoration. A few do indeed appear to meet at the spot indicated by Kern, but others meet at a lower level. Kern simply selected the highest among several possible vanishing points, under the impression that it corresponded to the average beholder's eye level.[10] That Masaccio placed the vanishing point at what he considered normal eye level does indeed seem highly plausible. But Kern, of course, did not know at what height above the church floor the fresco had been before its transfer to the façade wall. Now that, thanks to Ugo Procacci, the mural has been returned to its original location and reunited with its lower portion, the skeleton in the niche (fig. 5), it is apparent that Kern's vanishing point, 175 cm from the floor, is too high. It demands a beholder some 184 cm tall, a good deal above average in present-day Italy and even more so in the Quattrocento, when people were shorter than they are now (as indicated by any collection of suits of armor).[11] What Masaccio regarded as the normal height of human beings is evident from the skeleton in the fresco, which is "lifesize," being exactly in the picture plane; it measures five and a half palmi (160 cm).[12] For Masaccio, normal eye level must thus have been about five and a quarter palmi from the floor, or 153 cm, some 20 cm lower than Kern's vanishing point. Considering the dimensions of the whole mural, this difference may seem unimportant, yet it has considerable significance, as will be seen below.

The lateral vanishing point, or distance point (since it indicates the beholder's distance from the picture as set by the artist), is even more precarious in Kern's

[10] Cf. Kern, op. cit., p. 43.

[11] The present placement of the *Trinity* corresponds exactly to its original one, since a portion of the architrave was found *in situ,* as reported orally by Procacci and noted in Ursula Schlegel, "Observations on Masaccio's Trinity Fresco . . .," *Art Bulletin,* XLV, 1963, p. 21, n. 12. See also figure 7.

[12] From the head of the (restored) cranium to the heel. The donors, though kneeling, are of the same size; see below, p. 220.

diagram than the level of the central vanishing point (i.e., the horizon). Kern locates it by "restoring" the oblong abacus of one of the columns at the entrance to its original square shape, drawing a diagonal through this foreshortened square and continuing it to its intersection with the horizon. Theoretically, the method is unexceptionable; in practice, it cannot be carried out with any precision. The smallest error in reconstructing the square of the abacus—and such errors are impossible to avoid under the circumstances—will cause a minute change in the angle of the diagonal, which will produce a sizable shift of the distance point, and a consequent shift of all the points in Kern's diagram that depend on the location of that point. Moreover, since the two lines whose intersection defines the distance point meet at a rather sharp angle, a lowering of the horizon by as little as 20 cm will displace the distance point some 40 to 60 cm. It would be futile to argue the matter in greater detail. Suffice it to say that the beholder's distance from the picture as determined by Kern—520 cm, as pointed out before—is clearly too short; it ought to be about seven meters, roughly equal to the width of the aisle. We might add, however, that it was not at all necessary for Masaccio to assume a fixed distance of the beholder from the picture. He could—and probably did—achieve a correctly foreshortened image without reference to this distance.[13]

Once we realize the importance of seven palmi as the key measure for the design of the vault, we may hope to discover the same unit elsewhere in the fresco. Such is indeed the case, as evidenced by figure 4, which shows a grid, calibrated in palmi, superimposed on a photograph of the mural in its present state.[14] The most striking recurrence of seven palmi is the distance from the

[13] See H. Wieleitner, "Zur Erfindung der verschiedenen Distanzkonstruktionen in der malerischen Perspektive," *Repertorium für Kunstwissenschaft*, XLIII, 1920, p. 254. The distance point in the fresco can be verified—and the degree of Masaccio's accuracy measured—by a simple method, which Kern surely knew but failed to utilize, based on the difference between the apparent height of the vault and columns in the rear of the chapel and their real height (i.e., the height of the vault and columns at the entrance), as shown in figure 2. In this longitudinal section, the length of the vault is assumed to be nine palmi, and the horizon is placed five and a quarter palmi above the church floor. The visual ray descending from the top of the vault in the rear passes through the surface of the picture at *a* (four and one-third palmi lower than the real height of the vault) and intersects the horizon at A, 24½ palmi (7.15 m) from the wall. The ray descending from the abacus of the columns in the rear ought to intersect the horizon at the same point, but does so at B, somewhat closer to the wall (23 palmi, or 6.71 m). The two rays meet at C, 28½ palmi (8.30 m) from the wall and three palmi (88 cm) above the floor of the church. In a fully consistent perspective projection these three points would coincide. C obviously is not the true distance point, being more than two palmi below the horizon as determined by the convergence of the orthogonals. Who is at fault here, we wonder—we or Masaccio? If the fault were ours, it should be possible to make the two rays meet at the horizon line by changing the variables in our diagram, i.e., the level of the horizon and the length of the vault. But this proves to be impossible: if we raise the horizon to the level postulated by Kern (it obviously cannot be lowered), we increase the distance between A and B; and if we shorten the vault to seven palmi in accordance with Kern's ground plan, we move A and B closer to the wall but the distance between them remains unchanged (A would be 18 palmi, or 5.25 m, from the wall, B 16½ palmi, or 4.81 m). The fault, then, is Masaccio's: there is an error of slightly more than six percent in his perspective projection—not a very serious one, since it can be detected only by measurement rather than by direct inspection, but an indication that he very probably did not take a fixed distance of the beholder from the wall as his starting point.

[14] The photo, Soprintendenza neg. no. 104648, has been taken with such care that it shows no significant linear distortion horizontally or vertically. I have verified this by checking a number

218

floor of the church to that of Masaccio's chapel. Seven palmi above the chapel floor we reach the bottom line of the arms of the cross. The apex of the vault (i.e., the bottom line of the entablature) is exactly twenty palmi from the floor of the church. The abacuses of the columns at the entrance are three and a half palmi below the entablature, as we would expect; but it is something of a surprise to find that the abacuses of the columns in the rear are three and a half palmi below those in front. Thus the perspective projection of the vault is inscribed within a square of seven palmi on the picture plane, in what seems to be an attempt to harmonize surface design and depth. The harmony is somewhat forced, however, as shown by the two distance points in figure 2. In order to make distance point A coincide with B, Masaccio should either have made the rear columns a bit taller, or the rear arch somewhat smaller.

By perusing figure 4, the reader will readily find other important distances measured in whole palmi, such as that from the church floor to the rear edge of the skeleton's sarcophagus (three palmi) and that from the church floor to the top of the donors' heads (ten palmi, halfway from the church floor to the entablature). At present, the height of the kneeling donors is somewhat less than four palmi. However, as Ursula Schlegel has pointed out, the true edge of the platform on which they kneel is lost, and the present edge the work of restorers (see fig. 7). She suggests that the donors originally knelt at a slightly lower level (see fig. 6). In the grid of figure 4, this would be exactly the six-palmi line above the church floor, and the donors' height would then become exactly four palmi—an interesting confirmation of Miss Schlegel's conjecture. Our grid also lends support to another aspect of Miss Schlegel's reconstruction: the area covered by the fresco, she believes, must have been slightly wider and taller than it is today, to accommodate a painted frame. By extending the present edges of the mural at the top and sides to the nearest whole palmo, we gain the additional margin needed for such a frame. The original height and width of the mural were in all likelihood twenty-three and eleven palmi, respectively.

What could have been the purpose—or, better, purposes—of the numerical relationships pervading the *Trinity*? They bring to mind, of course, the Pythagorean tradition of harmonious numbers, whose significance for Renaissance architecture has been pointed out by Rudolf Wittkower.[15] They also serve to correlate ground plan and elevation, surface and depth. Finally—and this is by no means their least important function—they made it possible for Masaccio to transfer his complex and exacting architectural design intact from the small scale of the preparatory drawings to the "lifesize" scale of the fresco. No earlier artist had had to face this task, hence no established procedure was available. The architecture in Gothic painting, whether conceived as background or (in the case of interiors) as a "cage" for the figures, invariably lacks the structural solidity, the consistent scale of real buildings, even when it portrays existing structures such as Florence Cathedral. The third dimension may be effectively suggested but is never measurable. Masaccio, in contrast, wanted the chapel of the *Trinity* to

of measurements based on the photo against the same measurements in the original, and in the tracing of the fresco, made by Leonetto Tintori, in the Uffizi.

[15] *Op. cit.*

be as measurable in every respect as an actual piece of Brunelleschian architecture. Thus the Trecento technique of large-scale preparatory drawings (sinopie) on the first coat of plaster (arriccio), which were covered up area by area as the second coat (intonaco) was applied for each day's work of painting (giornata), would obviously not have been precise enough for his purpose; and there is no indication that he ever made a sinopia on the arriccio of the *Trinity*.[16] The time it took Masaccio to paint the mural could not have been much more than a month;[17] the work is done almost wholly in true fresco technique, with a minimum of additions "a secco." Nor did he use the cartoon method, which made its appearance only in the 1440s.[18] How, then, did he proceed? Did he superimpose a uniform grid of squares on his final drawing and transfer the entire design to a corresponding grid on the wall? There are remains of grid lines on the surface of the fresco, but these, as Oertel has pointed out, cover only limited areas (the figure of Mary and the capitals) and the several "islands" of grid lines are unrelated to each other; they did not form part of an over-all system but served only for the transfer of certain particularly difficult details. For the composition as a whole, Masaccio must have relied on a different method that has left no visible trace: a grid not mechanically superimposed but one whose lines represented the main horizontal and vertical divisions of the design. He could, for instance, have marked the vertical divisions by plumb lines hanging from a board attached to the wall above the mural, and the horizontals by strings weighted at both ends and passed over hooks driven into the wall on either side of the working area. Such an arrangement would have permitted him to move the strings out of the way and put them back in place as needed. But in order for the system to be workable, the intervals had to be defined as simply as possible—in whole palmi or half-palmi.[19]

The standardization of measurements we have seen in the architecture of the

[16] When the main portion of the fresco was transferred, about 1860, only the intonaco was detached from the wall; the arriccio was destroyed. There is no record of what if anything appeared on its surface. (If it had held drawings comparable to the sinopie underneath the *Triumph of Death* in the Camposanto in Pisa, one might expect someone to have noted the fact.) After the return of the upper part of the mural to its original location in 1952, the bottom part, which had always remained *in situ*, was stripped from the wall (and then reattached), to see if the arriccio held a sinopia; there was none. I am indebted for the above information to Leonetto Tintori, who was in charge of the entire project. In Piero Sanpaolesi's monograph on Brunelleschi (Milan, 1962) there are two illustrations (figs. 24, 25) described in the captions as tracings after the sinopia of the *Trinity;* they actually reproduce the tracing of the mural itself referred to in note 14 above.

[17] Leonetto Tintori was kind enough to tell me that he has discerned 24 giornate and thinks that there may have been a few more.

[18] See Robert Oertel, "Wandmalerei und Zeichnung in Italien," *Mitteilungen des kunsthistorischen Instituts in Florenz*, V, 1940, pp. 309 ff. Oertel, however, postulates the existence of a sinopia, an assumption which, in the light of Tintori's findings, is almost surely mistaken, since it is hard to believe that Masaccio made a sinopia for the upper part of the fresco but not for the lower part.

[19] Common fractions are awkward to calculate with, and decimal fractions were unknown until the seventeenth century. A detailed study of the partial grids must await publication of the full report of the restoration of the mural by Procacci and Tintori. For the capitals the horizontal intervals of the grid, according to Oertel, are 14.8 cm each, closely approximating half of a palmo (14.6 cm), while over the figure of Mary, oddly enough, the grid intervals vary from 12.5 to 13.9 cm but are always less than half a palmo (in the area of the head, the squares of the grid are subdivided into sixteen smaller squares). Could this be an experiment in proportional diminution so as to render the figure more accurately *di sotto in su*?

Trinity may also be observed in the figures. The skeleton, we recall, is lifesize, five and a half palmi. The donors must have been intended to have the same scale. Kneeling, they are four palmi tall, if we accept the slight lowering of their platform advocated by Miss Schlegel; were they shown standing, they would very probably be five and a half (i.e., the tops of their heads would be on a level with those of Mary and John).[20] We may conclude from this that donors and skeleton are at the same distance from the beholder. The sarcophagus is directly beneath the donors' platform, and the depth of both is identical—if the skeleton were placed three palmi higher, it would rest on the donors' platform but would retain its present size. The four figures inside the chapel occupy a spatial zone that is about two palmi farther from the beholder, and their height, therefore, is less: five palmi, with slight variations. Christ, measured from the heel to the top of the head, is exactly five palmi, God the Father a bit more (about 5.2 palmi), perhaps in order to leave enough space for the dove, while John is four and a half and Mary four and two-thirds. The feet of the latter two figures, however, are hidden from the beholder; if we allow for this by adding half a palmo to John, and a third of a palmo to Mary (who seems somewhat closer to the entrance), they too become five palmi tall.

The lesser height of the figures inside the chapel, as against those outside it, takes account only of their greater distance from the beholder measured along a line perpendicular to the wall; that we see them from below (so that, e.g., the feet of Christ are a good deal closer to the beholder's eye than is His head) is disregarded as a factor in reducing their apparent height. The same is true, of course, of the architecture—the apparent width of pilasters and columns remains constant throughout their length; if the pilasters had horizontal instead of vertical flutes, these too would have the same size at the bottom as at the top. Parallel lines running at right angles to the plane of the horizon are not permitted to converge in Early Renaissance perspective, regardless of their length. In extreme cases, such as the upper part of the triumphal arch in Mantegna's *St. James Led to His Execution* in the Eremitani or in the Ionic capitals of the *Trinity,* this rule produces oddly distended shapes. Had Masaccio applied the rule to the figures of Christ and God the Father as rigidly as he did to the capitals (he attempted it in the face of Mary), the results would have been frightening. His lack of consistency here is thus entirely understandable, even though Kern censures him for it.

More consequential is Kern's complaint that God the Father arches illogically through the space of the chapel, His feet resting on a platform attached to the rear wall while His hands support the arms of the cross close to the entrance. Until very recently, this view seems to have been shared by every scholar who commented on the fresco, including Krautheimer,[21] Tolnay,[22] and Schlegel.[23]

[20] There is, of course, no exactly fixed relationship between the height of a given figure kneeling and standing, but experiments I have made with normally proportioned adults five and a half palmi tall have yielded a close approximation of four palmi for their height when kneeling in the manner of Masaccio's donors.

[21] Richard Krautheimer and Trude Krautheimer-Hess, *Lorenzo Ghiberti,* Princeton, N.J., 1956, pp. 201, 243.

[22] Charles de Tolnay, "Renaissance d'une fresque," *L'Oeil,* January 1958, pp. 17 ff.

[23] Schlegel, *op. cit.,* p. 26.

Kern had defined the platform—the area $\alpha\beta\gamma\delta$ in his ground plan (fig. 1)— as "offenbar für die Aufnahme eines Sarkophags bestimmt"; he meant, I take it, not that the platform was originally intended to hold a sarcophagus in the fresco but that it resembles the platforms on scroll brackets supporting sarcophagi in Quattrocento tombs like that of Baldassare Coscia. According to Tolnay, the rectangular area visible above the platform and behind God the Father actually *is* a sarcophagus—the sarcophagus of Christ—rather than the upper portion of a wall or screen closing the rear of the chapel, as assumed by Kern and Schlegel. His interpretation, however, is clearly in error, for the length of the putative sarcophagus cannot be more than five palmi (i.e., the distance between the abacuses of the columns on either side of it), too short for a body of normal size; the sarcophagus of the skeleton is six palmi long, and that of Christ would have to be at least equal to it, unless we wish to tax Masaccio with an error in perspective far graver than any we have found so far in the architecture of the fresco. We must continue, then, to regard the area in question as part of the rear closure of the chapel. But can we be certain that the platform is attached to the rear wall? Or to put the question another way, is the vertical surface above the platform continuous with that below the platform? The only scholar so far to suggest that they are not has been Sanpaolesi; in his Brunelleschi monograph[24] he published a plan and longitudinal section of Masaccio's chapel (unfortunately, without analytical comment) that show God the Father's platform attached to a boxlike structure protruding from the rear wall, so that the front edge of the platform is equidistant from the front and rear of the chapel. In principle this is, I believe, the right solution.[25] Once we accept it as a working hypothesis, we begin to realize that Masaccio has carefully differentiated the two surfaces. The area above the platform is framed by a carved molding, while the one below is divided into vertical panels by means of inlaid strips of dark marble (fig. 8). The latter surface, moreover, shows a clearly defined shadow cast by John;[26] it must be located immediately behind that figure and thus cannot be the rear wall. The vertical plane to which God the Father's platform is attached would then be about three palmi from the entrance to the chapel; its height (including the shelf) would be equal to that of Mary and John, i.e., five and a half palmi in a longitudinal section of the chapel. Since God the Father, too, is five and a half palmi tall, the top of His head would be eleven palmi above the chapel floor, or two palmi below the apex of the vault. If the above reading of the visual evidence is correct, Kern's claim that the position of God the Father is spatially ambiguous must be abandoned. But we are now faced with a new problem: how to interpret the nature and significance of the object that supports God the Father's platform.

[24] Sanpaolesi, *op. cit.*

[25] In other respects, Sanpaolesi's drawings show many of the same faults as Kern's, including discrepancies of scale (in one of them, the horizon is 182 cm above the floor of the church, in another only 140 cm). Sanpaolesi also shares Kern's opinion that the area covered by the barrel vault is a square. Since the drawings are unaccompanied by verbal explanations, one wonders to what extent they represent the views of the draftsman, rather than the author's.

[26] I am grateful to John Coolidge for drawing my attention to this feature. Leonetto Tintori assures me that the shadow, which was invisible before the recent cleaning of the fresco, is entirely authentic.

Its height, as we saw, must be five and a half palmi; its width can be inferred, approximately, from the length of the platform, whose right-hand corner is visible just below John's chin (fig. 8). The object in question, then, appears to be about four palmi wide. Of its depth we have no indication; if it extends all the way to the rear of the chapel, it could be six or seven palmi. Is the object, as Sanpaolesi's drawing suggests, a kind of architectural promontory thrust forward from the rear wall for the sole purpose of bringing God the Father's platform close to the plane of the cross? I prefer to think of it as a tall box rising from the chapel floor, a piece of church furniture rather than part of the architecture of the chapel. Masaccio gives us a strong hint as to what kind of church furniture the box might be: the three panels on its front, outlined by inlaid strips of dark marble, strikingly resemble the three panels, again defined by inlaid strips, on the front of the skeleton's sarcophagus. Unless we are willing to dismiss this relationship as fortuitous, it indicates that God the Father's box, too, is a tomb, although a far more monumental one than that of the Everyman skeleton below. This could only be the sepulcher of Christ, its long axis placed at right angles to that of the skeleton's sarcophagus. Tolnay, then, was right in claiming that the sarcophagus of Christ is shown in the picture, even though he located it in the wrong spot. The presence of Christ's sepulcher, strange as it is, does not necessarily upset Miss Schlegel's interpretation of the symbolic meaning of the chapel itself. It may, however, lead her to modify some of her conclusions.

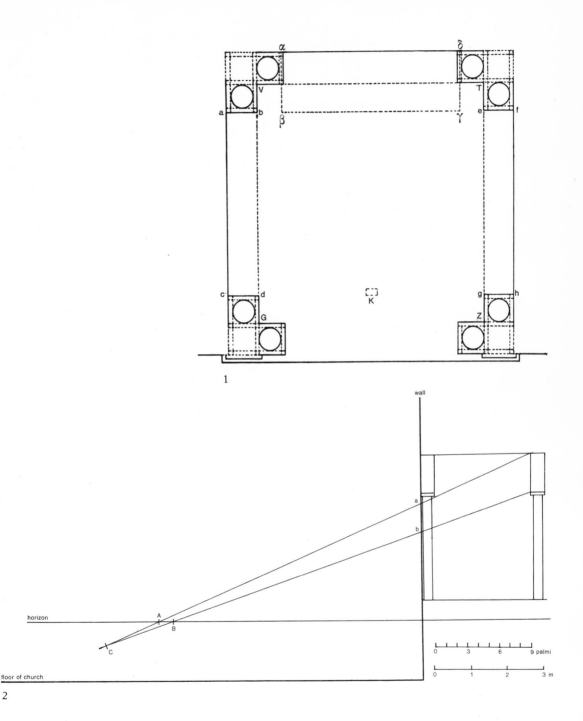

1

2

1. *Ground Plan of Chapel in Masaccio's* Trinity
(*from Kern*)

2. *Longitudinal Section of Chapel in Masaccio's*
Trinity, *based on figure 3*

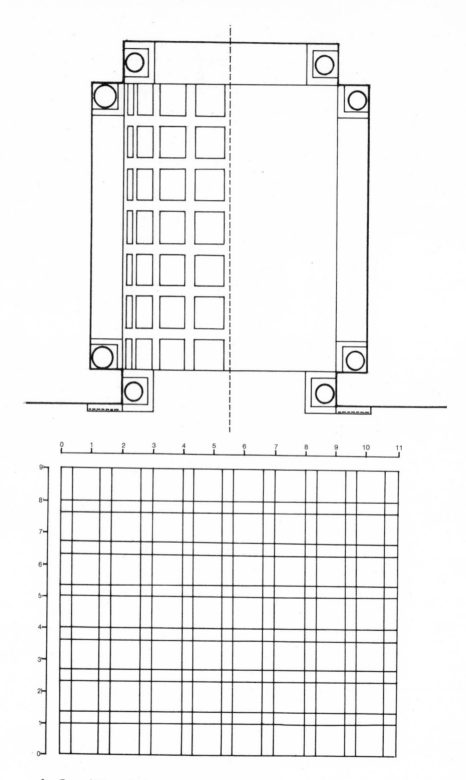

3. *Ground Plan of Chapel in Masaccio's* Trinity,
as here proposed (scales are calibrated in
palmi: 1 palmo = 29.18 cm)

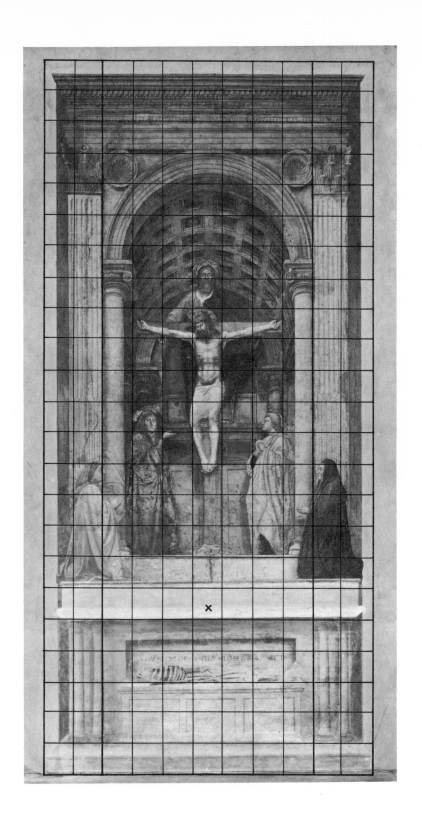

*4. Grid calibrated in palmi, superimposed on
figure 5*

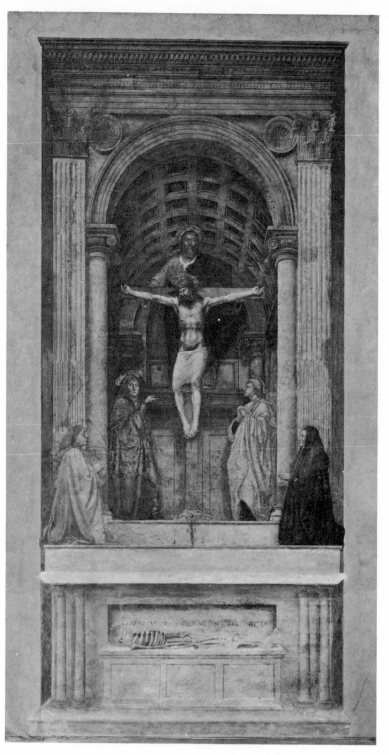

5. *Masaccio*, The Holy Trinity with Mary, St. John, Two Donors, and a Skeleton. *Florence, S. Maria Novella*

6. *Reconstruction of the Original Appearance of figure 5 (from Schlegel)*

7. *Masaccio*, The Holy Trinity *(main portion). Before restoration; lost areas outlined by Leonetto Tintori*

6

7

8. *Masaccio*, St. John, *detail of figure 5*

12

STUDY

*Rodin and
Carrier-Belleuse:
The Vase des Titans*

"Rodin and Carrier-Belleuse: The *Vase des Titans*,"
Art Bulletin, Vol. L, 1968, pp. 278-80

The exhibition "Rodin, ses collaborateurs et ses amis," held at the Musée Rodin in Paris in 1957, included a terra-cotta vase signed "A. Carrier-Belleuse."[1] It shows four nude male figures seated on a circular base in a variety of strained poses, their backs supporting a shallow bowl. The following year the Parke-Bernet Galleries, New York, sold two maquettes attributed to Rodin which, according to the catalogue, had been cast "in Paris from an original mold during Rodin's lifetime."[2] They now belong to the Houston Museum of Fine Arts (figs. 13, 15, 23, 24).[3] As Albert Alhadeff has pointed out, this pair of figures matches two of those on the Carrier-Belleuse vase.[4] Since he knew the vase only in the single view reproduced in the catalogue of the 1957 exhibition and met with the customary lack of response in his efforts to obtain additional photographs from the Musée Rodin, he could establish the correspondence between the Houston figures and those on the vase for only one of the two maquettes (figs. 13, 15) but correctly surmised that the same would be true for the other. Stylistically, their attribution to Rodin is incontestable; hence, as Alhadeff put it, "the current acceptance of the signature on the Carrier-Belleuse vase presents a difficult anomaly," since Rodin had repeatedly worked for Carrier-Belleuse. The latter, according to Alhadeff, merely rendered Rodin's maquettes in their completed form when he composed the vase. Since then, the vase has been reproduced, under the title *Vasque des Titans ou Coupe Carrier-Belleuse,* by Descharnes and Chabrun as "en réalité sortie des mains de Rodin," but with no reference to the Houston maquettes.[5] The catalogue of Rodin's oeuvre by Jianou and Goldscheider, on the other hand, omits the vase but includes the two Houston figures, as *homme assis* and *étude,* without mentioning their relationship to the vase.[6] They are assigned to the year 1887, a puzzling date in view of Alhadeff's persuasive arguments for placing them in the late 1870s. A pair of maquettes duplicating the Houston figures was recently sold at Sotheby's

[1] *Catalogue,* item 6, "Vasque Décorative, coll. Raymond Lévy."

[2] Hume Cronyn and Jessica Tandy Collection, sale Jan. 15, 1958, lots 41 and 42.

[3] Robert Lee Blaffer Memorial Collection; accession nos. 58–20a, 58–20b.

[4] "Michelangelo and the Early Rodin," *Art Bulletin,* XLV, 1963, p. 366 and fig. 8.

[5] Robert Descharnes and Jean François Chabrun, *Auguste Rodin,* Geneva and Paris, 1967, p. 42. In the caption, the location of the *Vasque* is given as the Musée Rodin (which presumably acquired it from the Raymond Lévy Collection).

[6] Ionel Jianou and Cécile Goldscheider, *Rodin,* Paris, 1967, p. 93.

(figs. 12, 21);[7] they were said to have come from Othilo Pesci, one of Rodin's assistants, who received them from the master as a parting gift. A third set of maquettes, evidently cast from the same molds as the Houston and Sotheby sets but including all four of the figures on the vase, appeared on the London art market at the same time (figs. 8, 14, 18, 19, 25).[8] Of the vase itself there are two replicas in the collection of David Barclay, Ltd., London; unlike the specimen in the Musée Rodin, however, these are unsigned, and made not of terracotta but of light gray plaster mixed with fine sand, which accounts for their grainy surface texture and less detailed finish (figs. 3, 4, 5, 6).

The key to the relationship of all these objects is to be found, rather unexpectedly, in a place that because of its remote location on the northern bank of the Columbia River one hundred miles east of Portland, Oregon, must be counted among America's least-known public art collections: the Maryhill Museum. It owns a signed terra-cotta specimen of the *Coupe Carrier-Belleuse* exactly duplicating the one in the Musée Rodin (figs. 1, 2), as well as four splendid terracotta maquettes for the figures, which, unlike those in Houston and London, are originals by Rodin rather than casts made from molds (figs. 7, 9, 10, 11, 16, 17, 20).[9] Before we proceed any further, it seems advisable to establish a numbering system for these figures. While the vase has no principal view, the location of the signature (identical in the Musée Rodin and Maryhill examples) provides a convenient fixed point. We shall, then, dub the figure to the left of the signature *Titan I* and his neighbor to the right *Titan II* (fig. 1). Going counter-clockwise, we reach *Titan III* (fig. 2, left) and *Titan IV* (fig. 2, right). The Houston set, as well as its duplicate sold at Sotheby's, thus consists of *Titan II* (figs. 13, 15, 12) and *Titan IV* (figs. 23, 24, 21).

Rodin's work for Carrier-Belleuse is not documented in detail, and will presumably remain so until the Rodin archives become accessible to scholarship.[10] It extended from 1864, the year Rodin entered the older master's workshop, to 1879-82, when he worked for the Sèvres factory under the general supervision of Carrier-Belleuse, who had been made head of the design section—"directeur des travaux d'art"—in 1875.[11] Alhadeff has suggested that the *Vase des Titans* was designed for Sèvres, but this cannot be true for several reasons. Rodin's work for Sèvres is fully documented, thanks to Roger Marx, who published all the master's "time sheets" submitted to the factory (Rodin was paid by the hour) and a complete list of all the pieces designed by Rodin.[12] These labors consisted entirely of surface decoration in drawing and low relief; the list does not contain a single project remotely comparable to our vase. Moreover, Sèvres was, and is, a porcelain factory that never produced any work in unglazed

[7] June 28, 1967, lots 17 and 18; the catalogue, oddly enough, illustrates the Houston maquettes, not those in the sale.

[8] I am indebted to Mr. David Barclay for my acquaintance with these maquettes.

[9] The director, Mr. C. R. Dolph, kindly permitted me to photograph and publish these works. They were acquired between 1915 and 1922 by Samuel Hill, the founder of the museum, either from Rodin or Loïe Fuller. Cf. Peter Selz in Albert E. Elsen, *Rodin*, New York, Museum of Modern Art, 1963, p. 203 n. 28.

[10] See the editorial in *Burlington Magazine*, 109, 1967, p. 605.

[11] Descharnes-Chalbrun, *op. cit.*, pp. 47, 62.

[12] *Rodin céramiste*, Paris, 1907.

terra-cotta, while Carrier-Belleuse and his studio turned out hundreds of pieces in that material. The *Vase des Titans* must have been one of these, issued in a "limited edition" of unknown quantity. Two specimens (perhaps those now in the Musée Rodin and at Maryhill) are listed in the catalogue of Carrier-Belleuse's works offered for public sale after the artist's death in 1887, as "Les Titans, Jardinière, terre cuite, 80 cm."[13] The only puzzling aspect of this entry is the size of the vases—presumably the height—which is about twice that of the known examples.[14] The two jardinieres may have had a tall base or, more probably, a separate large vessel resting in the shallow bowl. Both of these features are present in Carrier-Belleuse's original conception of the vase, which may be seen in a signed drawing, inscribed "V[ase] des Titans"; it was published in 1884 as No. 173 of two hundred of the artist's designs under the collective title *Application de la figure humaine à la décoration et à l'ornementation industrielles* (fig. 22),[15] with the caption "Les titans (Vase faïence et terre cuite. Piédestal pierre et bronze)." The vase proper, then, was to have been of faïence. The truncated fluted column that forms the base would have been of stone, girdled by a bronze band with a frieze of figures in relief. The subject of that frieze cannot be discerned in the drawing; it may have been the struggle of the Titans against the gods of Olympus. The role of the four large Titans as atlantes would thus represent their punishment, even though such an explicit motivation was hardly needed. Carrier-Belleuse's drawings in the *Application* portfolios abound in atlantes of every description (fig. 26 is a typical sample), and a quarter-century earlier, during his stay in England, he had designed a large jardiniere for the Minton china factory that anticipates the shape of the *Vase des Titans,* with putti in place of the adult nudes (fig. 28).[16] Still, the atlantes of our vase are exceptional in being identified as Titans; the others in Carrier-Belleuse's oeuvre, as well as their predecessors in seventeenth- and eighteenth-century decorative art, remain anonymous.[17] Carrier-Belleuse himself, on the evidence of his drawing, did not conceive the Titans as tormented beings. Their poses have the fluidity and easy grace characteristic of all the *Application* designs. Rodin, on the contrary, seized upon and exploited the tragic implications of the theme. His Titans, unlike those projected by Carrier-Belleuse, do not form a coordinated "team"; among the Maryhill maquettes, only *Titan II* (figs. 10, 11) has the attitude and function of traditional atlantes, conveying a far greater sense of strain than Carrier-Belleuse gave to such figures (compare fig. 22). The poses of the other Maryhill Titans reflect inner struggle and despair

[13] *A. E. Carrier-Belleuse, catalogue des oeuvres originales . . ., Vente après son décès,* Dec. 19–23, 1887, with introduction by Paul Mantz, lots 69 and 70.

[14] The specimen at Maryhill is 39.5 cm tall, those in London 37 cm. According to the catalogue of the 1957 exhibition, the Raymond Lévy-Musée Rodin vase measures 75 cm, a claim I have been unable to verify but which I suspect is mistaken, since the signature on the Maryhill and Paris examples is of the same size in relation to the height of the vase.

[15] Ten loose-leaf portfolios, Paris, Goupil & Cie.

[16] London, Victoria and Albert Museum, acc. nos. 8111–1863. Carrier-Belleuse designed only the lower part, which is worked separately from the vessel proper and stands 45 cm tall as against a total height of 94 cm—proportions strikingly similar to those of the *Vase des Titans.*

[17] A representative example of the latter kind is the pair of ormolu candelabra, in the shape of vases supported by atlantes, made by Matthew Boulton about 1765 for Sir Lawrence Dundas and now in the Victoria and Albert Museum (fig. 27).

rather than the effort to sustain a heavy burden. This shift of emphasis is particularly instructive in *Titan IV* (fig. 20), whose pose derives from the center figure in Carrier-Belleuse's drawing (fig. 22): Rodin has endowed it not only with a new spatial complexity but with a novel expressive force. In essence, the Maryhill maquettes are four individually conceived and self-contained creations, each enveloped in its own mood. To stress their solitary character, Rodin has placed them on separate mounds whose irregular shapes harmonize with the poses of the figures. He thus anticipates an important aspect of *The Thinker*. Indeed, *Titan III* (figs. 16, 17) has a brooding intensity that places it among the immediate ancestors of Rodin's most famous work.[18]

How are we to visualize the transformation of the four Maryhill maquettes into the figures on the *Vase des Titans*? The first step, clearly, must have been to detach them from their mounds. This, we may assume, was done by making casts of the maquettes in clay and reworking those details that needed it—the back of *Titan I* had to be freed from a mass of material clinging to it (fig. 9), the rock on the shoulders of *Titan II* (figs. 10, 11) needed to be removed, and so forth. Molds were then made of the figures in this "second state"; the maquettes in Houston and London all seem to have been made from these molds. One set of casts was presumably delivered to Carrier-Belleuse, who mounted them on the ring-shaped base of the jardiniere, added swags of drapery to link the figures as best he could, and elaborated the anatomical details.[19] Finally, still another set of molds was made for the finished vase as we see it in the two specimens at Maryhill and the Musée Rodin. The two unsigned casts of the vase in the David Barclay, Ltd., collection were probably made from these molds after Carrier-Belleuse's death. They differ from the signed ones not only in the material but in their less precise surface finish, a shallower bowl, and the lack of a well-defined circular plinth beneath the figures.

Regarding the date of Rodin's Titans, the Maryhill maquettes bear out the arguments advanced by Alhadeff for placing them in the years immediately after the artist's trip to Italy in 1875, which inaugurated Rodin's most intensely Michelangelesque phase and gave his style a new breadth that distinguishes it from the more academically correct modeling of the Loos monument (commissioned 1874) and the related wax study of a male nude in Kansas City.[20] The relation to the *Ignudi* of the Sistine Ceiling, pointed out by Alhadeff for *Titan II* and *Titan IV*, is equally true of the other two Titans, while the mood of all four approaches the early studies for the *Gates of Hell*.

Alhadeff has termed Rodin's work for Carrier-Belleuse an "ignominious ar-

[18] For the rather complex genesis of *The Thinker*, see Albert E. Elsen, *Rodin's Gates of Hell*, Minneapolis, 1960, *passim; idem, Rodin*, pp. 52–57.

[19] The measurements of all the sets of Titans here discussed are in close agreement, so far as I was able to determine, although I have not been able to measure every one of them myself. The lengths of the four figures are approximately as follows: *Titan I*, 31.5 cm; *Titan II*, 33 cm; *Titan III*, 29 cm; *Titan IV*, 26 cm. These values, however, are subject to an error of at least 10 percent. Apart from the difficulty inherent in taking exact measurements of any irregularly shaped three-dimensional object, the several sets of Titans vary in such details as the angle at which hands and feet are attached, since each cast must have been made from a number of partial molds and thus required considerable finishing by hand.

[20] "Michelangelo and the Early Rodin," pp. 366–67.

rangement." In one sense, this is surely correct, yet Rodin reserved for Carrier-Belleuse a respect and affection that he did not feel toward any of the other sculptors under whom he had worked in his younger years. "Carrier-Belleuse," he told Dujardin-Beaumetz, "avait quelque chose du beau sang du XVIIIe siècle. Il y avait du Clodion en lui; ses esquisses étaient admirables; à l'exécution, cela se refroidisait, mais l'artiste avait une grande valeur"[21] His portrait bust of the older master, done in 1882, is equally eloquent testimony of their friendship. It is possible to regard Rodin's warm feeling toward Carrier-Belleuse—or Dalou, for that matter—as a purely personal relationship divorced from the aesthetic sphere; or to explain it as a reflection of Rodin's own conservatism.[22] Neither interpretation is wholly misplaced, yet both imply that Rodin in fact owed little or nothing artistically to such "pontiffs of academic art" as these. Now that Rodin's fame as the grandfather of modern sculpture has been secure for half a century, we are beginning to take a more differentiated and generous view of some of his predecessors and contemporaries. Not all of them, we have come to realize, were mere conservatives in the École des Beaux-Arts tradition. What Rodin said of Carrier-Belleuse—"ses esquisses étaient admirables"—he might have said with even greater conviction of Carpeaux and Dalou. These three, the chief representatives of an eighteenth-century revival in sculpture long rejected by the Ecole des Beaux-Arts, deserve much more attention than they have received so far, not only in relation to Rodin but as significant figures in their own right. Carrier-Belleuse in particular remains practically unknown despite his close link to Rodin. Our analysis of the *Vase des Titans* is intended as a small contribution to such a study.

[21] As quoted in Descharnes-Chabrun, *op. cit.*, p. 35.
[22] Elsen, *Rodin*, pp. 13 ff.

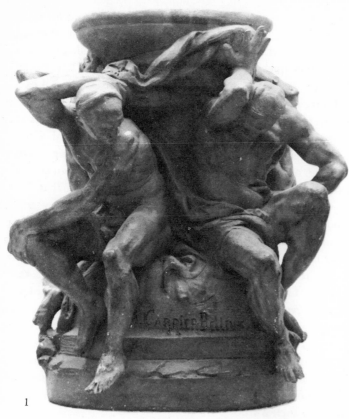

1

1, 2. Rodin and Carrier-Belleuse,
Vase des Titans. *Terra-cotta, late
1870s. Maryhill, Wash., Museum
of Fine Arts*

3, 4. Rodin and Carrier-Belleuse,
Vase des Titans. *Gray plaster;
after 1887 (?). London, David Barclay,
Ltd.*

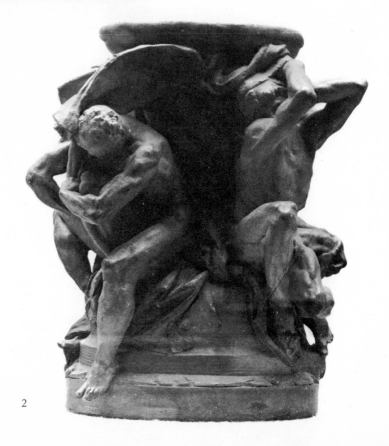

2

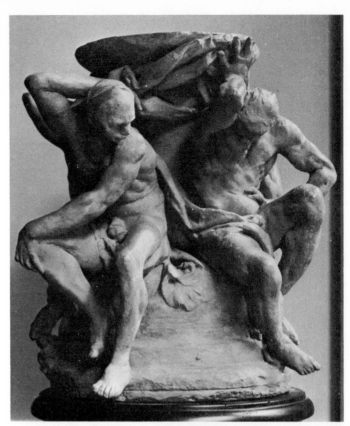

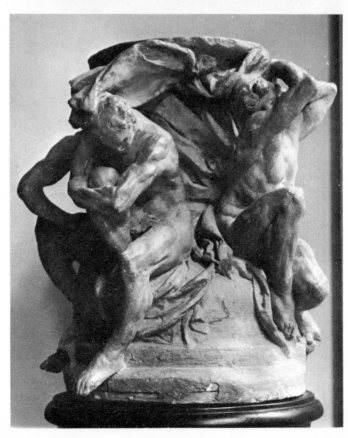

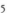

5

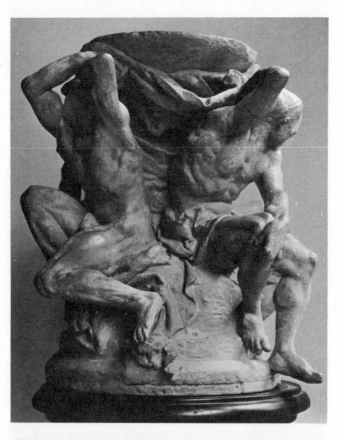

6

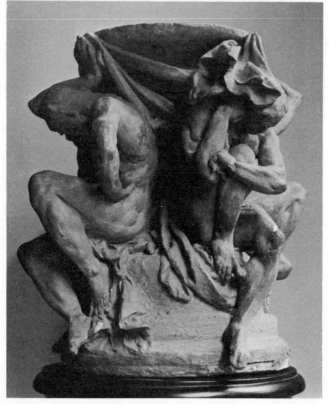

7

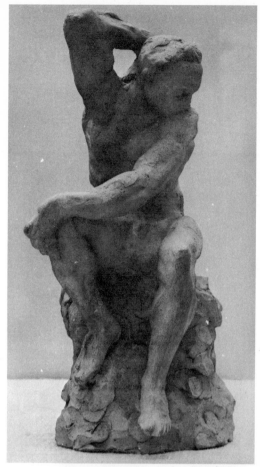

9

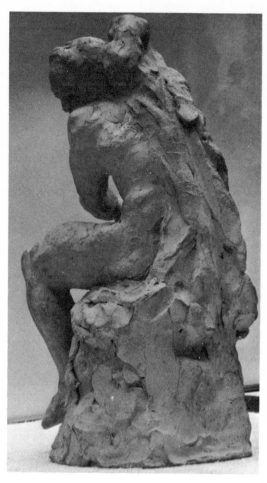

8

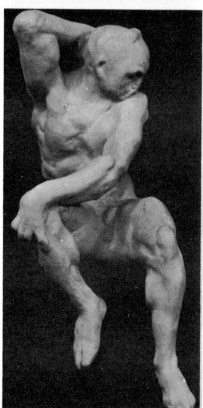

5, 6. *Rodin and Carrier-Belleuse,*
Vase des Titans. *Gray plaster;*
after 1887 (?). London,
David Barclay, Ltd.

Rodin, Titan I. *Terra-cotta, late 1870s*
7. *Maryhill, Wash., Museum of Fine Arts*
8. *London, art market*
9. *Maryhill, Wash., Museum of Fine Arts*

10

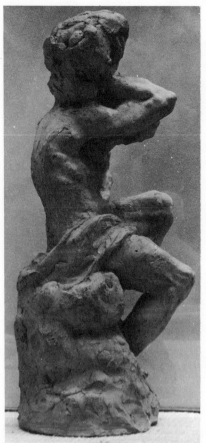

11

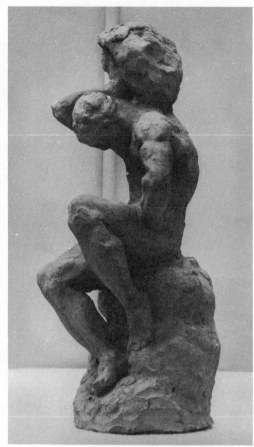

12

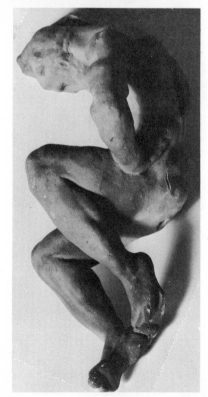

Rodin, Titan II. *Terra-cotta, late 1870s*
10. *Maryhill, Wash., Museum of Fine Arts*
11. *Maryhill, Wash., Museum of Fine Arts*
12. *Private collection (courtesy Sotheby & Co.)*

Rodin, Titan II. *Terra-cotta, late 1870s*
13. *Houston, Museum of Fine Arts*
14. *London, art market*
15. *Houston, Museum of Fine Arts*

13

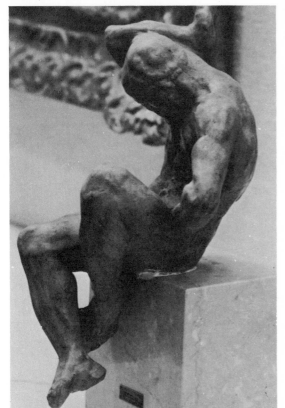

14

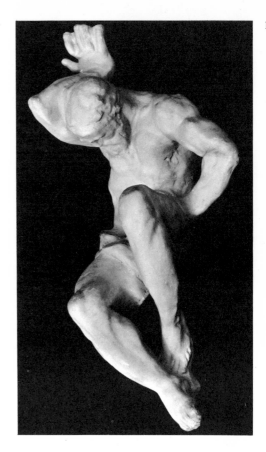

5

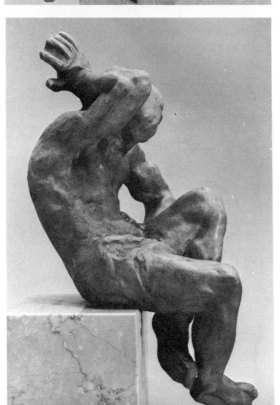

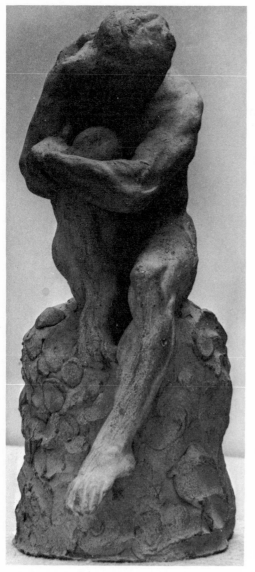 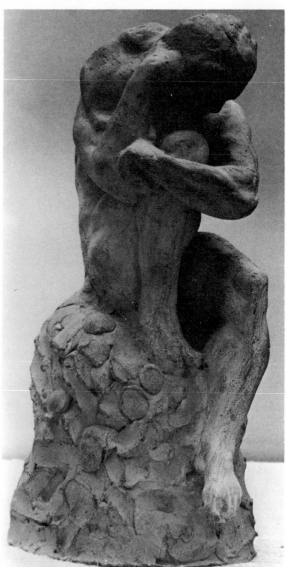

16 17

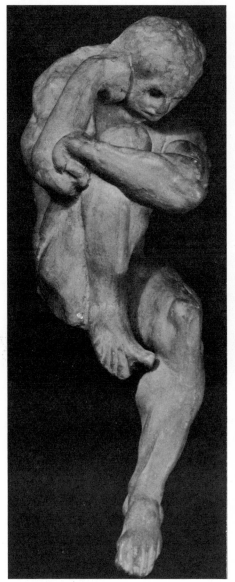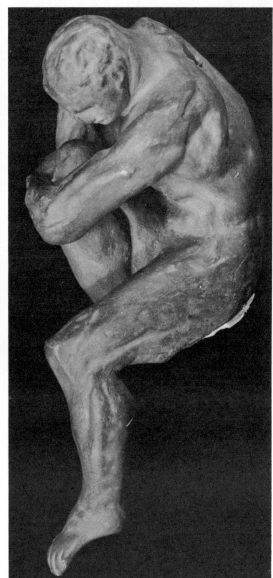

18 19

Rodin, Titan III. *Terra-cotta, late 1870s*
16. *Maryhill, Wash., Museum of Fine Arts*
17. *Maryhill, Wash., Museum of Fine Arts*
18. *London, art market*
19. *London, art market*

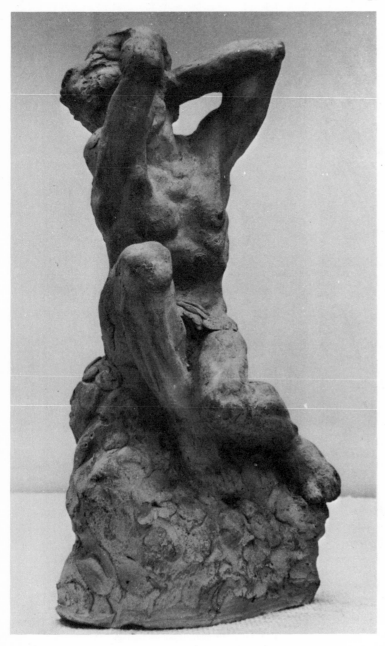

Rodin, Titan IV. *Terra-cotta, late 1870s*
20. Maryhill, Wash., Museum of Fine Arts
21. Private collection (courtesy Sotheby & Co.)

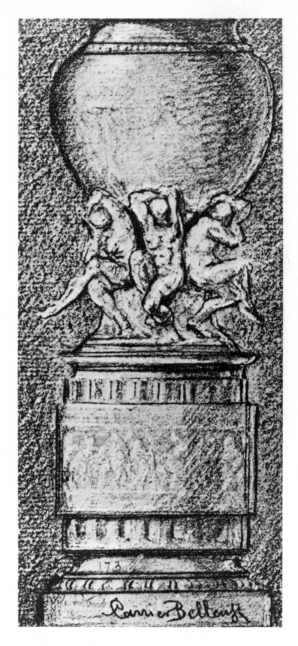

22. *Carrier-Belleuse, Drawing for* Vase des Titans
(*in* Application de la figure humaine . . . , *1884)*

23

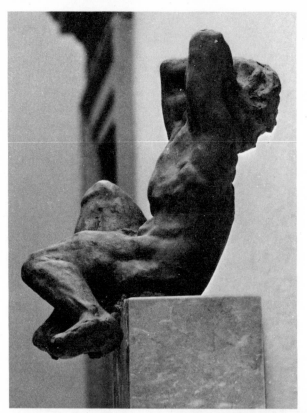

24

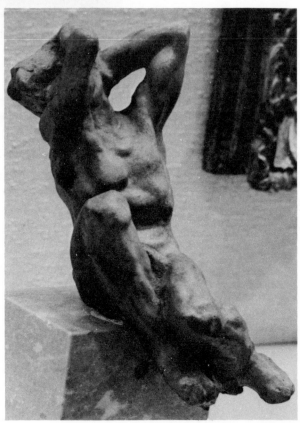

25

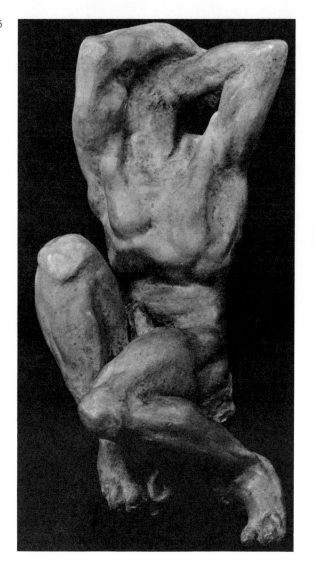

Rodin, Titan IV. *Terra-cotta, late 1870s*
23. Houston, Museum of Fine Arts
24. Houston, Museum of Fine Arts
25. London, art market

26

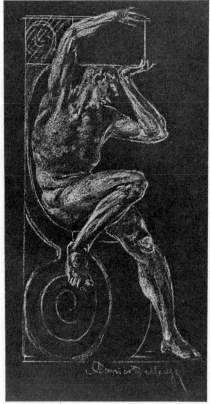

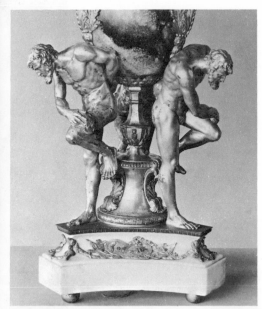

27

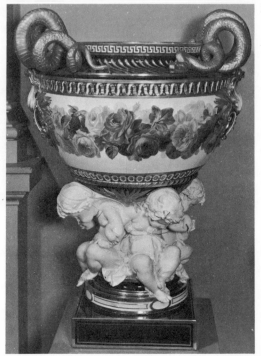

28

26. *Carrier-Belleuse, Drawing for
a bracket (in* Application de la
figure humaine . . . , *1884)*

27. *Matthew Boulton, Candelabrum
(detail). Ormolu, ca. 1765. London,
Victoria and Albert Museum*

28. *Carrier-Belleuse, Jardiniere.
Porcelain, 1863. London,
Victoria and Albert Museum*

13

STUDY

*Donatello
and the Antique*

"Donatello and the Antique,"
Donatello e il suo tempo: Atti dell'VIII° Convegno Internazionale di Studi sul Rinascimento,
Florence, 1968, pp. 77-96

Any discussion of Donatello and the Antique must begin, I think, with the admission that the subject has never been adequately explored.[1] What we do know is not a great deal, and much of that is uncertain. In their book on Ghiberti, Richard and Trude Krautheimer have given us an admirable chapter on "Ghiberti and Antiquity," defining the scope of Ghiberti's interest in ancient monuments, the kinds of monuments he knew, and the way his use of classical motifs evolved along with his own style.[2] None of this can be done as yet for Donatello. At best, I can offer some prolegomena, outlining some critical problems and suggesting what needs to be done if we are ever to arrive at the kind of understanding of Donatello's relationship to the Antique which we now have for Ghiberti.

Strangely enough—if we consider Donatello's reputation in the Renaissance as "the great imitator of the ancients"—none of the monographs written on the master since 1886, the 500th anniversary of his birth, includes a chapter on "Donatello and tthe Antique." There have been no Schlossers and Krautheimers in that field of study. The articles written on our subject[3] have contributed interesting observations about individual motifs and monuments, but the sum total of their insights is fragmentary and often doubtful: many of the relationships claimed are so vague as to be visually unconvincing, or they involve ancient monuments Donatello could not possibly have known. The neo-Attic "Altar of Kleomenes" in the Uffizi, repeatedly cited as a source for the Princess in the *St. George* relief, the *Bearded Prophet* from the east face of the Campanile, and the Salome in the Siena *Feast of Herod,* is a typical instance: its recorded existence does not go back beyond the late eighteenth century,[4] and its resemblance to any of the Donatello figures just mentioned is far from striking. Here we must

[1] Except for the addition of footnotes and some minor changes in the text, this paper is here printed as read at the Congress.

[2] *Lorenzo Ghiberti,* Princeton, N.J., 1956, pp. 277–93; cf. also pp. 337–52.

[3] Among the more important ones are: Fritz Burger, "Donatello und die Antike," *Repertorium für Kunstwissenschaft,* XXX, 1907, pp. 1–13; Arduino Colasanti, "Donatelliana," *Rivista d'Arte,* XVI, 1934, pp. 45–54; Geza de Francovich, "Appunti su Donatello e Jacopo della Quercia," *Bollettino d'Arte,* IX, 1929, pp. 145–71; Charles Picard, "Donatello et l'antique," *Revue archéologique,* XXVIII, 1947, pp. 77 f.; Osvald Sirén, "The Importance of the Antique to Donatello," *American Journal of Archaeology,* XVIII, 1914, pp. 438–61.

[4] Guido A. Mansuelli, *Galleria degli Uffizi (Cataloghi dei Musei e Gallerie d'Italia): Le Sculture,* I, Rome, 1958, pl. 116b.

learn from the methodological rigor of the Krautheimers; if we claim that Donatello knew a given piece of ancient sculpture, we should at least attempt to verify whether he could possibly have known the piece, or a similar one. The Census of Ancient Works of Art Known in the Renaissance, sponsored jointly by the Warburg Institute and the Institute of Fine Arts at New York University, has grown apace under the care of Dr. Phyllis Bober since the publication of the Krautheimers' Ghiberti book, and ought to yield important results if fully utilized by Donatello scholars.

At the same time, we must admit that "Donatello and the Antique" presents not only a far larger but also a far more difficult problem than "Ghiberti and the Antique." Ghiberti—if I may venture to summarize the Krautheimers' findings in a few words—knew a great variety of Roman sarcophagi but not much large-scale sculpture: a *Venus Pudica,* a head of Caesar, a Hellenistic torso. His development as an artist can be conveniently viewed in four major phases, and his relationship to ancient art follows the same pattern. There is, first, the stylistic phase of the competition panel, where classical motifs occur as carefully displayed "quotations," much as they do on the jambs of the Porta della Mandorla and in the *Annunciation* group of those years in the Museo dell'Opera del Duomo. Then, for about a decade, Ghiberti works in the International Gothic idiom that dominates the earlier panels of the North Doors and the statue of *St. John the Baptist;* during this phase, his interest in classical art is dormant. It reawakens toward 1415 and transforms Ghiberti's style in the later North Door reliefs, the heads on the frame, and the *St. Matthew* of 1419-22, which represents the climax of this third phase, the most overtly classicistic of Ghiberti's career. The fourth phase, that of the "Doors of Paradise," is characterized by the full integration of classical motifs into Ghiberti's personal style: the artist is able to invent freely in the classical idiom and to transform his borrowings from ancient sculpture in such a way that specific models are now difficult to identify. In his *Commentarii,* he projects a picture of classical art that closely parallels his own style—a limited but harmonious conception of ancient sculpture.

Donatello's oeuvre, in contrast, is not only far larger, more varied and complex; it also bears witness to a much more "modern" artistic personality—individualistic, "difficult," unorthodox—which means, among other things, that Donatello never acknowledged the authority of ancient sculpture as Ghiberti did. Ghiberti's classicistic view of ancient sculpture was, of course, at Donatello's disposal, and at times he adopted it, especially between 1423 and 1433: we see it in the busts of the Prophet and Sibyl on the Porta della Mandorla, the *Pazzi Madonna,* the decorative carvings on the St. Louis tabernacle, the Virgin and Angel of the S. Croce *Annunciation,* and the head of the bronze *David* (note the continuous, smoothly curved line linking the nose with the eyebrows). But the true heirs of Ghiberti's classicism—and of Nanni di Banco's, if you will—were Michelozzo and Luca della Robbia. Donatello, perhaps in part through his early friendship with Brunelleschi, was concerned with a great many aspects of ancient art that held little or no interest for Ghiberti: he responded intensely to Roman portraiture, from the Republic to the third century A.D.; he explored the rich world of Roman architectural ornament; he profited from a study of Roman historical reliefs to dramatize his narratives far more than did Ghiberti, whose temper was essentially lyrical; and he embraced as occasional sources of

inspiration Etruscan art, Early Christian and Byzantine art, and perhaps still other styles which he regarded as ancient.

In fact, the problem "Donatello and the Antique" raises an epistemological difficulty that applies, *mutatis mutandis,* to the Renaissance as a whole: whose definition of ancient art do we accept, his or ours? We are not yet at the point where we can attempt to draw the boundary lines of what Donatello considered "ancient art," but we must be prepared to acknowledge that they do not coincide with ours. They surely excluded all preclassical material (one wonders what Donatello might have thought of archaic Etruscan works). At the other end of the time scale, however, from Roman to Romanesque, his conception of the Antique probably included a great many things for which we today have other names. The broader historic reasons for this attitude need not concern us at the moment. Clearly, it was not Donatello's alone. We still wonder how it was possible for the Florentines of the Renaissance to accept the Baptistery, begun less than 400 years before Brunelleschi's day, as an ancient "Temple of Mars." And if it influenced the style of Brunelleschi, should we speak—as he would have—of the "influence of the Antique"? Let me cite an even more extreme example, which does not concern Donatello but illustrates the difference between the Renaissance conception of ancient art and our own. In or shortly after 1400, on the occasion of the visit to Paris of the Byzantine emperor Manuel II, a Paris goldsmith produced two medals honoring the emperors Constantine and Heraclius, respectively; these medals, or more probably replicas of them, were bought in 1402 by the Duke of Berry, who apparently accepted them as ancient originals. And until shortly before 1600, they were accepted as ancient both in Italy and the North.[5] They were often reproduced, as attested by the number of surviving copies, and must have been included in many collections of ancient gems and coins. The bust portrait of Heraclius even impressed Michelangelo, who derived certain aspects of his *Moses* from it.[6] We are quite likely to encounter this kind of "antique influence" in Donatello as well.

There are several instances in Donatello's oeuvre where the source of inspiration, however classical it may seem, could have been Early Christian, Byzantine, or still later. Such is the angel who supports from below the cloud-*mandorla* of the Virgin in the Naples *Assumption* (fig. 1); no corresponding figure occurs in earlier representations of the subject, and it has therefore been proposed that Donatello derived his angel from Coelus, the personification of the sky, in the upper right-hand corner of the famous sarcophagus in the Villa Medici (fig. 2) which was the model for Raphael's *Judgment of Paris* (known from an engraving of Marcantonio Raimondi).[7] Or Donatello's angel might have been suggested by the River Orontes beneath the *Tyche of Antioch,* a famous and often-copied Hellenistic composition. Now, Coelus survived in his customary supporting function in Early Christian art; we find him, for example, beneath the enthroned Christ on the Sarcophagus of Junius Bassus (fig. 3). And this Coelus shows some features

[5] Roberto Weiss, "The Medieval Medallions of Constantine and Heraclius," *Numismatic Chronicle,* seventh series, III, 1963, pp. 129 ff.

[6] See my essay in *Festschrift Ulrich Middeldorf,* Berlin, 1968, pp. 241–47 (and below, pp. 291–97).

[7] Picard, *op. cit.*

that bring him closer to Donatello's angels than are his pagan predecessors: Christ's foot rests squarely on Coelus' head, like the foot of Donatello's Virgin—a detail I have failed to find in the pagan examples—and he emerges from clouds, another specifically Early Christian feature, I believe.[8] Donatello, of course, could not very well have known the Sarcophagus of Junius Bassus, which was only discovered in the late sixteenth century, but the enthroned Christ above Coelus must have occurred fairly often in Early Christian art, so that we are not stretching plausibility too far in assuming that Donatello knew the same composition in another specimen. It may indeed have been the starting point from which Donatello developed that astonishing cloud-*mandorla* in the Naples *Assumption*.

The dancing angels on the balustrade of the Cantoria present a somewhat similar problem. Their "pagan" bacchanalian abandon has often been noted, but Roman putti do not dance in this fashion, and they never dance with wreaths, as do the angels on the right half of the Cantoria balustrade. Some ten years ago, Ernst Gombrich observed that there are wildly agitated wreath-holding putti (or rather Victories reduced to putti) on Byzantine ivory caskets, and suggested that these were Donatello's source of inspiration. Despite the great difference in size and style, there seemed to be no other way to account for the frantic movement and the wreaths of Donatello's angels; nor do I want to discount Dr. Gombrich's observation, since it would not be the only instance of Donatello's interest in ivories.[9] However, I now believe that the starting point from which our artist developed the Cantoria frieze lies elsewhere. One of the panels on the Prato Pulpit (fig. 4) shows two putti who correspond almost exactly to the two putti on a Roman sarcophagus in the storeroom of the Vatican Museum (fig. 5);[10] and these Roman putti are not dancing but boxing! Could Donatello have developed the angel panels of the Prato Pulpit and the Cantoria from Roman reliefs of putti engaged in athletic games, boxing and wrestling? Does this perhaps explain the often strangely aggressive behavior of his dancing angels on these pulpits? His long Roman sojourn between 1430 and 1433 would have given him ample opportunity to study such scenes, which occur not only on sarcophagi but also on gems.[11] The original design for the Cantoria, in 1433–34, had individual panels like Luca della Robbia's Cantoria, rather than the continuous frieze we see today;[12] Donatello must have submitted sketches for these panels, and when he changed the plan of the Cantoria about 1435 the sketches were left over. It seems likely that he utilized them for the panels of the Prato Pulpit, so that these represent an earlier stage of the Cantoria angel frieze.[13] That is why the "boxing angels" on the Prato Pulpit seem particularly instructive. Nor are they

[8] On the Villa Medici sarcophagus, Coelus emerges from a bank of rocks.

[9] See the discussion of the bronze doors in the Old Sacristy of S. Lorenzo, below, p. 256.

[10] Guido Kaschnitz-Weinberg, *Sculture del Magazzino del Museo Vaticano*, Città del Vaticano, 1936, N. 490 (p. 220 and pl. LXXXIII). The resemblance was discovered by Miss Ellen N. Davis, in a seminar report for me in 1964.

[11] E.g., Bruno Schröder, *Der Sport im Altertum*, Berlin, 1927, pls. 24, 14, and 68a.

[12] See H. W. Janson, *The Sculpture of Donatello*, Princeton, N.J., 1957, II, pp. 119 ff.

[13] According to the contract of 1428 for the Prato Pulpit, the panels of the balustrade were to show angels holding the coat of arms of Prato, as in the model (Janson, *op. cit.*, p. 109), recalling—and perhaps reflecting—the series of escutcheon-holding angel putti on the knob of the

the only evidence of the athletic ancestry of Donatello's dancing angels. Roman scenes of athletic putti always include a scene of the victor crowning himself to the accompaniment of a trumpet blast; and wreaths and trumpets occur repeatedly among the Prato panels (figs. 6, 7). One angel also wears a wide belt or waistband, as well as a wreath—perhaps another residue of athletic activity (fig. 7). The "victory trumpets" are sounded again on the Cantoria frieze (fig. 8), and one of the panels has an angel whose pose seems directly taken from the *pankration,* that free-style combination of boxing and wrestling which permitted the use of the feet for kicking (figs. 8, 9). Apparently this panel, and the "boxing angels" at Prato, were executed by assistants on the basis of Donatello sketches in which the athletic activities of putti had not yet been transmuted into dance movements.[14]

The shape of the wreaths is of particular interest. On the Cantoria frieze, one wreath is partly a slender hoop. Since on Byzantine ivory caskets the wreaths held by putti are sometimes reduced to hoops, I used to think that this odd combination of wreath and hoop in the Cantoria tended to confirm Dr. Gombrich's conjecture.[15] The matter is less simple, however. On closer inspection, it turns out that the hoop-wreath combination occurs several times, and in Prato as well as on the Cantoria (fig. 6). Donatello must have purposely introduced two distinct kinds of wreath—a regular kind, of even thickness and covered with leaves all around, and the type where the hoop to which the leaves are attached is partly exposed. Classical victory wreaths could indeed be of the latter kind, it seems; the origin of the form can be seen on the monument to a boxer in Tegea.[16]

That Donatello had a special interest in putti boxing is demonstrated once more by the Eros and Anteros group he inserted on the desk of St. Mark in the Sagrestia Vecchia. Their poses are again derived from ancient boxing putti, and clearly recognizable as such, as shown by comparison with the cameo that has been suggested as Donatello's source;[17] on the cameo, the two contestants

crozier of Donatello's *St. Louis.* Apparently, as late as 1428 putti were thought of as having only one possible function: to hold (garlands, scrolls, wreaths, coats of arms). The earliest post-classical dancing putti, by Donatello or any other artist, seem to be those of 1429–30 for the tabernacle of the Siena Font.

[14] That the Prato reliefs were viewed in their day as very much *all'antica* is attested by Pisanello, who made drawings after two of them (the third and fourth from the left), both on the verso of sheets with copies after ancient sculpture. See the catalogue, by Bernhard Degenhart and Annegrit Schmitt, of the exhibition *Italienische Zeichnungen der Frührenaissance,* Staatliche Graphische Sammlung, Munich, March–April 1966, items 9 (Milan, Ambrosiana) and 16 B (Berlin, Kupferstichkabinett), with illustrations and bibliography. These copies differ from the Prato panels in two respects: the figures are less tightly squeezed together within the frame, and they are contained by a boxlike compartment drawn in perspective, so that they appear to stand on an upward-sloping strip of ground, while in the Prato reliefs that strip has been eliminated and the entire background filled with mosaic (see figs. 4, 7). That the strip was originally intended, and not added by Pisanello, is evident from the fourth Prato panel (fig. 6), where a bit of this floor strip is still visible (bottom center). Since the balustrade reliefs of the Cantoria also show a strip of ground beneath the angels' feet (see fig. 8), it may well be that Pisanello copied not the Prato panels now *in situ* but their predecessors—the models (or drawings?) from which Donatello's assistants carved the present panels.

[15] Janson, *op. cit.,* p. 126.
[16] Schröder, *op. cit.,* pl. 18c.
[17] Illustrated in Ursula Wester, "Die Reliefmedaillons in Hofe des Palazzo Medici zu Florenz," *Jahrbuch der Berliner Museen,* VII, 1965, p. 47.

even wear the *cestus,* the boxing glove of antiquity. Neither scene, I am convinced, has anything to do with Eros and Anteros,[18] a concept that was not represented in the Renaissance before 1500.[19] What indeed would Eros and Anteros be doing on the desk of St. Mark? If the scene has a meaning beyond characterizing the Evangelist's environment as pagan, it might be a reference to "the athlete of virtue," a notion whose revival in the Early Renaissance has been demonstrated by Colin Eisler.[20] Perhaps the same concept also entered into the genesis of the dancing angels on the Prato Pulpit and the Cantoria.

Donatello's interest in ivories is strongly suggested by a comparison of the paired apostles on the bronze doors of the Sagrestia Vecchia with the paired figures in the lower portion of the Probianus diptych (figs. 10, 11). The resemblance includes not only the relationship of the figures to the frame but the ornament of the frame as well. On the other hand, the notion of arranging saints and apostles as a series of disputing pairs, two to a frame, does not seem to have existed in Early Christian art. In this respect, Donatello's source has been assumed to be the Romanesque paired apostles on the door jambs of the Pisa Baptistery.[21] He must have seen these, of course, but they bear no formal resemblance to the bronze doors. Yet paired apostles in separate frames existed before the Romanesque. The museum at Compiègne preserves three ivory tablets with such figures, of the ninth century—obviously the remnants of a full set that may have embellished a book cover (fig. 12).[22] Unfortunately, these tablets have lost their frames, but even so they seem a good deal closer to Donatello's apostles than the Pisa series or the Probianus diptych. Did Donatello know a Carolingian ivory, or perhaps an Early Christian ivory of paired apostles that no longer exists today? In either case, he would have regarded his source as a bona-fide ancient work.

The two boxing putti of the St. Mark tondo are as close to a direct "quotation" of ancient art as we are likely to find in Donatello. The relationship of the figures as well as their activity is retained from the classical model (either the cameo or an "athletic putti" sarcophagus, where we find similar combinations of vanquished and victor), but the poses are not literally copied. The same holds true of the triumph of putti on the helmet of Goliath in the bronze *David,* of the two "pagan" putti reliefs in the lower section of the Cantoria,[23] and of the bacchanalian scenes on the base of the *Judith.* Such "quotations," however, are confined to details; they are, so to speak, short sentences only, and even these are paraphrased rather than rendered exactly. Thus the design of the Cantoria as a whole is based on the entablature of a Roman temple such as that of the Temple of Concord; there is probably an exact ancient source for every one of the ornamental motifs employed here, but the context of the whole has been trans-

[18] As claimed by Wester, *loc. cit.*

[19] For the iconography of the subject, see Erwin Panofsky, *Studies in Iconology.* Oxford, 1939, and New York, 1962, pp. 95–129.

[20] *De artibus opuscula XL: Studies in Honor of Erwin Panofsky.* New York, 1961, pp. 82–97.

[21] Hans Kauffmann, *Donatello,* Berlin, 1935, p. 90.

[22] Adolph Goldschmidt, *Die Elfenbeinskulpturen . . . ,* Berlin, 1914, I, figs. 49–51.

[23] Their ancient models were identified by Robert Corwegh, *Donatellos Sängerkanzel . . . ,* Berlin, 1909, pp. 33, 38; the format and framing, however, again recall Early Christian ivories such as the Probianus diptych.

formed in the most daring and original fashion. Here a good deal of further research is needed before we can gain a coherent picture of the ancient sources from which Donatello derived his repeïtory of decorative forms. The installation of the two bronze heads in the lower section of the Cantoria, for instance, might have been suggested by the paired heads used as spouts on Roman fountain basins (fig. 13). A specific—but rather obscure—source exists for the ornamental frame of the stucco reliefs above the bronze doors in the Sagrestia Vecchia (fig. 14): it is part of the remains of a Roman building incorporated in the church of S. Maria in Cosmedin (fig. 15).[24] The tabernacle of the *Annunciation* in S. Croce (fig. 16) presents perhaps the most complicated problem in this respect. So far as I have been able to ascertain, there are no segmental pediments with terminal scrolls in Greek or Roman architecture, but close approximations may be found, on a small scale, on Roman funerary urns (fig. 17)[25] and tombstones (where the scrolls are derived from the *pulvinus,* or bolster, of Roman altars). Among the most likely sources for Donatello is the tombstone of Cornelia Tyche and Julia Secunda (fig. 18), which was known in the Renaissance.[26] Funerary urns are also the only Roman source for Donatello's framed and "shingled" pilasters, with their surface pattern of imbricated leaves (fig. 19).[27] Apparently our artist found the huge claw feet of these pilasters a bit awkward, so he designed a unique base of his own: linked scrolls combined with the toes of claw feet. The linked scrolls are again taken from Roman funerary art, such as the gravestone of Julia Victorina (fig. 20).[28] His capitals, too, are an odd combination, reflecting the single masks atop the Roman "shingled" pilasters as well as double herms (figs. 21, 22).[29]

The relief mode of the S. Croce *Annunciation,* with the figures carved almost in the round and placed in a boxlike, nonillusionistic space, is without parallel in Donatello's work; we know it from Greek grave stelae, and from classicizing Roman reliefs reflecting such stelae. But no ancient sculptor would have covered the background of such a panel with ornament. By doing this, and adding a compressed chair, Donatello has created what might be termed a "pseudo-interior" as a setting for the Virgin's encounter with the angel.

When Donatello takes the pose of a figure, or of a group, from an ancient source, he almost invariably reinterprets and transforms the motif in the most unexpected way; the change of boxing putti into dancers is symptomatic of his procedure. Hence our constant difficulty in pin-pointing specific models. The dancing Salome in the Siena *Feast of Herod* surely reflects classical nymphs or muses, but no ancient dancer duplicates her pose. In the Lille relief, Salome's movement seems closer to classical prototypes (fig. 23); I know, however, only one exact match for her in ancient art—a bacchante on a late Roman silver dish

[24] Ernest Nash, *Pictorial Dictionary of Ancient Rome,* London, 1961, fig. 1184.

[25] Georg Lippold, *Die Skulpturen des Vatikanischen Museums,* III, 2, Berlin, 1956, N. 56, p. 194.

[26] See Phyllis Williams, *Journal of the Warburg and Courtauld Institutes,* IV, 1940–41, pp. 47–66.

[27] For the specimen here reproduced, see Franz Cumont, *Recherches sur le symbolisme funéraire des Romains,* Paris, 1942 (anastatic reprint, 1966), p. 162 and pl. XI.

[28] Cumont, *op. cit.,* p. 243 and pl. XXI.

[29] For the latter, see Lippold, *op. cit.,* N. 38, p. 473.

from the Mildenhall Treasure in the British Museum (fig. 24), discovered a quar-ter–century ago.[30] While this particular specimen could obviously not have been known to Donatello, such motifs are stereotypes, widely used in metalwork as well as in terra-cotta, so that our artist could well have seen the equivalent of the Mildenhall bacchante on Italian soil. What attracted his attention to this figure is obvious: next to the bacchante is a low stool or stand, with a head rest-ing on it. While this was meant to represent a mask, to Donatello it could not but suggest the head of St. John. The relationship is interesting also as the only specific instance attesting Donatello's acquaintance with ancient low relief like that on Arretine pottery, which according to Vasari was the source of the master's *rilievo schiacciato*. I am not prepared, however, to accept Vasari's claim on the basis of this single case.

More characteristic of the difficulties we face in tracing specific figures in Do-natello's work to ancient models are the following examples, selected so as to illustrate various kinds of derivation problems. Sixty years ago, Fritz Burger ob-served that the central figure in the *Healing of the Irascible Son* on the Padua High Altar (fig. 25) resembled a soldier fallen from his horse on the Column of Trajan (fig. 26);[31] as an alternative source, he suggested a fallen hunter from certain Meleager sarcophagi.[32] About the same time, Aby Warburg as-serted that the Irascible Son was derived from a Pentheus being torn apart by Maenads, as represented, for instance, on a Roman sarcophagus in the Campo-santo in Pisa (fig. 27).[33] He termed this a case of "energetic inversion," since the leg of the Irascible Son is being reattached rather than torn out. To me, there can be no question that the figures cited by Burger match the pose of the Irascible Son far more closely than does Warburg's Pentheus; but they, in turn, appear to be adaptations of an earlier motif that has been overlooked so far and offers a still closer match: a satyr being thrown to the ground by a centaur, on a sarcophagus in the Vatican (fig. 28) which was probably known as early as the sixteenth century and perhaps before.[34] It has the pose of Burger's figures and, in addition, youth and nudity, as well as "energetic inversion" (the centaur is pulling at the satyr's leg). Even here, however, we can only speak of likelihood, not of certainty. Donatello might have taken the Irascible Son from any one of the sources adduced by Burger or Warburg, although perhaps less easily.[35]

The grieving mother in the same relief (fig. 29) presents a different kind of problem. Placed next to several figures of classical derivation—a pair of modified river gods on the ground and a Victory-like young woman—she, too, would seem to demand an ancient source. The most plausible model is the type of mourning woman represented by the *Cesi Dacia* in the Palazzo dei Conservatori,[36] or

[30] Cf. D. E. Strong, *Greek and Roman Gold and Silver Plate*, London, 1966, p. 197, pl. 60.

[31] Burger, *op. cit.*, pp. 7 f.

[32] *Ibid.*

[33] Reported by Fritz Saxl, "Über die Ausdrucksgebärden der bildenden Kunst," *Bericht über den XII. Kongress der deutschen Gesellschaft für Psychologie in Hamburg*, ed. Gustav Kafka, Jena, 1932, p. 20.

[34] Lippold, *op. cit.*, III, 1, Berlin, 1936, N. 513, pp. 49 ff., pl. 29.

[35] Neither Burger nor Ernst Gombrich, who cites Burger with approval (*Norm and Form*, London, 1966, pp. 123 ff.), considers the physical difficulty of observing and accurately copying a detail such as the fallen soldier on the Column of Trajan without the aid of scaffolding.

[36] It is the keystone of a Trajanic triumphal arch and was presumably aboveground in the

the conquered Germania on a coin of Tiberius that occurs twice in the sketchbooks of Jacopo Bellini (fig. 30).[37] But here a complicating factor intervenes: it is likely that this coin—or one of several related monuments—had given rise in the early Trecento to a new type of Crucifixion, with the Virgin and St. John seated on the ground just as Germania and her male counterpart flank the trophy pole on the coin.[38] The mother of the Irascible Son thus may well be a "reclassicized" version of the Virgin Mary from this "Crucifixion of Humility" rather than stem directly from an ancient source.

Such an overlapping of classical motifs revived in the Trecento—or surviving throughout the course of medieval art—with the same motifs revived by Donatello directly, occurs a number of times. Krautheimer has observed the same phenomenon in the work of Ghiberti. The best-known instance for Donatello is the Entombment of Christ used on the Rome Tabernacle, the Padua High Altar, and the S. Lorenzo Pulpits; here mourning gestures from the death and burial of Meleager on Roman sarcophagi are grafted onto the same gestures transmitted to Donatello via the Trecento and the Byzantine *threnos*, which of course derives from ancient scenes of mourning.[39] Something of the same sort must be assumed for the two fleeing putti in the lower left-hand corner of the Siena *Feast of Herod* (fig. 31). Their ultimate ancestor is a figure often found in Roman painting, as in the scene of Hercules strangling the serpents, from Pompeii (fig. 32); she is fleeing from the central event, one arm cut off by the frame, while turning her head to look back. This motif survived throughout medieval art.[40] A striking example, which Donatello must have known, is the fleeing youth in Niccolò di Pietro Gerini's *Martyrdom of St. Matthew* in Prato (fig. 33). But all these precedents are single figures, and adults, while Donatello uses a pair of putti. A directly revived classical motif, it seems, has intervened—the fleeing children from Medea sarcophagi (fig. 34). These alone, however, are not sufficient to explain Donatello's use of the motif. We need both traditions to account for it. That our artist knew the Medea children is clear from the *Heart of the Miser* relief in Padua, where they and Medea herself appear among the fleeing spectators to the right (fig. 35).

The same kind of problem recurs in the S. Lorenzo Pulpits, with their extraordinarily complicated interweaving of medieval and classical elements. Thus Irving Lavin pointed out some years ago that the Risen Christ (fig. 36) reflects the old man leaning on a staff at the foot of the bier in Meleager sarcophagi (fig. 37).[41] This is surely true, and helps to explain the incredible weariness of Donatello's Christ. The traditional way to represent Christ stepping out of His tomb, as attested by countless Trecento examples and the famous fresco by Piero della Francesca, is to show Him frontally. Yet there are a few examples in Sienese

fifteenth century. It has been recorded from the sixteenth century on; see Cornelius C. Vermeule, III, *The Dal Pozzo-Albani Drawings . . . in the Royal Library at Windsor Castle* (Transactions of the American Philosophical Society, new series, 56, vol. 2), Philadelphia, 1966, p. 12, N. 8223.

[37] Victor Goloubew, *Les dessins de Jacopo Bellini,*, II, Brussels, 1908, pls. XXVII, XLIII.

[38] See Dorothy C. Shorr, *Art Bulletin*, XXII, 1940, pp. 61–69.

[39] See Kurt Weitzmann, *De artibus opuscula XL: . . .*, pp. 478–90.

[40] Cf. Janson, *op. cit.*, pp. 71 f.

[41] "The Sources of Donatello's Pulpits . . .," *Art Bulletin*, XLI, 1959, p. 30; Burger, *op. cit.*, had suggested the same source, though less specifically.

painting around 1400 that have Christ rising in profile, or near-profile (fig. 38). Apparently Donatello, having just returned from a lengthy sojourn in Siena when he started work on the Pulpits, remembered this version of the Risen Christ, and "reclassicized" it by superimposing the old man from the death of Meleager.

That the S. Lorenzo Pulpits are still in many respects *terra incognita,* despite all the work that has been done on them, hardly needs saying. One of our unfulfilled tasks is to disentangle and account for the classical motifs in the main reliefs (the putti scenes above them, I am convinced, have nothing to do with Donatello and were added after his death).[42] Again I must confine myself to a single example of how intricately such classical motifs can be interwoven with medieval elements. In the *Crucifixion,* a rather static scene as a whole, executed in large part by an inferior hand, there is a flurry of movement on the left: a woman—it must be Mary Magdalene—is racing toward the cross, pulling along a Roman soldier who looks back, as he runs, to the soldier with a lance standing against the pilaster on the extreme left (fig. 39). This sequence of figures has been adapted—freely but unmistakably—from their counterparts in Imperial Lion Hunt sarcophagi of the third century A.D. (fig. 40). Several specimens of these have survived; there are two, one of them unusually large, in the Palazzo Mattei.[43] Little doubt, then, that Donatello could have seen a sarcophagus of this type. His borrowing of the running figures has gone unrecognized, I suspect, because in their new incarnation they have not only a new context but a new physical power and emotional impetus. Here, as in other cases, we are left to wonder whether Donatello adopted these figures simply because their agitation fitted in with his own style, or whether he associated any sort of meaning with them relating to Christ. Did he perhaps look upon the victorious lion-killing hero as a pagan embodiment of virtue equivalent to Christ's victory over Evil? Could he possibly have known, or had any thoughts about, the identity of the running figures in the sarcophagus? It seems strange that the helmeted woman whom he turned into Mary Magdalene is Virtus, announcing by her presence that the lion hunt is emblematic rather than real.[44]

Looking back upon the instances of classical borrowings in Donatello discussed so far, we are struck by the fact that they are all of the sort which makes it impossible for us to identify specific monuments as Donatello's sources. We can speak of types of compositions, classes of sarcophagi, or individual motifs, but not of any particular sarcophagus. The reason, obviously, is that we have been dealing with what Alois Riegl termed the "Spätrömische Kunstindustrie," stereotyped products of little or no individuality. There can be no question—and no surprise—that the great majority of Donatello's borrowings of antique motifs come from this kind of material. But what about the famous monuments of ancient Rome that remained aboveground throughout the Middle Ages: the statues on the Lateran, the triumphal arches, the Column of Trajan? Surely Donatello must have studied them. Did they not leave any imprint on his work? Of the statues on the Lateran, all we can say is that their very existence must have fired

[42] Cf. Janson, *op. cit.,* pp. 215 f., note 7.

[43] Vermeule, *op. cit.,* pp. 29, N. 8457, and 52, N. 8749, for the larger of the two.

[44] For the significance of the subject, see Richard Brilliant, *Gesture and Rank in Roman Art* (Memoirs of the Connecticut Academy of Arts and Science, XIV), New Haven, 1963, pp. 186 f.

the imagination of Donatello and Alberti in the revival, practical and theoretical, of the free-standing sculptural image of man. In that sense, we might claim that the bronze *David,* the lost *Dovizia* on her column, and the *Gattamelata* were inspired by the Lateran statues. But the bronze *David* is as far, in form and sculptural feeling, from the *Spinario* as the *Gattamelata* is from the *Marcus Aurelius.* The *Dovizia* may have reflected a classical statue more directly, but we do not know what she looked like except in the vaguest outline.[45] As for the sculpture on the triumphal arches, I believe I can cite at least one specific relationship to Donatello. Among the reliefs of earlier date incorporated in the Arch of Constantine there is the *Congiarium* of Marcus Aurelius (fig. 41), with the emperor on a tall podium and a number of figures in the foreground in front of that platform. One of these, seen from the back, is trying to pull himself up in order to look over the edge of the podium; and that motif recurs in the *Apotheosis of St. John* in the Sagrestia Vecchia (fig. 42). The main part of the latter composition, with its daring *di sotto in su* perspective and oddly abstract architecture, owes nothing to Roman sources; but the *Congiarium* relief clearly helped Donatello to dramatize the scene by placing it on a tall "stage" with spectators below, and one spectator peeking over the edge.

The reliefs on the Column of Trajan were hard to see from the ground, and no drawings after them are known before the end of the fifteenth century. Thus the far-reaching claims of Burger regarding their influence on Donatello must be treated with caution;[46] nor has he established visual correspondences sufficiently compelling to bear him out. Still, Donatello could have studied the lower range of the reliefs. That he did so is suggested by some aspects of the Siena *Feast of Herod.* One striking feature of the Column of Trajan is the frequent recurrence of figures behind walls, with only their heads and shoulders visible. This may be reflected in Donatello's unusual device of placing the first and third acts of the tragedy in the background of Herod's palace—the executioners behind the first wall, the delivery of the head to Herodias behind the second (figs. 43, 44). The severely simple architecture of the palace, with its emphasis on the seams between the building blocks, also recalls the kind of utilitarian structures that fill so much of the narrative on the Column of Trajan. The direct impact of the great Roman monuments on Donatello, then, would seem to have been very limited, so far as our present knowledge goes. And I doubt whether further research will change this conclusion.

There remains the refractory problem of Etruscan influence on Donatello. According to a document recently published by John Spencer,[47] Etruscan tombs were opened and their contents preserved as early as the mid-fifteenth century. Nor can there be any doubt that, as André Chastel has pointed out,[48] the Early Renaissance showed a growing interest in things Etruscan. We also know, from letters by Nanni di Miniato and Poggio Bracciolini,[49] that Donatello was

[45] Cf. Kauffmann, *op. cit.,* pp. 41 ff.

[46] Burger, *op. cit.,* pp. 6–9.

[47] "Volterra, 1466," *Art Bulletin,* XLVIII, 1966, pp. 95 f.

[48] "L'Etruscan revival au XVe siècle," *Revue archéologique,* I, 1959, pp. 165–80.

[49] Janson, *op. cit.,* pp. 101, 125.

interested in archeological finds and had, in fact, the reputation of an expert in such things. We have ample reason to assume, therefore, that he saw Etruscan antiquities. What kind he saw, how he responded to them, whether indeed he differentiated between Etruscan and Graeco-Roman objects (and if so, on what grounds), all this we do not know. Some of these questions might be answered if Etruscan influence in his work could be securely established. But this is just where the difficulty lies. For the kind of Etruscan art Donatello is likely to have found interesting—that is, Etruscan art from the late fifth century onward—is so replete with borrowings from Greece that we have trouble differentiating what Donatello may have taken from the Etruscans and what from the Greeks or the Romans. Let me illustrate the problem. André Chastel has suggested that the sphinx throne of the Padua *Madonna* consciously follows an Etruscan model such as the cinerary urn from Chianciano, in the shape of a mother and child on a sphinx throne, in the Museo Archeologico, Florence.[50] I remain unconvinced— the resemblance of the Chianciano figure to Donatello's *Madonna* is no greater than that of any number of other goddesses on sphinx thrones, both Greek and Roman.[51] Donatello's throne has, in fact, a unique shape that is not duplicated in any ancient work. Let us note its distinctive features: the sphinxes have only a single front leg, terminating in a kind of bud from which the head grows like a flower (fig. 45). The area between the front leg and the sphinx's belly is open— the Virgin's right foot fills this space. Since she is standing rather than sitting, the throne has to be tall and shallow; the back is rounded, and rises with the curve of the sphinxes' wings. In ancient sphinx thrones, whether Etruscan, Greek, or Roman, the back is low and square; only the sides are decorated (Donatello's throne has the Fall of Man on its back; fig. 46), and the sphinxes are imbedded in the sides of the throne, so that there is no opening behind the front legs. Nor do they show the terminal bud-plus-head feature of Donatello's sphinxes. We can account for the Padua throne only by presupposing several sources. While the idea could have come to Donatello from any Greek, Roman, or Etruscan deity on a sphinx throne, the combination of sitting sphinxes with open spaces between front leg and belly and with a scene in relief between their juxtaposed rears seems to derive from Roman table supports, such as a specimen in the Vatican (fig. 47).[52] And the peculiar single front leg with terminal bud and head is taken from Roman table legs (fig. 48).[53] We have here, then, the same heterodox merger of classical forms that we found in the S. Croce Tabernacle. The furniture of the four Evangelist tondi in the Sagrestia Vecchia, too, is freely and fancifully invented out of classical details. St. Matthew's throne has, in fact, a sphinxlike creature for an arm rest that suggests the later sphinx throne of the Padua *Madonna*.

There is, I think, one instance where Etruscan influence is less doubtful. In the tondo of *St. John's Vision on Patmos*, the figure of the Evangelist is strongly reminiscent of Etruscan tomb effigies, both in pose and in the peculiar limpness

[50] Chastel, *op. cit.*, pp. 172 ff.
[51] For examples see G. M. A. Richter, *The Furniture of the Greeks, Etruscans, and Romans*, London, 1966, *passim*.
[52] Richter, *op. cit.*, p. 113 and fig. 573.
[53] *Ibid.*, p. 112 and fig. 580.

and shallowness of the body (figs. 49, 50). These Etruscan effigies do, of course, have their successors in Roman funerary art, but none of the Roman effigies seem to match the *St. John* quite so well. More difficult to determine, yet also more significant in its long-term effect, is the influence of Etruscan small bronzes. These are likely to have been in more plentiful supply than Roman or Greek bronze statuettes, and we can trace their influence in the middle years of the Quattrocento among the small figures decorating the bronze grating of the Cintola Chapel in Prato Cathedral.[54] Did they by any chance contribute to the genesis of Donatello's trio of bronze putti for the Siena font in the late 1420s? Many Etruscan bronze statuettes are attached to chests or vessels, often precariously perched on the handles. Might not this peculiarly Etruscan balancing act have suggested to Donatello the placing of his Sienese putti on shells, which are an equally precarious base (fig. 51)? If he learned from Etruscan examples how to balance his putti on such uneven surfaces, then the Etruscans may even claim a modest share in the genesis of the bronze *David,* who also stands on a rather complicated mound made up of a wreath and Goliath's head and helmet.

In conclusion we must turn to the area of ancient art that evoked the most creative response from Donatello: Roman portraiture. One is tempted to say that Roman portraits helped him to discover his own artistic identity—his essentially "Roman" temper as against Ghiberti's "Greek" outlook. As early as 1410-14, Nanni di Banco had put Roman portrait heads of the third century A.D. on some of his *Quattro Coronati,* but in the process of being filtered through Nanni's style these heads lost their individual character; what remained was a deeply felt statement of the personality ideal of the Late Antique—a Christian soul in a classical body, as it were. It was Ghiberti, in the third phase of his stylistic development, beginning toward 1415, who first revived a specimen of Roman portraiture properly speaking: his head of Caesar on the North Doors.[55] Although it is the only head of its kind among the many that decorate the frame of those doors, I wonder whether it might not have stimulated Donatello's awareness of Roman portraiture, an awareness of which there is no sign among his work until the first of the Campanile prophets, the *Beardless Prophet* of 1416–18. This head—thin-lipped, with the characteristic deep lines framing the mouth—so completely reflects the austere "father image" quality of Republican portraits that almost any specimen will serve to establish the relationship; needless to say, Donatello did not literally copy any one portrait head.[56] There is clearly an incongruity between the head of the *Beardless Prophet* and the still conventional body of the statue—Donatello began his reshaping of the traditional prophet type with the head, and left the execution of the body largely to his assistants.

Between 1418 and 1420, both Donatello and Ghiberti performed a different and more fundamental reshaping of traditional statue types. Ghiberti's *St. Matthew,* as Krautheimer has pointed out,[57] is based upon the classical image of

[54] Janson, *op. cit.,* p. 146.
[55] Krautheimer, *op. cit.,* pl. 67 and fig. 107.
[56] To derive the realism of the *Beardless Prophet* and the *Zuccone* from Claus Sluter (as first proposed by Louis Courajod, *Leçons . . .,* Paris, 1901, II, pp. 277 ff. and 585) seems to me utterly impossible.
[57] Krautheimer, *op. cit.,* p. 91.

poets and orators in the shell niches of "Asiatic" (i.e., Greek) sarcophagi; and Donatello's second Campanile prophet, formerly nicknamed "Moses," has the classic Greek pose first developed in Attic funerary monuments and copiously re-used in Roman art for mourners, captive barbarians, and philosophers. Donatello may well have adopted the gesture from ancient statuettes of philosophers, of which half a dozen specimens have survived, in bronze as well as marble.[58] Ghiberti's *St. Matthew,* apart from his classical precedents, also reflects the in-fluence of Donatello's *St. Mark,* but it shows one novel aspect that cannot be accounted for by either of these sources: the suggestion of movement in the stance, the rhetorical gesture of the right hand, endow the statue with an actively forensic character—he preaches to the beholder. It is for this reason that the *St. Matthew* protrudes from his rather shallow niche to an even greater extent than Donatello's *St. George.* I suspect that Donatello saw a challenge in the *St. Matthew,* a challenge he met in his *Zuccone.* The *Zuccone,* obviously, is even more forensic than the *St. Matthew,* but he is a Roman *rhetor,* not a Greek orator—one is tempted to call him a tribune. It is not only the toga that proclaims his *Romanitas,* but also the head, which, unlike that of the *Beardless Prophet,* has the fascinating ugliness and expressive intensity of Roman portraits of the early third century A.D. The so-called *"Jeremiah,"* the last of the series, is even more overtly Roman, with his exposed right shoulder and a head as savage as a portrait of Caracalla (fig. 52). What models did Donatello use for these figures? It seems more than doubtful that free-standing portrait statues of *togati* were available to him, and Roman historical reliefs such as those on triumphal arches and the Column of Trajan could have furnished him with little more than a familiarity with Roman costume. At least for the *"Jeremiah,"* I think I can suggest a more specific source: Roman tombs of orators, such as that of Quintus Sulpicius Max-imus in the Museo Nuovo Capitolino (fig. 53). The deceased (actually he was a boy orator, but the portrait makes him look adult) stands in a niche, clad in his toga and displaying a scroll in his left hand much as the *"Jeremiah"* does. Donatello could not have known this particular specimen, which was discovered only in the last century.[59] But surely this type of funerary monument was not unique, and other examples may have been known in the Quattrocento. This is not the place to speak of the impact of the *Zuccone* and *"Jeremiah"* on Renais-sance art. I cannot resist pointing out, however, that even Ghiberti acknowledged Donatello's achievement in one of the prophets on the frame of the East Doors, the only "Roman" figure in the entire set and—to my mind—an echo of the *Zuccone.*[60]

A dozen years after the completion of the Campanile prophet series in 1436, Donatello faced a similar challenge. The *Gattamelata* stands in the same relation to Roman military portraits as the *Zuccone* and *"Jeremiah"* do to the toga stat-ues. It is an equestrian monument *all'antica,* but of a kind that never existed in ancient Rome: a general in full armor on horseback. Must we not assume that Donatello knew a statue similar to that of the Augustan military tribune, Marcus

[58] E.g., Lippold, *op. cit.,* III, 2, N. 15, p. 239, pl. 114 (with list of other specimens).
[59] Nash, *op. cit.,* fig. 1155.
[60] Krautheimer, *op. cit.,* pl. 126a.

Holconius Rufus, now in Naples (fig. 54)? The *Gattamelata's* pseudo-antique suit of armor (fig. 55), heavily embossed with classical motifs, could have been suggested only by such a statue, since the equivalent figures in historical reliefs are on too small a scale to permit the display of elaborately decorated armor. And the baton of command carried by the *Gattamelata* never seems to occur in Roman images of military leaders on horseback, only in standing figures like the Naples statue. To be sure, the *Regisole* in Pavia was clad in armor, but if Donatello knew it he probably did so from drawings rather than in the original, and in any event the *Regisole's* armor does not seem to have been decoratively embossed. Nor did the *Regisole* have a baton in his right hand; his very name tells us that he made the same imperial gesture as the equestrian *Marcus Aurelius* in Rome.[61] We may describe the genesis of the *Gattamelata,* then, by saying that Donatello took an image of the type of *Marcus Holconius Rufus,* modernized the armor to some extent, and put it on horseback. Nothing betrays his intention more strikingly than the head of the *Gattamelata* (fig. 56). It is clearly not a real portrait; the general had died in old age, after a long illness, at least six months before Donatello came to Padua. If a death mask was taken, and used by Donatello, no trace remains of it in the features of the statue. Whatever the individual features of this face, its most notable quality is a Roman intellectuality and nobility of character which Donatello must have taken from portrait heads of the era between Augustus and Trajan. There is one head in particular (fig. 57), in the storerooms of the Vatican Museum,[62] that displays the qualities which Donatello, in the *Gattamelata,* resurrected as a triumphant image of Rennaissance *virtù.*

[61] See L. H. Heydenreich, "Marc Aurel und Regisole," *Festschrift Erich Meyer.* Hamburg, 1959, pp. 146–59.

[62] Kaschnitz-Weinberg, *op. cit.,* N. 622.

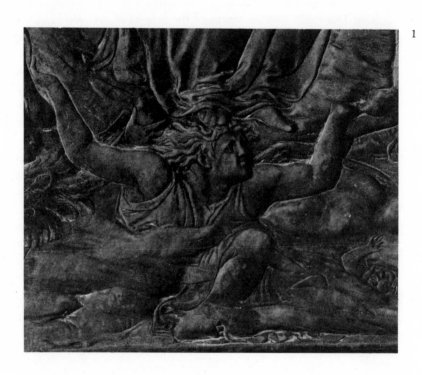

2

1. *Donatello*, Assumption of the Virgin
(*detail*), *on Tomb of*
Cardinal Brancacci. 1427–28.
Naples, S. Angelo a Nilo

2. *Roman Sarcophagus (detail).*
3rd century A.D. *Rome, Villa Medici*

3. *Sarcophagus of Junius Bassus*
(*detail*). *ca. 359* A.D.
Gotte Vaticane

3

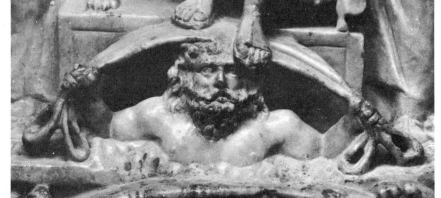

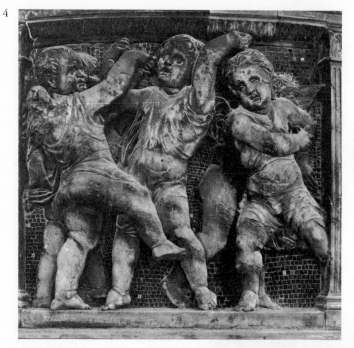

4

5

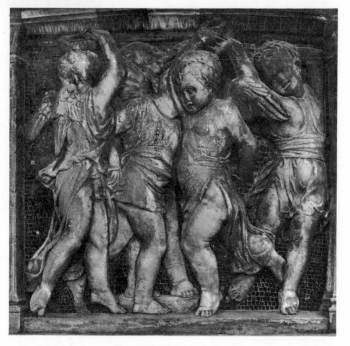

6

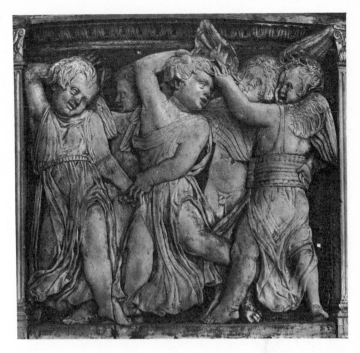

7

4. *Donatello,* Dancing Putti, *on Outdoor Pulpit. 1433–38. Prato, Cathedral*

5. *Roman Sarcophagus (detail). Museo Vaticano*

6. *Donatello,* Dancing Putti, *on Outdoor Pulpit. 1433–38. Prato, Cathedral*

7. *Donatello,* Dancing Putti, *on Outdoor Pulpit. 1433–38. Prato, Cathedral*

8. *Donatello,* Cantoria *(detail). 1433–39. Florence, Museo dell'Opera del Duomo*

9. Pankration *Wrestler. Bronze statuette, Roman. Paris, Louvre*

8

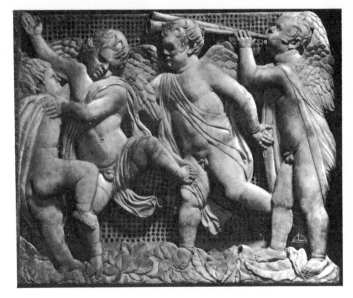

9

10

11

12

10. *Donatello, Panel of Bronze Door.*
1437–43. Florence,
S. Lorenzo, Old Sacristy

11. *Diptych of Probianus*
(lower portion). Ivory, ca. 400 A.D.
Berlin, Staatsbibliothek der
Stiftung Preussischer
Kulturbesitz

12. *Three Tablets (from a book cover?).*
Ivory, 9th century. Compiègne,
Musée National

13. *Two Spouts, on Roman Fountain*
Basin. Rome, Museo Nazionale
Romano delle Terme

14. *Donatello, Frame (portion) of*
relief, SS. Cosmas and Damian.
Stucco, 1434–37. Florence,
S. Lorenzo, Old Sacristy

15. *Roman Architectural Ornament.*
Stucco. Rome, S. Maria in Cosmedin

13

14

15

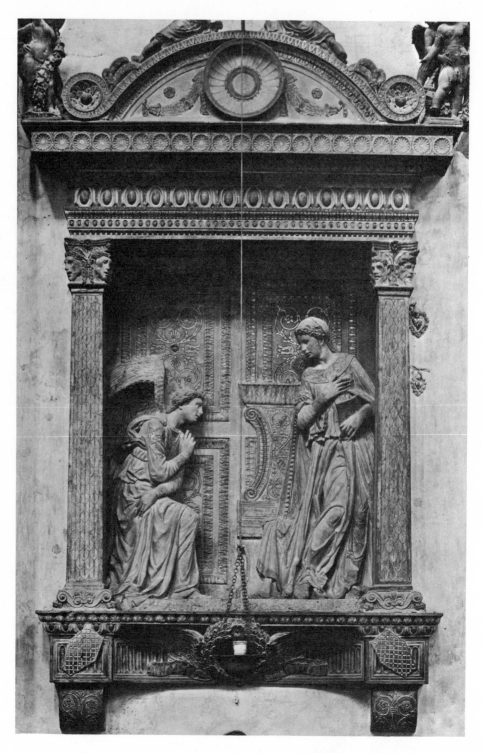

16. *Donatello, Tabernacle of the*
Annunciation. ca. 1428–33.
Florence, S. Croce

17. *Cover of Cinerary Urn. Roman.*
Museo Vaticano

18. *Tombstone of Cornelia Tyche and*
Julia Secunda (from drawing in
the Codex Coburgensis). Roman.
Paris, Louvre

19. *Cinerary Urn of Tiberius*
Claudius Victor (detail). Roman.
Paris, Cabinet des Médailles

20. *Tombstone of Julia Victorina*
(detail). Roman. Paris, Louvre

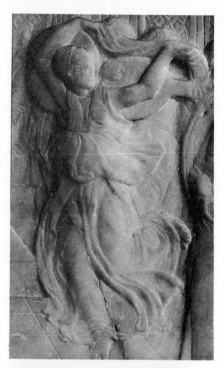

23

21. Donatello, Capital on
Annunciation *Tabernacle. ca. 1428–33.*
Florence, S. Croce

21

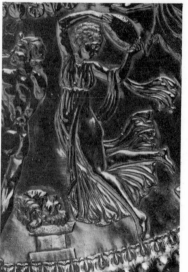

22

24

23. Donatello, The Feast of Herod
(detail). Marble, ca. 1433–35.
Lille, Palais des Beaux-Arts,
Musée Wicar

24. Roman Platter (detail), in
the Mildenhall Treasure. Silver,
4th century A.D. *London,*
British Museum

22. Double Herm. Roman.
Museo Vaticano

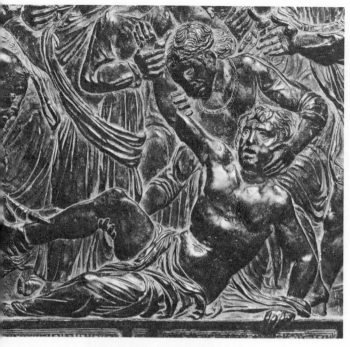

25

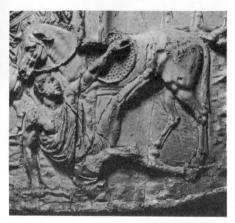
26

28

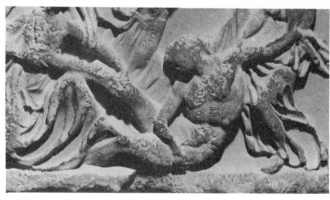
27

25. Donatello, Healing of the Irascible Son *(detail of son). Bronze, 1446-50. Padua, S. Antonio*

26. Soldier Fallen from His Horse *(from cast). Bronze, 106-13 A.D. Rome, Column of Trajan*

27. Pentheus Torn by Maenads *(detail), on a Roman Sarcophagus. Pisa, Camposanto*

28. Satyr Thrown by a Centaur *(detail), on a Hellenistic Sarcophagus. Museo Vaticano*

29

30

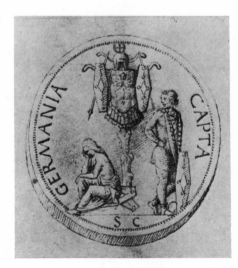

29. Donatello, Healing of
the Irascible Son *(detail of mother).*
Bronze, 1446-50. Padua, S. Antonio

30. Jacopo Bellini, Coin of
Tiberius. *Leadpoint drawing, retouched*
with pen; ca. 1450. Paris, Louvre

31. Donatello, The Feast of Herod
(detail), on the Baptismal Font.
Gilt bronze, ca. 1425.
Siena, S. Giovanni

32. Infant Hercules Strangling
the Serpents *(detail). Roman wall*
painting. Pompeii, House
of the Vettii

33. Niccolò di Pietro Gerini,
Martyrdom of St. Matthew *(detail).*
Fresco, ca. 1390. Prato, S. Francesco

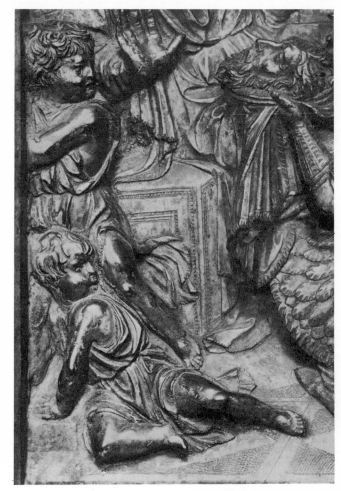 31

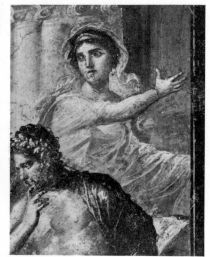 32

 33

34

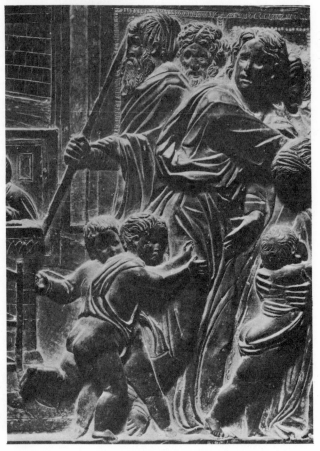

35

36

37

38

34. *Roman Medea Sarcophagus (detail).*
Rome, Museo Nazionale Romano delle Terme

35. *Donatello,* Miracle of the Heart of
the Miser *(detail). Bronze, 1446-50.*
Padua, S. Antonio

36. *Donatello,* Resurrection *(detail),*
on Bronze Pulpit. ca. 1460-70. Florence, S. Lorenzo

37. *Roman Meleager Sarcophagus (detail of drawing*
in the Codex Coburgensis). Rome, Villa Albani

38. *Taddeo di Bartolo,* Resurrection *(detail),*
on 2nd predella of High Altar. ca. 1400.
Montepulciano, Cathedral

41

39. *Donatello*, Crucifixion *(detail)*,
on Bronze Pulpit. ca. 1460–70.
Florence, S. Lorenzo

40. *Imperial Lion Hunt Sarcophagus*
(drawing in the Dal Pozzo-Albani Collection,
Windsor Castle). 3rd century A.D.
Rome, Palazzo Mattei

41. *Congiarium of Marcus Aurelius.*
161–80 A.D. *Rome,*
Arch of Constantine

42. *Donatello*, Apotheosis of
St. John. *Stucco, 1434–37.*
Florence, S. Lorenzo, Old Sacristy

42

43

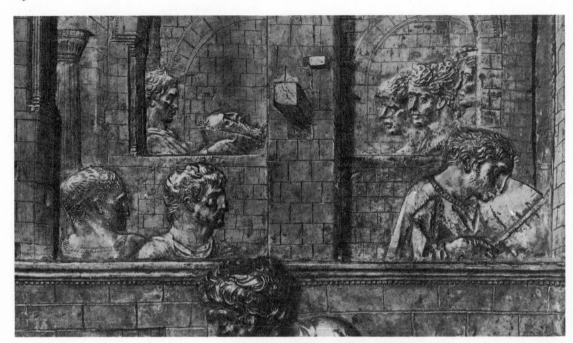

44

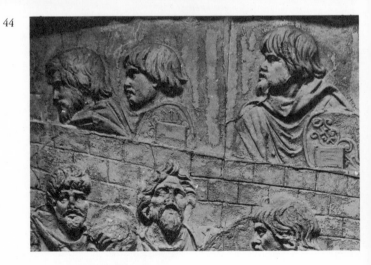

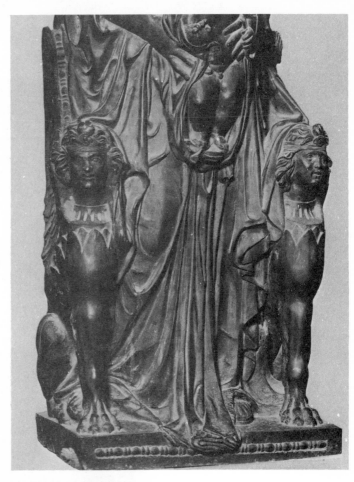

43. *Donatello,* The Feast of Herod
(detail), on the Baptismal Font.
Gilt bronze, ca. 1425.
Siena, S. Giovanni

44. Dacians Behind a Wall
(from cast). Bronze, 106–13 A.D. Rome,
Column of Trajan

45. *Donatello,* Madonna Enthroned
(detail). Bronze, 1446–50.
Padua, S. Antonio

46. *Donatello,* Adam *(detail of back*
of Madonna Enthroned*). Bronze,*
1446–50. Padua, S. Antonio

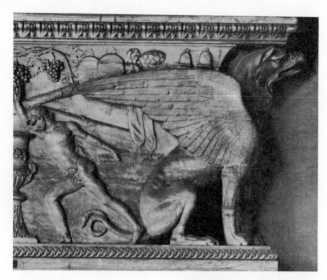

47

48

47. *Roman Table Support (right half).*
Museo Vaticano

48. *Roman Table (detail).*
Museo Vaticano

49. *Donatello,* St. John on Patmos
(detail). Stucco, 1434–37.
Florence, S. Lorenzo, Old Sacristy

50. *Cover of Cinerary Urn from Vulci. Etruscan.*
Florence, Museo Archeologico

51. *Donatello,* Dancing Putto,
on the Baptismal Font.
Bronze, 1429. Siena, S. Giovanni

52

53

52. *Donatello*, Jeremiah.
1427–35. Florence,
Museo dell'Opera del Duomo

53. *Tombstone of Quintus Sulpicius*
Maximus (detail). 94 A.D. *Rome,*
Museo Nuovo Capitolino

54. Marcus Holconius Rufus.
Augustan. Naples, Museo
Archeologico Nazionale

55. *Donatello*, Gattamelata
(without horse). Bronze, 1448–50.
Padua, Piazza del Santo

56

57

56. *Donatello*, Gattamelata *(detail)*. *Bronze,*
1448–50. *Padua*, *Piazza del Santo*

57. Portrait of a Man.
Late 1st century A.D. *Museo Vaticano*

14 STUDY

The Right Arm of
Michelangelo's Moses

"The Right Arm of Michelangelo's *Moses*,"
Festschrift Ulrich Middeldorf, eds. Antje Kosegarten and Peter Tigler,
Walter de Gruyter, Berlin, 1968, pp. 241-47

The "action in repose"—in James Ackerman's memorable phrase—of Michelangelo's *Moses* has given rise to two contrasting interpretations of the statue: as a timeless image of the Lawgiver's character, combining the active and the contemplative life, or as a specific historical moment, when Moses sees his people dancing around the golden calf and is about to rise in his wrath and shatter the Tables of the Law (fig. 1).[1] The latter view, widely shared in the last century (among others, by Burckhardt, Grimm, and Justi), survives today only in the patter of tourist guides. Its most elaborate refutation is an essay by Sigmund Freud,[2] whose argument rests largely on the position of the right arm. According to the naturalistic interpretation, the hand grasping the beard expresses rising anger, while Freud maintains that what we see is not the calm before the storm, "not the inception of a violent action but the remains of a movement that has already taken place. In his first transport of fury, Moses desired to act . . . but he has overcome the temptation, and will now remain seated. . . ."[3] A moment before, the right hand had violently clutched the beard in uncontrolled rage, endangering the Tables; it was in order to save them from falling to the ground that Moses has relaxed his grip on his beard.

Freud even illustrates this hypothetical earlier phase with a drawing made to his specifications (fig. 2). Yet he acknowledges that his analysis has no scriptural sanction, and wonders in the end whether "we have taken too serious and profound a view of details which [Michelangelo] had introduced quite arbitrarily or for some purely formal reasons with no hidden intention behind. . .; perhaps. . . he has not completely succeeded, if his design was to trace the passage of a violent gust of passion in the signs left by it on the ensuing calm."[4] Apparently Freud sensed that while his reading of the visual evidence was a good deal more subtle than that of his predecessors, it left a residue of uncertainty: viewed psychologically, as an expressive gesture, the action of the right arm remains ambiguous.

De Tolnay, without polemicizing against Freud, by implication rejects a purely

[1] For a survey of these views, see Charles de Tolnay, *The Tomb of Julius II*, Princeton, N.J., 1954, pp. 103–4.

[2] Published anonymously in *Imago*, III, 1914, pp. 15 ff., and frequently reprinted; my references are to the English translation in Sigmund Freud, *On Creativity and the Unconscious* (Harper Torchbooks), New York, 1958, pp. 11–41.

[3] *Ibid.*, p. 33.

[4] *Ibid.*, pp. 40–41.

psychological interpretation. The touching of the beard, he claims, is a traditional element in the iconography of Moses, along with the Tables and the horns, as evidenced by a late Romanesque bronze statuette, in a style close to that of Nicholas of Verdun, in the Ashmolean Museum, Oxford (fig. 3).[5] The analogy between the two figures is indeed striking, despite their vast differences in scale, style, and date. Clearly, Michelangelo did not invent the beard-touching gesture. But we are now left to ponder the following problems: What, if anything, does the gesture mean? Is it an attribute of Moses? And where did Michelangelo take it from, since he could hardly have known the Ashmolean statuette?

The second of these questions must be answered in the negative. So far as I have been able to determine, the Ashmolean statuette is the only instance before Michelangelo of Moses touching or grasping his beard. The gesture itself, however, occurs in a number of examples ranging from the eleventh century to 1400 (those to be discussed below are no more than a representative sampling) and in a considerable variety of contexts, which ought to permit us to deduce its meaning. Closest to the Ashmolean statuette in style, date, and locale is a *St. John,* one of the four Evangelists supporting the foot of the Cross of St. Bertin in the Museum of St-Omer (fig. 4), a Mosan work about two decades earlier than the Ashmolean *Moses.* While his three companions are represented in conventional fashion, busily writing their gospels, John's head is tilted sharply upward and to his left. The left hand grasps the beard; the right, holding the pen, dangles idly (the book that once rested on his lap has been broken off). What might be the *tertium comparationis* linking the two figures and accounting for the use of the same gesture? John obviously is shown beholding the Vision on Patmos, which singles him out among the other Evangelists;[6] and the Ashmolean *Moses,* too, lifts his head toward the Lord above. The grasping of the beard, then, at least in these two instances, would seem to denote "awe in the presence of the Divine." We shall have to test this interpretation against the other cases available to us.

Unfortunately, the earliest example of the gesture in sculpture known to me yields no information in this respect: it is a mid-twelfth-century fragment from St-Denis—probably of a *voussoir* figure from the west portals—in the Louvre, consisting only of a head and a left hand.[7] All the other early examples I have been able to find occur in narrative contexts, not in isolated figures, indicating that the St-Omer *St. John* and the Ashmolean *Moses* were the exception rather than the rule. In a recently discovered stone relief of Mosan workmanship in Utrecht, ca. 1150-60, the gesture is made by a soldier standing next to the enthroned Pilate as both are witnessing the *Crucifixion* (which fills a separate companion plaque)—a situation that clearly demands "awe in the presence of the Divine."[8] That awe, or fear, is the primary meaning of the gesture is further

[5] *Loc. cit.;* cf. Hanns Swarzenski, *Monuments of Romanesque Art,* London, 1954, pls. 226, 227.

[6] *Ibid.,* figs. 396–99. For John as the divinely inspired *theologos* in medieval art, cf. Meyer Schapiro, in *Studies in Art and Literature for Belle da Costa Greene,* Princeton, N.J., 1954, pp. 331 ff.

[7] Marcel Aubert, *Moyen Age* (Musée National du Louvre, *Description raisonnée des sculptures,* I), Paris, 1950, p. 58, fig. 56; I am indebted to Dr. William M. Hinkle for bringing this work to my attention.

[8] The reliefs, found during excavations in the Pieterskerk, are about to be published in monograph form, with an analysis of the iconography, by Professor Rosalie M. Green of Princeton

suggested by the way it is used in the famous copy of the Utrecht Psalter made at St-Bertin or Canterbury about 1200.[9] In the miniature for Psalm 29 (30), the Psalmist is seated on the ground under a crescent moon, weeping and clutching his beard to illustrate the words, "weeping may endure for a night ..."; and in that for Psalm 6 (fig. 5), an old man clutching his beard appears conspicuously among the Psalmist's enemies, who are "ashamed and sore vexed." The last two examples might be expected to yield some clue as to the origin of the gesture, but such is not the case. Our motif does not occur in the corresponding places (or anywhere else) in the Utrecht Psalter itself and its two previous copies,[10] nor have I been able to find any instances in Carolingian art. Classical antiquity, too, fails to provide a source for it.[11] What appears to be the earliest example so far has been pointed out by Meyer Schapiro: the possessed man whose demon is being exorcised by Christ, in a miniature of the Codex Aureus in the Escorial (Echternach, mid-eleventh century); an Ottonian model such as this must have inspired the motif in the Parma Ildefonsus manuscript (Cluny, ca. 1100; fig. 6), where the heretic Jovinianus clutches his beard to show that he has been bested in debate by Ildefonsus.[12] The gesture would thus seem to have been invented in the area between the Meuse and Moselle, since the early examples are all linked with the style of that important region.[13]

University, who read a paper on the subject at the annual meeting of the College Art Association of America in New York in late January 1966. The beard-pulling soldier recurs more than a century later in Cimabue's *Crucifixion* fresco in the Upper Church of S. Francisco, Assisi.

[9] Paris, Bibliothèque Nationale, MS lat. 8846; [H. Omont], *Psautier Illustré, XIIIe siècle, Paris, Bibliothèque Nationale*, Paris, n. d., pls. 15, 38; cf. Swarzenski, *op. cit.*, p. 37, and fig. 5.

[10] London, British Museum, MS Harley 603, and Cambridge, Trinity College, MS R. 17, both produced in Canterbury in the early eleventh and mid-twelfth century, respectively.

[11] According to Otto Brendel ("Der schlangenwürgende Herakliskos," *Jahrbuch des Deutschen Archäologischen Instituts*, XXXVII, 1932, p. 200), Amphitryon is pulling his beard "in embarrassment" in a Pompeiian mural of the *Infant Heracles Strangling the Serpents* (House of the Vettii; K. Schefold, *Die Wände Pompeijs*, Berlin, 1957, VI, 15, I n, p. 144). However, Amphitryon—whose beard is too short for effective pulling—merely places his right index finger against his chin in a gesture of puzzled thoughtfulness that is well established in ancient art. Subsequent discussions of the mural do not comment on Brendel's interpretation of Amphitryon's gesture; cf., most recently, A. Greifenhagen, "Zwei Motive pompejanischer Wandgemälde auf Goldglas und Tonlampen," *Münchner Jahrbuch der bildenden Kunst*, XVI, 1965, pp. 47–54 (with bibliography). Amphitryon's gesture appears to be identical with that described under "Ratlosigkeit" (perplexity) by G. Neumann (*Gesten und Gebärden in der griechischen Kunst*, Berlin, 1965, pp. 109 ff.); in some of the Greek examples cited there, the fingers may lightly grasp a lock or two of the beard, but this incidental and casual fingering never seems to have developed, in ancient art, into the firm pulling of the entire beard such as we find in Mosan Romanesque art.

[12] Meyer Schapiro, *The Parma Ildefonsus* ... (Monographs ... sponsored by the Archaeological Institute of America and the College Art Association of America, XI), New York, 1964, fig. 4 and p. 15, note 29; the author terms the gesture "a sign of great tension." Cf. also *ibid.*, fig. 75 and p. 65, for the recurrence of the motif in the Madrid copy of the Cluny manuscript (ca. 1200). I owe this reference to the kindness of Dr. Erwin Panofsky. Dr. Schapiro generously provided the photograph of the Parma Ildefonsus miniature here reproduced.

[13] This conclusion must now be modified in the light of a recently published paper which was brought to my attention through the kindness of Professor P. H. von Blanckenhagen: P. Gjaerder, "The Beard as an Iconographical Feature in the Viking Period and the Early Middle Ages," *Acta Archeologica*, Copenhagen, XXXV, 1964, pp. 95–114. The rich material adduced by the author clearly establishes the Germanic origin of the beard-pulling gesture, even though its significance in Viking art remains obscure. Until the eleventh century, the motif seems to have been confined to Scandinavia and Ireland. Its appearance on the Continent may well have been due to the Normans, which would help to explain why the Romanesque examples occur mainly in the art of the Meuse and Channel regions (exceptional instances cited by Gjaerder are two capitals in S. Juan

After the foregoing, we are not surprised to find our motif entering the reper-
tory of High Gothic sculpture on the transept portals of Chartres Cathedral,
whose style in its origins is so clearly indebted to the art of Nicholas of Verdun.
The tympanum of the right portal of the north transept shows *Job on His Dung-
hill,* tormented by the Devil and flanked by his wife and the three friends (fig.
7). One of these pulls his beard, badly frightened by the sight of Job's misery
and the horrifying Devil. A few years later, the same figure appears, on a smaller
scale, in the *Job* episode on the tympanum of the Calixtus Portal at Reims
Cathedral.[14] William Hinkle, the only scholar to discuss the significance of
the gesture,[15] interprets it as "cynical deliberation," by analogy with the high
priest on the lintel of the left portal of the south transept at Chartres, who makes
the same "gesture of calculated malevolence" as he watches St. Stephen being
led away to be stoned.[16] The high priest's gesture, however, does not necessar-
ily express malevolence; it may well be intended to convey that he is vexed and
distraught after his disputation with the saint, like the figure pulling his beard
and clutching his head in the scene of *St. Stephen Disputing* on the tympanum
of the south transept of Notre-Dame, Paris, where the meaning of the gesture
is clear enough (fig. 8).[17] The vexed and distraught elder clutching his beard
must have been a fairly widespread figure in Gothic art during the middle years
of the thirteenth century, for we find him again soon after among the Jews under
the cross in the *Crucifixions* by Nicola and Giovanni Pisano. The most expressive
example occurs on the pulpit in S. Andrea, Pistoia (fig. 9). It was from Giovanni
Pisano that Duccio took over the motif as one of numerous gestures denoting
awe, fear, and amazement in the *Crucifixion* of the Maestà Altar (fig. 10). He
shows, in fact, two variants: one frightened elder clutches one-half of his forked
beard, the other "combs" his with his index finger.

 The further appearances of the gesture in the Trecento derive either from Duc-
cio or from Giovanni Pisano. The Italianate form of the motif also established
itself in the north through Jean Pucelle, who adopted it from Duccio in the *Cru-
cifixion* of the Hours of Jeanne d'Evreux about 1325.[18] Nevertheless it re-
mained rare in fourteenth-century art on either side of the Alps. Not until ca.
1400 do we find it in contexts other than the customary ones. Surely the most

de las Abadesas, Gerona, and a jamb statue of *St. Andrew* by Gilabertus in Toulouse). In connection
with its early appearance at St-Denis, it is interesting to note that the Cross of St. Bertin probably
reflects the lost Cross of St. Denis, which must also have been of Mosan workmanship ca. 1150,
if the splendid enamel plaque in the Museum of Fine Arts, Boston, once formed part of it; cf.
Rosalie M. Green, "Ex Ungue Leonem," *De artibus opuscula XL: Essays in Honor of Erwin Panofsky,*
New York, 1961, pp. 157–69. Perhaps the Cross of St. Denis had a beard-grasping figure similar
to the *St. John* on the foot of the Cross of St. Bertin, which suggested the use of the gesture among
the *voussoir* figures of the west portal.

[14] William M. Hinkle, *The Portal of the Saints of Reims Cathedral* (Monographs . . . College Art
Association of America, XIII), New York, 1965, fig. 87.

[15] *Ibid.,* p. 55.

[16] *Ibid.,* fig. 91.

[17] Begun 1257; cf. H. Karlinger, *Die Kunst der Gotik* (Propyläen-Kunstgeschichte, VII), Berlin,
1927, p. 392. The motif here derives from such Romanesque precedents as the debate between
Ildefonsus and Jovinianus (our fig. 6). See note 12 above.

[18] James J. Rorimer, *The Hours of Jeanne d'Evreux* (Metropolitan Museum of Art), New York,
1957, pl. 14 (fol. 68 v).

unexpected use of the gesture at that time occurs in a manuscript of *L'Epître d'Othèa à Hector*, by Christine de Pisan, illuminated by a highly individual master who may have come to Paris from Lombardy:[19] Polyphemus grasps his beard in shocked surprise as Ulysses, who has crept up behind him, puts out his eye. Of equal interest, although rather more orthodox, is the appearance of the motif in the bust portrait of Heraclius on the obverse of one of the pair of medals purchased by the Duke of Berry in November 1402 (fig. 11). Its meaning here, as in the *St. John* from the foot of the Cross of St. Bertin and the Ashmolean *Moses*, is very clearly "awe in the presence of the Divine"; the emperor's head is raised toward the bundle of rays above him, and from his mouth issue the words, ILLVMINA VVLTVM TVVM DEVS.[20] This, then, is the vision that sent Heraclius forth among the Gentiles to retrieve the True Cross, and his hands eloquently convey his state of mind: the left clutches his beard while the right "combs" it, thus combining the gestures of the elders in Duccio's *Crucifixion*.

The argument about the date and place of origin of the two medals may now be regarded as settled, since Roberto Weiss has demonstrated that the Greek inscription must have been furnished by one of the Byzantine court officials who accompanied Emperor Manuel II Palaeologos on his visit to Paris in 1400–1402.[21] The Duke of Berry, who bought them from Antonio Mancini, a Florentine merchant in Paris, very soon after they were made, must have thought them authentic products of antiquity, for he immediately had replicas made of them.[22] The several versions of both medals known today are copies or variants of these replicas.[23] Inasmuch as the antiquity of the two medals went unquestioned until the end of the sixteenth century, some of these variants may have been produced more than a hundred years after the originals entered the duke's collection.[24]

Strangely enough, the Heraclius medal seems to mark the end of the tradition we have been tracing. I have been able to find only one instance of its survival in fifteenth-century art (see note 28). When Michelangelo employed the motif in his *Moses*, he must have revived it after a lapse of more than a hundred years. Where did he take it from? Among all the examples discussed above, the only one he is likely to have known is the Heraclius medal, unless we are willing to suppose, against all plausibility, that he singled out the beard-clutching elder

[19] Paris, Bibliothèque Nationale, MS fr. 606, fol. 11; Jean Porcher, *Medieval French Miniatures*, New York, 1959, p. 59, pl. LXI.

[20] The words are a slight modification of the Vulgate text of Psalm 66:2, which also occurs in the Introit of the Feast of the Exaltation of the Cross (September 14), as pointed out by S. K. Scher (*The Medals in the Collection of the Duke of Berry*, M.A. thesis, New York University, 1961 [typescript], pp. 136–37). The prayer continues on the curve of the waning moon from which the bust emerges: SUPER TENEBRAS NOSTRAS MILITABOR IN GENTIBUS. The moon, an ancient symbol of the city of Byzantium (Scher, *loc. cit.*), also symbolizes the *tenebrae* in contrast with the Light Divine above.

[21] Roberto Weiss, "The Medieval Medallions of Constantine and Heraclius," *Numismatic Chronicle*, seventh series, III, 1963, pp. 129–44.

[22] See *ibid.*, pp. 133, 142.

[23] *Ibid.*, pp. 134 ff.; see also Scher (*op. cit.*), for an analysis of the individual specimens.

[24] Weiss, *op. cit.*, pp. 129, 138.

from the multitude in one of the *Crucifixions* by Nicola or Giovanni Pisano. The Heraclius medal and its pendant were widely known in Italy. They influenced Pisanello, the obverses of both were copied in two large marble tondi on the façade of the Certosa of Pavia, and collectors of ancient gems and coins must have coveted them. Michelangelo thus may have seen the Heraclius medal either in Florence—perhaps in the Medici collection—or in Rome; it is hard to imagine that there were no copies of the medals in the Vatican. There is, moreover, an obvious analogy between the vision of Heraclius on the medal and Moses' confrontation with the Lord on Mount Sinai. Odd as it may seem that Michelangelo should have borrowed a motif of medieval origin from a northern Gothic source which he regarded as antique, our proposal helps us to understand more than one aspect of the *Moses*. It accounts for the very long, stringy beard of the statue, unique in Michelangelo's oeuvre and very different from the beards of the Moses images most familiar to him, those on the walls of the Sistine Chapel.[25] And it clarifies a rarely noted detail: it is not the right hand of the *Moses* alone that engages the beard but also the left, since the longest rivulets of hair at the tip of the beard come to rest among the fingers of that hand. This feature could have been derived only from the unique ambidextrous gesture of the Heraclius bust, although in Michelangelo's statue the action of both hands is far less emphatic.

Finally, the medal may explain why Michelangelo equipped his *Moses* with horns. These, based on a mistranslation of the Hebrew word for "light" in the Vulgate, were a traditional attribute of Moses in medieval art,[26] but the Florentine Early Renaissance did not favor them; Ghiberti omitted them entirely in the *Moses* panel of the "Doors of Paradise," and in their Sistine Chapel frescoes Botticelli and Signorelli substituted twin bundles of golden rays (had a humanist discovered the mistranslation?). The rays, of course, could not be rendered in marble, yet it seems a bit strange that Michelangelo should have reverted to the "horns of illumination." Apparently he felt it essential to include these signs of divine favor, bestowed upon Moses immediately after he had received the Tables (Exodus 34:29), just as Moses' encounter with the Lord reverberates in his slightly uplifted head and the engagement of the hands with the beard. In a sense, then, we may substitute the Heraclius bust for Freud's drawing as representing Moses' condition just before Michelangelo portrayed him. He is shown in a state of *détente* after the high drama of facing the Lord.

But we must be careful not to fall into the error of the nineteenth-century critics—an error still shared by Freud's interpretation—who viewed the statue as representing a specific moment of Moses' career.[27] The "post-encounter" aspect of the figure is only an aspect, and not even the dominant one, of Michelangelo's conception. It is to be understood in terms not of psychological plausibility but of the *Pathosformel* Michelangelo found in the Heraclius portrait and adapted to

[25] Well reproduced in L. D. Ettlinger, *The Sistine Chapel before Michelangelo*, Oxford, 1965.

[26] See De Tolnay, *op. cit.*, p. 104.

[27] Freud acknowledges (*op. cit.*, pp. 38–39) that this reading of the visual evidence had been largely anticipated as early as 1863 in W. Watkiss Lloyd's *The Moses of Michelangelo*, although he came to know this essay only after he had formulated his own conclusions.

his own purposes. In doing so, he achieved an action echoed in repose comparable to that of Donatello's Campanile statue of *Abraham and Isaac*. There, too, the climax of the drama has passed: the angel has come and gone, and Abraham's hand, though still holding the knife, relaxes its grip while his upturned face still mirrors the anguish of the father about to sacrifice his son.[28]

[28] An interesting northern parallel to Michelangelo's use of the "beard-gesture" has kindly been brought to my attention by Professor Hans Kauffmann (fig. 12); it occurs in a *St. Andrew* on one of the wings of an altar by the Master of the St. Bartholomew Altar in the Altertumsmuseum und Gemäldegalerie, Mainz (*Kölner Maler der Spätgotik*, Wallraf-Richartz Museum, Cologne [exhibition catalogue], Cologne, 1961, pp. 103–4, no. 31, pls. 69, IX). In this late work of the master, contemporary with Michelangelo's *Moses*, the left hand "combing" the beard is almost a mirror image of the right hand in the Heraclius medal, so that here, too, the use of our motif is a revival rather than the survival of a medieval tradition. Apparently the Master of the St. Bartholomew Altar, shortly before his death, had come to know the Heraclius medal through a local humanist who considered it antique, and "quoted" the gesture to show off his antiquarian *Bildung*, but without grasping its expressive purpose. That the medals were known to German humanists of the early sixteenth century is attested by Johannes Cuspinianus (1473–1529), who owned a specimen of the Heraclius one; see Weiss, *op. cit.*, p. 129, note 2. Cf. also Erwin Panofsky, "Conrad Celtes and Kunz von der Rosen: Two Problems in Portrait Identification," *Art Bulletin*, XXIV, 1942, pp. 39–54 (54, note 76). An even earlier revival of our gesture on the basis of the Heraclius medal may be the bust of *Cicero* by Jörg Syrlin the Elder on the choir stalls of Ulm Cathedral (1474; W. Vöge, *Jörg Syrlin der Ältere und seine Bildwerke*, II, Berlin, 1950, p. 74, pls. 34–36). As Vöge points out, the program of the stalls was inspired by early northern humanists; one of them might have known the medal and brought it to Syrlin's attention.

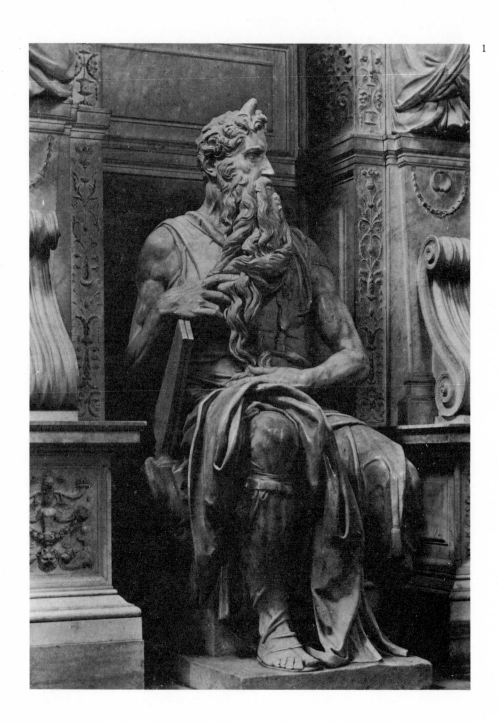

1

2

1. *Michelangelo,* Moses. *1513–15.
Rome, S. Pietro in Vincoli*

2. *"Reconstruction" of the prior
emotional state of Michelangelo's*
Moses *(after Sigmund Freud,
Imago, 1914)*

3. Moses. *Bronze statuette,
late 12th century. Oxford,
Ashmolean Museum*

4. St. John, *from foot of the Cross
of St. Bertin. ca. 1160. St-Omer,
Museum (after Swarzenski)*

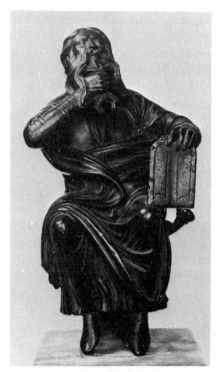

3

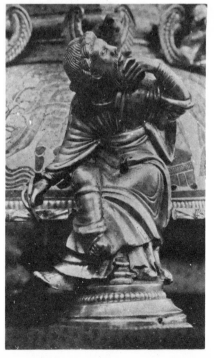

4

5

6

5. *Illustration for Psalm 6 (detail),*
in MS lat. 8846, fol. 11v. ca. 1200.
Paris, Bibliothèque Nationale

6. Ildefonsus Arguing with Jovinianus
(detail), in MS lat. 1650,
fol. 12v. ca. 1100. Parma,
Biblioteca Palatina

7. Job on His Dunghill *(detail),*
on tympanum of right portal,
North Transept. ca. 1220.
Chartres, Cathedral

8. St. Stephen Disputing,
on tympanum of South Transept.
ca. 1250. Paris, Notre-Dame

9. *Giovanni Pisano,* Crucifixion
(detail), on Pulpit. 1298–1301.
Pistoia, S. Andrea

10. *Duccio,* Crucifixion *(detail),*
on the Maestà Altar. 1308–11.
Siena, Museo dell'Opera del Duomo

7

8

9

10

11

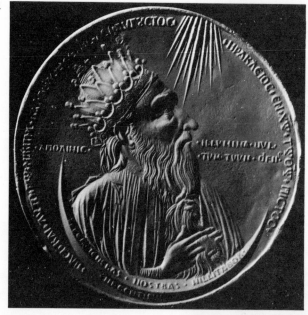

11. *Heraclius Medal, obverse (from cast).*
1400–1402. Paris, Cabinet des Médailles

12. *Master of the St. Bartholomew Altar,*
St. Andrew *(detail), on wing of*
an altarpiece. 1510–20. Mainz,
Altertumsmuseum und Gemäldegalerie

12

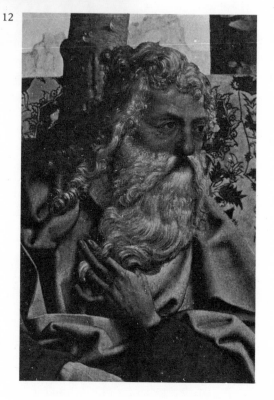

15 STUDY

The Meaning of the Giganti

"The Meaning of the *Giganti* ,"
Il duomo di Milano: Atti del Congresso Internazionale, Milano, Settembre, 1968 ,
ed. Maria Luisa Gatti, Vol. I, La Rete, Milan, 1969, pp. 61-76

The *giganti* of Milan Cathedral are the large statues (somewhat taller than life-size) that stand on the pier buttresses, in the zone just below the roof level, supporting the waterspouts. They take their name from the documents, which inform us that the earliest of these figures were made shortly before 1400 and that many others followed in quick succession.[1] These are to be found on the buttresses of the choir, but, in the later Quattrocento and after, the same program was continued along the flanks of the building, so that today we have what can only be described as a small army of *giganti*. What is their purpose? How was this very ambitious scheme conceived, and what are its antecedents, formal and iconographic? If we are to attempt an answer to these questions, we must try to find it in the early *giganti,* those dating from the first quarter of the fifteenth century, since they set the pattern for the rest.

Somewhat surprisingly, the scholarly literature has not concerned itself with this problem, so far as I am aware. Ugo Nebbia and Costantino Baroni, who studied our *giganti* in detail, did so purely in terms of chronology and authorship, trying to correlate the individual statues with the numerous masters' names, both Italian and foreign, recorded in the documents.[2] Despite their pioneering labors, there would seem to be room for a good deal of further work in this difficult area; but that is not my purpose. One reason why there is so little agreement about the authorship of the early *giganti* is the trouble we have in differentiating the statues mentioned in the account books. Most of them are referred to simply as "gigantes" pure and simple, and an occasional "gigas armatus" or "gigas deschalzus" does not really help to clarify matters, since we have a number of armed as well as of barefoot *giganti* to choose from. Still, these adjectives have a certain interest: they indicate that the term *"giganti"* as used in the Cathedral records is not a synonym for over-lifesize statues but refers to the special class of beings represented here. The large size of the figures is determined by the scale of the building and by their distance from the street-level beholder, rather than by the subject matter. Our statues, then, would retain the

[1] Ugo Nebbia (*La Scultura del Duomo di Milano,* Milan, 1908, pp. 53 ff.), argues that by 1400 several *giganti* must have been finished and installed, since Jean Mignot, in his critique of the design of the Cathedral (January 11, 1400), refers to five waterspouts on the exterior of one of the sacristies, and the waterspouts, in many though not in all instances, are carved from the same block as the *giganti.* The earliest specific reference to a *gigante* in the Cathedral records dates from 1403 (Nebbia, *op. cit.,* p. 61, note 2).

[2] Nebbia, *op. cit.,* and Costantino Baroni, *Scultura gotica Lombarda,* Milan, 1944, pp. 138–64.

status of *giganti* even if they happened to be less than lifesize. What this means is that in looking for the sources of our *giganti* we must survey the entire field of giants in medieval art regardless of their actual measurements.

Ultimately, needless to say, our *giganti* are the descendants of the *Gigantes* of classical antiquity, that race of earth giants who had to be subdued by the gods of Olympus and whose punishment was everlasting servitude. The best-known of them was Atlas, carrying the world on his shoulders; hence the entire class of male figures supporting heavy burdens came to be known as atlantes. How these atlantes—or telamones, to use the alternative term—were transmitted from ancient to medieval art need not concern us at the moment. They seem to have existed in illuminated manuscripts, in both the East and the West, throughout the early Middle Ages.[3] What interests us is their reappearance in monumental sculpture, which coincides with the emergence of the Romanesque style, toward the end of the eleventh century. This is clearly an Italian phenomenon, although it spread from there throughout the rest of Europe in the course of the twelfth century. What did these Romanesque predecessors of our *giganti* support, and where do they appear in the sculptural decoration of churches? Despite their great popularity, as witnessed by the large number of surviving examples, their role was a curiously restricted one. Those carved in the round support thrones (fig. 1), or the columns of porches, choir screens, and pulpits; those in relief, the frames of portals (fig. 2). In either case—and this seems to be true of all the early examples—they stand, or kneel, on the ground, separated from the pavement only by a plinth, base, or molding, as if their strength (like that of the *Gigantes* of antiquity) depended on contact with the earth. Only toward the middle of the twelfth century do these atlantes begin to show a degree of "upward mobility": they now appear on top of columns, as supporters of lintels and archivolts,[4] and on capitals.[5] The meaning of Italian Romanesque atlantes can be inferred not only from their position of servitude, their strained poses and anguished expressions, but from an extraordinary image (fig. 3) that occurs among the Genesis scenes of Master Wiligelmus on the façade of Modena Cathedral: in the Sacrifice of Cain and Abel, the Lord is shown in a circular gloriole supported by an atlas, with the inscription: HIC PREMIT, HIC PLORAT, GEMIT HIC, NIMIS ISTE LABORAT.[6] It tells us—I am here adopting the interpretation of Roberto Salvini—that the Lord presses while the atlas weeps, sighs, and labors ex-

[3] See Edmund W. Braun, s.v. "Atlant" in *Reallexikon zur deutschen Kunstgeschichte,* ed. Otto Schmitt, I, Stuttgart, 1937, cols. 1179 ff. The most recent survey of the subject, with a useful bibliography, is D. P. Snoep, "Van Atlas tot Last," *Simiolus,* II, 1967–68, pp. 6 ff.

[4] E.g., main portals, S. Zeno, Verona (Hans Dekker, *Romanesque Art in Italy,* New York, 1959, pl. 260); gospel pulpit, Salerno Cathedral (G. H. Crichton, *Romanesque Sculpture in Italy,* London, 1954, pl. 85a, and Dekker, *op. cit.,* pl.135); pulpit, S. Ambrogio, Milan (Crichton, *op. cit.,* pl. 26). Atlantes also appear as the crowning element of paschal candlesticks at Anagni, Salerno Cathedral, and the Cappella Palatina, Palermo (Dekker, *op. cit.,* pl. 117; Crichton, *op. cit.,* pls. 85b, 89).

[5] E.g., Monreale, cloister (Crichton, *op. cit.,* pl. 88; Dekker, *op. cit.,* pl. 161); gospel pulpit, Salerno Cathedral (Dekker, *op. cit.,* pl. 135); Modena Cathedral, choir (George Zarnecki, "A Romanesque Candlestick in Oslo . . .," *Kunstindustrimuseet i Oslo, Arbok,* 1963–64, pp. 45 ff.).

[6] See Roberto Salvini, *Wiligelmo e le origini della scultura romanica,* Milan, 1956, pp. 84 f., 110, fig. 39, and Herbert von Einem, *Das Stützengeschoss der Pisaner Domkanzel,* Cologne and Opladen, 1962 (Arbeitsgemeinschaft für Forschung des Landes Nordrhein-Westfalen; Geisteswissenschaften, Heft 16), p. 41, fig. 48. Cf. also Meyer Schapiro, "From Mozarabic to Romanesque in Silos," *Art*

cessively. Thus the Atlas of antiquity has taken on the role of sinful mankind laboring under the weight of the Lord to expiate its disobedience to His command. In much the same way, the atlantes supporting bishops' thrones, pulpits, or church portals may be viewed as sinners forced to sustain divine authority.[7] The analogy with the classical Atlas may have been reinforced by the fact that the *Nephilim* of Genesis, that sinful race which issued from the union of the sons of God with the daughters of men and perished in the Deluge, are rendered as "giants" in the Bible, both Greek and Latin.[8]

How are we to bridge the three-hundred-year gap between these modest-sized *giganti* of the Italian Romanesque and those on the buttresses of Milan Cathedral? The next stage in the development of the medieval atlas, we may expect, will be a fuller integration with the structure of the building. And this crucial step was taken not on Italian soil but in Norman England. It is surely more than coincidence that the earliest example of it exists at Durham, which has a better claim than any other site to being the birthplace of the structural system of Gothic architecture. The Chapter House of Durham Cathedral had an apse with ribbed groin vaults, and each of the four ribs rested on a capital supported by an atlas, not at ground level but at window height (fig. 4).[9] Stylistically, the Durham atlantes, datable toward 1140, are derived from Italian models (fig. 5).[10] Their function, however, as well as the fact that they constitute a "team" whose number is determined by the number of ribs employed, is unprecedented and pregnant with future possibilities.[11] No longer confined within the small-scale context of portals, pulpits, and choir screens, these atlantes belong to the realm of monumental architecture.

From the Durham *giganti* it is but a short step to those of Laon Cathedral half a century later. Here they appear on the exterior, supporting the cornice of the roof over the nave (fig. 6). Since they are correlated with the buttressing system (there is an atlas directly above every nave buttress), their number is very much larger than at Durham; for the first time, we can speak of a small army of *giganti,* as in Milan. Yet the Laon atlantes are still a far cry from the Milanese ones; they are of modest size, like those at Durham, and in relief, rather than carved in the round. Another step was necessary to complete their evolution,

Bulletin, XXI, 1939, p. 364, for an illuminating discussion of the form of this titulus, which has many analogues in Romanesque art.

[7] The identification of atlantes as images of Sin or Vice is explicit at Piacenza Cathedral, where the small atlantes supporting the lintel of the main portal are inscribed USURA and AVARITIA; see Crichton, *op. cit.,* p. 39. At S. Antonino, Piacenza, a figure of Adam after the Fall forms part of the doorpost of the portal, in the pose and function of an atlas (Crichton, *op. cit.,* pl. 28b; Geza de Francovich, *Benedetto Antelami,* Milan and Florence, 1952, pl. 23, fig. 42).

[8] See fig. 32.

[9] The drawing appeared in Robert William Billings, *Architectural Illustrations and Description of the Cathedral Church at Durham,* London, 1843, pl. 5. For the most recent discussion of the Chapter House and its atlantes, see Linda Seidel, "A Romantic Forgery: The Romanesque 'Portal' of Saint-Étienne in Toulouse," *Art Bulletin,* L, 1968, pp. 37 f. (with bibliography).

[10] Seidel, *loc. cit.,* emphasizes the stylistic relationship with the atlantes on the trumeau at Beaulieu as well.

[11] That the Durham Chapter House scheme was known and imitated on the European mainland is evidenced by the ribbed groin vault over the stairwell in one of the towers of Castel del Monte in Apulia (begun 1240); each of the six ribs rests on a corbel in the shape of a nude, crouching atlas. See Carl Arnold Willemsen and Dagmar Odenthal, *Apulien,* Cologne, 1958, figs. 90–92.

and that step was taken at Reims Cathedral about 1240.[12] There, as at Laon, every buttress is topped by a *gigante,* but now these figures are lifesize and fully three-dimensional (fig. 7). The earliest of the Reims atlantes, like those in Milan, are on the choir; the series was subsequently continued along the flanks of the church. With minor variations, they all represent a single type: muscular and heavy-set, they are powerful laborers who display all their strength in sustaining the heavy load on their shoulders (fig. 8). Nevertheless, in contrast to their Romanesque predecessors, they seem neither anguished nor on the point of collapse. While the strain of their task is reflected in their poses and expressions, they discharge their duty with a dignity and purposefulness never seen before. The words describing the *gigante* of Master Wiligelmus in Modena, "plorat, gemit, nimis laborat," do not fit them in the least. It is difficult to see them as images of sinful humanity suffering divine punishment; we are tempted to say, rather, that they calmly fulfill a necessary task. Is this change in the character of the sculptured *gigante* simply a matter of style, reflecting the difference between Romanesque and Gothic? Our answer should probably be "yes," provided we are willing to think of style as a quality of the cultural climate rather than of artistic form alone. For, interestingly enough, giants as a species had undergone an upgrading, a rise in status, during the twelfth century; and this trend, too, apparently began in England and northern France. Thus John of Salisbury quotes his teacher, Bernard of Chartres, as having said, "We, like dwarfs standing on the shoulders of giants, can see more and farther not because we are keener and taller but because of the greatness which supports us and lifts us up."[13] This striking simile, honoring the achievements of the past—and more particularly, we may assume, of the classical, pagan past—by comparing our ancestors to giants, was soon taken up by a good many other authors. It came to be so widely known, in fact, that we even encounter it in Italian Mannerist art theory, which could describe the artists of the later sixteenth century as dwarfs standing on the shoulders of the giants of the High Renaissance.[14] It was toward the end of the twelfth century, too, that the image of the "good giant" St. Christopher was coined, who carries the world, in the person of the Infant Christ, on his shoulders as the Christian counterpart of the classical Atlas.[15] Atlas himself could appear as a "good giant" in astronomical manuscripts; we find him represented there holding up the heavens because he was a "magnus astrologus." He may have a companion, who also sustains the heavens and who turns out, surprisingly, to be the Biblical giant Nimrod (fig. 9).[16] Nimrod appears here not as the

[12] For the date, see the catalogue of the Council of Europe exhibition, *L'Europe Gothique,* Paris, 1968, which included one of the atlantes (No. 42, p. 27, with bibliography).

[13] See R. Klibansky, "Standing on the Shoulders of Giants," *Isis,* XXVI, 1936, pp. 147 ff.

[14] Gregorio Comanino, *Il Figino,* Mantua, 1591, p. 254, quoting Figino. See James H. Turnure, "The Late Style of Ambrogio Figino," *Art Bulletin,* XLVII, 1965, p. 36, who suggests that Figino may have taken the simile from Lomazzo.

[15] See Louis Réau, *Iconographie de l'art Chrétien,* III, 1, Paris, 1958, p. 311.

[16] Fritz Saxl, "Verzeichnis astrologischer und mythologischer illustrierter Handschriften . . . in römischen Bibliotheken," *Sitzungsberichte der Heidelberger Akademie der Wissenschaften, phil.-hist. Klasse,* VI, 1915, fig. 42. On Nimrod as astronomer, cf. C. H. Haskins, *Studies in the History of Mediaeval Science,* Cambridge, Mass., 1924, p. 342. On the transformation of Atlas into Evangelists in certain Ottonian manuscripts, see Erwin Panofsky, *Studies in Iconology,* Oxford, 1939, and New York, 1962 (Harper Torchbooks), p. 20, note 10. The four Evangelists supporting the wooden lectern from

builder of the Tower of Babel but as King of the Chaldaeans and the author of a treatise on astronomy, and hence another "good giant." The dignified appearance of the *giganti* at Reims, then, is not altogether unexpected.[17] It may also be relevant to note that their position on the building had originally been reserved for angels, as we know from one of the drawings by Villard de Honnecourt (fig. 10). No wonder that at least one of the Reims *giganti* (fig. 11) is actually smiling!

One other aspect of the Reims atlantes anticipates those in Milan: they are correlated not only with the buttresses but also with the sculptured gargoyles. It is, in fact, their specific task to support these strongly projecting waterspouts. The *giganti* on the nave of Laon Cathedral do not yet have this function. There are, however, two *giganti* between the portals on the façade at Laon who support waterspouts (fig. 12). They recur, far more prominently, on the Reims façade (fig. 11). Perhaps it was they who suggested the change from angels to *giganti* on the buttresses of the choir and nave. The purpose of the Milanese *giganti* is exactly the same: they, too, stand on buttresses and support gargoyles.

But we still have to bridge the 150-year gap between the Reims *giganti* and their successors at Milan Cathedral. There are, it seems, no other such cycles during this interval.[18] In view of the strong German influence at the Milan Cathedral workshop, we might well expect to find antecedents for our *giganti* on German soil between 1350 and 1400, especially in churches linked with the Parler family, but this is not the case, to the best of my knowledge. We are thus forced to the conclusion that the Milanese *giganti* are inspired by those at Reims Cathedral. How exactly this came about we do not know, since there is no way to determine from the existing documents who introduced the idea of the *giganti* at Milan. One thing is evident, however: the architect or master mason responsible for planning our *giganti* could not have known what the Reims atlantes really look like. He probably knew them only from schematic drawings such as those in the sketchbook of Villard de Honnecourt, which showed their placement above the buttresses and their function of supporting waterspouts, but could not serve as a guide to the sculptors who had to design and execute the Milanese *giganti*. Whereas the Reims *giganti* are all, in essence, variants of a single well-established type, those at Milan show an astonishing diversity. There is no awareness of a single basic model; apparently the masters who designed our *giganti* were left to their own devices in visualizing these figures, and thus borrowed

Alpirsbach (parish church, Freudenstadt; ca. 1150) do not derive from this Ottonian tradition but rather from the corner supports of the Dome of Heaven (for which see Karl Lehmann, *Art Bulletin*, XXVII, 1945, pp. 1 ff.).

[17] In Italy, too, atlantes experienced a rise in status about 1200: on the façades of Spoleto Cathedral and of S. Rufino, Assisi, they support rose windows, i.e., the "disk of heaven" which stands for Christ. See Karl Noehles, "Die Fassade von S. Pietro in Tuscania," *Römisches Jahrbuch für Kunstgeschichte*, 9/10, 1961–62, pp. 62 ff. This development, however, was confined to a few Central Italian monuments and remained without consequences, except insofar as it helps to account for the puzzling appearance of atlantes as the corner supports of the Dome of Heaven in the vault mosaic of the Scarsella in the Baptistery in Florence (ca. 1225–30). Cf. Noehles, *op. cit.*, p. 66, and Lehmann, *op. cit.*, fig. 41.

[18] As isolated reflections of the Reims atlantes we may cite an atlas from the destroyed rood screen of Mainz Cathedral and another, supporting a waterspout, from the nave of Frankfurt Cathedral, both ca. 1240–50; reproduced in Braun, *op. cit.*, figs. 6–8.

from a variety of sources. If we are to track down these sources, we must be prepared to survey the entire range of giants in the religious and secular iconography of medieval art. Such a task is far beyond the scope of this paper. All I can hope to do is to demonstrate the method in a few typical instances. Even these, I believe, will suggest the extraordinary diversity of the prototypes used by the designers of our *giganti*.

There are a few *giganti* whose iconographic meaning is fairly obvious. One of them—number 43 in Nebbia's numeration—is a Samson-Hercules rending a lion (fig.13).[19] We cannot be sure which was intended here: both were considered giants because of their superhuman strength and were often compounded in medieval art, so that the lion's skin, which our figure is wearing, could be given not only to Hercules but to Samson as well.[20] Moreover, both had architectural associations: Hercules with the famous Pillars, Samson with the city gate of Gaza. Another identifiable *gigante*—Nebbia's number 60—must be derived from an Aquarius (fig. 14). The model may well have been some astronomical manuscript such as Digby 83 in the Bodleian Library, Oxford (fig. 15). These treatises, as Fritz Saxl has shown, were among the chief vehicles for the transmission of classical imagery in the Middle Ages. Hence the nudity of the manuscript Aquarius and of the Aquarius-*gigante*. Presumably, a human figure projected upon the stars was a giant almost by definition. But nudity must also have been considered a generic attribute of atlantes, as evidenced by the large number of nude, or nearly nude, figures among our *giganti*. Here we meet another aspect of the classical tradition; many of the atlantes in Italian Romanesque sculpture are nude. This type was transmitted to the Trecento by Giovanni Pisano and his school, e.g., in the atlas beneath the Pistoia Pulpit, which retains not only the nudity but the anguished pose and expression of its Romanesque predecessors (fig. 16).[21] Among the nude *giganti* at Milan, there is at least one—Nebbia's number 49—whose pose and expression still betray an echo of this "sorrowful atlas" tradition (fig. 17). The type even entered northern art in the nude atlas of Lucas Moser's Tiefenbronn Altar (fig. 18); the ruined face indicates a proper awareness of the antique connotations of such a figure.[22] Did Moser perhaps pick up the idea in Milan?

Another obvious starting point for some of the Milanese *giganti* was the "good giant" St. Christopher, draped but barelegged and leaning on a tree trunk. The *giganti* of this type, of course, carry a waterspout rather than the Christ Child, but with a similar show of effort. The clearest instance is Nebbia's number 59 (fig. 19), which brings to mind the well-known bronze statuette, dated 1407, in the Boston Museum of Fine Arts (fig. 20).[23] The latter work has been re-

[19] As observed by Nebbia, *op. cit.*, p. 56 f.

[20] Cf. Réau, *op. cit.*, II, p. 236, and Panofsky, *op. cit.*, pp. 117, 157.

[21] See also the two large atlantes flanking the portal of S. Quirico d'Orcia, which stand on lions and thus take the place of columns or pilasters (Adolfo Venturi, *Storia dell'arte italiana*, VI, Milan, 1906, pp. 190 f., fig. 125).

[22] Cf. H. W. Janson, *Apes and Ape Lore in the Middle Ages and the Renaissance* (Studies of the Warburg Institute, 20), London, 1952, pp. 119 f., 151 f.

[23] See Georg Swarzenski, *Bulletin of the Museum of Fine Arts*, Boston, XLIV, 1951, pp. 84 ff. and Richard Krautheimer and Trude Krautheimer-Hess, *Lorenzo Ghiberti*, Princeton, N.J., 1956, pp. 83 f.; at present, the statuette is attributed by the museum staff to Nanni di Banco.

garded both as Florentine and as northern European, but is almost surely North Italian.[24] A second *gigante* of this kind even hitches up his garments with his right hand, as if he were standing in water (Nebbia 33; fig. 21). There are also some beardless *giganti* that seem to belong to this group, reminding us that St. Christopher could on occasion be represented as a youth (e.g., Nebbia 52; fig. 22).[25] But St. Christopher's tree trunk must have come to be regarded as a generic attribute, too: many of the nude *giganti* have one, whether old or young.

In most instances, the waterspouts—usually grotesque animals, human figures, or devils—are not very closely linked with the *giganti* whose task it is to support them. There are, however, some interesting exceptions to this rule, such as the nude youthful *gigante* carrying a ram on his shoulder like a classical Kriophoros (Nebbia 57; fig. 23). Particularly strange is the fact that he is shown running, yet this may be the clue to the origin of the image. A running Kriophoros—a shepherd fleeing from wolves—appears in late classical representations of the months, where he stands for April, as in the floor mosaic from the Great Palace in Istanbul (fig. 24). The image survived in some medieval calendar cycles, although with the shepherd standing rather than running.[26] It was, we may assume, simply the combination of man and animal that prompted the Milanese sculptor to take over this pagan counterpart of the Good Shepherd. In another *gigante,* the ram has turned into a huge dog (Nebbia 56; fig. 25), and the figure is smiling to betoken his awareness of the humor of the situation. The shepherd here has turned into a hunter, as indicated by the horn, which is attached to a strap hanging from his shoulder. And this horn carries us back to the calendar cycles, for in these March is often represented by a hornblower (fig. 26).[27] The horn is also the attribute of a true giant, Nimrod, who was reputed to be a mighty hunter. We see him "col corno"—as he is described in *Inferno,* XXXI, 71—in an illustrated Dante codex of the Trecento (fig. 27). Another *gigante* (Nebbia 55; fig. 28) further burlesques the dog-carrying hunter. The canine waterspout is of more modest size now, but the horn has been grotesquely enlarged, and the *gigante* is blowing it with puffed cheeks. A second hornblower in our series (Nebbia 50; fig. 29) is less easily explained, for she is a woman, the only *gigantessa* among the early members of the cycle. To account for her, we may have to look at her neighbor to the right, who must have been carved by the same artist (Nebbia 51; fig. 29). He is a youthful knight in armor, who

[24] I owe this insight to the kindness of Ulrich Middeldorf, who observed that a *St. Christopher* closely matching the Boston statuette in style and type occurs on the tomb of Prendiparte Pico (d. 1394) by Paolo di Jacobello dalle Masegne, in S. Francesco, Mirandola (see Pietro Toesca, *Il Trecento,* Turin, 1951, p. 426, fig. 391). Richard Krautheimer informs me that he has independently arrived at the same opinion. It may be worth noting that large sculptured images of St. Christopher on the exterior of churches were something of a North Italian specialty in the Trecento, as evidenced by the specimens on the north façade of St. Mark's, Venice, and at Gemona (see Otto Demus, *The Church of San Marco in Venice* [Dumbarton Oaks Studies, VI], Washington, D.C., 1960, p. 186).

[25] E.g., in the fresco by Bono da Ferrara in the Eremitani Church, Padua.

[26] Demus, *op. cit.,* p. 154, listing three sculptured examples of this Byzantine type in the West: St. Mark's, Venice; Trogir; and Otranto.

[27] E.g., in addition to Ferrara Cathedral: Parma, Baptistery; Fidenza Cathedral; and Cremona Cathedral (Francovich, *op. cit.,* figs. 303, 449, 489).

312

originally held a weapon in his right hand. The fact that his waterspout is a vicious-looking dragon suggests that he is modeled on a St. George—who was not an "official" giant but, as a dragon-slayer, the relative of Samson and Hercules. Could the lady hornblower have been derived from the princess associated with St. George? She wears a wreath of flowers on her head, indicating her status as a virgin if not as a princess. Her waterspout, a nude woman with a hideous serpent wound around her, represents the opposite of chastity, the vice of *luxuria*. Perhaps, then, the *suonatrice di corno* is the virgin in the legend of the hunt of the unicorn, who blows the horn to signal her companions that she has caught the elusive beast.[28] I have yet to find, however, a visual example of "the lady with the unicorn" carrying a hunting horn, let alone blowing it. There is still a third possible explanation, and to my mind the most likely one: in Romanesque cycles of the months, the horn-blowing personification of March may be accompanied by a youth wearing a wreath and carrying a flower (Ferrara Cathedral; fig. 26), or by a young woman carrying a flower and personifying Spring (Cremona Cathedral; fig. 30). Our *suonatrice* may thus be a conflation of these figures, a Primavera sharing the attributes of March and April. As for the waterspout, we know from the documents that it was done by another sculptor,[29] so that its link with the *gigantessa* may be a very tenuous one.

Our "St. George" is not the only *gigante armato* among the early atlantes of Milan Cathedral. There are several others, but they seem to offer no clues to a specific identity and may simply be "mighty warriors" in a generic sense. One of them (Nebbia 67; fig. 31) holds a tree trunk like the *giganti* of the St. Christopher type; his right hand once held a weapon of which only the handle survives. He is also barelegged and barefoot, a rather strange feature for a warrior. Perhaps this figure—and some others of similar type—are related to still another iconographic tradition: the race of giants (*Nephilim*) mentioned in Genesis. They were illustrated in Byzantine Octateuch manuscripts (fig. 32), where they appear as heavy-set, barelegged and barefoot figures, with long hair and beard, carrying crude weapons. The source of this tradition must have been images of Barbarians in classical art. Whether these Byzantine Old Testament giants were sufficiently well known in Trecento Italy to have influenced our *giganti* still remains to be determined.

After this brief excursion into the iconographic puzzles of the Milanese *giganti*, we must, in conclusion, consider their possible relationship to the *giganti* of St. Mark's in Venice and of Florence Cathedral. Those on the façade and on the north flank of St. Mark's would seem to be clearly inspired by Milan. The earliest of them appear to date from about 1420. In contrast to our *giganti*, however, they all belong to one type: they are nude, and the waterspouts they support have the shape of urns, so that they look like greatly enlarged versions of the Four Rivers of Paradise.[30] The giants of Florence Cathedral present a more complex problem. Let me briefly summarize the known facts:[31] in 1408

[28] This possibility was suggested to me by Professor Caleca of the University of Pisa.
[29] Nebbia, *op. cit.*, p. 62.
[30] See Camillo Boito, *La Basilica di S. Marco*, Venice, 1881 ff., pls. 85, 212, 213, 218, 219, 228, 229, 231, 236, 237. So far as I know, these figures have never been studied in the scholarly literature.
[31] See H. W. Janson, "Giovanni Chellini's *Libro* and Donatello," *Studien zur toskanischen Kunst:*

Nanni di Banco and Donatello carved two lifesize marble statues, destined for the tops of two of the buttresses of the *tribuna* of the Cathedral. These figures, however, were never installed, evidently because they were too small to be seen effectively at such a height. Two years later, the *operai* commissioned Donatello to make another statue for the same location, a terra-cotta figure three times life-size, which he finished in 1412. He then began a second statue of the same kind but did not complete it, since the entire cycle was abandoned for the time being. The *operai* revived it fifty years later, when they commissioned Agostino di Duc-cio to produce a terra-cotta statue as tall as Donatello's (I suspect that he merely completed the second giant begun by Donatello). The third giant was to be of marble, but Agostino, who had been asked to carve it, abandoned the commission. In 1501 the block was turned over to Michelangelo, who carved his famous *David* from it. This statue, however, was never installed on the buttress for which it had been intended. What interests us here is the decision of the *operai*, between 1408 and 1410, to abandon the cycle of lifesize statues of prophets for the Cathedral buttresses and to replace it with colossal figures nine braccia (i.e., more than five meters) tall. Sheer size seems to have been the determining factor, rather than iconographic significance: Donatello's first giant statue was simply called "huomo grande" in the documents. It came to be termed a *Joshua* only after it was finished, but the name never caught on—everybody called it "the Gigante." The second giant, begun by Donatello and completed after a fifty-year interval by Agostino di Duccio, appears in the contract as "uno ghugante overo Erchole," *Erchole* here being simply a synonym for *gigante*. The *operai* left it to the *ceremoniere* of the Cathedral to find an appropriate title for the figure, and the documents fail to tell us what name, if any, he chose. The marble giant, it is true, is called "a prophet" in the contract, but without a name, and later entries simply call it a *figura* or *gigante*. It did not become a *David* until the block was entrusted to Michelangelo. What we have here, then, is some awareness of the original program, a cycle of prophets, overshadowed by a concern with sheer size, with *giganti* as a distinct class of statuary. According to Florentine Quattrocento usage, a *gigante* is simply a *huomo grande,* a colossal statue; the term has lost the iconographic connotation of servitude or support that still clings to it in Milan. Now, it is entirely possible that the Florentine *operai* thought up the notion of a series of *giganti* for their Cathedral all by themselves. On the other hand, the *giganti* cycle in Milan was begun in the 1390s, and a few years later several *giganti* were already completed and installed. In view of the well-known rivalry between Florence and Milan at the time, we may assume that the building of Milan Cathedral aroused considerable interest among Florentines. Thus a program as ambitious as the Milanese *giganti* cycle may well have been known in Florence soon after its inception, and may have influenced the decision of the *operai* in 1410 to launch a *giganti* cycle of their own. If this conjecture is right, the Milanese *giganti* form an essential evolutionary link between the atlantes of Reims Cathedral and Michelangelo's *David*—between High Gothic and High Renaissance.

Festschrift Ludwig Heinrich Heydenreich, Munich, 1964, pp. 131 ff. (and above, pp. 107–16), and Charles Seymour, Jr., *Michelangelo's David,* Pittsburgh, 1967, pp. 21 ff.

1

2

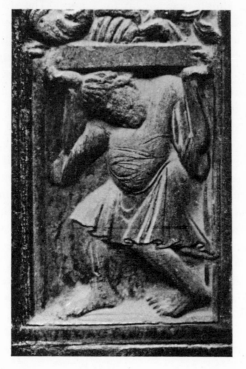

3

1. *Atlas, on Episcopal Throne.*
12th century. Bari, S. Nicola

2. *Atlas, on Main Portal.*
Early 12th century.
Modena, Cathedral

3. *Master Wiligelmus,* Cain and
Abel Sacrificing *(detail).*
1100-1110. Modena, Cathedral

4. *Apse, Chapter House (engraving). ca. 1140.*
Durham (destroyed 1796)

5. *Two Atlantes, from Chapter House.*
ca. 1140. Durham, Cathedral Library

6

7

8

6. *Atlas, above Nave Buttress.*
ca. 1190. Laon, Cathedral

7. *Exterior of Choir (detail).*
ca. 1240. Reims, Cathedral

8. *Atlas. ca. 1240.*
Reims, Cathedral

9. Atlas and Nimrod, *in Cod. Pal.*
lat. 1417, fol. 1r. Biblioteca
Vaticana

10. *Villard de Honnecourt,*
Exterior and Interior Elevation
of a Bay of the Cathedral
of Reims, *in MS fr. 19093, lxii.*
ca. 1240. Paris,
Bibliothèque Nationale

11

11. *Atlas, on Façade. ca. 1240.*
Reims, Cathedral

12. *Atlas, on Façade. ca. 1190.*
Laon, Cathedral

13. *Gigante 43. ca. 1400.*
Milan, Cathedral

12

14

14. Gigante 60. *ca. 1400.*
Milan, Cathedral

15. Aquarius, *in MS Digby 83.*
Oxford, Bodleian Library

16. *Giovanni Pisano, Atlas,*
on Pulpit. 1298–1301.
Pistoia, S. Andrea

17. Gigante 49. *ca. 1400.*
Milan, Cathedral

18. *Lucas Moser,* Last Communion
of St. Mary Magdalene *(detail).*
1432. Tiefenbronn,
Parish Church

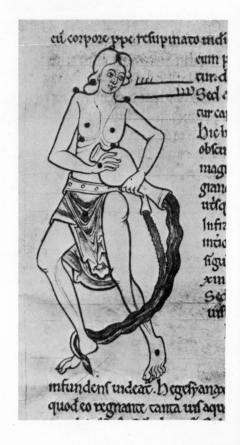

1

16

17

18

19

19. Gigante 59. *ca. 1400. Milan, Cathedral*

20. St. Christopher. *Bronze statuette, 1407.*
Boston, Museum of Fine Arts
(Arthur Tracy Cabot Fund)

21. Gigante 33. *ca. 1400. Milan, Cathedral*

22. Gigante 52. *ca. 1400. Milan, Cathedral*

20

21

22

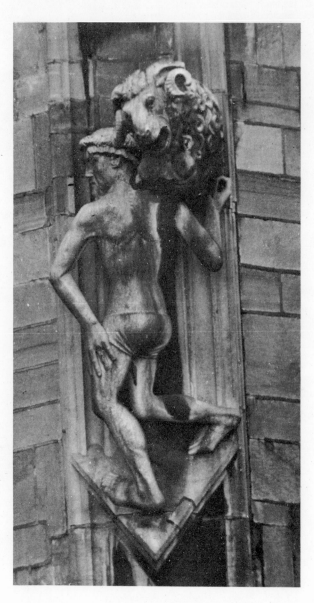

24

23. Gigante 57. *ca. 1400. Milan, Cathedral*

24. Kriophoros, *in Floor Mosaic. Early 6th century. Istanbul, Palace of the Byzantine Emperors*

25. Gigante 56. *ca. 1400. Milan, Cathedral*

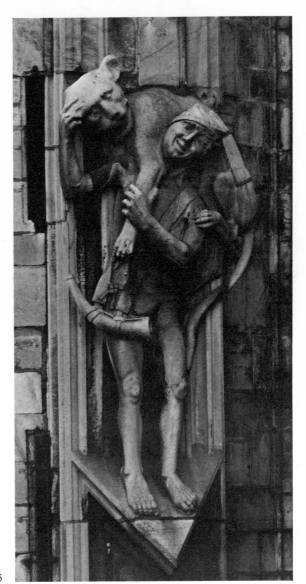

25

27

26

28

26. April *and* March. *12th century.*
Ferrara, Cathedral

27. Nimrod, *in MS Egerton 943,*
fol. 55v. 14th century. London,
British Museum

28. Gigante 55. *ca. 1400.*
Milan, Cathedral

29. Giganti 50 *and* 51. *ca. 1400.*
Milan, Cathedral

30. March *and* Spring. *12th century.*
Cremona, Cathedral Porch

29

30

31

32

31. Gigante 67. *ca. 1400.*
Milan, Cathedral

32. Nephilim,
in Seraglio Octateuch,
fol. 54v. Istanbul, Topkapu
Palace Museum

16

STUDY

*Criteria of Periodization
in the History of
European Art*

"Criteria of Periodization in the History of European Art,"
New Literary History: A Journal of Theory and Interpretation,
Vol. I, No. 2, 1970, pp. 115-22

In a famous essay, "Norm and Form," Ernst Gombrich has recently pointed out that the "procession of styles and periods known to every beginner [in the history of art] ... represents only a series of masks for two categories, the classical and the non-classical." The former category, in Gombrich's listing, is represented by Classic, Renaissance, and Neo-Classical, the latter by Romanesque, Gothic, Mannerist, Baroque, Rococo, Romantic, all of which were originally terms of abuse (and, we may add, Impressionist and Cubist). Present-day art historians no longer share the positive or negative values once implicit in these labels. "We believe we can now use them in a purely neutral, purely descriptive sense." But, the author points out, this confidence is justified only so long as we do not try to define the limits of these categories too closely. When we do, we soon realize the fundamental difference between our methods of classification and those of the zoologist: "In the discussion of works of art description can never be completely divorced from criticism." Hence our perplexities in the debate about styles and periods.

Gombrich is certainly right. The very fact that we still use these traditional terms, however much their meaning has shifted since they first gained currency, betokens a kind of intellectual imprisonment. After all, even if we succeed in eliminating every trace of their normative flavor, they freeze the current groupings and divisions within the history of art and thus discourage us from looking for possible alternatives. We are all in Gombrich's debt, then, for having made us aware of the extent to which we are playing with loaded dice. Nor can we, I think, hope to play the game without loaded dice of *some* sort (although we might well want to exchange some or all of our present set for others), notwithstanding Gombrich's faith in "objective criteria" for judging such matters as correctness of drawing, balanced composition, lucid narrative, and the presentation of physical beauty as classical norms. Be that as it may, the insight his essay provides into the hidden normative weighting of so many of our key terms challenges us to re-examine the entire "procession of styles and periods" in Western art. (Prehistoric and non-Western art have problems of their own, some of which are dealt with in George Kubler's essay, but they are of another sort.)

The historian of literature—or, for that matter, of any subject other than the visual arts—is likely to wonder, as he looks over Gombrich's list of terms, why there are so many more of them than he is accustomed to in his own field. He will also want to know what exactly is the difference between "styles" and "periods." The two questions are not unrelated, although the link between them

may not be obvious at first glance. They become even more pressing once we realize that Gombrich's "procession" is far from complete (for his purposes, it did not have to be): it omits Archaic ("not-yet-Classic"), Hellenistic ("no-longer-Classic"), and Medieval, three terms conspicuously normative in origin, as well as the nonweighted terms derived from political-dynastic or cultural entities such as Roman, Early Christian, Byzantine, Carolingian, Ottonian. This latter group refers to successive phases of Western art during the first thousand years of our era. There are no weighted labels within this very considerable time span, for the simple reason that it was thought unworthy of serious attention until the present century. Nor are there such labels for any of the phases of ancient art preceding the Archaic. Measured in purely chronological terms, then, Gombrich's normative categories cover only two limited areas: Greek art from about 600 B.C. to the Roman conquest, and Western European art from about 1000 to 1900. Both are centered on "peaks of perfection"—Classic Greek art of the century between Pericles and Alexander the Great, and the Italian High Renaissance about 1500. Gombrich concerns himself only with these 1,500 years, out of a total of more than 5,000 during which we can trace a continuous tradition for historic Western art, beginning with the Old Kingdom in Egypt. He does so because they embrace the traditional core areas of art-historical study, and because to him the twin peaks of Classic Greek and Italian High Renaissance art remain objective realities. Whether or not we share the latter conviction (there are many today who resist it), we can well understand why he concentrates on the "weighted" phases of Western art; for the weighting itself, regardless of its validity, has been unquestioningly accepted for so long that it now is a historic fact of the first importance. We do not know who first proclaimed the doctrine that Greek art had reached perfection in what we are accustomed to calling the Classic age, but it must have been widely accepted not later than the time of Augustus. As Gombrich has demonstrated, it was taken for granted by both Pliny and Vitruvius, the two Roman authors on whom Vasari modeled his account of the development of Renaissance art toward perfection in Michelangelo and Raphael. This normative view also affects our knowledge of the monuments themselves: works of art cherished as Classic stand a far better chance than others to be known to posterity. Even if the originals are destroyed, they tend to survive in multiple copies, like the *Doryphorus* of Polyclitus. The same attitude is reflected in two artistic phenomena that have been with us since Roman (and perhaps since Hellenistic) times—Classicism, the conscious imitation of the Classic, and Archaism, the imitation, for special purposes, of the not-yet-Classic or indeed of the downright Barbaric (Primitivism). Finally, the belief in Classic perfection has colored our view of the evolution of artistic traditions quite unrelated (or assumed to be unrelated) to the Greek heritage. Thus Gothic art is often regarded as having reached its peak in the High Gothic or Classic Gothic cathedrals of France from 1200 to 1250, after a fairly brief Early Gothic phase and before a very long Late Gothic phase that lasted into the sixteenth century. Some modern scholars speak of Classic Mayan art or Classic Indian sculpture; and certain kinds of African Negro sculpture have been acclaimed as Classic examples of Primitive art. We even find perfection in negative achievement (e.g., a Classic *faux-pas,* a Classic boner), although here Classic has lost its evolutionary implications.

The idea that Greek art—or any other art that forms a coherent tradition—

strives toward the perfect realization of its potential and then declines, is obviously patterned on the life cycle of the individual: a fairly rapid growth to maturity followed by a gradual but ever more perceptible lessening of creative power. The analogy may be thought naive, just because it is so close at hand. A more sophisticated model drawn from the realm of biology would seem desirable but remains to be found. Still, imputing a quasi-human life to artistic forms has one signal virtue: it postulates that their evolution is irreversible. This is more than can be said of the alternative method, descended from the aesthetics of Burke and Schiller, which regards the history of art as a series of pendulum swings between polar opposites such as Optic and Haptic, Additive and Divisive. Gombrich rightly points out the shortcomings of such schemata and pleads for an unabashed "perfectionism." The life-cycle analogy, however, is peculiarly selective. We tend to apply it only to what we think of as periods of exceptionally high achievement; the rest of the history of art (which is to say most of it) has no clearly perceived peaks of perfection. There is no Classic phase in the art of Ancient Egypt or Mesopotamia, nor in Roman art or the art of the earlier Middle Ages. At the same time, we exempt individuals of exceptionally high artistic rank from the standard life-cycle pattern—who would dare to claim that the late works of Rembrandt or Beethoven represent a decline from their peak achievements?

Gombrich does not help us to resolve these paradoxes. When he warns that normatively weighted terms such as those he lists are not readily convertible into value-neutral morphological ones, he does not want us to cease using these labels altogether; he argues, rather, against the belief that "all works of art created in these distinct periods of human history . . . must share some profound quality or essence which characterizes all manifestations of the Gothic or the Baroque." Among art historians, this belief is clearly on the wane today. But on what grounds, we wonder, does Gombrich speak of Gothic or Baroque as "distinct periods of human history" if there is no such thing as Gothic Man or Baroque Man? Even if we assume that he meant "distinct periods of art history" (which need not correspond to periods in other fields of history) his answer is less than satisfactory. He advocates what he calls "a principle of exclusion" instead of a search for common morphological features, such as the desire to avoid being academic which he claims is shared by all present-day artists. While it is true that Gothic and Baroque originated as terms of exclusion (i.e., designating two different ways of being other-than-classic), I find it difficult to discern an equivalent "desire to avoid" which could be said to unite all Gothic or Baroque artists. How meaningful, for instance, would it be to state that Rubens and Vermeer both wanted to avoid being like Raphael? As a matter of fact, Rubens—but not Vermeer—did want to be like Raphael in some ways. Meyer Schapiro has pointed out that "in some periods there are opposed styles with forms that resist classification as elements of a common art." This has been increasingly true ever since the fifteenth century, and is strikingly evident today. But the more diverse the styles within a given time span, the less helpful becomes Gombrich's principle of exclusion. To say that all modern artists want to avoid being academic tells us nothing about their various ways of not being academic, and it is these, after all, that interest us. Art historians specializing in the nineteenth and twentieth centuries analyze their subject in terms not of periods, styles, or schools but of movements

(e.g., Impressionism, Cubism, Dada, Pop), none of them dominant or stable enough to be "period styles" at any time but identifiable nonetheless by their morphological and ideological continuity. It is not unhistorical, I think, to regard the Gothic as a movement—perhaps the earliest clearly discernible one in the history of art; starting at the Abbey of St-Denis shortly before 1150, it spread at varying rates of speed in every direction until, a century later, it had transformed the art of the entire Catholic West. From then on, the many regional variants of Gothic collectively formed the period style of the West for about two hundred years, a period style identifiable not by a common essence but by the morphological continuity of each regional variant with the original Gothic of the Ile de France. Moreover, the rest of Europe was quite aware of the origin of Gothic; it was known abroad as *opus francigenum* or *opus modernum*—the first style to be labeled "modern" by its own practitioners. Thus we hardly need a principle of exclusion (even if we are willing to assume that Abbot Suger of St-Denis and his masons were motivated by such a negative aim) in order to define Gothic as a distinct period of art history.

Surprisingly enough, some awareness of *opus francigenum* as the earliest modern architecture seems to have survived the coining of the derogatory label of Gothic. The *Cyclopaedia* of Ephraim Chambers, first issued in 1727, informs us, s.v. "Gothic architecture," that there are two kinds, ancient and modern; the former, brought from the North by the Goths in the fifth century A.D., is exceedingly massive, heavy, and coarse, while modern Gothic runs to the other extreme, being light, delicate, and rich to a fault. Under "Architecture," we further read that modern Gothic was encouraged by the French kings, especially Hughes and Robert Capet. Finally, s.v. "Modern," we learn that the term "modern architecture" is sometimes applied, though improperly, to both the "Italian manner of building, as being according to the rules of the antique," and Gothic architecture; it ought to be used for architecture "which partakes partly of the antique . . . and partly of the Gothic." Here apparently Chambers excerpted a different source. One wonders what examples of "partly antique, partly Gothic" buildings that author had in mind; certain seventeenth-century French châteaux and English country houses might satisfy his definition. As for "ancient Gothic," it obviously refers to what a century later was dubbed Romanesque (corrupt Roman) to distinguish it more clearly from Capetian Gothic, which by then was very highly regarded.

As an art-historical label, Romanesque has had a career very different from that of Gothic. Coined as a term of exclusion denoting medieval architecture before the Gothic, it covered a variety of styles over a span of some 700 years. The earlier of these styles have since been given separate, value-neutral terms (Anglo-Saxon, Carolingian, Ottonian), so that Romanesque today refers to the architecture associated with the revival of large-scale sculpture from the late tenth to the twelfth century; it also refers to the sculpture and painting of this two-hundred-year span. But its lower boundaries remain vague, and its morphological features vary so much from place to place that the concept of a Romanesque "period style" is far less coherent than that of Gothic. As a consequence, there have been no claims that Romanesque art expresses the spiritual essence of Romanesque Man as distinct from Gothic Man; in fact, Wilhelm Worringer, writing on the *Geist der Gotik* shortly before the First World War (the English transla-

tion has the misleading title *Form in Gothic*), discovered the "Gothic spirit" in all sorts of Romanesque and pre-Romanesque works.

If Gothic—and its conceptual descendant, Romanesque—are likely to remain meaningful as both styles and periods, this cannot be said of two other members of Gombrich's "procession," Mannerism and Baroque. Mannerism (derived from *maniera*, a pejorative label for the imitators of Michelangelo and Raphael in the writings of classicistic Italian critics of the seventeenth century) was launched by Max Dvořák in 1920 as a major period in literature and the arts, intervening between High Renaissance and Baroque but akin to neither. Dvořák saw it as related both to the Middle Ages and the twentieth century in its return to spiritual absolutes and its aversion to sensuous nature. After more than forty years of controversy John Shearman, the most recent critic to attempt a definition of Mannerism as a major period in the history of art (as well as of literature and music), regards it as a direct outgrowth of the High Renaissance and terms it "the stylish style." This would seem to be an attempt to split the difference between the Dvořák faction and the reductionist critics (Gombrich, Craig Smyth) to whom Mannerism is only one of several styles during the interval between High Renaissance and Baroque. The latter view is likely to prevail. The status of Baroque as a major period in the history of art embracing the seventeenth and part of the eighteenth century varies from country to country. It is least fully accepted in England and France (where the original pejorative meaning of the word as a synonym for bizarre or extravagant still appears in current dictionaries); more so in America and Italy (under German influence); and without reservation in Germany (as early as 1888, in *Renaissance und Barock*, Heinrich Wölfflin had argued for the Baroque as a period style with distinct values of its own rather than as a degenerate late version of Renaissance art). At present, art historians have three alternative ways of employing Baroque: as an art-historical period of the same order of magnitude as Renaissance; as an art-historical period within the Renaissance, i.e., the last major subdivision of the Renaissance conceived as a "megaperiod" (to use a term proposed by Erwin Panofsky) separating the Middle Ages from the Modern era (in this frame of reference, its order of magnitude corresponds to that of Gothic); and as one of several trends of style between 1600 and 1750, exemplified by Rubens, Pietro da Cortona, and Bernini. The first alternative tends to postulate Baroque Man as distinct from Renaissance Man and Gothic Man (in a famous lecture of 1913, Wölfflin claimed that the Baroque "saw differently" from the Renaissance), whose spiritual essence is presumably expressed not only in art but in literature and music as well; to demonstrate this essence requires great ingenuity in manipulating abstract concepts as well as a very judicious choice of examples. The second, more modest alternative offers fewer difficulties: it accommodates a certain continuity of development from the sixteenth to the seventeenth century and is less in conflict with the periodization patterns of other branches of history; even here, however, there is an implicit assumption of morphological unity that cannot be readily demonstrated. Only the third alternative leaves us free to admit how difficult it is to bring, let us say, Georges de La Tour, Poussin, and Pietro da Cortona (all painters born within three years of each other) into a common focus; but it poses the problem of how to classify and label all those artistic phenomena that lie outside this restricted definition of Baroque. Ideally, such labels ought to convey something of the

336

aesthetic qualities of the works of art to which they refer. Yet, to judge from past experience, labels of this kind are apt to be coined only in the heat of critical acclaim or disapproval and thus automatically "weighted." Value-neutral, purely morphological labels, it seems, can be coined—and made to stick—only in the realm of ornament (e.g., strapwork). The art historian looking for terms to apply to what he perceives as non-Baroque styles in the seventeenth century is thus likely to borrow them from political history (Queen Anne, Restoration, Louis XIV) and to endow them with as much morphological significance as they can accommodate. If their capacity is often all too limited, these political-dynastic labels at least have the virtue of resisting inflation into over-all period styles.

What, then, will be the future of our value-charged terminology? Of one thing we may be sure: there will be more such terms for art historians to cope with as new movements make their appearance on the artistic scene; they seem incapable of giving rise to any other kind of label. The normatively weighted classifications for the art of the past are likely to survive as well, but as styles with more clearly defined boundaries rather than as all-embracing periods, and with their residual normative implications ever more neutralized. Their relative importance will probably shrink as art historians turn increasing attention to non-Western fields where such terms never existed. I venture to hope that this trend will also promote closer cooperation and interdependence between art-historical scholarship and the other branches of historic study.

Acknowledgment of Sources

For permission to reprint these essays, grateful acknowledgment is made to the following sources:

The Art Bulletin, published by the College Art Association of America:
 Vol. XIX, 1937, pp. 423-49 ("The Putto with the Death's Head")
 Vol. XXVIII, 1946, pp. 49-53 ("Titian's *Laocoon Caricature* and the Vesalian-Galenist Controversy")
 Vol. L, 1968, pp. 278-80 ("Rodin and Carrier-Belleuse: The *Vase des Titans*")

De artibus opuscula XL: Essays in Honor of Erwin Panofsky, ed. Millard Meiss, New York University Press, 1961, pp. 254-66 ("The 'Image Made by Chance' in Renaissance Thought")

Arts and Sciences, published by New York University:
 Vol. II, No. 1, 1963, pp. 23-28 ("Fuseli's *Nightmare*")

Studies in Western Art: Acts of the Twentieth International Congress of the History of Art, Princeton University Press, 1963, pp. 98-107 ("Nanni di Banco's *Assumption of the Virgin* on the Porta della Mandorla")

Studien zur toskanischen Kunst: Festschrift für Ludwig Heinrich Heydenreich, Prestel, Munich, 1964, pp. 131-38 ("Giovanni Chellini's *Libro* and Donatello")

The Renaissance Image of Man and the World, ed. Bernard O'Kelly, University of Ohio Press, Columbus, 1966, pp. 77-103 ("The Image of Man in Renaissance Art: From Donatello to Michelangelo")

Art and Philosophy: A Symposium, ed. Sidney Hook, New York University Press, 1966, pp. 24-31 ("Originality as a Ground for Judgment of Excellence")

Aspects of the Renaissance: A Symposium, ed. Archibald Lewis, University of Texas Press, 1967, pp. 73-85 ("The Equestrian Monument from Cangrande della Scala to Peter the Great")

Stil und Überlieferung in der Kunst des Abendlandes: Akten des 21. Internationalen Kongresses für Kunstgeschichte in Bonn, 1964, Berlin, 1967, pp. 198-207 ("Observations on Nudity in Neoclassical Art")

Essays in the History of Art Presented to Rudolf Wittkower, Phaidon, London, 1967, pp. 83-88 ("Ground Plan and Elevation in Masaccio's *Trinity* Fresco")

Donatello e il suo tempo: Atti dell'VIII° Convegno Internazionale di Studi sul Rinascimento, Florence, 1968, pp. 77-96 ("Donatello and the Antique")

Festschrift Ulrich Middeldorf, eds. Antje Kosegarten and Peter Tigler, Walter de Gruyter, Berlin, 1968, pp. 241-47 ("The Right Arm of Michelangelo's *Moses*")

Il duomo di Milano: Atti del Congresso Internazionale, Milano, Settembre, 1968, ed. Maria Luisa Gatti, Vol. I, La Rete, Milan, 1969, pp. 61-76 ("The Meaning of the *Giganti*")

New Literary History: A Journal of Theory and Interpretation, published by the University of Virginia:
 Vol. I, No. 2, 1970, pp. 115-22 ("Criteria of Periodization in the History of European Art")

List of Photographic Credits

The author and publisher wish to thank the libraries, museums, and private collectors for permitting the reproduction of paintings, prints, sculpture, and drawings in their collections. Photographs have been supplied by the owners or custodians of these works except for the following, whose courtesy is gratefully acknowledged. Numerals in parentheses indicate the essay in which the work is illustrated.

A. C. L., Brussels: (5) 11; (10) 10; Alinari (Anderson, Brogi): (3) 2; (4) 2; (5) 1, 4-7, 9, 12-14, 16; (7) 1-15, 17, 19-21, 24, 25; (9) 3, 5, 8, 10, 15-17, 19-22, 26; (10) 9; (13) 1-4, 6-9, 14, 16, 21, 25, 29, 31-33, 35, 36, 39, 42-47, 49, 51, 52, 54-56; (15) 26, 30; Archives Photographiques, Paris: (10) 1, 4, 5, 11, 14; (14) 7; Britiish Museum (copyright), London: (4) 3, 5; Census of Ancient Works of Art Known in the Renaissance, Institute of Fine Arts, New York University: (13) 40; Courtauld Institute of Art, London: (15) 4-8, 10-12; Deutsches Archaeologisches Institut, Rome: (13) 13, 22, 26-28, 34, 44, 48; Deutscher Kunstverlag, Munich: (9) 18; *Forma e Colore*: (15) 15; Fototeca, Fabbrica del Duomo, Milan: (15) 13, 14, 17, 19, 21-23, 25, 28, 29, 31; Fototeca Unione, American Academy in Rome: (13) 15, 41, 53; Gabinetto Fotografico Nazionale, Rome: (9) 27; (14) 1; Giraudon, Paris: (10) 18; (13) 19, 20; Hirmer Verlag, Munich: (5) 8; Martin Hürlimann, Zurich: (9) 30; Istituto Centrale del Restauro, Rome: (14) 10; Bildarchiv Marburg: (10) 7; Museum of Fine Arts, Boston: (1) 12; Metropolitan Museum of Art, New York: (1) 10; National Buildings Records, London: (10) 8; A. Paoletti, Milan: (5) 10; Phaidon Press: (7) 16; R. Rémy, Dijon: (10) 15; Sadea/Sansoni: (15) 16; H. Schmidt-Glassner, Stuttgart: (9) 29; Soprintendenza alle Gallerie, Florence: (9) 13; (11) 5, 7, 8; Sotheby & Co., London: (12) 12, 21; Walter Steinkopf, Berlin: (7) 22; Warburg Institute, London: (15) 9, 15, 20, 27, 32; Villani, Bologna: (9) 1